Penelope Fitzgerald

Preface by Hermione Lee, Advisory Editor

When Penelope Fitzgerald unexpectedly won the Booker Prize with *Offshore*, in 1979, at the age of sixty-three, she said to her friends: 'I knew I was an outsider.' The people she wrote about in her novels and biographies were outsiders, too: misfits, romantic artists, hopeful failures, misunderstood lovers, orphans and oddities. She was drawn to unsettled characters who lived on the edges. She wrote about the vulnerable and the unprivileged, children, women trying to cope on their own, gentle, muddled, unsuccessful men. Her view of the world was that it divided into 'exterminators' and 'exterminatees'. She would say: 'I am drawn to people who seem to have been born defeated or even profoundly lost.' She was a humorous writer with a tragic sense of life.

Outsiders in literature were close to her heart, too. She was fond of underrated, idiosyncratic writers with distinctive voices, like the novelist J. L. Carr, or Harold Monro of the Poetry Bookshop, or the remarkable and tragic poet Charlotte Mew. The publisher Virago's enterprise of bringing neglected women writers back to life appealed to her, and under their imprint she championed the nineteenth-century novelist Margaret Oliphant. She enjoyed eccentrics like Stevie Smith. She liked writers, and people, who stood at an odd angle to the world. The child of an unusual, literary, middle-class English family, she inherited the Evangelical principles of her bishop grand-fathers and the qualities of her Knox father and uncles: integrity, austerity, understatement, brilliance and a laconic, wry sense of humour.

She did not expect success, though she knew her own worth. Her writing career was not a usual one. She began publishing late in her life, around sixty, and in twenty years she published nine novels, three biographies and many essays ~~and reviews. She changed~~ publisher four times when she started ~~with~~ Collins, and she never had an agent to ~~~~ her publishers mostly became her fri~~ends~~ dark horse, whose Booker Prize, with ~~~~ to everyone. But, by the end of her li~~fe~~

D1264071

it several times, had won a number of other British prizes, was a well-known figure on the literary scene, and became famous, at eighty, with the publication of *The Blue Flower* and its winning, in the United States, the National Book Critics Circle Award.

Yet she always had a quiet reputation. She was a novelist with a passionate following of careful readers, not a big name. She wrote compact, subtle novels. They are funny, but they are also dark. They are eloquent and clear, but also elusive and indirect. They leave a great deal unsaid. Whether she was drawing on the experiences of her own life – working for the BBC in the Blitz, helping to make a go of a small-town Suffolk bookshop, living on a leaky barge on the Thames in the 1960s, teaching children at a stage-school – or, in her last four great novels, going back in time and sometimes out of England to historical periods which she evoked with astonishing authenticity – she created whole worlds with striking economy. Her books inhabit a small space, but seem, magically, to reach out beyond it.

After her death at eighty-three, in 2000, there might have been a danger of this extraordinary voice fading away into silence and neglect. But she has been kept from oblivion by her executors and her admirers. The posthumous publication of her stories, essays and letters is now being followed by a biography (*Penelope Fitzgerald: A Life*, by Hermione Lee, Chatto & Windus, 2013), and by these very welcome reissues of her work. The fine writers who have done introductions to these new editions show what a distinguished following she has. I hope that many new readers will now discover, and fall in love with, the work of one of the most spellbinding English novelists of the twentieth century.

Hermione Lee
2013

By the same author

EDWARD
BURNE-JONES

PENELOPE FITZGERALD

FOURTH ESTATE • *London*

Fourth Estate
An imprint of HarperCollins*Publishers*
1 London Bridge Street
London SE1 9GF

www.4thestate.co.uk

This Fourth Estate paperback edition published 2014

First published in Great Britain by Michael Joseph Ltd in 1975
First paperback edition published by Hamish Hamilton in 1989

This revised edition previously published in paperback by Sutton Publishing in 1997

A catalogue record for this book is available from the British Library

ISBN 978-0-00-758822-0

Printed by CPI Group (UK) Ltd, Croydon CR0 4YY

MIX
Paper from
responsible sources
FSC® C007454

INTRODUCTION

If you stand in front of a large Burne-Jones painting, such as *King Cophetua and the Beggar Maid* in Tate Britain, or any other of his major works in oil, stained glass or tapestry, the modern world immediately recedes. The spell cast is hard to resist. No other English artist in the late nineteenth century so completely transports us into another realm where literary or mythological allusions meld with gently refulgent colour, in compositions that have been cunningly designed and elaborately finessed. The subtle strength of Burne-Jones's imagery owes much to his study of the Italian Renaissance, and in his work we find the last great flowering of the Renaissance tradition before modernism ran like a virus through all the arts, here and there turning its back on the past while determinedly heralding the importance of modernity. Burne-Jones, whose preference in art was for stillness, remained a stalwart opponent: having been brought up in Birmingham, in close proximity to some of the most damaging aspects of the Industrial Revolution, he famously announced that 'the more materialistic science becomes, the more angels shall I paint'.

Burne-Jones's response to the age in which he lived resonates with present-day anxieties about the social, cultural, financial and political implications of globalisation. Yet there are many reasons why he is so deeply sympathetic. The high-minded and deeply earnest John Ruskin cannot have been easy to tease, but when pseudo-Gothic and medieval public houses began to appear on street corners, Burne-Jones gently provoked him with the remark, 'Your doing, my dear.' Penelope Fitzgerald's biography gives us Burne-Jones's humour as well as his idealism, the man and his art, while tracing the trajectory of a career that transformed Ned Jones into Sir Edward Burne-Jones, the internationally renowned artist who was socially much in demand. Penelope Fitzgerald's narrative teems with famous figures from the Victorian era, and inevitably it is bound up with the history of Pre-Raphaelitism, for although Burne-Jones and his friend William Morris were not part of the original Pre-Raphaelite Brotherhood, they were drawn in during the late 1850s by D. G. Rossetti. Burne-Jones's early, painstakingly detailed pen-and-ink drawings on

Arthurian subjects equal in intensity the finest productions in this vein. He went on to make more robust the Pre-Raphaelite achievement, while Morris busily created outlets for its decorative style, through his determination to revive craft and to reform domestic design.

Penelope Fitzgerald seems at home amid this crowded setting. Admittedly, the six years she spent researching and writing this book gave her an impressive intimacy with her subject. But also relevant here is the fact that she herself was descended from a formidable tribe. There were three bishops in her family background, and immediately after she completed this biography, she wrote *The Knox Brothers* about her father (the writer and editor who brought *Punch* into the twentieth century) and her uncles, among whom was the Anglo-Catholic priest Ronald Knox who, after agonies of indecision, 'poped', then wrote about his spiritual journey and became a famous apologist for Roman Catholicism. From *The Knox Brothers* alone, quite apart from her later novels and her biography of the poet Charlotte Mew, it is evident that Fitzgerald understood the complex tensions harboured by individuals and within families. She was well prepared for the entangled loyalties within the Pre-Raphaelite circle, its creative brilliance as well as its dysfunctional ingredients. As a biographer, her observations are wry and sane.

Burne-Jones's mother died six days after his birth. He claimed that it left him with persistent guilt and made him ever after kind to women. The lack of a mother very probably triggered his desperate need for female affection. When he first met Georgiana Macdonald, who was to become his wife, she was only ten years old. They became engaged when Georgie was fifteen. Over the years, this small woman had to put up with a great deal, not least the emotional crisis caused by Burne-Jones's great passion for the Greek beauty Maria Zambaco and which was made worse by her public suicide attempt when he tried to extract himself from their relationship. Fitzgerald admires Georgie's firmness, her dignity and steadfastness. Others have remarked that she gazed at the world through pale grey eyes: Fitzgerald adds that these eyes 'did not so much seem to reprove small mindedness as refuse to admit its existence at all'.

The Birmingham of Burne-Jones's childhood had showed him that advancing industrialisation brought in its wake moral squalor. In response to this he looked back to medieval times, to what he felt

to be a more pristine world, and fed his mind on chivalric ideals. Fitzgerald understands this well: 'What he knew from his own experience was that beauty was an essential element without which human nature is diminished. If art gives us beauty it will make us more like human beings.' Amid the casual flow of imagery that surrounds us today, this argument may seem bluntly utilitarian and overly simplistic. But there is no doubt that Fitzgerald here identifies one of Burne-Jones's core beliefs. In old age his need for beauty sharpened his obsession with young women. He became completely besotted with one after another, including May Gaskell, to whom he wrote often five or six times a day, Fitzgerald reminding us that in this period there were in all seven posts in the course of a single day. It did not seem to matter to him that she was married. 'Mrs Gaskell, if not firm, must have been a tactful woman,' Fitzgerald remarks. 'She managed a difficult situation extremely well.'

This dry authorial voice is one of the pleasures of this book. Another is the use of idiosyncratic detail. Whistler, who favoured full-length portraits, is glimpsed weeping over his inability to capture on canvas the tightly trousered legs of his patron Frederick Leyland. After an outing which Burne-Jones made with three others, there is a trip back into London by means of a hired fly because one of the party, Ellen Terry, has suddenly taken against the train and refuses 'to get into the nasty thing'. And when Burne-Jones becomes a regular guest at country house parties, Fitzgerald reminds us how icily cold such houses could be, 'so that the ascent to the bedroom, candle in hand, was like an Arctic expedition'. We learn that once back in London, the artist took to meeting his young women in the heated Palm House at Kew Gardens. No wonder Georgie at one point goes in search of a country retreat where her husband can be removed from the fray of life. She travels to Brighton, turns her back on it, and walks over the Downs to Rottingdean. Here she finds an empty house on the village green which is promptly bought. One of its attractions was that the view from the back looked on to the Downs. From the front, the biographer notes, 'you could see the solid little grey church, which had survived gales and fires and even the restorations of Gilbert Scott'.

Fitzgerald's narrative repeatedly excites with the interest that surrounds Burne-Jones's artistic development. She takes us inside the studio, identifies recurrent themes, tracks commissions and

recognises the importance of exhibitions, particularly those held at the Grosvenor Gallery where the rich brocades and theatrical décor set off his art to perfection. 'From that day', his wife writes, with reference to its opening exhibition in 1877, 'he belonged to the world in such a sense that he never had done before, for his existence became widely known and his name famous.' Less happy was his relationship with the Royal Academy of Arts, from which he eventually resigned; and at the famous Whistler vs Ruskin trial he loyally, if reluctantly, gave evidence on Ruskin's behalf, which Whistler never forgave or forgot. Fitzgerald is an able guide to many things, but brings expert knowledge of flowers to Burne-Jones's use of them in his paintings. She evidently travelled far in search of his pictures, his decorative schemes and stained glass, and, although her critical analysis remains pleasingly light, she can be very discerning. His art, she concludes, is 'based on ideas and treatments that had lingered for years in his mind, a mind that was obliged to repeat certain obsessional patterns corresponding to the inner life'.

Alongside the procession of paintings that runs through this book are the many friendships which Burne-Jones enjoyed with writers and artists: with Swinburne and George Eliot; with 'Tad' – Sir Lawrence Alma-Tadema, the jocular painter of domestic scenes in ancient Greek and Roman times – with the painter of moral allegories G. F. Watts, with Ford Madox Brown, Val Prinsep and others. To some extent Fitzgerald's rich knowledge of Victorian art may have been stimulated by her friendship with the White Russian émigré and former Tate curator, Mary Chamot, who knew a great deal about Burne-Jones and kick-started the research for this book by lending its author the notebook Burne-Jones filled during a trip to Italy in 1871, a fact mentioned in Hermione Lee's indispensable biography of Penelope Fitzgerald.

The overall tone of Fitzgerald's biography of Burne-Jones is affectionate and admiring. But it does not ignore the tragic notes, which increase as time goes on. Burne-Jones is particularly saddened by the mental confusion that engulfed Ruskin and by Morris's decline. He is deeply moved by the sight of Morris's coffin on a haywain decorated with moss and entwined with striplings of willow. It was the exact opposite, Fitzgerald notes, of Lord Leighton's funeral, for the former President of the Royal Academy had lain in state in Burlington House before a public procession took him to his funeral

at St Paul's Cathedral. But it was Morris, not Leighton, that Burne-Jones had in mind when he wrote to May Gaskell, '... the King was being buried, and there was none other left'. Throughout this book, the reader's sympathy with Burne-Jones steadily deepens. Fitzgerald describes him at the beginning of 1898, aged sixty-five, his clothes now frequently crumpled, unlike the 'ridged' trousers worn by his fashionable son Phil, after much careful ironing. Burne-Jones was, we are told, 'more puzzled than ever by a world which was too arrogant to recognise that its restlessness was the result of a neglect of beauty'. Under the influence of this book's persuasive portrait, it is hard not to agree.

Frances Spalding
2014

To Valpy, Tina and Maria

CONTENTS

Picture Acknowledgements

Permission to reproduce illustrations has been kindly given by the following: Victoria & Albert Museum for photographs of Mrs Pat Campbell, May Morris, William Morris, Margaret Burne-Jones and Kate Vaughan; Sotheby's on behalf of a private owner for *Georgiana Burne-Jones* by Burne-Jones; British Museum for cartoons of Burne-Jones in middle age (from *Letters to Katie*, by permission of Macmillan London and Basingstoke); London Borough of Hammersmith Public Libraries for photographs of the Burne-Jones and Morris families, *Georgiana Burne-Jones* by Edward Poynter, Edward Burne-Jones and his son Phil, and Edward Burne-Jones and Angela Mackail; St Cecilia's Window, Christ Church Cathedral, Oxford, by kind permission of the Dean and Chapter of Christ Church Cathedral.

While every effort has been made to trace the owners of copyright material reproduced herein, the publishers would like to apologise for any omissions and would be pleased to incorporate missing acknowledgements in future editions.

FOREWORD AND ACKNOWLEDGEMENTS

Burne-Jones regarded with gloomy distaste the prospect of becoming the subject of a biography. Yet he was a late Romantic, whose pictures, on his own admission, are a series of images scarcely to be understood without a knowledge of the life which projected them. In this book I have tried to trace faithfully the daily life with its successes and disasters which he accepted with a modest irony peculiarly his own, and the inner life of a painter who might have said, with Jung: 'If I had left these images hidden in my emotions, they might have torn me in pieces.'

Any biographer of Burne-Jones must start from the *Memorials* collected during the six years after his death by his wife Georgiana, and from the materials for it which she deposited in a tin box in the Fitzwilliam Museum. There are, however, many other sources, particularly for the second part of his career, from 1870 to 1898. Most of the bibliography given at the end of this book consists of contemporary accounts and reminiscences. But beyond these there are diaries, notebooks and work-lists and more than three thousand letters written by Burne-Jones to his friends, who kept them out of affection, even when they were asked to throw them away.

My gratitude is due to the following people for their kindness and hospitality, and for generously allowing me to make use of papers in their possession: Miss Mary Chamot, who encouraged me to begin to research, and Professor W.E. Fredeman, who explained to me how to set about it; Mr Oliver Bagot, Mr Francis Cassavetti, Mrs Imogen Dennis, Lord Hardinge of Penshurst, the Dowager Lady Hardinge of Penshurst, Mr George Howard, Mrs Celia Rooke, Mr Lance Thirkell, Lady Tweedsmuir and the Society of Antiquaries of London.

I should also like to thank the following people who have answered enquiries and helped me in many different ways: Mrs Raymond Asquith, Lord Baldwin of Bewdley, Mme Marielle de Baissac, Mr Wilfrid Blunt, Mr Toby Buchan, Dr Raymond Chapman,

Mr Charles Carrington, Mr Leslie Cavan, Lord and Lady Clwyd, Mr Norman Colbeck, Dr Malcolm Easton, Professor Leon Edel, Dr Irmgard Feldhaus (Clemens-Sels Museum), Lady Gibson, Miss Phyllis Giles (Fitzwilliam Museum Library), Sir William Gladstone, Professor Gordon Haight, Miss L.F. Hasker (Hammersmith Borough Libraries), Mr Philip Henderson, Miss Helen Henschel, Mr Charles Jerdein, Mr Jeremy Maas, Lady Mander, Professor Roderick Marshall, Mrs June Moll (University of Texas at Austin), Mr David Masson (Brotherton Collection, University of Leeds), Mr Tom Nelson, Mr Peter Norton, Mr Richard Ormond, Mrs Dorothy Parish, Mr Terry Pepper, Mrs Louis Reynolds, Mrs Mary Ryde, Mr A.C. Sewter, Mr E.E.F. Smith (Clapham Antiquarian Society), Mr D.E. Clayton-Stamm, Miss Susie Svoboda, Mr E.F. Thomas (churchwarden of St Margaret's, Rottingdean), Mr W.S. Taylor, Mr F.H. Thompson (Society of the Antiquaries of London), Mr Raleigh Trevelyan, Mrs Elizabeth Wansbrough, Miss M. Walls (The Grange Museum, Rottingdean). In particular I should like to thank Mr John Christian for his patience and expert knowledge in correcting the typescript; the staff of the Print Rooms of the British Museum, the Fitzwilliam Museum, the Victoria & Albert Museum, the Watts Galleries, Compton, the William Morris Galleries, Walthamstow; and my own family.

The following publishers have kindly given permission for extracts quoted in the text: George Allen & Unwin (*The Winnington Letters* edited by Van Akin Burd); Peter Davies Ltd (*The Macdonald Sisters* by Lord Baldwin, and *The Young du Maurier* edited by Daphne du Maurier); the Yale University Press (*The Letters of George Eliot* edited by Gordon S. Haight).

P.M.F.

1
1833–53

A Childhood Without Beauty

Edward Burne-Jones was born on 28 August 1833, as Edward Coley Burne Jones, the only surviving child of Edward Richard Jones. He never knew his sister, who died in infancy, nor his mother, who died a few days after his birth, but he felt all through his life that he had lost them and sorely missed them.

Mr Jones was a not even moderately successful Birmingham gilder and frame-maker. He was probably of Welsh descent, but his ancestry is lost among many Joneses; as Burne-Jones pointed out when he at last took the step of hyphenating his name; to be called Jones is to 'face annihilation'. He did not know the Christian names of his grandparents on either side: his mother might have been more likely to keep the family annals, but she was dead.

The widower and his pale, delicate, unassertive little son continued to live over the shop, sharing a small bedroom overlooking the timber-yard behind it, where the raw wood for the frames was kept. Every Sunday, after listening to an Evangelical sermon with other small tradesmen at St Mary's, Whitall Street, they went to visit Mrs Jones's grave, and Ned was frightened to see his father cry. 'There's one thing I owe to my father, that is his sense of pathos. Oh, what a sad little home ours was and how I used to be glad to get away from it.'[1] Half-holidays also meant a visit to the churchyard where Mr Jones sometimes gripped his head so hard that he cried out with pain. This kind of commemoration did not strike him, then or afterwards, as strange. He only pointed out that, had he guessed then what adult life was like, he wouldn't have passed his childhood in such a 'needlessly saddish manner'.[2] His clothes were made out of what was left over from his father's suits, every penny was saved, and Mr Jones, putting in long hours in the

workshop, tiptoed up to bed so as not to wake the child. In an age of self-help, this father could show thrift and sobriety, but not confidence. His failure in business was the result of unworldliness and inefficiency in the craft itself; as a hard worker, he set an excellent example.

Housekeeping for the disconsolate family was undertaken by a Miss Sampson, described by Lady Burne-Jones as 'uneducated, with strong feelings and instincts'. Ned recalled being sometimes given a penny and spending it on a 'mutton-pie, sodden with rancid fat'[3] as a relief from her cooking. It was Miss Sampson who told him, when he was building a child's city of small stones, that 'you must not call it Jerusalem, Edward'; she acted as a represser of fantasy, useful to a child whose imagination is strong enough to thrive on opposition and to become - as Burne-Jones pointed out - 'his private torment'. Ways had to be devised early on to avoid telling Miss Sampson what he was thinking about, so that it could remain to trouble him. He suffered for as long as he could remember from bad dreams, and from waking to find 'large anxious faces of grown-ups' bending over him. It was his habit as an artist to speak of his dream world, where real and unreal mixed without priority, as if it were his own retreat, but in fact he never seriously entered it without apprehension.

Mr Jones's shop was at 11 Bennett's Hill, itself quite a new and very respectable street in a district which had recently covered green fields with raw pavements. 'The town itself has walked uphill', in the words of the local comic singer Dobbs, the population having nearly doubled between 1821 and 1831. At the corner of the hill and Waterloo Street was a News and Commercial room; near to it, with a bold classical portico, was the Society of Artists' building, which was probably the reason why Mr Jones opened as a frame-maker close by. All this was decorous and decent, but inescapably near was a frightening Birmingham which lay in wait, after a not long process of 'coming down', for the failed small clerk and tradesman. This was the swarming city of 'Brummagem roughs' and Irish immigrants, which was neither policed nor lighted (except in winter) until 1839; Newman, in his first days at the Oratory, said that the Irish congregation 'made the air like drinking hydrogen or carbonic gas'. Although the town escaped the worst of the cholera epidemics, these were the hungry thirties, and the masses of operatives (including working children of seven and upwards) were

unskilled and unsettled, going home to crowded 'courts' and rookeries where dozens of families clung together, sharing one tap and one privy. Birmingham was said to have over a thousand of these red-brick warrens, more than any other city, and among them were 'scores of houses of ill-fame'. In 1848, when after a long agitation the Government introduced the Health of Towns Bill, the official Inspector to the Board of Health respectfully laid before them for consideration that 'the borough of Birmingham is not so easily healthy as it may be, on account of unpaved streets, confined courts, open middens and cesspools and stagnant ditches'. The Birmingham 'wares' themselves, on the other hand, exhibited an alarming vitality. Thomason's in Church Street claimed that he could do all that Cellini did, and cast anything in bronze, including life-size statues; Pemberton's would imitate any pattern in 'metallic bedsteads', Jennens and Betteridge would manufacture *any* object in papier-mâché inlaid with pearl shell. It would be quite wrong, of course, to think of all these products as shoddy: Gillott's took pride in the fact that Charles Reade had written the whole of *It's Never Too Late to Mend* with only one of their steel pen-nibs. The 'thousands trades' had their thousand separate voices, and though the city was never quite without music – rarely, indeed, without Handel's *Messiah*, which was given at festivals from 1823 onwards – it was hideous with the volleys fired off in iron-lined proofing-houses where the gunsmiths tested their weapons all day. 'At night,' Carlyle wrote in *Past and Present*, 'the whole region burns like a volcano, spilling fire from a thousand tubes of bricks'. The streets at large reeked of drunkenness, the universal resource. The Town Council, when Edward Burne Jones was six, received a report from the Borough Magistrates to the effect that 'the present police force was totally inadequate to maintain the peace'. In fact, in the Chartist Riots that year Mr Jones was sworn in, surely one of the most unlikely of special constables, and for a few weeks of terror of the streets seemed ready to crawl uphill and overwhelm them.

A queer, close life took its quiet course in the back shop in Bennett's Hill, bolted against Saturday night drunks. Mr Jones and his friend, Mr Caswell, turned over pictures left for framing, and the old dark canvases which Mr Caswell, who was retired, liked to buy cheap and touch up; at one time they got what must surely be a Turner, but 'the sea was too quiet' and Mr Caswell added a number

of large waves; or they would talk about 'the first historical painter that Birmingham had produced, and how Mr Gillott the pen-maker had paid £1,000 for a historical picture and felt disgusted, and then they would shake their dear old heads'.[4] To the little boy the stock-in-trade was repulsive, dark and oily-smelling, in faded frames. Like most lonely children, he drew pictures – mostly of demons – to give substance to the stories he told himself, but the feeling at 11 Bennett's Hill was that nothing should be wasted, and Mr Caswell immediately 'made me draw a coffee-pot with all the reflections (and no doubt it wasn't a bad thing to do) but when you looked closer demons were coming out of the pot'.[5] Music he loved, but he scarcely realised this yet, since there was no good choral singing at St Mary's and Mr Jones could not afford, or did not choose, to go to concerts. Sixty years later, Burne-Jones said that he had passed a childhood without beauty. There was none, certainly, in the little house itself or the 'chairs, carpets, tables and table furniture each duller and more commonplace than the other', or the picture of a cemetery over the 'hard square-featured clock', showing the tombs of Miss Sampson's Yorkshire relatives.

Beauty, therefore, was something the child could only recall in fragments, which could not really be distinguished from happiness; he meant such things as the smell of currant-loaves and wallflowers in Mr Caswell's kitchen-garden, and rare outings with Mr Jones, who, wretched though his taste in art might be, 'would walk tired miles to see a cornfield'. There were also the pretty faces of the Miss Choyces, farming cousins in Warwickshire, where he was sent occasionally – it was a milk and cheese farm – in the dubious hope of his growing stouter. The Choyces took him on one occasion to see the Cistercian monastery at Charnwood, and he dreamed for years of being shut away in peace behind its great doors. But, for Burne-Jones as for Ruskin, beauty was not inherited but earned. Ruskin, so he tells us in *Praeterita*, learned to love the movement of water through watching the gutter at the back of a baker's shop; Burne-Jones began to love plant form by being allowed to pick one wall-flower. Beauty they both felt as a craving which could be satisfied and perhaps only valued – for as artists neither of them ceased to be Evangelical at heart – only after a hard struggle. Ruskin, however, also warns us that those who are starved of beauty in childhood will find the love of it in later life 'rampant and unmanageable'.

Many of these details were recalled by Burne-Jones in the last few years of his life and taken down by his faithful studio assistant, Thomas Rooke. These notes were of course used by Lady Burne-Jones in her *Memorials*, and yet without falsification (that was impossible to her) she seems to have made her husband's childhood gentler and more pathetic than it really was. She left out the child's horrors, which are not less real when they are overheard and half understood. The bird-scarer passed the gate on the way to the open fields, and would stop suddenly and pull horrible grimaces.[6] In a house a few doors down, a father had cut off a boy's fingers when he wouldn't take his hands off the cloth. Another had mistreated his son so horribly that one of them had taken poison, and though he was brought round the poison 'worked itself out' years later, making him mad.[7] Three miles along the road out of Birmingham a lonely shack had to be passed where a man had lived who had gone crazy through disappointment in love; the pond where he had drowned himself was still in front of the shack.[8] Terror attached to certain names and words – 'progeny' was one – and to the sight of the swollen full moon. All these were lonely fears, but less so than his first experience of education, when he was seven years old. His aunt, Mrs Choyce, took him to a small school at Henley-in-Arden during one of his country visits and stayed to talk to the master while Ned went on alone into the classroom, where he met 'a shout of derision'[9] from the boys he when they saw how small he was. Writing fifty years later to Olive Maxse, he described himself as 'the kind of little boy you kick if you are a bigger boy'.[10]

This may have been a good preparation for King Edward's Free School 'where I proceeded at the age of 12'. By this time Burne-Jones had developed, in spite of his delicacy, a surprising power of survival. At King Edward's, magnificent grammar school though it was, 'the masters sometimes fought the boys'. Ned himself was stabbed in the groin during prayers 'and I found something warm on my leg and putting my hand there found it was blood'. He had the uneasy distinction of being taken home in a cab, to avoid explanations with the headmaster; it was the first time he had been in a cab and he was sick on the floor.[11] Later came the traditional challenge 'from a very large boy' to fight him after school. Ned, who was terrified, 'flew at him like a dog and then it was all over and I was sick as a dog'.[12] Instruction was in two large rooms for all classes, and order was kept

by beating and by end of term prizes. But in his seven years he received an excellent education and never quite got over his surprise at knowing more Latin, history and geography than William Morris, who went to Marlborough.

Like many imaginative children, Burne-Jones could only learn from one master, though his temperament, needing an absolute hero, rejected Mr Thompson's name and the coarse black hair on his hands. 'I worshipped him when I was little, and we used to look at each other in class. I wonder what he thought when he looked.' The boy survived furious beatings to absorb what the teacher had to give; his habit was to improvise on a few words read out at random – 'with the flattest sentence in the world he would take us to ocean waters and the marshes of Babylon . . . and the constellations and abysses of space'. To this Burne-Jones must have responded completely, since to the end of his career he drew inspiration from the word itself – the image that springs from the name. He noticed, however, as he listened to Mr Thompson's fantasies in word-derivation, that the master was sometimes drunk.[13]

Ned entered King Edward's in 1844, ten years after the school had been rebuilt to Barry's hard Gothic designs, which left the outside impressive and the inside dark and draughty. The headmaster was Dr Prince Lee, a magnificent autocrat who taught the boys that every minute of life was accountable, his motto being *Salpisei* – 'the trumpet of judgement shall sound'. Ned was put into the 'commercial' department, where Greek was not studied, and the boys left at fifteen or sixteen with a sound preparation for business. It was Mr Thompson who advised Mr Jones, when his son was fifteen years old, to let him stay on at school. Instead of going straight to a counting house at eight shillings a week, which meant a positive contribution to the economy of Bennett's Hill, Ned passed straight into the Classical school, where boys were prepared for university. His friends received the impression, when they called for tea at Bennett's Hill, that 'he always used to have nice things about him, to a schoolboy extent'. In point of fact, as Ned told Rooke, his pocket money, until he was eighteen years old, was a penny a week, and his father allowed him to sell his school prizes to buy his class books.[14] Even homework was an extravagance because it meant burning a candle till two o'clock in the morning.[15] Mr Jones agreed to this, because he supposed it was the right thing.

In the upper forms of the school Burne-Jones had his first real experience of friendship, that is, of openly giving and receiving affection; he formed his own circle, who were staggered by his practical jokes (these sometimes attracted the attention of the police) and fascinated by his queer mixture of gentleness and underlying fierceness, not so well hidden then as it was later. This was the second quarter of the nineteenth century, the golden age of intense male friendships, whose delicate emotional balance is hard to assess today. Chivalry and uncertain hope entered into them when the boys, in the haven of the school library, made themselves 'exquisitely miserable' over Keats on 'long hot afternoons' or read Tennyson's *Morte d'Arthur* and *In Memoriam*. Outside, they were adolescents, and Ned was growing too tall for his strength. They were 'quizzed' by the girls, and at a loss for a smart reply.

It was Richard Dixon who first introduced Burne-Jones to Keats; coming from a large poor Methodist household, he later became a canon of Worcester, a poet and the correspondent of Gerard Manley Hopkins. Another intimate was Cormell Price; 'Crom' was two years younger than Ned and had known him in the Commercial school. He was to try many things – medicine, Russia, teaching – before becoming headmaster of the United Services school (and consequently of Stalky & Co), without ever adapting significantly to this world. He began and ended as hopelessly enthusiastic and unpractical Crom; others looked after him. Harry Macdonald was the son of another Methodist minister on the Birmingham circuit, whose large family were to be of the greatest importance to Burne-Jones.

Both Dixon and Cormell Price support Burne-Jones's recollections of the crude misery of Birmingham. Crom Price remembered seeing men killed at prize fights. 'At Birmingham school a considerable section of the upper boys were quite awake to the crying evils of the period,' he told Mackail, William Morris's biographer. '. . . I remember one Saturday night walking five miles into the Black Country, and in the last three miles I counted more than thirty lying dead drunk on the ground, more than half of them women.' As small boys it had shocked them and made them run faster for the safety of the lighted shop fronts. Now it was a matter of humanitarian conscience. How could the world be served?

From concern with human suffering and the uneasy craving for

beauty there was only a short step, for an adolescent thinking young Evangelical, to the edge of the Apostolic movement. (The precise shade of Mr Jones's Evangelicalism can be judged by the fact that Ned was not allowed to read novels until he was in the First Class, but did occasionally go to the theatre.) In 1849, the same year that Ned entered the Classical school, Newman was sent to Birmingham and arrived in a fly full of luggage and plaster Madonnas to open the Oratory in an old gin distillery in Alcester Street. His first sermon, preached to hundreds of operatives and dirt-poor Irish, with a sublime inappropriateness that could only come from great spiritual depths, was on 'how to escape the false worship of the world'. There was of course no question of Mr Jones and his son attending mass. But 'the effect of Newman, even on those who never saw him', Burne-Jones told Frances Graham, was a 'leading – walking with me a step in front'. The adventure of the Oratory impressed him as a glorious gamble 'putting all this world's life in one splendid venture . . . in an age of sofas and cushions he taught me to be indifferent to comfort, and in an age of materialism he taught me to venture all on the unseen.' In this way Newman at long distance touched the unborn firm of Morris & Co., and through wallpaper and rushback chairs would continue to preach that there are greater things in this world than comfort.

Newman was in no way a mediaevalist and did not recognise the 'note' of sanctity in the mediaeval church, but those who saw and heard him from a distance did not always make this distinction. The Oratory entered into the classroom mythology of the King Edward's boys, and Ned became 'Edouard, Cardinal de Birmingham', sending missives illuminated in red and blue, while Crom Price was a less distinguished member of the 'Order of St Philip Neri' (Newman's own order). When the 'cardinal' was invited during his holidays to Hereford by a brother of Mr Caswell's, a further transformation took place: at the cathedral he heard church music well sung for the first time, and saw in the building itself something he had never guessed from the brand new Gothic of King Edward's. He was in direct contact with beauty, the acute physical and emotional effect of 'old music' combining with the remoteness of the lamp-lit chancel. It was his own 'note'. At the same time he passed easily under the influence of a young, serious, singing and choir-mastering Puseyite clergyman, John Goss, who had been at Oxford in the heroic days of Newman's secession, attending his last

university sermon on 'the parting of friends'. This had now been printed, and Goss lent the volume to Ned. It became clear to Burne-Jones that he must be a priest like Goss; if he was to serve the drunks and vagrant workers that littered the pavements on the way to school, it must be in a community like the Oratory, or perhaps like the semi-monastic group suggested in Hurrell Froude's *Project for the Revival of Religion in Great Towns*. There must be a meeting point between the need to serve and the need for beauty. Mr Jones, when his son returned to Birmingham, was quietly ready to exchange his pew in St Mary's for one in Puseyite St Paul's, where there was ceremonial and music. He had made up his mind that Ned was to become, if not a successful manufacturer of steel pens, then a bishop.

This, of course, meant Oxford, although most of the Upper School boys went on to Cambridge. Dixon was ready to matriculate and Crom Price, two years younger, hoped to follow them. Both of these were down for Pembroke, where the master, Dr Jeune, was a former headmaster of King Edward's, but Goss had been at Exeter, and for Exeter, therefore, Mr Jones put down his son. When he found that Ned, unlike Dixon, had not been awarded an exhibition, he faced a total payment, over the three years before an honours degree, of about £600. There would be tuition fees of about £20 per annum, coals, room-rent, hire of furniture, charges for servants (about £30 a term), kitchen bill, buttery bill (for bread, butter and beer), washing bill, college subscriptions; even the travelling expenses to Oxford were a consideration. With heaven knows what further economies and calculations, Mr Jones 'determined to send him at his own expense'. The Bennett's Hill house was let, except for the workshop, and a smaller house taken, where Miss Sampson and the furniture accompanied them, father and son shared a bedroom as usual, and a lodger was squeezed in as well. This was in the Bristol Road, which the *Memorials* tell us 'provided better air and exercise', though in fact the drains at this time ran into open ditches on the west side.

Ned matriculated on 2 June 1852. He had his first sight of the city of Oxford, the river, and the meadows. Excitement, and possibly some guilt at the sacrifices made for him, brought on a severe illness, the first since he had nearly died at birth, but one which was to set a pattern for the rest of his life – heart weakness, spectacular fainting, a black depression on recovery. Harder to bear, at the age of nineteen,

was delay; he would have to wait till the following spring before there was room for him in the overcrowded college.

Kicking his heels in Birmingham, he went to call for the first time on his school friend Harry Macdonald, and so met the family where, a few years later, he would find his wife. They were then living in a house in Nursery Terrace, Handsworth, the Rev. George Macdonald having been recently appointed for the second time to the Birmingham circuit.

In 1852 the minister's house was crowded from attic to cellar. The children at home were Harry, Alice, Carrie, Georgie, Fred, Agnes (the prettiest) and Louisa. They had already lost two little brothers, and had gone upstairs to see one of them 'stamped with the marble hue of death'; Carrie had only two more years to live.

Their story (as it is told by their descendant Lord Baldwin in *The Macdonald Sisters*) is of an unworldly preacher bringing up, or rather letting his wife bring up, a large family on a tiny income, sometimes less than £200 a year, so that to buy a book or to have the piano tuned was a heroic event. This, however, was never felt as poverty, and the affection between the sisters was very close. They all had in common integrity and decisiveness – William de Morgan said that they never began a sentence without knowing how it would end. Visitors who were in the least pretentious were cut short. Lord Baldwin records that a preacher who spoke of his heart as 'black, and full of stones' was told by little Louie that he must mean his gizzard. This firmness went with a tendency to melancholy and poor health. What redeemed it, besides its own moral purity, was a dry sense of humour and an acceptance of the 'stages of life', which implied a reverence for life itself.

Such unworldliness, combined with sharpness, could alarm casual visitors. Ned shrank. But the praying, singing, cooking, sewing, turning, boot-patching, 'putting-up' of preserves, making do, giving charity, racing up and down stairs, self-criticising and self-improving could make way at once for a lonely visitor. Ned, although he called with Crom Price, could be seen at once as lonely. To Georgie, a child in a pinafore, his pallor and delicacy suggested that he needed looking after. Georgie, at the age of ten, was quite used to this. She noticed also an unexpected source of power in him, like an illumination, when the conversation moved him.

How Burne-Jones – the *Memorials* are 'confident that the mystery

which shrouds men and women from each other in youth was sacred to him' – dealt with his own growing sexuality can hardly be judged. He referred to it only ironically, for example, in reference to a visit to the theatre when he was staying at the Camberwell home of his father's sister, Aunt Catherwood. Mr Catherwood took him to the Lyceum pantomime, where they stood in the pit and Ned fell hopelessly in love with the probably forty-year-old Fairy of the Golden Branch. 'She held out something, and I thought it was too beautiful ever to be.' But this was not surprising, since the Fairy – supported by Blueruino, an Illicit Spirit – was none other than Madame Vestris herself. Complementary to these fantasies was the very strong reaction of a sisterless young man, in the presence of young girls *en fleur*, on the verge, some sooner, some later, of a natural but despoiling experience. This, which was to be one of the recurrent themes of his painting, took its origin from the daughter-crowded minister's house in Nursery Terrace.

In the Hilary Term of 1853, Burne-Jones finally went up, and passed from the small shop and the grimy streets of Birmingham to Newman's own university.

2
1853–5

OXFORD: LOSS AND GAIN

Burne-Jones's disappointment with Oxford was at first intense, proportionate to the vastness of his expectations. There was still no room in college for him when he arrived in the January of 1854. He had to get his meals out and sleep, a most unwelcome raw provincial guest, in someone else's study. In a few weeks he was writing to Cormell Price that he meant only to try for a pass degree. 'I'm wretched, Crom, miserable.' The stones did not cry out, he could not find the 'note'. The absence of Newman seemed a positive element. On the other hand, he made in these first few weeks a new friend who seemed as disgusted as himself. This was a thickset dark curly young man – variously described as 'triumphantly' and 'unnecessarily' curly – who to judge from his Oxford parlour photograph, seems to have worn a velveteen jacket and to have clenched his fists very hard. Ned had noticed his name, the *Memorials* tell us, when he wrote it on his matriculation paper the year before: William Morris.

Morris took instantly to Burne-Jones, whose background was so unlike his own. This, like many of the things Morris did, must have been a matter of instinct, which told him that the likenesses between the two were as important as the differences. Physically they looked as unlike as they well could do. Ned was too tall and too pale, gentle, fragile, hesitant, with wide very light eyes and a face 'oddly tapering towards the chin', quietly witty until he was excited, then outrageous; Morris looked strong. There was unmanageable energy in his mind as well as his body, so that his characteristic gesture was to hit the air, or his own head, with a kind of smothered exasperation. Morris broke chairs beneath him, Ned sank into them 'as though his whole spine was seeking rest'. Together they looked

12

like a blundering king and an ailing aspirant to knighthood. Morris had the impatience – as Bernard Shaw pointed out – of the comfortably off, whereas Ned, at Oxford, was 'distinctly the poorest of anyone I knew'.[1] According to Mackail, neither of them realised this until Ned went to stay at the Morris family house near Walthamstow, but this seems unlikely, particularly as Morris, within a few weeks of meeting Burne-Jones, characteristically offered to share all his money with him.

On the other hand, both were emotional and tender-hearted young men who could rapidly be rendered helpless by affection, and both were depressives who had to face a life-long struggle with melancholia. This black enemy was always in waiting. Both of them had come to Oxford with the same kind of not yet directed idealism, both meant to take orders. Morris, like Burne-Jones, had been under the influence of one of the 'devoted remnant', his private coach, F.B. Guy, who had survived, just as John Goss had done, the storm of Newman's resignation. If he could not give half his money to Burne-Jones, then he was ready to give all of it – catching readily on to this idea – to found a monastic community. In discussing this they must have discovered, what perhaps they might have taken for granted, that both were mediaevalists. But here Ned's ideas were still hazy, a region where Keats and Tennyson, the Oratory, Hereford Cathedral and the Fairy of the Golden Branch all met, whereas Morris, who had been given a suit of armour at the age of seven and ignored his lessons at Marlborough in favour of books of mediaeval architecture, was already an expert on details. He 'seemed to have been born knowing them', Ned thought. Morris already distinguished between two imaginary worlds of the Middle Ages: one clear, hard, active, brightly coloured, highly sexed and plainly furnished, the other a limitless wandering which always led, in the end, to the warring sides of Morris's temperament, and the difficulty of reconciling them was to cause him both emotional suffering and political inconsistency. The community, if it could be managed when Morris came into £900 per annum the following year, would belong to the second dream.

Meanwhile they poured out their disillusion to each other on 'angry walks'. Although Pusey was still at Christ Church, he was now fifty-three and had grown stout; the university, Matthew Arnold wrote in 1854, 'in losing Newman and his followers had lost

its religious movement, which after all kept the place from stagnating'. As a matter of fact, if they could have waited in patience, Morris and Burne-Jones would have seen the beginnings of change in Oxford: the Royal Commission of 1850 had suggested some, Jowett was already at Balliol, and the new University Museum was soon to arise, 'complete in every detail down to panels and footboards, gas burners and door-handles' under the eye of Ruskin. It seems, however, that much of their disappointment arose from their choice of college. According to Mackail, the 'coarseness of manners and morals' at Exeter was 'distressing in the highest degree' to Morris. Burne-Jones, curiously enough, perhaps because he was used to Saturday nights in Birmingham, seems to have minded it less. 'One night a man threw a heavy cut-glass decanter of port at someone sitting next to me', he told Rooke, 'and it went between us both and smashed to pieces on the wall behind, so that we were both drenched in port, shirts and faces and all over our clothes, as though we were covered in blood.'[2] What impressed Burne-Jones was that the man responsible, who had to be dragged forcibly out of Hall, later became 'a high dignitary of the church'. Those who did not throw decanters were in a minority. William Redmond, the painter, visited his elder brother at Exeter in 1854: 'my brother did not belong to the aesthetic set . . . and among them two of them were pointed out to me as special oddities . . . These were William Morris and Edward Jones.'

The city, however, was beautiful, still surrounded by its pastoral meadows, as Ned described it, except on the railway side, and 'there were still many old wooden houses with wood carving and a little sculpture here and there. The chapel of Merton College had been lately renovated by Butterfield, and Pollen, as a former Fellow of Merton, had painted the roof of it. Many an afternoon we spent in that chapel. Indeed I think the buildings of Merton and the cloisters of New College were our chief shrines in Oxford.' A Miss Smythe had been taken as a model for the angel faces on the Merton chapel roof, a reminder that the ideal of celibacy was the most vulnerable part of the scheme of monastic life. Ned very soon found Oxford a place of unspecified 'heart-aches', and Morris's incoherent story, *Frank's Sealed Letter* (1856), which, Mackail tells us, has 'many details directly taken from his own life', indicates that 'wild restless passions' were giving him the reputation of 'a weak man'. These were troubles which ran side by side with the lack of spirituality in the university.

If Exeter was uncongenial, however, there was plenty of company in Pembroke, where the King Edward's boys were installing themselves as a 'set'. Dixon had gone up a term earlier, and had been joined by two others. Charlie Faulkner (included although he had been educated privately) was a delightful straightforward person, admired by the others because he was their only mathematician. William Fulford, who was older than the rest, was noted as a talker, such a compulsive one that only Morris could stop him, and then virtually by force. In one of their rooms, usually Faulkner's, and drinking nothing stronger than tea, they sat down to put the world to rights. It is possible that they remained exclusive not altogether from choice. Lady Mander has shown in her *Portrait of Rossetti* that Faulkner, even much later as a Fellow, was laughed at by the young bloods for his 'Birmingham boots'. Morris, certainly, was content to accept the 'set' as it was, and Dixon remembered how Ned told him 'in an earnest and excited manner' how strongly he felt the expansion of his emotion through friendship in this first year. Nevertheless, his hero was no longer the dapper Fulford but 'Top' – his own name for Morris – taken, presumably, from the just-published *Uncle Tom's Cabin*. 'Come and see him,' he wrote to Crom Price, 'not in the smoke-room or in disputations (the smoke-rooms of the intellect) but by the riverside and the highways, as I alone have seen and heard him'. Much-loved Crom was always a person to be written to and a keeper of letters, so that many of these details come from him. A year later, having won a scholarship to Pembroke, he did come up to 'see and hear' Morris, and the set was complete.

In October Ned and Morris were able to get rooms in college, and Ned was awarded an exhibition, though this does not seem to have been paid regularly.[3] In the intervals of brass-rubbing, listening to Pusey's sermons on justification, and exercising at Maclaren's gym in Oriel Lane, where Ned, who had a very strong wrist, proved unexpectedly good at foils, Morris began a lifelong habit of reading aloud to his friend.

This habit was already well established among the set. They took turns to read Shakespeare in each other's rooms, and Burne-Jones remembered 'a poor fellow dying at college while I was at Oxford – his friends took it by turns to read *Pickwick* to him – he died in the middle of the description of Mr Bob Sawyer's supper party . . . and we all thought he had made a good end'.[4] Morris and Ned together,

however, absorbed books as an immediate physical experience. Books were as important to their future careers as painting itself, life for them, and to Burne-Jones in particular, as has been said, the word and the image were inextricably bound up. Books, also, were a form of friendship between them, speaking through the shyness which both of them had to overcome.

Some of those they read were apparently their set texts of Church history and theology, but they were also collecting their own sacred books. Keats reappeared, with Tennyson's *Morte d'Arthur*; the Arthurian legends were still so little known that they formed a kind of secret bond. In fact, Tennyson's original introduction to the *Idylls* had been an apology for using such a queer old story which most men would burn as 'trash', but it had set light to a fire of its own, and Crom was told to learn *Galahad* by heart. The monastic brotherhood – still much under discussion – would be the Order of Galahad. They also read Morris's favourite, the *Arabian Nights* in the Lane illustrated edition, Carlyle's *Past and Present*, and the second volume of *The Stones of Venice*, in which Ruskin relates a nation's art to its moral values. The three books which mattered most to them, however, are less familiar today. They were Kenelm Digby's *The Broadstone of Honour*, de la Motte Fouqué's *Sintram and His Companions* and the *Heir of Redclyffe*, by Charlotte M. Yonge.

The Broadstone of Honour, or the True Sense and Practice of Chivalry was the book which Burne-Jones kept by his bedside for the whole of his life, even after he had come to feel, or at least to say, that it was childish. It is by the antiquarian Catholic Revivalist, Kenelm Digby, who tells us that he conceived the idea when he was travelling with a band of like-minded friends, collecting 'whatever legends were credible and suitable to the present age'. It is hard to think what Digby could have meant by 'credible' here. The castle of Ehrenbreitstein gives the title because the fortress on the rock seems 'lofty and free from the infection of a base world'. The Arthurian knights are not 'enchantments which exist but in a dream of fancy . . . These images are the *only* objects substantial and unchangeable.' Here Platonism and Victorian mediaevalism meet.

The *Broadstone* is elaborately but not intelligibly planned – indeed, it could hardly be so, since the crowded pages were to correspond to 'the symbolical wanderings of the ancient knights',

during which, Digby says, the Catholic faith itself will save him from inconsistency. Book 2, *Tancredus*, which must certainly have been Burne-Jones's favourite, winds gradually into a maze of stories and miracles, designed to show that the knights and monks of old possessed every conceivable virtue. At the end we are returned to nineteenth-century industrial England, 'and it is as if the night had closed on us, and we are among tangled thorns'.

The author forestalls objections by telling us that these are 'thoughts that breathe, and words that burn'. It is not a book to analyse, but to be lost in, and if we cannot do this we are not likely to understand Morris's early poems or Burne-Jones's early water-colours, the freshest of all their art.

Sintram and his Companions is the winter story in the tales of the four seasons by H. de la Motte Fouqué. Its inspiration is Dürer's *Knight, Death and the Devil*, which appears as the frontispiece, and this woodcut version meant more to Morris and Burne-Jones at Oxford than any other graven image. Ned, who was beginning to try to draw, was fascinated by the compact oneness of man and horse, and the electric tension of the line. 'No scratching of the pen,' Ruskin wrote, 'nor any fortunate chance, nor anything but downright skill and thought will imitate so much as one leaf of Dürer's.' But to Fouqué, 'musing on the mysterious engraving', the importance of the Dürer was its allegory of the noble soul. The hero's inspiration, in his struggle against his own violent nature, is his mother Verena, who cannot receive him in her cloister in the snows until 'all is pure in thy spirit as in here'. The vile dwarf, 'the little Master', appears to him in moments of sexual temptation, and Death, the bony pilgrim, plays an ambiguous rôle, so that at the end Sintram, who has met him more than once on his journey upwards, must still wait for him.

Among the many haunting moments is the fear which possesses Sintram at the first sight of his own reflection in his bright shield. This image of adolescence recognising its own possibilities entered deeply into Burne-Jones's imagination. The idea of Sintram's perseverance went to reinforce others, his father, for example, walking 'tired miles' to see a cornfield, Newman at the Oratory, Morris's offer of all his income to found 'the monastery'.

If *Sintram* is inspired by Dürer's engraving, *The Heir of Redclyffe* is inspired by *Sintram*. This, Charlotte M. Yonge's first real novel, was published in 1853, the very year that Ned and Morris first read it,

and, like her other books, was corrected by Keble. Against the background of an amiable country vicarage the hero, Sir Guy Morville, struggles to control the inherited curse of a violent temper. He even cures himself of biting his lip and of 'cutting pencils'. And Keble's teaching, that we can live life as a 'common round' and still give up the world, is understood so intensely by Guy that his soul consumes his body.

There was, of course, nothing unusual in two young men reading and feeling deeply affected by these three books in 1853. The *Broadstone* had been one of the hermetic texts of the Young England movement, which Disraeli had tried, or pretended to try, to turn into practical politics. Newman had been so agitated by *Sintram* that he could only read it in the garden, and alone. The *Heir* was to be the favourite reading of the young officers in the Crimea. The odd thing is not that Morris and Burne-Jones should have read them so eagerly, but that doing so should have turned them into artists. In 1853 they both intended to enter the Church; in 1854 they still meant to found a monastery. Within a few years they would be collaborating in a decorators' firm. But there was no real change of moral direction.

The direct link beween Sintram toiling through the snows and the ideal of craftsmanship was Ruskin. Far more attractive than Carlyle's specific of hard work was Ruskin's doctrine that to work at anything less than the highest was blasphemy. The second volume of *Modern Painters* told Burne-Jones and Morris that painting was 'a noble and expressive language, invaluable as the vehicle of thought, but by itself nothing', and, as Ned recalled, everything was put aside when the *Edinburgh Lectures* came out and Ruskin declared that academic painting was at an end and that truth and spirituality lay 'with a very small number of young men' who were working here and now in England. These were the Pre-Raphaelites, 'a somewhat ludicrous name'. In this lecture, as Morris read it aloud to him, Burne-Jones heard for the first time the name of Rossetti; 'so that for many a day after that we talked of little else but paintings which we had never seen, and saddened the lives of our Pembroke friends.'

However, the two of them had not been affected in quite the same way. The *Edinburgh Lectures* singled out the Pre-Raphaelite Brotherhood (P.R.B.) for three things: their technical superiority,

their 'enormous cost of care and labour' (this was to become Ruskin's Lamp of Sacrifice), and their 'uncompromising truth' which in itself was a moral quality. Morris accepted all these things; so that later, when it appeared to him that art, after all, was not a teacher, he would be driven to exclude it from his ideal commonwealth. But Burne-Jones did not, either then or later, believe that art was a moral instrument of any kind. The idea struck him not only as unlikely ('hardly anything is a lesson to anyone' he told Rooke[5]) but irrelevent. What he knew from his own experience was that beauty is an essential element without which human nature is diminished. If art gives us beauty it will make us more like human beings.

At the beginning of 1854 Ned wrote a letter to his father which indicates clearly the 'unmanageable' nature of his need for beauty that winter. 'I have just come in from my terminal pilgrimage to Godstow and the burial place of Fair Rosamund. The day has gone down magnificently; all by the river's side I came back in a delirium of joy, the land was so enchanted with bright colours, blue and purple in the sky, shot over with a dust of golden shower, and in the water, a mirror'd counterpart, ruffled by a light west wind – and in my mind pictures of the old days, the abbey, and long crosiers, gay knights and ladies by the river bank, hawking parties and all the pageantry of the golden age – it made me feel so wild and mad I had to throw stones into the water to break the dream. I never remember having such an unutterable ecstasy, it was quite painful with intensity, as if my forehead would burst. I get frightened of indulging now in my dreams, so vivid that they seem recollections rather than imaginings, but they seldom last more than half an hour; and then the sound of earthly bells in the distance, and presently the wreathing of steam upon the trees where the railway runs, called me back to the years I cannot convince myself of living in.'

From this it appears that 'ecstasies' and day-dreams were an accepted part of Ned's life; in fact that he induced them, and that his experience of Godstow arose from a combination of the winter twilight, the water, pure colour, the legend of Fair Rosamund and her name itself. Burne-Jones seems to have gone on these visits by himself, and the feeling of alienation at the sight of the railway is characteristic. On the other hand, back at Pembroke there was the

tea-kettle and chaff of an enviable simplicity, often apparently, ending with a bear-fight, which consisted of pushing someone else over on the floor.

An acute crisis was gathering which bear-fights could not relieve, and it was in this year that Burne-Jones, and probably Morris also, lost their belief in any doctrinal form of Christianity. For Burne-Jones, the process of loss was an agony, even though mid-nineteenth-century Oxford was well accustomed to counsel on the matter. At one point he was very near to 'going over' and following Newman, Hurrell Froude and Wilberforce on the path to Rome. This, in 1854, would have been called 'submitting'. Certainly, Morris and he did not emerge on the other side with the same faith. Morris's belief was ultimately in this earth, 'the nesting and grazing of it', the men and women that inhabit it, and what they could make with their hands. To Morris, humanism came naturally. Burne-Jones, on the other hand, had long been accustomed to hiding his deepest convictions. In later life he was reported as blandly saying that the Resurrection was too beautiful not to be true, and quoting with approval R.L. Stevenson's Samoan chief who refused to discuss the Deity, saying that 'we know at night someone goes by among the trees, but we never speak of it'. He became adept at such evasions. But in truth he found, like Ruskin, that to be born Evangelical is a lifelong sentence. He continued to believe in the Gospels, but transferred the meaning of the events, in particular the Annunciation, Mary's loss of her Son, and the Passion, to the everyday life of humanity. The Redemption meant the alleviation of suffering in this world, and Judgement Day was a continuous process; and there were only two questions asked in Judgement – why did you, and why didn't you?[6] The artist has the opportunity to supply the beauty which most lives noticeably lack and for which they cry out, even if they scarcely know it. In so far as he fails to show beauty to other people the artist will be asked, 'Why didn't you?'

While these convictions came painfully to him, Burne-Jones had very little reason to believe that he would ever make an artist at all, yet, oddly enough, he had already received his first commission. Archibald Maclaren, surely one of the most unusual proprietors of a gym that Oxford has ever seen, had compiled a volume of the fairy ballads of Europe, and entrusted Ned with the illustrations. Ned had begun a series of minute figures in pen-and-ink, for steel engraving, in the style of Richter and still more of Dicky Doyle, whose set for

Ruskin's *King of the Golden River* appeared in 1851. Doyle, however, had been trained by his father since infancy in exact draughtsmanship, whereas Burne-Jones had nothing but Mr Cawell's hints, a few evenings at the Birmingham School of Design, and his own amateur sketches. The illustrations drove him to despair, and in fact were never finished, although Maclaren deferred publication in the hope of getting them.

Meanwhile Morris and Ned were on fire to see the Pre-Raphaelite paintings of the *Edinburgh Lectures*, or some of them, or even one of them. The place for modern pictures was Wyatt's, in the High Street. They were allowed there on sufferance, Wyatt apparently lacking the dealer's instinct which would have told him that the well-off Morris, in his untidy clothes, was a potential buyer. 'We used to be allowed to *look* at Alfred Hunt passing through the shop – it would have been too great an honour to be allowed to speak to him.'[7] This was because Hunt, the water-colourist and landscape artist, was reputed to have *seen* Millais and Holman Hunt. But in this same year, 1854, Wyatt exhibited Millais's *The Return of the Dove to the Ark*, lent by Mr Thomas Combe, the director of the Clarendon Press. The gesture of the girl on the left, gravely and confidently holding the dove to her breast, had seemed 'dull' to Ruskin, but made a deep impression on Burne-Jones. Six years later, when Butterfield commissioned him to do an Annunciation window, 'I insisted on [Mary] taking a dove to her bosom – an innovation; and Butterfield never asked me to do anything again.'[8]

During the following long vacation, Morris went for a tour of northern France and Belgium, and Ned, depressed and penniless, had no alternative but to go home. On the way to Birmingham he passed through London, staying as usual with his Aunt Catherwood. He emerged, half-deafened by brass bands, from the Crystal Palace Exhibition. Paxton's building itself struck him as a 'length of cheerless monotony, iron and glass, glass and iron'; he did, however, have the chance to visit the Academy, where he was not looking, but searching. He understood what the Crystal Palace meant, but didn't like the meaning. The Academy pictures, sacred, grand-historical, domestic, fruit-and-flowers, animals and children, seemed not to have meaning at all. Maclise he particularly objected to, resenting the Maclise illustrations to La Motte Fouqué. The picture of the year was Frith's *Ramsgate Sands*, which was bought by Queen

21

Victoria; what Ned was looking for was spirituality expressed through colour. In the *Stones of Venice* Ruskin had just written of colour as the 'sacred and saving element – the divine gift to the sight of man'. He had also dismissed Salvator Rosa's pictures as 'gray'; as Burne-Jones told Rooke, 'I was very sorry when Mr Ruskin said I mustn't like Salvator Rosa, but I didn't hesitate.'[9] Only in Holman Hunt's *Light of the World*, which was exhibited in the Academy that summer, did he find what he was beginning to understand by colour. Later he came to feel that Hunt's eccentric schemes only worked on very small canvases 'and then they can't be put out of mind'.[10] He ceased to admire the *Light* 'except for the lantern light, and the things against the door'. But in 1854 he had not yet seen a Rossetti.

The next months had to be spent in the crowded little house in the Bristol Road, where Miss Sampson cooked as she had always done and Ned had to conceal from her in the old way his painful religious doubts. He was also tormented, as he wrote to Crom Price, by 'love-troubles I have been getting into', and terribly stuck with the drawings for *The Fairy Family*. Morris's letters described the wonders of the cathedral towns of northern France, and gave as much comfort as the travel letters of luckier friends usually do.

Term was late, because of the cholera epidemic, and Ned was 'sick of home and idleness'. But Morris blew back like a rough wind with a whiff of French onions and water-meadows, and in October they were able to get rooms next to each other in the old buildings at Exeter, appropriately 'gable-roofed and pebble-dashed'. Here Morris began a new series of readings, this time from Chaucer. He was not disappointed in Ned's reaction, and perhaps did not notice that, once again, it was different from his own. Burne-Jones's interpretation of Chaucer was weaker than Morris's, but more subtle. He never liked the *fabliaux*, and thought of them, just as to begin with he thought of Morris's table manners, as the lessening of an image. Before long he came to accept Morris as he was, but he continued to avoid the *Miller's Tale*. On the other hand he was a most discriminating reader of the *Legend of Good Women*, the *Parlement of Fowls*, the *House of Fame* and the *Romaunt of the Rose*. With true insight, he saw Chaucer as sophisticated, courtly and sad. He understood perfectly Criseyde's remark that we are wretched if we despair of happiness, but fools if we expect it; he responded to what was wistful, dry and ironic in Chaucer, and also to his occasional

lapses into total sentimentality. It was only when, at the end of their lives, Morris and Burne-Jones set out at last to collaborate on the Kelmscott *Chaucer* that the discrepancy between them, which they would never admit, appeared.

It might still be possible, it seemed in the autumn of 1854, to found the Brotherhood, even if by now it would have only the most tenuous link with Newman. Crom Price was still willing. But Morris had begun to write poetry, was mad about the French cathedrals which everyone must visit at once; Crom noticed that the two friends 'diverged more and more in views, though not in friendship'. It was at this point that Burne-Jones 'wanted very much to go and get killed' and actually tried to join the army: the Crimean War had been declared in March, and the Government was offering commissions to undergratuates to replace the terrible losses from untreated wounds and Asiatic cholera; Ned applied to the Engineers,[11] and would have been just in time for the march on Balaclava. It was a mercy that he was rejected on the score of delicate health as, neat though he was in all his movements, he was defeated by the simplest mechanical devices, even drawing-pins.

Morris himself put an end to this agony by the sheer presence of friendship; and at the end of May 1855, when they ought to have been entering seriously on their second Trinity term, they were all at Camberwell – Ned, Morris and Crom Price – scrambling about London to see pictures. They had got permission to visit the collection of Benjamin Windus, which at this time included Millais's *Isabella*, Madox Brown's *The Last of England*, and Arthur Hughes's study for *The Knight of the Sun*, though Windus, like other collectors, had 'laid off' by buying Maclise's *Youthful Gallantry*. But there were no Rossettis in his house at Tottenham Green, and therefore nothing to correspond with the *Blessed Damozel*, which Morris and Burne-Jones had just read in a chance copy of *The Germ*. At the end of the summer, however, they were introduced at Oxford to Mr Combe himself – kindly, encouraging, boring, a patron of Hunt and Millais since 1850. At Mr Combe's they saw, at last, a water-colour drawing by Rossetti – *The First Anniversary of the Death of Beatrice – Dante Drawing the Angel*.

All that the friends liked was 'jolly'; everything they did not like was 'seedy'. Morris still felt that the French cathedrals had been jolliest of all and that Ned must see them; since Ned was too poor to afford the

train fares, they must go about on foot. A walking party was made up for the next vacation – Morris, Ned, Crom, William Fulford – though at the last moment Crom could not come.

This was Burne-Jones's first venture abroad. Fulford and he read Keats to each other at the railway hotel at Folkestone before the crossing, and at Amiens he was up early to make a drawing of a street scene. As they walked the French roads, the rich mythology of William Morris developed; his boots were uncomfortable and he tramped on in 'gay carpet slippers', attempting, like the Heir of Redclyffe, to control his violent temper. The slippers wore out as they reached Beauvais, where they attended High Mass at the cathedral on 22 July.

Beauvais, like Hereford, Burne-Jones apprehended as a synthesis of music and spatial relations: 'the ancient singing . . . and the great organ that made the air tremble . . . and the roof, and the long lights that are the most graceful things man has ever made.' But with this Morris had little patience. He had hoped to avoid Paris altogether, dreading the effect on his temper of the restorations to Notre Dame; but Burne-Jones in particular wanted to see the Louvre, and Morris consoled himself by leading his friend up to Fra Angelico's *Coronation of the Virgin*, making him shut his eyes and only open them at the last moment. 'I didn't imagine I liked painting till I saw Fra Angelico,'[12] he told Rooke. They bought engravings of the *Coronation*, regretting that there were no coloured ones.

At Rouen he wanted to hear vespers every afternoon and evening, and was disappointed that they had to wait till Saturday. They travelled, since the failure of the carpet slippers, mainly by the hated railway and 'a queer little contrivance with one horse', of which the expense must have been paid largely by Morris. They went home through Chartres, then, en route for Calvados, to Le Havre. It was there, as they walked back and forth on the quays in the summer night, that decision came to them and they 'resolved definitely that we would begin a life of art'. Morris was to be an architect, and Burne-Jones (whose main experience was still his inability to draw *The Fairy Family*) was to be a painter. Neither of them felt that this was in any way a desertion. As Morris wrote to his mother, they were 'by no means giving up their thoughts for bettering the world'. 'We were bent on that road for the whole past year', Burne-Jones remembered,

'and after that night's talk we never hesitated more. That was the most memorable night of my life.'

It is odd to reflect that only a few months later Whistler was to arrive in Paris as a student of the *avant-garde* and was to begin the 'French set' – the etchings of northern France. At first sight, nothing could be more different than Whistler's ferociously painterly approach and Burne-Jones's self-dedication to what he had felt, through space and music, as the life of the spirit. In no case would the two have collided as Ned walked blindly up to the *Coronation*. And yet, when in later years Burne-Jones told Rooke: 'I don't want to copy objects; I want to show people something',[13] the two came closer together than Whistler would have cared to admit.

The decision which Morris and Ned had made on the quays needed endless talking over: separation was impossible, and Morris soon went to Birmingham, where he must either have slept in the dining-room, or shared with the Joneses' lodger.

3
1855–6

MORRIS AND JONES: THE QUEST FOR A VOCATION

Instead of a monastery, they were going to start a magazine. It was to be in the spirit of *The Germ*, and so not unworthy of the Brotherhood. Morris paid the expenses, and was editor; the title he chose, the *Oxford and Cambridge Magazine*, was unpretentious, though Mackail tells us that at this time he bought a pair of purple trousers. The set, most of whom were in Birmingham for the vacation, were called upon, and Morris contributed some of his early poetry. 'You can write poetry on a train or an omnibus,' he told Burne-Jones.[1] There were evenings of enthusiasm, where the almost unstoppable Fulford read them two thousand lines of Tennyson, and there was still time for furious discussion. The final arrangements for the magazine were with Bell and Daldy, who published it at one shilling a copy.

While the magazine was in the planning stages, Burne-Jones found, at Cornish's shop in New Street, the book which was to mean more to him than any other – Malory's *Morte d'Arthur*. It was the Southey edition, and since it was expensive he read a little every day and bought cheap books, 'to pacify the bookseller'. But Morris, when he heard of it, bought it at once, and generously lent it to his friend while he dashed off on further visits.

It was, therefore, in the two-up, two-down house in Bristol Road that Burne-Jones confirmed his idea of life as a quest for something too sacred to be found, and ending with the death of a king and friend betrayed, which would be the ultimate sadness (*Morte Arthur saunz guerdon*). In the city beyond, Joseph Chamberlain was just beginning operations in the firm which was to produce twice as many steel screws

as the whole of the rest of Britain. Crom and Ned walked round the back-garden, reading in particular the story of Perceval's sister, who died giving her life-blood to heal another woman, and asked that her body should be put on a ship which departed without sail to the city of Sarras. Without the concept of the book as hero, Victorian idealism can hardly be understood. Morris returned, was enchanted immediately, and had the book bound in white vellum. It was the Quest without Tennyson, and it seems that at first they were embarrassed to speak about it to anyone but Crom, so deeply did they feel the spell of this lost world and its names and places. Yet Burne-Jones must also have noticed that Guinevere and the Haut Prince laughed so loudly that they might not sit at table, that Sir Lancelot went into a room as hot as any stew and found a lady naked as a needle, that the Queen, through Sir Ector, sharply demanded her money back from him, and that a gluttonous giant raped the Duchess of Brittany and slit her unto the navel. In fact Burne-Jones's letters show that he *did* notice this and that he could overlook in the *Morte* what he could not stomach in Chaucer. Malory's wandering landscape became in its entirely 'the strange land that is more true than real', but not just as an escape, the refuge of the romantic without choice. He found what is of much more importance to the artist, a reflection of personal experience in the fixed world of images.

So far Ned had not told his father what he intended to do, or even that he had given up the idea of the Church. During the Michaelmas Term of 1855 he at last did this, and Mr Jones, whose business by now was in very low water, quietly put away his hopes of seeing his son a bishop, and waited for the moment when he would become a grand historical painter like Maclise.[3] But other well-wishers in Birmingham were shocked and hostile, and Ned perhaps felt that he would get more understanding from his favourite cousin Maria Choyce, one of the farming family at Harris Bridge in Worcestershire. In a long letter to her from Oxford,[4] dated October 1855, he speaks feelingly of the 'little brotherhood in the heart of London' which he had hoped to found after his ordination – this dream still lingered – but 'delay broke up everything' and reading French and German philosophy 'shivered the beliefs of one, and palsied mine'. This is probably as near as we can get to the crisis of faith in Burne-Jones and Morris.

*

Weary work, this [he continues, rather incoherently] if, doubting, doubting, doubting – so anxious to do well, so unfortunate – friendly sympathy growing colder as the void broadens and deepens. I am offending everybody with my 'notions' and 'ways of going on' – general uselessness in fact – yes, I fear I have reached the summit of human audacity now as to claim forbearance from the omnipotent many, and even of acting honestly by publishing my defection. I shall not grace my friends now by holding that highly *respectable* position of a clergyman, a sore point that, giving up so much respectability, going to be an artist too, probably poor and nameless – very probably indeed – and all because I can't think like my betters, and conform to their thinking, and read my bible, and yes, dear friends, good advice, not very profound perhaps, rather like sawdust to a hungry man.

Never mind, Y, [Ned's pet name for Maria Choyce] you won't cut me will you, or give me up for an utter reprobate, because I am not going to preach immaculate doctrines in stainless gloves and collar, and be a 'dear man', and have slippers worked for me, without stint of wool and canvas, till I marry into a respectable family – perhaps grow fat, who knows?

Ned calls this a 'savage, gloomy letter' written on a 'damp, dark day'. It underlines once again the fact that what he had experienced was a change not of faith but direction; he must find a profession which didn't give 'sawdust to the hungry man'. Sintram and Guy, mentioned (together with Clive Newcome) in another letter, are still the heroes of sacrifice, 'so anxious to do well'. Thackeray's Clive Newcome, of course, outrages his family by intending to become a painter. As Dixon wrote later, 'we had all a notion of doing great things for men; in our own way, however: according to our own will and bent.'

The letter to Maria explains Ned's first contribution to the *Oxford and Cambridge Magazine*, which was not an illustration (woodcuts were found to be too expensive) but a 'tale' – *The Cousins*.[5] The hero is rejected by his beautiful cousin at a dance because he turns out to be poor, and he leaves the house to wander through the London streets. Although there are a good many of these wanderings in Victorian fiction, Scrooge's flight being one of the earliest, Ned's story does not feel like imagination. The sight of drunks and

prostitutes huddled in the doorways brings back his remorse of childhood years 'when a lean starved face pressed itself into silly flatness against a pastry-cook's window when I was within'. He sees a woman knocked down as she carries her child and the blood from her mouth spatters over him. All he can think of is to offer money, and money again to a wretched young girl whose mother wants to send her out as a prostitute. At Waterloo Bridge, the haunt of suicides, he feels an 'oppressive haunting' from the lost lives in the dark swift river which later comes back to him in dreams. Calling again on his cousin to make a last appeal, he notices a water-colour which he has 'commissioned from a young friend' of Dante's vision of hell, with Dante standing in the flow of the 'iron-walled city'; this is, so to speak, a Rossetti which was never painted. The 'tale' ends with the hero's nervous breakdown and attempted suicide in a river, from which he is rescued by a less worldly cousin.

The Cousins was a great success with the set, and Ned, who had a pleasant deep voice, was asked to read it aloud and although this brought on an agony of shyness and at the end he rushed out of the room. His only other 'tale', *A Story of the North* (February 1858), is almost a pastiche of *Sintram*. He may perhaps have had a hand in the article on Oxford (April 1856) which looks forward to a time when closed places will be abolished, 'ruinous colleges' swept away, 'and there in the parks will stand the new Museum, all glorious in bright stone, already sobering with time', while married Fellows return to their domestic hearth, girl undergraduates brighten the streets, and 'pale students' are actually allowed to take books out of the Bodleian. This last prophecy is the only one which has not been fulfilled, although the Museum still does not look sober.

The contribution which meant most to Burne-Jones himself was his essay on *The Newcomes*, in which he found room to praise Rossetti's *Blessed Damozel* and *Hand and Soul*, and his illustration to the *Maids of Elfenmere*. Though he did not know it as yet, Rossetti had been highly gratified by this article 'being unmistakeably genuine'. But Ned deliberately did not follow up his beginnings as a writer. He did not, as he had first of all intended, produce articles on Ruskin and *Sintram*. Very well aware of his limitations, he felt that he would be wrong not to concentrate on the one profession he had chosen.

How did a young man become a painter in 1855? Mr Jones might

well have pointed to the expanding Birmingham schools of design, or to Samuel Line's private school of decoration and engraving (also in Birmingham), which opened at five in the morning. These, of course, supplied designers for Birmingham's industry. But equally hard work was required of the fine artist, and Birmingham had also been the starting-point of David Cox; his name was revered there and he was now living in honourable retirement at Harborne, on the outskirts. Turner also was much collected, had of course the blessing of Ruskin and had been a close friend of one of his patrons, Mr Gillott the steel-penmaker. Both these successful artists had followed the right way of early apprenticeship, for which Ned was already about ten years too old. Later the water-colourist must hope for old aristocratic or new manufacturing patrons, and the good offices of the Royal Water-Colour Society.

The career of the painter in oils, nobler but less directly useful, was concentrated on the Academy, although the R.A. had not yet reached its period of supreme power which was to come in the seventies and eighties. The painter was trained from childhood. He passed several preliminary years at Sass's (until poor Sass went mad in the 1830s – then it was Gandish's), and entered the Academy Schools in his teens. At that very moment Albert Moore and Simeon Solomon were beginning there at the age of sixteen, and Fred Walker, at eighteen, was apprenticed to a wood-engraver while he studied. The course, though shorter than it had been, still meant at least two years' study of the antique before life drawing was permitted. Until recognition came, the 'artist professed' kept body and soul together by doing illustrations, ornamental capital letters (a great resource), wood-cutting and engraving (the Dalziel brothers and Lane employed as many as forty 'peckers' on their special editions) – even, as Madox Brown had had to do, by preparing calotypes.

The wood engraver was described as looking wistfully out from his lamp-lit night-work while the more fortunate painter, after the daylight had gone, went out to his haunts. But the painter lived under the recurrent threat of varnishing day. Time ran out, his 'subject' might be stolen. According to Whistler, as the fatal day approached 'artists locked themselves into their studio – opened the door only on a chain – if they met each other in the street they barely spoke. Models went round silently with an air of mystery.'

The completed work departed in a cab, or, if the artist was poor, on foot, amid the laughter of the bystanders, to its fate before the Hanging Committee. Sales depended largely on Academy showings, and to a noticeable extent on Ruskin's *Academy Notes* as soon as these began to appear in 1855. Engraving fees, if a picture was likely to 'take' as a popular print, were important: they had a great bearing on the choice of subject, and Frith at one time was offering £200 for good suggestions. Fame was reached when a picture was railed to keep back the crowd; respectability came with election as an Associate. It was a life of splendours and *misères*, but the English painter still felt his craft as honourable, hard-earned and necessary to society. Art was not yet fashionable, as it was to become in the seventies. The emphasis was not on beauty but on worth, and the painter was felt to be worthy. '[We artists] should cut a sorry figure if we laid down our brushes at any given hour,' Holman Hunt wrote, 'our lesson in art is the example it gives of strenuous effort.'

All this was of no interest to Burne-Jones. Like all living organisms, he anxiously searched his environment for what was hostile and what would be friendly to life; his instinct rejected the acceptable course of 'doing things properly'.

It has been said that in his article on *The Newcomes* Burne-Jones had managed to praise Rossetti's *Maids of Elfenmere*. This was an illustration to William Allingham's *Day and Night Songs*, published by Routledge in 1855. It showed the three white-clad singing maidens hand in hand casting their spell over the half-unwilling lover. The Dalziels, in the face of great difficulties (the design as handed to them was unreversed and in mixed pencil, wash, coloured chalk and ink), had reproduced it wonderfully well. Burne-Jones was struck by three things: the weirdness, the suggestion of music itself in the rhythm of the drawing, and the concentrated expression in the man's face. The *Memorials* tells us that he returned to *The Fairy Family* with a new vision – one might say a new dissatisfaction, for although he made the figures larger he could not finish them. But the iron will-power which was so discerning in him now prompted him to drop the whole attempt, to disappoint his father and offend more people with his 'notions' and to appeal, somehow and in some way, to the man who had done *Dante Drawing the Angel* and now the *Maids of Elfenmere*.

Morris had written *his* difficult letter home, announcing his change of intentions, at the same time as Ned. He took his pass degree in the

November of 1855, and in the following January signed his articles with the architect G.E. Street, whom they had met respectably at the Oxford Plainsong Society, and whose office was then in Beaumont Street. Morris seemed fairly and solidly started in his profession, among old friends. Ned, without much prospect of an honours or even a pass degree, set out for London after what must have been an awkward Christmas in Birmingham.

'I was two and twenty, and had never met, or even seen, a painter in my life. I knew no one who had ever seen one, or had been in a studio, and of all men who lived on earth, the one I wanted to see was Rossetti.'

4

1856

AN APPRENTICESHIP TO ROSSETTI

In saying that he had never even seen a painter Burne-Jones was less than grateful for the glimpses of Alfred Hunt in the print shop and for the efforts of his aunt, who had introduced him, as a schoolboy, to her brother-in-law Frederick Catherwood.[1] But this, which had seemed important at the time, was of no account now, although as usual he made straight for his aunt's house in Camberwell. This was 10 Addison Place, a quiet narrowly plain brick house near St Giles's church, due, at the time of writing, to be pulled down.

Ned was encouraged in his undertaking by a kind letter from Ruskin, acknowledging a copy of the January issue of the Magazine, which he had ventured to send him. A letter from Ruskin seemed to bring him to the approaches of the world he must enter. He set out on foot from Camberwell to Great Ormond Street. He had been told that Rossetti taught in the Working Men's College there.

The Working Men's College was a new venture – it was established in its final form in 1854, when it incorporated the earlier People's College and took over their hall under the workshops of the Tailors' Association. It represented the highest ideals of its founder, F. Denison Maurice, whose aim was not to improve the skill of craftsmen – that was the job of the Government schools at South Kensington – but to give working people the same education as the better-off, in an institution which they could run themselves.

'We are meeting you all as *men*', he wrote, 'to enable you to work together as men.'[2] But by a sad and familiar process, the majority of the students were not the workers whom Maurice wanted to reach, but mainly 'clericals', followed by a high proportion of jewellers and cabinet-makers. Furthermore, the admission of women soon led to

social functions, teas for the poor and, as the older members complained, 'overmuch dressing'.

Admission was one shilling, four shillings for the term, and the instructors gave their services free. Ruskin, of course, had been the inspiration of the place, taught there and wrote his *Elements of Drawing* for them; at this point Rossetti, at his own request, was helping him with his Thursday night drawing class. This seems to have been open to the public, but Burne-Jones went instead to the monthly council meeting, also public, in Great Titchfield Street at which, he was told Rossetti might appear.

The atmosphere on all occasions seems to have been much like a school, with elected monitors 'to stop people loitering round the fire' and a small charge for tea. Ned sat at a table, he told Mackail, and had thick bread and butter, 'knowing no one'. He had no idea of speaking to Rossetti: he simply wanted to look at him. But the atmosphere was one of comradeship, and the pale, thin, ingenuous appearance of Burne-Jones aroused, as it usually did, a desire to help. A stranger spoke to him across the table, and another one, Vernon Lushington, offered to tell him when Rossetti entered the room. Lushington was a most interesting person, who had been three years at sea as a midshipman before coming up to Cambridge, and was now just starting his career as a lawyer and philanthropist. As a matter of fact, Ned probably knew him already – he had contributed to the magazine – but he was certainly thankful to see him at that moment.

After an hour of speeches, Rossetti did come, 'and so I saw him for the first time, his face satisfying all my worship, and I listened to addresses no more, but had my fill of looking, only I would not be introduced to him'. The introduction came a few nights later in Vernon Lushington's rooms, where Rossetti (with his brother William Michael quietly in the background) was apparently established as hero and tyrant: someone criticised Browning's *Men and Women* and was 'rent to pieces'. Ned was presented, and with rapid generosity Rossetti told him to come to his studio the next day. This was at Chatham Place, at the north-west corner of Blackfriars Bridge, where Rossetti, ignoring the strong river smells, looked out on three sides at the moving lights and small craft of the Thames. The rooms were full of piles of drawings and books; something about Ned's face made Rossetti want to exaggerate, and he told him

that books were only of use to prop things up. This was a great deal for the follower of King Arthur, Clive Newcome and the *Broadstone* to swallow. The picture on the easel (later the *Fra Pace*), was a watercolour of a monk drawing a mouse in the margin of an illuminated manuscript. Ned felt that he had been 'received very courteously', and since no one came he stayed 'long hours' watching Rossetti at work, not guessing that he particularly hated this. Mrs Virginia Surtees, in her *Catalogue Raisonné* of Rossetti, mentions a tradition that Burne-Jones was allowed to put in the mouse, but it can hardly have been on this occasion. In the small hours he walked back again from Blackfriars to Camberwell.

The courteous reception of 'a certain youthful Jones . . . the nicest young fellow in – dreamland', as he described him to Allingham, was due to real gratification on Rossetti's part. The Pre-Raphaelites had fallen apart, he had for the time being almost given up his struggle to paint in oils, was defeated by his attempt at a contemporary subject in *Found*; if he had turned to 'Froissartian' subjects this was very probably because he had read some of Morris's early poems in the magazine and felt a new source of inspiration. 'He asked much about Morris . . . and seemed much interested in him.' Although he was not without patrons, and was still encouraged by Ruskin, he was often in a state of 'tinlessness', borrowing small sums from his family. He was no longer the leader he had been to Hunt and Millais, and his fine illustrations to the Moxon Tennyson were still in the future. In his emotional life he was feeling the combination of anguish and convenience in the mid-Victorian double standard. The conveniences were Fanny Cornforth and Annie Miller, the young barmaid from the Cross Keys who was supposedly the property of Holman Hunt; the anguish was Elizabeth Siddal, who had been sent abroad on doctor's advice during the winter of 1855–6 and whose 'arm chair that suits her size' stood in the corner of the studio.

The image of Lizzie Siddal recalls Rossetti's preoccupation with illness – illness and its remedies, even the most unlikely – and the fact that he could only really warm to those who were unsuccessful, 'seedy' or even 'dreadfully ill'. The death of his friend Walter Deverell in 1854 after months of poverty and sickness had shocked him deeply, and certainly the delicate appearance of Burne-Jones would only recommend him to Rossetti; it was almost as though he had been sent in Deverell's place. It may be said then that in the

January of 1856 Rossetti's generosity, morbidity and princely powers of encouragement were waiting to expand, and that this was a meeting fortunate on both sides.

Ned became acutely restless; he wrote a long account to Morris at Walthamstow, rushed up to Oxford for a noisy meeting with the Brotherhood and the long-suffering Maclaren, on to Birmingham and, probably at his father's suggestion, back again to Exeter for the Easter Term. The effect of his wild exaltation upon Morris, returned to his room in St Giles's and his articles with Street, was unsettling. Their friendship was not enough to hold Ned to Oxford, and at the beginning of May he was back in London for the Academy. Morris, who joined him there for the day, was struck by Arthur Hughes's *April Love*, and commissioned Ned to buy it; Ned went round to Hughes's lodgings in Pimlico, and more than thirty years later he could recall his expression when he came in with the cheque.

Burne-Jones never returned to Oxford as a student again, neither did he intend to go on living in Camberwell. Aunt Catherwood found him changed. Both Morris and he had let their hair grow, and wore soft hats. But in any case, it was not possible to launch out into a new life from the Camberwell house where, as the *Memorials* put it, 'to write a letter on Sunday was a marked thing, [and] to sit on one chair rather than another was to arouse the anxiety of its owner'. Much though Ned loved his aunt, Camberwell was, as he put it later, 'a seemingly needless neighbourhood'.

His intention was to live with William Fulford, who was said to 'have grown very serious', and had moved to London on the £100 per annum which Morris was now giving him to edit the magazine. Ned, on the other hand, had at the moment no income at all, and together they quartered the cheaper streets. One of these – in 1856 – was Sloane Street, then a cobbled road bespattered with dung and deafening with the noise of horse traffic. They took lodgings with one of the less frightening landladies at 13 Sloane Terrace. Fulford, however, had to return to Oxford for a few weeks, and Burne-Jones, who had never lived by himself before, concentrated the whole force of his nature on his worship of Rossetti.

Of this, one of the happiest years of his life, Burne-Jones's first memories were of weeks of light-headedness, largely the result of hunger. On leaving Exeter he was, he told Rooke, almost penniless. 'When I came away in the fourth year [*sic*] there was a lot of money

(about £20) owing to me but I never claimed it. Neither did I ask my father for any, for I was much too proud; I had barely half-a-crown about me.'[2] A good digestion, for despite every other kind of weakness Ned usually had that, enabled him to survive something close to starvation alternating with princely blowouts at Rossetti's favourite restaurants: the Bell Savage Inn, the Gun Tavern, and 'the little *à la mode* beef shop off Sloane Square'. He could not accept too much hospitality from the Macdonalds, who were now living in Walpole Street, their father having been appointed to the London circuit; he could not apply to Mr Jones, who was still struggling on with Miss Sampson, waiting for the grand historical painting. Unlike Rossetti, he had nothing to pawn. Finally,

> I was very hard up and much in want of the smallest sums of money – so I asked a lady who had been a friend of my mother's – almost the only one I knew who had been intimate with her, and asked her to lend me two pounds – but she didn't send me anything, only wrote back to say that she hoped my present straits to [*sic*] teach me in future. So I got nothing by that but humiliation, and you may guess whether I was furious or not, and I made up my mind that nothing should ever induce me to ask anyone for money again.'[3]

It had not occurred to him that an appeal to his dead mother's name would fail; and though Burne-Jones's finances are a complicated study, he never did borrow money from an individual again.

The necessary things were not eating and sleeping, but being with Rossetti and learning to paint. When he had the boat fare, he went from Chelsea to Blackfriars by river; otherwise he walked, but he was not allowed to go to Chatham Place every day. He was permitted to watch Rossetti make the initial drawing in pencil and go over it in violet carmine, and then to come back again three or four days later, but never to see 'the hard stage'.[4] This 'overlooking', with the glorious encouragement of Rossetti, who believed at this time that English poetry had come to an end with Keats but English painting was only just beginning, was all the apprenticeship Burne-Jones had until he attended evening classes in the following year. Everything else had to come by the way as he worked.

To recommend himself further to his master, who was in reality

only six years older than himself but seemed so much more, Burne-Jones tried to turn himself into a Londoner. It was a kind of saturation process, to produce what Henry James called a 'cockney *convaincu*'. First Rossetti's language must be imitated; a good deal of it Ned knew already – 'stunner' was current in Oxford in 1850, so were 'ripper', 'spiffy', 'cheesy', 'jammy', 'spoony', 'nobble', 'stock-dolloger' (for a knock-down blow), 'ticker' (for watch), 'crib' (for lodgings), and 'tin' (for money) but 'tinlessness', and perhaps 'bogeys' for the spirits of the departed, were additions by Rossetti; so was the richly resonant, not quite English intonation which carried with ease 'through rolling drums'. Then the 'great Italian' would walk the streets half the night, trailing his umbrella under stars and gaslight, and leaving Ned ill with tiredness: 'it became too much for me, it would have killed me.'[5] Nevertheless, when he was not allowed to accompany Rossetti he would tramp round himself, as though the nightmare of *The Cousins* had come true, past the terrible nightly parade of prostitutes and child prostitutes in the Haymarket, the pawnbrokers who would accept anything – even babies' coffins if the babies could be got out of them – and the doorways which were the last refuge of the homeless. 'What walks I have had in London streets,' he wrote to Mrs Gaskell, 'haunted walks – wretched ones.'[6] He grew to like barrel-organs, because they were the music of the streets. Not to be touched by it was a proof of hard-heartedness. Of London brutality he kept a curious memory. When the Guards were brought back from the Crimea in 1856 and passed by, almost every man mutilated or bandaged, he saw the crowd laugh at them.[7] Probably at this time he had a hallucination which recurred at intervals throughout his life: a man with a black bag would come up to him in the street, whistle in his ear, say 'God bless you' and quietly move away.[8]

With amazement Ned tried to adapt himself to Rossetti's careless and lordly domestic arrangements. He was not introduced to Lizzie Siddal, although she had returned to London in May 1856 and was living in her own rooms in Weymouth Street. Except for the landlady's occasional 'wench', there seemed to be no one in attendance. The studio itself, where the artist presided in a long flannel gown over a plum-coloured frock coat, had none of his 'discrimination for all that was splendid'. The whole place was full of junk. There were musical instruments that could not be played,

broken furniture, and the despised books; on one occasion Rossetti threw out of the window all the books that 'obstructed life', but the river returned them in a stinking heap. Bills were not regarded as they were in Birmingham. Accounts were not paid, colourmen and wine merchants protested, a Jewish pawnbroker arrived and swept away most of Rossetti's trousers for only £3, leaving him 'rather shabby'. With this went a natural prodigality. 'What he did he did in a moment of time, design was as easy as drinking wine . . . I used to say to him, why do you paint in colour that you know is not permanent? But he wouldn't listen to me or entertain the point for a moment.'[9] In the studio Ned saw drawings scratched out, thrown away, stuffed in drawers which, if he had dared to open them, would have shown him dozens of beautiful pencil and pen and ink studies of Lizzie. Watercolour was not used as it was by David Cox or in the 'Views' in Mr Jones's back shop, but mixed with gum, hatched and stippled and applied with a dry brush, or scraped away to make the white lights. A set which had been given to Burne-Jones were produced, Malcolm Bell tells us, when Rossetti called, 'in all their wrappings and protections. Without a word Rossetti took them and to their owner's horror and dismay, tore the whole set in two and went away.' This was intended as a sign that Ned, who was timidly painting on a background study, had progressed far enough not to need them. Still more amazing was Rossetti's scorn of patrons, and the violence of his opinions. He advised his pupil to turn over the pages of Mrs Jameson's *Sacred and Legendary Art*, 'and when you come to the name of Rubens, spit here'.[10] Indeed, Rossetti used the strongest language Ned had ever heard. 'The first time he used a bad word, he saw that I was shocked, but he said in his lofty way, you must know, Ned, that I've tried to eliminate that word from my dictionary but find I can't do without it.'[11] Other evidence (for example Allingham's diary) suggests that this word was 'bloody', but the recent publication of one of Rossetti's limericks, preserved by Bertrand Russell, opens up many other possibilities.

Saving was not a virtue at Chatham Place, morality was not; generosity ruled, but Rossetti took as well as gave. 'I'm sure there wasn't a woman in the world he couldn't have won for himself! Nothing pleased him better, though, than to take a friend's mistress away from him.'[12] By 1855 Rossetti had broken with Annie Miller, but the search for 'cordian stunners', red-haired and wheaten-

haired models, went on by day and night, and Fanny Cornforth appeared in the studio. Burne-Jones felt, like the warmth of a fire, the expanding sexuality of the ménage. The temptation of his ingenuousness was sometimes too much for Rossetti. 'Jones is an angel on earth and too good to be true,' he told Boyce. But Burne-Jones told Rooke that Gabriel:

> once gave a woman 5/- to go after me – one night as I was going quietly to my bus. He told her I was very timid and shy and wanted her to speak to me. I saw him talking to her as I looked back, and then she came after me and I couldn't get rid of her. I said no, my dear, I'm just going home – I'm never haughty with those poor things, but it was no use, she wouldn't go, and there we marched arm-in-arm down Regent Street – I don't know what any of my friends would have thought if he had caught sight of me.[13]

Some of these experiences were lessons on what to avoid. But there were two deeper patterns that Burne-Jones began to study from Rossetti. The first was the art of concealment. Rossetti himself carefully separated the mystical and superstitious self, darkly concerned with the coincidence of his name and life with Dante's, from the respectable son and brother to his family, and again from the dashing cove, more English than the English, and familiar with pawnbrokers, slop-shops and music-halls. The work which was the magic mirror of the manifest heart could equally be called 'my rubbish' or 'the daubs'. Burne-Jones was to find increasingly over the years that there was a solace in manoeuvring the different aspects of his own personality, sometimes to disconcert people, often to keep them at a distance. And character can be fragmented by space as well as time. Different as he was, as a human being, from Rossetti, Burne-Jones also was to feel himself 'twice-born', an inhabitant of two centuries at once.

The second pattern was one that Burne-Jones himself constantly acknowledged. 'He taught me to have no fear or shame of my own ideas, to design perpetually, to seek no popularity, to be altogether myself.' Design was not only the measure of the artist's invention, but the evidence of how far the hand had followed the soul. In *Hand and Soul* Rossetti's Chiaro dell'Erma found that the study of beauty

alone was an illusion, but so too was commitment – his grand political allegory of peace was spattered with the blood of fighting factions. The painter had only one necessity – to paint his own soul so that he might known her; 'seek thine own conscience – not thy mind's conscience, but thy heart's.' From Rossetti, Burne-Jones learned to strengthen his Midlands obstinacy and to defy all criticism and rejection in pursuit of his own style.

In all this Ned heard the note of authority which he needed, and 'in the miserable ending years I never forgot this image of him'. When, all through his life, he started a new canvas and asked himself, 'would he have liked it?', he was thinking of the judging and approving Gabriel of Chatham Place.

'Clinging tight to Gabriel whom I loved, and would have been chopped up for' (as he described it to Frances Graham), obsessed, over-excited, under-nourished and still with no idea how to paint, Burne-Jones needed the wholesome relief of Saturdays when Morris, after a week or so apart, began coming up from Oxford. The furniture cracked and suffered, Malory was read aloud, as in former days. It was a solid point of reassurance. But Ned could not rest until this friendship too was ratified by Gabriel. 'When I told him about Morris he said, "What's he going to be? He's going to be a painter, isn't he?"'[14] Morris was introduced, and felt the enchantment. On Saturdays they felt privileged to accompany him to the theatre, even though he sometimes grew impatient and took them away (to the distress of Ned, who was longing to know what happened in the fourth Act) go go to a drinking cellar 'not nearly so diverting as the play, but Gabriel said it was seeing life, and so we went'. On Sundays Rossetti called at Sloane Terrace, and the two green young men made tea, receiving a prince in hiding, and deeply grateful when 'it became clear that he liked to be with us'. Rossetti told them that he shared their feeling for the *Morte*, and Ned continued to read Dante in translation, as he had done ever since he saw the *Anniversary of the Death of Beatrice*, but without feeling that he understood it completely.

'Rossetti used to design wonderfully in pen and ink. I used to do it because I saw him do it, as a pupil does – though I never satisfied myself in it.'[15] About this time Burne-Jones began what seems to have been his first finished work, a pen-and-ink drawing, *The Waxen Image*. He may have put off oil painting because the smell of

turpentine made him sick – as it certainly did – or because Rossetti was working mainly in water-colour, but the delay was probably a matter of timidity and sheer inability to afford even the 'ha'penny colours from the oilman' which Rossetti said he used (in fact, he dealt with Roberson's). The two panels of *The Waxen Image* appear to be an illustration of Rossetti's poem *Sister Helen*, but there is an interesting variation: instead of the witch destroying her betrayer, the maiden consults the witch to get her lover back, only to see him die in her arms; and this begins a series of what can only be called defences by Burne-Jones of the *femmes fatales* of legend and poetry; as far as he was concerned, all pretty women were defensible. *The Waxen Image* is the first of a series of finely, even anxiously, drawn subjects – even the faintest shadows are cross-hatched – which include *Going to the Battle, The Wise and Foolish Virgins, The Kings' Daughters, Sir Galahad,* and *The Marriage of Buendelmonte.* Buendelmonte, with seventy-one recognisable figures, is the first design to show the typical ambiguous Burne-Jones weather – the central poplars blow in a storm, but others are still – and the first to show a figure of love, which may be crowned or blindfolded; we are not meant to know which. Though they were not the last pen-and-ink drawings he did, they left him with a permanent dislike of what he called 'etching and scratching, and lines to fill up corners'. When he became a master-draughtsman he found his own instrument – pencil.

One can feel the weight of patient lamp-lit evenings in these drawings, and in fact some of this work, which he carried about everywhere with him in a portfolio, was done at the Macdonalds, where in his loneliness he now called often. He was welcomed as before. Aggie, the prettiest, sat for him – she is the princess on the right in *Going to the Battle.* To the young ones, 'Mr Edward' was a kind instructor who not only helped them with their drawings and history in what seems to have been one of the most natural Victorian relationships of all – teacher and pupil – but gave them a glimpse of a world they had never even suspected, where beauty was an object of reverence instead of earning quiet reproof for worldliness. In return, Ned had to learn yet another language; the Macdonalds called a mind an 'understander', idle conversation a 'mag' (from 'magpie'), unhappiness 'the screws', and a nap a 'modest quencher'. 'Bare is back without brother behind', the family proverb on the value of friends, he understood well and indeed, in

the absence of Morris, felt. He had a bewildered sensation of falling in love with them all. But a sure instinct of self-preservation led him to fifteen-year-old Georgie.

Her photograph taken a few months later, in a buttoned black dress and white collar, shows her almost doll-like in size but with a modest dignity, ready for everything, and with a look as though she were about to swallow life like a plum and was not quite sure if she approved of it. Her hair, which at this date had bronze tints in it, is smoothed down and the pose does not show her grey eyes. Several writers have described, and Burne-Jones frequently painted, the sensation of meeting their fearless crystalline gaze, which did not so much seem to reprove small-mindedness as refuse to admit its existence at all. Yet Georgie was sympathetic, kind and witty, not least about her own misadventures.

Her firmness met Ned's gentleness; they fell truly in love and he began courting. She was learning drawing at the new Government Schools of Design which were then at Gore House, Kensington, and he could escort her there. He also attended Hinde Street chapel, which he hated, but the Macdonalds went nowhere else on Sundays. It was in this way that he learned that Georgie, like himself, no longer believed in doctrinal Christianity. He took her to the Academy – her second visit – to see *April Love*, now Morris's property, Hunt's *Scapegoat*, Millais's *Blind Girl*; Georgie had also seen the *Ophelia*, but so far had never been allowed to read Shakespeare, and of course had never been to a theatre.

In three weeks they were engaged. When Ned 'spoke' to Georgie's father he was asked nothing about his prospects, which could not well have been worse, but was given consent simply on consideration of character. Mr Jones was told, in his turn, by Ned at the side of his mother's grave, and made a bewildered visit to London. Ned and Georgie agreed on the day of their wedding, however distant: it would be the same as his day of acceptance – 9 June, the anniversary of the death of Beatrice. Georgie felt the excitement and the honour when she was taken to what she calls 'the shrine of Blackfriars'; on Rossetti, who did not know much about Methodist ministers' households, she made the impression of a country violet.

'I love you all more than life, and George in some intense way that never can be expressed in words,' Burne-Jones wrote to ten-year-old

Louie, the youngest of the sisters, in the August of 1856. If the Reverend George Macdonald, unworldly in his study, had little idea of what an artist's life entailed, Burne-Jones himself had not much more. He envisaged himself and Georgie, Morris and Louie, working and learning together in some secluded place, a tower, or a small town with streets leading into the fields, though this, like his dream at the monastery at Charnwood, was a delusion – he needed streets, traffic and company to be at his best. As a practical step, he began to attend night classes in life drawing at Leigh's[16] in Newman Street; Louie was helped with 'her' pen-and-ink subjects, one of which was a *Sleeping Princess*. When the *Memorials* tell us that 'the figure . . . is the same type that he used in 1890', Georgie means that in 1856 the unawakened girl was drawn from herself, just as thirty-odd years later it would be drawn from her daughter.

In August 1856, Street moved his office from Oxford to Bloomsbury, and there was no reason why Morris should not share rooms with Ned. They took furnished lodgings near Street's new office, in Upper Gordon Street. These, however, were disapproved of; 'Gabriel thought them too expensive, and he was worried at our not knowing how to help ourselves',[17] though a reference to Ned shouting for his dinner suggests that the standard of living had been raised. Rossetti suggested his old rooms at 17 Red Lion Square, which he had once shared with Walter Deverell. Morris, of course, must be a painter, and even Dixon, on a visit from Oxford, was persuaded to try – so was Philip Webb, the head clerk from Street's and Morris's staunch companion; Webb, however, made too many exact measurements to get started at all.[18] Morris, after a heroic struggle to carry on at Street's and do six hours' drawing a day at art school, threw in his hand and took up almost the only craft which he could never master – painting. For this, old Mrs Morris blamed Burne-Jones, her son's quiet friend whom she had liked so much, and who had even listened to stories of William's nursery days until firmly stopped by Morris himself; she divined, with maternal shrewdness, the real balance of will-power between them.

Mrs Morris may well have been right. If Morris had remained in the profession of putting solid buildings on the earth and designing large spaces, like the barns and cathedrals he loved, for extended family groups, he might not have been driven through life by 'these outstretched feverish hands, this restless heart'.

The relationship between Rossetti and Morris had in it, from the very beginning, a hint of uneasiness. Morris tried to submit totally, but couldn't; he had no more talent for humble discipleship than for painting. Burne-Jones recalled that 'it was funny to see them together ... [Rossetti]'d say to Morris as he came in of a morning, what do you think about that? and Morris would say well, old chap, mightn't it be put up a bit?'[19] Again, Morris was well off and a buyer (he had bought the *Fra Pace*), and Rossetti could never feel cordially towards patrons. Worse still, the robust and fattening Morris seemed never to be ill, scarcely even 'seedy'.

The move to Red Lion Square was made at the end of November 1856. Although the front window had been cut to give a higher light, the rooms were shabby, dark and unfurnished and had apparently not been cleaned for the last five years, since Rossetti, supervising, was still able to recognise an address which poor Deverell had scribbled on the wall. They were also remarkable for their dampness. 'When Deverell got ill and retired to the back room, the doctor came out and patted Rossetti's head and said "poor boys! poor boys!"'[20] The move was exhausting, the first 'respectable housekeeper' Morris engaged was intoxicated. She was replaced by the 'unfailing good temper' of Red Lion Mary, who soon gave up the battle for cleanliness. She, however, was prepared to sew draperies and read bits from Reynolds' Newspaper to Ned as he painted, and could equally well provide 'victuals and squalor at all hours' (his own phrase) or a suitable lunch for Louie Macdonald, who made them wait for it while she pronounced a blessing. It is surprising to find, even among helpless Victorian lodgers, that Mary had to wind up their watches and musical boxes and issued them with clean nightgowns only when she felt like it, but not surprising that Ned was favoured in this and in every other way. Although Morris paid the greater share of the rent, he took the smallest room without hesitation: Ned was delicate, and needed good air. In spite of this, Burne-Jones was the wild centre of evening parties, an energetic theatre-goer, and a superb teller of ghost stories in the dimly-lit studio.

The emptiness of the rooms led to some of Morris's first experiments in design, and the ordering of hugely mediaeval furniture in solid wood. Burne-Jones's first illustration of Chaucer, and first attempt at applied art, was on the wardrobe, designed by

Webb, which he decorated towards the end of their tenancy with scenes from the *Prioress's Tale*. Earnest and touching as the design is, it conceals a typical Burne-Jones allusion to Chaucer's unfortunate little St Hugh – 'I saye that in a wardrobe they him threwe', that is, in a privy. In the end the wardrobe, which is now in the Victoria and Albert, became Ned's wedding present to Morris, who took it with him wherever he moved.

The two friends had begun to live out *Hand and Soul*, realising both sides of Rossetti's metaphor, as interpreters of the dream and as mediaeval handicraftsmen. The measurements of the furniture were wrong, and Burne-Jones did not know how to lay the ground for his colours, but they persevered in the spirit of Ruskin's 'stern habit of doing the thing with my own hands till I know all its difficulties'. Here Rossetti could not teach them, although he goodnaturedly tried his hand at painting the chairs.

Rossetti, however, began to carry them tempestuously about with him wherever he went. Burne-Jones's life was one of expanding circles of friendship; the first had been the Brotherhood; now he entered the second. He was introduced, first of all, to the survivors of the P.R.B. and its followers: Arthur Hughes again, Millais, with whose highly-strung emotional nature Ned felt immediately in tune, James Smetham, Madox Brown, Holman Hunt, F.G. Stephens, by now resigned ('Stephens is Stephens still' as Rossetti described him) to a life as a dullish journalist and faithful friend and correspondent to the rest. Burne-Jones learned from Stephens to smoke clay pipes, and in 1890 was still writing to him: 'Get well and strong, dear fellow, and we'll smoke long clays when we are eighty.'[21] All these older friends took more or less kindly to the strange spirit of gaiety which had swept over Gabriel on the acquisition of these new disciples. 'Calling one day on Gabriel at his rooms in Blackfriars,' Hunt wrote, 'I saw, sitting at a second easel, an ingenuous and particularly gentle young man whose modest bearing and enthusiasm at once charmed. He was introduced to me as "Jones", and was called "Ned".' Towards Hunt, who had just returned from the Middle East, Rossetti's conscience was not quite clear, and it was on this occasion that Ned saw him passing his paintbrush again and again, conciliatingly, through Hunt's golden beard. Hunt, however, marked this Jones as a young man – at last – who might be taught something, to draw properly, not to use vermilion, to go to Field's,

the only place, in Hunt's opinion, for colours. James Smetham has left a similar impression in his little pen-and-wash drawing of Burne-Jones watching nervously while two visitors 'overlook' his work on the easel.

Another call, which seemed very far west in a hansom cab, was to Little Holland House, the home of the Prinseps and the studio of G.F. Watts. Here Rossetti introduced him as 'the genius of the age', and Mrs Prinsep, pitying his embarrassment, also marked him down as someone in need of protection. Val Princep, the painter son of the house, was under the spell of Gabriel, and recalled that at this time the 'main requirements', apart from trying to catch Rossetti's intonation, 'were to read *Sidonia* and Browning'. This of course Ned had done, and now he had the further honour of being taken to Devonshire Place to meet the Brownings.

Also present that evening was Charles Eliot Norton, the American scholar and man of letters. 'Twelve years ago I met one evening at Brownings' . . . two young fellows lately from Oxford named Morris and Jones. Jones very shy and quiet, and seemed half overpowered by the warmth of eulogy which Browning bestowed on a drawing that Jones had brought to show him – a drawing . . . of infinite detail, quaint, but full of real feeling and real fancy.' This was probably the *Waxen Image*; to show it was an ordeal, and Elizabeth Browning, Norton tells us, tried in vain to put Ned at his ease.

Norton was also a dear friend of Ruskin, whom he had met in this same year, 1856, on a tour of Switzerland, when he had ventured to introduce his sisters on board a lake steamer. If this suggests an early story by Henry James it is not surprising, since Norton was also to be James's mentor in matters of art. Wherever Norton enters the course of events, there is a breath of Bostonian high-mindedness, goodness and tedium.

Ruskin was a different matter, and by the winter of 1856 he was calling at Red Lion Square every Thursday, or even more often, 'better than his books, which are the best books in the world'. Ruskin, carrying away drawings, fussing and advising, was extending his patronage and his need, half shrinking and half effusive, to love and be loved. Here Burne-Jones came out to meet him, and the sympathy between them was something that would outlast disagreements, and even the darkness of insanity. Burne-Jones understood not only the

greatness of Ruskin but his strange reversions to infancy, the compensation for a lonely childhood. Whereas Madox Brown was critical when Ruskin was 'rompish' and helped himself too frequently to cake, and Rossetti saw him 'in person [as] an absolute guy', Burne-Jones was never surprised to find him at the circus, at the Christie minstrels, or dancing a Scottish reel; his unaffected admiration made nothing of Ruskin's oddities, though the balance of relationships was delicate. 'He was a most difficult child.' But this mattered nothing in comparison with the warm of meeting another 'scorner of the world'. This was Ruskin's message as well as Newman's. It is to the credit of humanity that whenever it has been clearly put, there have always been people to attend to it.

This can have been one of the few periods in Burne-Jones's life when he was *not* reading Ruskin, since he had given every copy he possessed to Georgie as a betrothal present. Meanwhile, Georgie and Morris drew together only slowly, but Ned of course still had his permitted outings with his sweetheart – now referred to as 'my stunner', although, as Norton noticed, she looked not Pre-Raphaelite, but exactly like a Stothard print. One outing where pennilessness did not matter was to the National Gallery, which, though it was still hemmed in with washhouses and barracks, had started its career as a representative collection. Under Sir Charles Eastlake it now had an annual purchasing grant of £10,000 and a clear mandate to buy early German and Italian pictures, for the 'primitive rooms', with Ruskin to advise on how to protect them against London soot.

Here Burne-Jones studied the Van Eyck *Marriage of Arnolfini* (acquired in 1842). The year before his death he told Georgie that his whole life long he had hoped to do something as rich and deep in colour as the *Arnolfini*, and now it was too late. 'It's all very well to say it's a purple dress – very dark brown is more like it.' The extreme depths of the blacks, the corresponding whites with no pure white in them, the strange room, the tender marriage symbolism, the orange, the famous mirror (which Holman Hunt had already copied in *The Lost Child*) continued to haunt him. In 1858 the gallery also possessed Botticelli's *Virgin and Child*, the *Three Maries* from the Lombardo-Baldi collection, and three Perugino panels, one of which, the St Michael, has a waisted suit of fantastic armour, like birds' wings or fishes' scales; this is the dream armour which Burne-

Jones already preferred to careful historical reconstructions. To go forward a little, in 1860 the gallery acquired the Filippo Lippi *Annunciation* which Ned studied in hopeless admiration at its use of gold, and Fra Angelico's *Christ Glorified in the Courts of Heaven*, surely the origin of Morris's remark that the heads in a picture should be 'all in a row, like shillings'. In 1862 came the Piero di Cosimo *Mythological Subject* (then called the *Death of Procris*). In front of these pictures the shadow of the young Burne-Jones, in his soft hat, must still hover, as it does in the tapestry courts 'like little chapels' of what was then the South Kensington Museum. No amount of travel abroad could give him the familiar love which he had for these treasures when he had scarcely a shilling in his pocket.

The book which expressed what Ned could hardly put in words about these pictures was Rio's *Poetry of Christian Art*, translated in 1845 because of what the introduction calls 'the daily increasing taste and appreciation of early Italian art'. This, of course, was a sign of the times. Christian Art, in fact, is the heroine of the book, brought to life by Giotto, humbly served by Fra Angelico, cruelly betrayed by the Medici, who favoured profane poetry and banking houses, rescued by Savonarola, betrayed again by the 'defection' of Raphael; in Venice she was in her glory with Carpaccio, and Rio speaks of visitors 'whose looks and gestures showed that the picture of St Ursula sleeping had put them into an ecstasy', but once again she was betrayed by Squarcione, rescued just in time by Gentile Bellini, and destroyed by the paganism of the seventeenth century. Aesthetic considerations are not Rio's concern. Botticelli is little mentioned; Ruskin's (and Proust's) favourites, the blonde-haired *Daughters of Jethro* in the Vatican, are criticised because they draw attention away from Moses. But Rio has presented the history of Italian art as an adventure worthy of Sintram. This was the book which Ned put aside to give to Georgie on their wedding day.

This was a year when the air seemed 'sweet and full of bells' to Burne-Jones, and although Morris, in a letter of 1875, recalls these as the 'tin-pot bells of St Pancras', he also calls them 'well-remembered days, when all adventure was ahead'. Later still, in 1893, Burne-Jones wrote to Mrs Helen Gaskell that he was alone in London and;

it was a little like it was when I first came to London and hadn't a

friend . . . I wandered alone the streets looking in pawn-brokers' shops, and went over all the streets I used to know, I even dined at the same place where I first dined with Gabriel the first time I was admitted to that heavenly company and I thought and thought and thought.[22]

So sure an instinct has the human heart for its happiest time.

5
1856–60

THE LONG ENGAGEMENT

There is a mild irritation in Rossetti's letter to Allingham on 16 December 1856: 'Jones is doing designs (after doing the ingenuous and the abject for so long) which quite put one to shame, so full they are of everything.' But there is also his characteristic generosity, and he threw himself into finding some way for Ned to make a living. His method of doing this was to praise his protégé to the skies as 'unrivalled by any man I know', to produce examples from his capacious pockets, and to approach even his own not too numerous patrons; these had come to know him and made their own deductions. The *Illustrated London News* not surprisingly turned down the idea of the quite inexperienced young Jones working for them as a draughtsman. Gabriel next approached James Powell and Son, the glass manufacturers. According to May Morris, he told them that a 'young chap called Jones would do them some good stuff'. For this firm Burne-Jones produced his first cartoon for a window.

This cartoon, *The Good Shepherd*, is a strong apprentice's design in Rossetti's manner, a broad-hatted Christ with nail-holes in large square hands, 'in such a dress as is fit for walking the fields and hills', carrying a sheep which chews the vine-leaves round his hat. Although it drove Ruskin 'wild with joy' it seems not to have been used until 1861, when it was carried out for the congregational church in King Street, Maidstone. But Powell's commissioned more work, the *Adam and Eve, Tower of Babel* and *Solomon and Sheba* for St Andrew's College, Bradfield, a window for Waltham Abbey and, at the suggestion of the architect Woodward, the *St Frideswide* window for Christ Church, Oxford. This (although Malcolm Bell tells us that Burne-Jones was thrown out by being supplied with the wrong

measurements) is truly the 'stained glass of a stunner' as he described it to Swinburne, who was writing the 'labels' – a dazzling mass of jewel colour, strikingly different from his *St Cecilia* of 1874 on the opposite side of the chancel. In these first designs, he indicated the lead lines and the colouring himself.

Two points may be made about the beginning of his thirty years' career as a great designer of windows. First, it was absolutely necessary to the life that Morris and he had mapped out for themselves that their art should be, as far as possible, public. 'Portable art is ignoble art,' says Ruskin in *The Two Paths*, and none of Browning's *Men and Women* affected Burne-Jones more than the Pictor Ignotus who shrinks from the private patron:

> These buy and sell our pictures, take and give
> Count them for garniture and household stuff,
> And where they live must needs our pictures live . . .

The beauty of art should be for as many people as possible to stand in front of; it should 'show people things'. Secondly, his earliest attempts made it clear that Burne-Jones was born with the gift of filling spaces. This natural gift of design he estimated calmly, knowing it was necessary but wanting to learn other things, and never confusing it with Chiaro's struggle to paint the soul. This is well shown by his attitude to Japanese art, which he tried to explain to the earnestly collecting William Michael Rossetti. 'Japanese art is well placed and no more; but the making of patterns is no trifle – it's a rare gift to be able to do it.'[1]

With easel painting he went ahead much more slowly, and here, whatever the Pictor Ignotus might say, private patrons must be found, and without exhibitions, since Rossetti hated them. Apart from Ruskin and Mrs Street, who bought *The Waxen Image*, Burne-Jones's first patron was T.E. Plint, a kindly and (as it turned out) not very businesslike Leeds businessman. He had the habit of paying artists in advance for their work, which Rossetti regarded as a mere stockbroker's device in the hope of rising values; but in fact Plint meant kindly, and understood what it was to be tinless. For him Ned began on two water-colour panels: 'I have chosen the Blessed Damozel for my year's work.' But this was to be interrupted.

It is difficult to tell at this distance of time why, in the summer of

1857, Rossetti suddenly decided to remove his followers from London to Oxford to decorate the new Debating Hall of the Union building. Rossetti, as a friend of the architect Benjamin Woodward, seems to have expected to get a definite commission for work on the Museum and may have been offered the Union in compensation. Certainly the Building Committee was induced to agree without waiting for a general meeting. The artists' materials and board (this would only mean half-price vacation lodgings) were to be paid, but they were to give their work free. The inducing must have been done by Rossetti and Morris, who came to Oxford with him, for Woodward was a sick man, soon to be a dying one. It was, in any case, hard to get an opinion from his firm, since Woodward was completely silent, his partner Sir James Deane chattered and Deane's son stammered.

The commission was to undertake what was then called a fresco, but was actually painting direct on to the brick walls of the gallery. The gallery was pierced with twenty six-foil windows, the light from which would in any case make the surrounding decoration almost invisible. Rossetti also without consultation, decided on a series of scenes from the *Morte d'Arthur*. He thought he could manage two of them himself.

This meant returning to London to recruit eight more artists. Madox Brown, the old professional who had been carefully trained in every branch of his art by Baron Wappers, stoutly refused to take part. Philip Webb and Street, who knew a good deal about mural painting, seem not to have been consulted. Morris and Ned of course would come, even though this meant Ned stopping work on his commission for Mr Plint. Arthur Hughes, who had worked for a time in Rossetti's studio, came uncomplainingly. Spencer Stanhope was a well-off, well connected, unassuming young painter who had studied under Watts, and had had a studio directly underneath Rossetti's in Chatham Place. He came, and so, rather against his mother's better judgement, did young Val Prinsep. Staying as a guest with Woodward was a much more considerable figure, John Hungerford Pollen, who was now Professor of Fine Arts in the Catholic Univeristy of Dublin. It was he who had decorated the ceiling of Merton chapel, and he brought with him assistants, including Miss Smythe, model for the angels, and the support of the 'artistic ladies' who were beginning to make their appearance in

North Oxford. Rossetti calculated that the work could be done in six weeks.

This leads one to wonder how seriously the authorities took the idea in the first place. The 'frescoes' were to be done on whitewash and could always be whitewashed over again, as indeed Rossetti eventually suggested that they should be. When in the end it became clear that the project would never be finished, the committee had the last three bays finished without difficulty by William Rivière.

Meanwhile Morris and Burne-Jones were sent on ahead, and took lodgings at 87 High Street. When Rossetti arrived they lived like a band of paint-stained, clay-smoking brothers, rejecting invitations to dinners and 'evenings', even on one occasion taking a train up to London and back to avoid them. It seems remarkable that they were asked out so often, until it is remembered that Stanhope and Prinsep were both very eligible young men.

As to the work itself, Rossetti's colour scheme of blues, reds and greens was undoubtedly a brilliant one, though it was blackened by the gas chandeliers within a year. The photographic reproductions edited by Holman Hunt in 1906[2] also show that Rossetti's design of *Lancelot's Vision of the Sanc Grael* was the only one of reasonable standard, but the plaster was not dry, and the small brushes he had ordered were quite inadequate. Perhaps because he realised this, Rossetti seems to have changed his mind and decided not to take the project seriously either. The stories of larks on the scaffolding and frightening quantities of soda water ordered in from the Star Hotel give an atmosphere of farce, but the younger painters were seriously trying to prove themselves. 'Over the work the boy's curls fell.' Hunt, staying with the Combes, noticed Ned's 'personal manner of beseeching earnestness', and Val Prinsep remembered him gliding in before the door was half open and sitting straight down to a pen-and-ink drawing. Morris, having made a mess of his painting, slaved away at the decoration of the roof, with the help of faithful Charlie Faulkner, now a Fellow of University College. Poor Arthur Hughes also worked seriously; he had even brought his dress clothes, and it is painful to hear of Gabriel giving orders that Morris should squeeze into the trousers 'although Hughes was taller . . . and rather thin'. It was not only the stunning larks but the strain of working hard till the light failed and earning nothing that kept the

atmosphere that summer at fever pitch.

At the end of the long vacation there was no prospect of completion. Hungerford Pollen, who had at first unexpectedly joined in the chaff, coming round at eight in the morning to drag Ned out of bed, returned to Dublin leaving his assignment unfinished, although Miss Smythe had 'put in' the Brand Excalibur. Val Prinsep was recalled to London by Mrs Prinsep, who requested Ruskin to fetch him, saying he was learning nothing. Their places were taken, as the term began, by undergraduates who as Hunt acidly says 'were induced to cover . . . certain spaces'. Among them was Swinburne, who had come up to Balliol the year before. In November Rossetti perhaps to his own relief, was called away; Elizabeth Siddal was seriously ill in London.

Morris and Ned moved to new term-time lodgings at 13 George Street, and Ned, still wishing to prove himself, worked doggedly on at the Union. The subject Rossetti had set him was *Nimuë Luring Merlin*, and his design (in spite of Hunt's compliments) was, for once, stiff and unsatisfactory – two figures of equal height facing each other across a wall. Spencer Stanhope (*Sir Galahad and Three Damsels in the Forest of Arroy*) laboured on by his side. 'As time went on,' he wrote, 'I found myself more and more attracted to Ned . . . he appeared never to leave his picture as long as he thought he could improve it.' But a string-course ran right through the heads of Nimuë and Merlin, and the brick-interrupted faces were a disaster.

Morris's feelings were quite different, because at the end of the long vacation he had met and fallen in love with Jane Burden, the seventeen-year-old daughter of an Oxford stableman. She had been admired in church, introduced by Mr Combe, and was the Guinevere of Rossetti's design. A little drawing by Rossetti shows Morris diffidently offering her a large ring, over which she bends her dark head and her 'neck like a tower'. Morris therefore stayed on in George Street for most of the following year, and in the February of 1858, Burne-Jones had to go back to Red Lion Square by himself.

In appearance he was changed, because, like Morris, he had grown a short beard; the last glimpse of the clean-shaven Ned is the sleeping Lancelot in Rossetti's Union mural, for which he sat as model. Emotionally, he was suffering a deep reverse after the excitement of the last year. Red Lion Square, it is clear, was never meant to be lived in alone; how little he was in touch with Morris

was shown in a letter to Crom Price: 'Is Topsy in Oxford?' He painted on the Chaucerian cupboard, though still sickened by the smell of oils. He could not have helped reflecting on the good fortune of Topsy, who would be able to marry when he chose, whereas Ned's engagement to Georgie had already lasted a year and a half and dragged on in aching unfulfilment. He was behind with Mr Plint's commission, was worried by letters from home where Mr Jones was 'in business trouble a good deal', could not afford to visit the famous Manchester Art Treasures Exhibition of 1875, and had not even the fare home to Birmingham.

In the early summer of 1858 he fell seriously ill. This was the intensely hot year of the 'great stink', when the condition of the Thames sewage at last drove Parliament to legislate, and the combination of marsh fever, loneliness and frustration made Burne-Jones almost too weak to move.

It is easy to dismiss the constant illnesses of Victorian letter-writers as self-induced, but if we do so we are put to shame by the ready anxiety of the sufferers' friends. Cures were not expected; an illness at that time was a lifelong companion. Fainting, weakness and nightmares were part of Burne-Jones's tensely-charged nature: Rossetti called them 'Ned's ups and downs'. In this acute 'down' he was rescued by the auntly and overwhelming Mrs Prinsep, who carried him off bodily to Little Holland House; her doctor tactfully told her that if she had not intervened it would have been too late.

The rambling old place in Melbury Road was at the same time a refuge and a centre of eccentric yet stately hospitality. Holman Hunt felt that Mrs Prinsep, surrounded by her sisters, 'could not but make an Englishman feel proud of his race'. All admired the sheer size of the family, 'Elgin marbles with dark eyes', although du Maurier complained that 'the women offer Tennyson, Browning and Thackeray cups of tea almost kneeling'. Those early days seem to have been a perpetual summer: strawberries came from a Kensington farm, children romped on the lawn, Tennyson read aloud under the trees; Julia Cameron had not yet begun to menace all-comers with her camera, and inside there was quiet in the shadowy rooms, where Watts's canvases glowed on the walls. Watts had his quarters upstairs in another 'quaint set of rooms' (for which, incidentally, he paid rent), and the huge Val Prinsep, who

had carried Ned up the ladders when they were both at work at the Union, now carried him up to bed.

The most telling part of the experience of Burne-Jones was not so much Mrs Prinsep's kindness, for nearly every woman he met wanted to look after him, but the day-to-day living in a house where nothing was ugly, nothing was saved up to be used again, and beauty was taken for granted. He was, also, in contact with a highly skilled artist, for although Watts was largely self-trained, he had been working since the age of ten and was amiably accustomed to pupils.

It was here, Burne-Jones said, that he learned that 'painting is really a trade; the preparation and tools are so important'.[3] Watts was at work on the sumptuous *Countess Somers*, almost life-size, in Venetian rose and ochre and his favourite indigo. Although Watts did not let his pupils copy, the portrait was a lesson in itself on the handling of colour. Meanwhile the real Lady Somers accompanied her sister, Mrs Prinsep, on a call on Georgie; it was a visit of inspection, during which the minister's family was not daunted.

Little Holland House, however, could be a dangerous place. We have a description by Ruskin in the *Winnington Letters* of Ned's second visit the following spring, with Watts in the drawing-room painting, apparently, in an arm-chair. The atmosphere was one of charged sensibility, with Tennyson shaking like the 'jarred string of a harp' as he complained about the recent Moxon edition, illustrated by Rossetti, Millais and Hunt, among others, while Ruskin defended the artist's right to interpretation. '. . . Behind me, Jones . . . laughing sweetly at the faults of his school as Tennyson declared them, and glancing at me with half wet half sparkling eyes.' A day or two later he gives a truly Ruskinian classification of Ned's smile (as opposed to Watts's, which seems to have been fairly normal); it is 'like a piece of sugar candy – he is white and fair . . . all done in *light* – the lips hardly smiling at all.' One's reaction to this is that Ned must be got out of Little Holland House as soon as possible, and in fact both Rossetti and Morris began to think so. Gabriel believed that the air of Kensington was unhealthy. In an affectionate letter, beginning 'Dear dear old Ned',[4] his advice is to leave the Prinseps, put the *Blessed Damozel* aside and start 'one or two small things' to sell at once; Plint is used to long delays in any case.

In September, when Ned emerged from Little Holland House, he found that Morris did not want to return to Red Lion Square at all.

While on holiday, rowing down the Seine with Webb and Faulkner, he had worked out plans to build his own house; in fact he had already bought a piece of land at Upton in Kent. Ned perambulated the streets again, and found rooms in what is now Fitzroy Street, but was then 24 Russell Place. So unobtrusively did he go that even Red Lion Mary was not sure of the date.[5]

His evenings were sometimes spent at the Hogarth Club, one of the very numerous exhibiting, talking, smoking and mutual-help groups of the gregarious Victorian artist. Madox Brown and Rossetti were on the committee, and Spencer Stanhope and George Boyce were among the members. Boyce's diaries record a meeting at Red Lion Square, but the club had now moved to 6 Waterloo Place. Burne-Jones, at least, had hoped for a quiet 'mag' there in the evenings, but was appalled by the meetings, resolutions and regulations which seemed inseparable from it. He began to realise that he was not a man for public life. The Hogarth, however, was of importance to the forward young spirits at the Academy schools, who were allowed to look in and saw there pictures which were exhibited nowhere else.

It is rather a surprise to find that Burne-Jones, who had had so little instruction himself, had now begun teaching at the Working Men's College. Ruskin was still attending there, having abolished the too-popular modelling classes (from which 'men appeared smudged with white clay'), in favour of more serious drawing. Ned (who appears in the records as Edward Burne Jones, Exeter College, Oxford, Painter, giving him a dignity he hardly possessed) acted at first as assistant to Madox Brown; later he had his own drawing class, the Figure and Animals, on Mondays and Fridays. One must hope that he was never called upon to do horses, which always worried him; though his sketches in the Victoria and Albert suggest he had very poor models, probably cab horses. But Ned was an excellent teacher. From his first lessons with Louie Macdonald to the very night he died he continued to help and encourage beginners.

Once again, it is a drawing by Rossetti which gives us Ned's appearance at the time, with his first beard and sad, very light eyes. This is a study for the head of Jesus in Rossetti's *Mary Magdalene at the Door of Simon the Pharisee*, for which the dazzling actress Louisa Herbert had been persuaded to sit. The Magdalene's figure, however, with its brawny arms, was taken from a

Scandinavian prostitute of the tough, good-natured type – according to G.A. Sala, the original *Jenny*. 'The Magdalene was taken from a strapping Scandinavian,' Burne-Jones told Rooke. 'She *was* a splendid woman, beyond doubt . . . she always used to call me Herr Jesus quite seriously, not knowing my name – which pleased him exceedingly.'[6]

The courtesy of this scene is a reminder that Burne-Jones in these early days did try to act upon the pity for women which is evident in *The Cousins*. He brought home an 'unfortunate' to Red Lion Square for Mary to feed and clothe – it is to Mary's credit that she didn't object to this – and a little later we have a glimpse of him rescuing a drunken woman from a small crowd of onlookers and taking her to safety.

'1859 March 6 Sunday,' Boyce wrote in his diary, 'Crowe Faulkner Jones and self rowed to Godstow to see "stunner", the future Mrs W. Morris. On return all dined at Topsy's including Swinburne: Morris and Swinburne mad and deafening with excitement.' Ned was at Oxford to see about Powell's commission for the Christ Church window; a few weeks later he met Boyce on a quieter occasion, escorting him and his sister to see the illuminated manuscript of the *Roman de la Rose* in the British Museum. On the 26 April he was back in Oxford for Morris's wedding. Georgie and her sisters came down with him, Dixon, now a curate, performed the ceremony, but this could not have eased the feeling of separation as Morris and Janey set off for their wedding journey. Worse still, The Revd George Macdonald had been appointed to the Manchester circuit, and in September Georgie left London with her family.

At this desolate moment Val Prinsep and Charlie Faulkner suggested a tour of Italy. Presumably Ned had been paid by Powell & Co. for his window designs, so he could afford to go. 'Dear little Carrots,' he wrote to Swinburne, who was still supposed to be writing labels for the *Frideswide*, 'the saving grace is that I am soon to see Florence for the first time.'

'My dear Browning,' Rossetti wrote on 21 September, 'you know my friend Edward Jones very well; only being modest, he insists you do not know him well enough to warrant his calling on you in Florence.' It was a pity, after the kindheartedness of this, that the party in fact missed the Brownings and only came across them for a

short time in the cathedral in Siena. They travelled in four weeks through Paris, Marseilles, Genoa, Livorno, Pisa, Florence, Venice, Milan and back by rail through the Mont Cenis pass. Ned spoke no Italian and, so he declared, only one word of French – 'oui'; this according to Ruskin, was an advantage, as speaking the language leads to the 'enviable misadventures' which are so tedious to hear about afterwards. These misadventures, perhaps because Prinsep, who had studied at Gleyre's, spoke French so well, certainly took place: after Faulkner left they came home penniless, having had nothing but coffee and a roll for two days and having crossed the Channel in the worst storm of the year.

Ned, who was ill nearly all the way, and every time they got into a railway carriage, must have been something of a nuisance, but Prinsep saw that he was suffering from something more than 'Ravenna fever': the overwhelming impact of the Brera, the Uffizi, the Pitti and the Accademia and, still more, the sight of Italian painting at home in its own cities. He had made a number of copies from Old Master paintings – 'working at pictures' is his own description – and seems to have been particularly struck by the early frescoes. Venice was 'bright and stunning', and Italy itself was an enlargement of existence so great that he only allowed himself to go there three times again in his life, feeling that every visit had to be earned.

'I have worked very hard at art for two years and find it difficult to live', Ned had written to Miss Sampson, who complained from Birmingham that her old age was not being provided for. This was true enough, and yet life without Georgie was unbearable. In the end the situation was resolved by the kindly intervention of Madox Brown, who gave the young couple a chance to see more of each other by inviting Georgie for a month's visit to their home in Fortress Terrace, Kentish Town. For the past few years Brown had been through all kinds of difficulty – even his wife's shawl had had to go into pawn – and yet in 1860 Georgie was not ever made aware of the strain an extra guest would put on the household. The young lovers could meet discreetly at musical evenings, or at dinners where only good friends sat round the table laid with the large cheap willow-pattern plates which the Pre-Raphaelites favoured, as the only honest pattern available.

Ned hesitated, a pilgrim at the gates of love. He had about £30 ready money in the world, and to this Georgie could add only a small table and the wood-engraving tools which she had been given for her course at South Kensington. There was some plain deal furniture at Russell Place. Mr Plint suddenly sent £25 'which you may need just now' nearly doubling Ned's capital; but he now owed a good deal of work to Mr Plint.

In the Academy of 1859 Hughes had exhibited his *Long Engagement* under its original title from *Troilus and Criseyde*.

> For how might ever sweetness have been known
> To hym that never tasted bitterness?

The four years' wait had been bitterness enough for Georgie and Ned, and they reached a decision which was quite unworldly. Georgie went home to make her preparations – not very elaborate ones, as she seems to have taken an old pair of boots on her honeymoon – and Ned passed what the *Memorials* call an 'unsettled week', not in putting his lodgings in a fit state, but in painting 'kind and cruel ladies' on a deal sideboard. They were married in the church which is now Manchester Cathedral and, as they had promised, on 9 June 1860 – the anniversary of the death of Beatrice.

Dante, and Rossetti himself, were indeed very much in their minds. On 23 May – the day of Dante's birth – Gabriel had married Elizabeth Siddal. The young Joneses were to join them in Paris; Georgie had never been abroad before. They started south from Manchester to Dover, stopping for the first night at Chester. But here nervous worry caused Ned to fall ill, and Georgie started her married life as a sick nurse in a strange hotel bedroom. Her spirits were strong enough for this: Lord Baldwin tells us that they only wavered when her coral necklace broke and she had to go down on hands and knees to look for the rolling beads.

From Paris, Rossetti sent her an encouraging letter: 'Dear Georgie (do let me please, or else Ned shall punch my head as soon as he is well) . . .'[7] Although he marvels that Ned and Georgie could 'get up life to notice anything' in such a dull place as Chester, he finds Paris equally dull, and the French are absurd,

translating 'potage à la Reine' as 'soup to the Queen'. They are 'quite sick of it here', Lizzie is not well enough to see the sights and they will soon be back in England. Long before they had expected, therefore, Ned and Georgie started their new life in London.

6

1860–2

EXPANSION: THE FIRM, RUSKIN AND ITALY

Only two people very much in love could have looked with confidence at the Russell Place rooms. They had not even been tidied since Ned left, the water-supply was poor – Poynter, who lived there afterwards, had to save water by washing up in a slop-basin – and there were no chairs. The only reliable article of furniture was a solid oak table made at the Boys' Home in Euston Road,[1] which is still in family use. But Mrs Catherwood did not forget their love of music, and sent a small plain walnut piano. Burne-Jones set to work to decorate this.

His idea was to make the decoration answer to the music itself. What he liked best were stringed instruments ('the rumble of the 'cello comforts my belly,' he said),[2] accompanied voices, and as soon as he had a chance to hear it, 'old Italian music' – Carissimi and Stradella. His reaction, he said, was 'entirely emotional'. The little piano shows Death on the left-hand side, corresponding to the two bass octaves; his face is hidden by a veil. On the right there are seven seated girls, in olive, brown and white, listening to a stringed instrument for the extreme treble. Whereas Death is crowned and veiled, the girls are simplified into rounded shapes, but the two parts are connected by the feeling that Death also is listening to the music; at some point the girls will realise that he is only a step away. Determined that Georgie's piano should not fade like the Union murals, Ned used lacquer and deepened the colour with a red-hot poker. In the event, the colour lasted longer than the works of the piano. The decoration does not 'represent' music but is an exact equivalent of the piano's music, just as Browning's *Galuppi* is the

equivalent of the toccata which made him 'feel chilly . . . I grow old'.

Georgie's singing was not at all ambitious. She set Rossetti's *Song of the Bower* to a waltz, and Keats's *In a drear-nighted December* to Beethoven's piano sonata Op. 10, No. 2, and, if the company felt like it, she would sit at the little piano until two or three in the morning, lending a charming air of spirited respectability to their bohemian evenings.

Possibly the red-hot poker was suggested by a new friend, William de Morgan, who, although he did not start experimenting in pottery glazes till the 1870s, was always a great deviser of dodges. De Morgan at this time was only just out of the Academy schools, and it was he and Burne-Jones between them who were accused by the outspoken little maid of losing the key of the beer barrel; amazing that there should be a little maid at all, when Mrs Beeton, in 1861, gives £150 p.a. as the correct income for employing a maid-of-all-work (and a girl occasionally). Another view of Russell Place is given by the young George du Maurier, recently arrived from Paris, and introduced by Val Prinsep: his visit made his dream of 'five o'clock tea with stunning fellows chatting with Emma [his fiancée]', and a piano 'rendered of untold value by my important paintings'. Georgie, who felt that it was 'well to be amongst those who painted pictures and wrote poetry', was glad to welcome two poets among her callers, even though, until some rush-bottomed chairs arrived, she had to receive them sitting *on* the table; the poets were Allingham and Swinburne. William Allingham, the author of the *Day and Night Songs* where Ned had seen Rossetti's illustrations to the *Maids of Elfenmere*, now wrote his fairy poems from the safe employment of a customs officer in Lymington. He was serious and sensitive, 'talking of Christianity, Dante, Tennyson and Browning'. Later in life he became finical and difficult, was obsessed with germs, refused to touch door-handles, and had to be forcibly got up and dressed, though his Anglo-Irish charm never faded. But whereas Allingham, in 1860, was a presentable mid-Victorian version of a poet, Swinburne had to be accepted by his hosts as a kind of fiery freak or phenomenon, who at the end of the evening would be extinguished by drink and had to be sent home, labelled, in a cab, or, as Rossetti put it, 'describing geometrical curves on the pavement'. He was still only twenty years old. In such a creature a capacity for affection is an added danger, and Swinburne's friends could be divided

into those who were and were not good for him. He was sympathetic to young married couples, nesting peacefully in their happiness. He amused both Janey Morris and Lizzie Siddal: the *Memorials* record that when in this same year, 1860, they went to the theatre 'in our thousands' it was Lizzie who declared that the boy selling playbooks was frightened at seeing her own red hair at one end of the row and Swinburne's at the other: 'good Lord, there's another of 'em!' This is one of Lizzie's few recorded remarks, and one can feel in the story Georgie's affection for them both, heightened by her excitement at going to a theatre at all.

The description given in the *Memorials* is startlingly vivid, and conveys the shock of pure beauty which Georgie felt when Lizzie took off her bonnet in the upstairs room of their Hampstead lodgings, and shook out the gleaming folds of the famous hair. As a minister's daughter, Georgie could see the best in everyone and get on passably with most, but she loved Rossetti's wife. To Georgie was written the most touching of Lizzie's remaining letters, sending 'a willow pattern dish full of love to you and Ned'.[3]

In spite of the confusion, the beer barrel and Georgie's dressmaking, Burne-Jones felt a physical release and a new ability to work. His two real apprentice pieces, which mark the beginning of an individual style, are the *Sidonia* and *Clara Van Bork*, now in the Tate Gallery. *Sidonia the Sorceress*, in a translation published in 1849 of William Meinhold's *Sidonia Von Bork, die Klosterhexe*, was the book which Rossetti had been pressing upon all his followers. 'You seem mighty scandalised about Sidonia – I have never read the book,' Ruskin wrote to Ellen Heaton. 'Edward only told me that she was a witch.' Although Malcolm Bell calls it a 'most entrancing novel', it is not at all like *Sintram*, having the strong savour which pleased Rossetti, and Ned may have hesitated before finding a scene for illustration. One can hardly imagine his Sidonia dancing, as she does in the book, on the coffin of her suffocating sister to drown her feeble cries, or fighting off the sexual assaults of the courtiers 'with hands and feet'. They are two grave little water-colours, in which Burne-Jones selected the incident of the bees which try to reach Sidonia's golden hair through its net, and her gentle sister Clara carrying a nest of young doves.

For Sidonia's oddly-patterned dress he studied a portrait of Isabella d'Este at Hampton Court; the galleries there, open to the

public since 1830, were a centre for all students of art – Sass took his school there in a body, making them take off their hats before the Raphael cartoons. But for the deep blacks and shadowed whites, Burne-Jones made his first attempt at imitating the colour of the *Arnolfini*.

When they were finished, Ned, anxious to help with the troubles in Birmingham, wrote to his father to make frames to them. But even these two frames, for pictures about one foot by six inches, taxed Mr Jones to the uttermost. Asked to make a mirror with roundels, like the one in the *Arnolfini* portrait, he faltered, and although it appears in *Fair Rosamund and Queen Eleanor*, it had to be returned to his workshop, where it stayed, the ends never quite meeting. However, the *Sidonia*, with its frame, went to Mr Plint in time for Christmas that year.

How were the young Joneses supported? We have seen the kindness of Rossetti and Ruskin in recommending possible buyers (not always successfully: Miss Ellen Heaton of Leeds, for instance, flatly refused the early *Cupid's Forge* which Ruskin pressed upon her). There were Mr Plint's small cheques; there was an element of sheer chance – once Ned found half a sovereign unexpectedly at the bottom of his waistcoat pocket. It never occurred to Georgie, brought up in a trusting and praying household, to worry about how their wants would be supplied. To Ned, on the other hand, money worries had been familiar ever since he could walk and talk, yet there was a certain lightheartedness. 'Never say "bill" – it's a coarse word,' he once told Mary Gladstone.[4] He had been poor and unhappy; now he was poor and happy.

For country air, Ned and Georgie were welcome at Red House, the new home 'strongly built of red brick' which Philip Webb had designed for Morris and which was now ready for visitors. It was in an old apple orchard at Upton, in Kent, ten miles out of London, and it was not for nothing that in Morris's last romance, published in the year of his death, the heroes return to 'the little hills of Upmead'. Here, from the moment the wagonette met them at Abbey Woods station, Morris and his friends were happy together. Almost anyone was welcome who thought as he did about the crafts. Morris, Ned, Faulkner, Rossetti, Lizzie, and any other visitor immediately set to work at painting the ceiling – never to be quite finished – with red, blue and green diaper patterns; they also, of course, decorated the

furniture, though the Red Lion settle and wardrobe were already in place. Janey embroidered hangings, Georgie had brought her engraving tools. In the afternoon the girls jaunted about in the pony trap (Janey had been brought up among horses) exploring Chislehurst common. Ned didn't care for these expeditions: 'I hate the country – apples alone keep me in good spirits,' he wrote to his father; but he gloried in the wine, the practical jokes, and the feeling of hard work together. His paintings of Morris and Janey in the *Wedding of Sire Degrevaunt*, underneath the gallery from which the guests flung apples at their host, have still not quite faded from the walls.

Evening was the time for music and hide-and-seek (Janey and Georgie were still only nineteen) and Ned said that he had seen Janey laugh 'until, like Guinevere, she fell under the table'. In his graceful red chalk sketches for further decorations, Janey is seen in her long mediaeval dress, putting her arms round her husband's neck from behind. This reminds us that all the young wives were in unfashionable dresses of gathered serge or linen; they had leather belts and embroidered collars and cuffs, in some cases designed by Morris himself.

Although Rossetti tended to laugh at the red brick and told Webb that architects were 'only tradesmen', he too was expansive and genial. In their seasons the apples and roses came, and in their season came three pregnancies: Lizzie Rossetti, Janey Morris and Georgie Jones were all expecting babies in 1861.

As a matter of necessity, the Burne-Joneses moved into a larger set of rooms at 62 Great Russell Street. Ned, however, now had the prospect of plenty of work, for in the spring the firm of Morris Marshall, Faulkner & Co. had opened business. Boyce's diary records that he took his 'future', Miss Subeiron, for a musical evening at Russell Square (26 January 1861) and '[Jones] talked of a kind of shop where they would jointly produce and sell painted furniture'. The 'shop' opened at 8 Red Lion Square, where a basement was rented for workshops and a tile and pottery kiln. Charlie Faulkner acted as book-keeper, and Burne-Jones, Rossetti, Madox Brown and Philip Webb were the other original members. The firm was created partly for practical reasons – Morris needed to make more money – partly for emotional ones, to prolong the joy in shared work which they all felt at the Red House; and partly on principle, to realise

Ruskin's attack in *The Stones of Venice* on 'servile ornament' and to bring into the Victorian revival of the useful arts the spirit of the mediaeval workshop. In this spirit everyone lent a hand. Georgie quietly put aside her attempts at wood-engraving and began to paint tiles, Janey supervised the embroidery, and a foreman, George Campfield, was found at the Working Men's College.

A call of £1 per share was made upon the partners, but Burne-Jones earned his contribution back immediately with four tile designs at five shillings each and he received five shillings for attendance at each meeting. For the first time he began to keep accounts, in two little parchment-bound notebooks. Though they are not always accurate, and not always added up right, they record one side of his life from 1861 until 1897, the year before his death. They begin with a pen-and-ink drawing of Morris resplendent as Judas in a stained-glass window, while on the opposite page a thin Burne-Jones stands on a barrel-shaped Morris in the gutter. Throughout the notebooks Ned complains, in the margin, of poor payment and overwork, of Morris's unreasonable conduct, of his pretended stinginess and real fondness for a glass, or several glasses, of good wine. The two friends are playing out the comic rôles which they had fallen into almost as soon as they met. Then, with Morris's death, all jokes cease.

'We have many commissions', Ned wrote to Crom Price, who was now trying his luck as a tutor in Russia, 'and shall probably roll in yellow carriages by the time you come back.' There was nothing amateur about the firm, even if it was experimental. They were up against stiff competition: the public were used to Burges's solid furniture and the designs of Owen Jones and Butterfield; the South Kensington Exhibition of 1862 would provide a testing ground which might mean their failure or success. As a show piece for this they collaborated on what Ned's workbook calls 'painted gold cabinet for Seddon' – the King René cabinet – and this panel, which also exists in a water-colour and a stained-glass version, is as sumptuous in its red, gold and grass-green as the other two, by Rossetti and Madox Brown. His earnings at the beginning were certainly not high: he got £8 for the *Virgin and Child* and *Seven Angels Playing Bells* for Kentish Town church, and the same rate for a window for Frederick Leighton, one of the firm's earliest patrons. Burne-Jones's transactions are made more difficult by his treating

the firm as a bank for drawing cash, but he certainly finished the year 1861 £5 in debt.

'My dear Ned, Lizzie has just had a dead baby,' Rossetti wrote on 2 May, entrusting him with the task of telling 'Top and all'. In the short time that was left to her, poor Lizzie tried to adopt an eight-year-old girl, while Gabriel had to prevent her from giving away 'a certain small wardrobe' to the Joneses. When they went to see her for the first time after her recovery she was sitting on a nursing chair by the empty cradle, and looking up, said, 'Hush, Ned, you'll wake it.' With this prelude the twenty-year-old Georgie, without any of her sisters or her mother within call, began to prepare for her own confinement in the autumn.

During the summer, too, Ned could not always be with her; he was occasionally away from home, in camp with the Artists' Corps of volunteers which he had joined, with Morris and Rossetti, during the invasion scare of 1859. This was the occasion of Boyd Houghton's delightful *Volunteers in Hyde Park*, and Tennyson's *Riflemen, Form!* 'Review' subjects became so common that Frith decided not to paint one, although it was suggested to him that he might put a fat woman in the foreground of the picture being hit in the eye by a ginger-beer cork. The Working Men's College voted to volunteer, but not to drill on Sundays.

Most of the stories of artists on duty come from W.B. Richmond. Leighton, of course, was in command, speaking many languages fluently, and Watts made an unexpected appearance on horseback, his silky beard blowing in the wind. Simeon Solomon is said to have been unwilling to take the oath, substituting 'Drat it!' Burne-Jones, on the other hand, with more capacity for obedience than Morris or Rossetti, and much more than Solomon, made 'a pretty good soldier'.[5]

The early success of the firm (which surprised Arthur Hughes, who had 'rather despaired of its establishment') was in every way fortunate, since Burne-Jones now lost a good private patron. On 13 July Mr Plint died – of 'increased breathlessness', according to the *Leeds Mercury* – leaving his affairs in some confusion. Kindly Mr Plint's love of pictures had outrun his discretion, but his executors were not so kindly, and Madox Brown and Rossetti were both caught short on their commissions. Burne-Jones solved the difficulty ingeniously, since he had on his hands a triptych of the *Adoration*,

painted for St Paul's, Brighton. His name had been suggested by the architect (and organist) of the church, G.F. Bodley, who had admired Ned's drawings of poppies made in the early morning at Red House. The triptych was finished, with Janey as the Virgin and Morris, Swinburne, Ned himself and 'a black-haired organ-grinder' among the shepherds and kings. It was, however, difficult to read at a distance, and Burne-Jones produced an altered version on a gold background; this went down to Brighton, and Plint's executors accepted the first one.

The picture had a curious history, and the man who bought it from the executors shot himself. This is probably the patron who, Burne-Jones told Rooke, took him for a drive in a cab and told him that 'he was always thinking about women, he never remembered an hour in which – whatever he might be engaged in – they were not his main thought and everything else an outer shadow. This man had a nice wife, a house and family. The next day he committed suicide.'⁶ The next purchaser poisoned himself, and it finally came back to Bodley himself from a builder who had bought it for £7 as an 'old Italian picture'.

In the October 1861 a son, Philip, was born to Ned and Georgie. Neither the doctor nor the midwife arrived in time, and Ned, who had never delivered so much as a kitten, had to do what he could until reliable Nurse Wheeler (who had attended Lizzie) arrived, and found him in worse case than the baby. His remark 'children and pictures are too important to be produced by one man', dates from this moment, when he realised that he would have a family to paint for and a new bond of love which must at times be a source of pain.

The godfathers, by proxy, were Rossetti and Ruskin. Both had every generous intention, but neither remembered to send the customary gift, until old Mrs Ruskin heard of it and indignantly sent off a silver knife, spoon and fork.

Ned's health did not pick up that winter, and Ruskin, returning from abroad, was dissatisfied with the conditions of 'my dear children'. 'Jones, who promised to be the sweetest of all the P.R.B. designers, has just been attacked by spitting of blood, and I fear, dangerously', he wrote to Norton on 19 January 1862. Fortunately Dr Radcliffe, who like all Burne-Jones's doctors became a collector of his work, pronounced that the blood was not from the lungs but the throat. Ned next had to meet a call on the partners of the firm for a

new £19 share which Morris, though he managed with amazingly little capital, felt obliged to make. Conditions were certainly not easy for the young mother who knew nothing about new babies and the young husband struggling with large cartoons laid out on brown paper in the next room. They lived from day to day, and the disadvantages of romanticism appeared when Ned incautiously looked in a shop window and seeing a watch set with sparklers which he knew that Georgie *must* have, spent what was nearly their last £8 in the world. The Dalziel brothers, brought to the so-called studio by Holman Hunt, found it 'crowded with works', but a passing reference in the *Memorials* to Ned sitting down on a February morning to 'such work as the light permitted' suggests that he was economising even on candles.

That same dark February morning brought the news that Lizzie Siddal had swallowed an overdose of laudanum. Georgie would not let Ned go out, but hurried with Red Lion Mary to Chatham Place to see her lying dead on the bed, at peace after a terrible night of stomach pumping and hopeless consultations. This sight, which remained an 'ambush at the heart' for Rossetti and for Georgie herself, was followed by the serious illness of the Joneses' own four-month-old Philip. The baby recovered, but the young parents were exhausted, and Ruskin, who had been waiting for the right time to offer help, pressed them to come to Italy, a plan he had already put forward several times.

They were to be his guests, but Ruskin was sincere in declaring that he needed their company as much as they needed the journey. Ruskin was deeply concerned with the need to make records of Italian works of art which he saw perishing in all directions through ignorance and decay. With daguerreotypes and photographs, with his own drawings and those of numerous assistants (he sometimes took his pupils from the Working Men's College with him), he struggled to perpetuate 'the lovely things that are also necessary'. Ned would help him by making sketches, in particular for Ruskin's studies of Bernardino Luini for the Arundel Society. But there were darker and nobler passages in Ruskin's mind, particularly in that side of him which, as he wrote to Norton in 1858, was tormented by wanting 'to get everybody a dinner who hasn't got one'. He had just signed the preface of *Unto This Last*, his noble attack upon *laissezfaire*, which had already aroused bitter objections when it

appeared in the *Cornhill* and had deeply wounded his own father. He hoped to find solace in the company of the 'dear children'.

The atmosphere was at first that of a great treat, and the young Joneses still called their friend 'Mr Ruskin'. The Macdonalds offered to look after the baby, Aggie came to fetch it, and on 15 May 1862 they sailed from Folkestone. They were to go straight from Paris through the St Gothard pass to Milan, where Ruskin wanted to copy the Luini *St Catherine* himself.

To travel with Ruskin was an experience which he himself looks back upon, in *Praeterita*, with nostalgia. He scorned trains and those who 'let themselves be dragged about like cattle, or felled timber, through the country they are visiting'. Instead, he sent over a hired private carriage fitted for luggage and sketching materials. Dinner was always served in a private room, and sacristans and *conservatori* hastened to open their treasures to Ruskin. The young Joneses, after months of worry, were overawed and grateful, but they soon realised that their host was to be pitied. One of the self-torturing objects of his journey was to call on Adèle Domecq, the wine-merchant's daughter who had first broken his heart; in fact Ruskin, who himself admired Byron so much, appeared to the wondering eyes of the Joneses, as he threw himself on to the sofa, as a Byronic figure. This, to be sure, was tempered by his sending a letter or a telegram to his parents on every day of his travels. Under his protection they visited the Louvre, crossed the Alps and reached Milan, but then, by arrangement, they went on alone with a long list of works to be copied. The first of these were the Giotto frescoes at the Arena Chapel, a revelation to Burne-Jones, who had been told to make drawings from the Virtues and Vices. Then they went on to Venice.

My dear Gabriel,[7] Ned wrote on the 10th of June, . . . I have thought about you constantly and hoped you were happyish. I could sit and write a regular love-letter to you now! . . . It is only 5 weeks since we left but it seems such a long time that so much must have happened and I hear nothing about you . . . Venice [is] simple heaven, except when there's a hell of a stink enough to stifle you, but away it goes, and everything is as sweet as ever – you *must* come and see it someday before it is quite ruined. Georgie and I are alone in a vast hotel, and dine alone at a table for fifty . . . We are happy enough on the days when I am all right . . . we are perishing though

for home news . . . except one very large [letter] from Top, weighing a 100 weight and positively having 20 shillings stamp on it, all tracing paper for windows and not a word – stern business only . . .

This fairly expresses the homesickness and awkwardness of the young couple, made worse in Ned's case by a touch of malaria. 'We are enjoying ourselves intensely,' he wrote at the same time to Ruskin. 'I am at work on a little head of Paolo in the Ducal Palace.' He struggled with details of Veronese, Bonifazio, and Tintoretto. The effect on him was dissatisfaction and a longing to start on his own work again. 'One could do a dozen designs for one little worthless copy,' he told Ruskin, 'but oh, it does one good.'

From Geneva, Ruskin wrote a remarkable letter to his father. Old Mr Ruskin (like old Mrs Morris) was doubtful of the influence of this new friend, who was certainly poor, and probably 'low'. To this Ruskin returned a passionate attack on snobbery, requesting his father to:

ask Jones out to any quiet dinner . . . ask him anything you want to know about mediaeval history – and try to forget that he is poor. I wish you to do this, observe, entirely for your own sake – that you may have the pleasure of knowing your son's real friends, and one of the most richly gifted, naturally, of modern painters.

The tracing papers sent out by Morris were probably for the designs for four of the stained glass panels at Harden Grange. Burne-Jones was well aware of his responsibilities to the firm, but on his return, after ten weeks away, he felt a new kind of creative vigour. 'Directly my eyes close a canvas appears and I scrawl away with brown and white – yes, dark figures on a white ground, that's the secret; you have done me so much good by giving me a chance to see the old miracles.' The Venetians in particular were a miracle, and, of course, Luini. Compared with Luini, Ruskin said, Leonardo did 'but stained drawings', and Burne-Jones, at this stage, agreed with him. Indeed, the endless series of round-faced babies which he began to draw as soon as his own were born were always called, in the family, 'Luini kids'.

Ned found Morris and Janey, with another daughter born to them

now, thriving among the apple trees. The firm had had two stalls at the 1862 Exhibition and, in spite of his long absence, Ned earned £99 10s this year from window and tile designs. These included the *Cinderella* and the *Beauty and the Beast* tiles, all fired, after a process of trial and error, in the basement at Red Lion Square. The *Sleeping Beauty* set returns to the favourite theme which he had drawn with Louie, in a guileless fairytelling style, with drowsy cooks and dropped ladles. The tiles were painted in blue, yellow, olive-green and violet slip by Charlie Faulkner's two sisters, Kate and Lucy; they were commissioned for the overmantels of Birket Foster's new house at Witley.

Meanwhile Rossetti, somewhat recovered from Lizzie's death, was moving into a large old riverside house, No. 16 Cheyne Walk. He began to go out. Ned was summoned to accompany him, and with Whistler and Boyce they called on Swinburne at his Dorset Street lodgings, bringing willow-pattern plates 'as a contribution to his housekeeping'. The old comradeship, after so much suffering, was renewed, and Burne-Jones naturally turned to Rossetti's studio to start painting in earnest, as it seemed to him, for the first time.

7
1863–5

GREEN SUMMER: A SEASON OF HAPPINESS

By 1863 Burne-Jones knew that his metaphor as a painter must be the human image, and he set himself seriously to learn to draw from life. Though he sometimes borrowed a lay figure from Gabriel – Georgie and he were once stranded outside a public-house with it when they were trying to take it home in a cab – he now entered with much more confidence into the world of models.

The best male models were Italians. Only the genre painters relied on English ones – drunks, old soldiers, old actors who 'did the expressions'. Alessandro di Marco, superb among the Italians, who 'seemed to stride out from Signorelli's grand frescoes', was an organ grinder. Gaetano Meo, Greek by origin, Sicilian in temperament, the Nostromo of the studios, adept at everything, was found by Simeon Solomon playing a harp in the streets. Meo declared that in Paris artists dined with their models and treated them as human beings – not so in London. Burne-Jones and Rossetti, however, were exceptions.

The women might be divided into three groups. At the top were professionals like the 'inexorable' Miss Silver and the superb Augusta Jones (later Johnson) who gave definite appointments which could not be trifled with. 'In those days', Ned told Rooke, 'I had a model who used to write, "Sir, you are competent to elect Wednesday; or Friday next week." She had an old lover, and her stories used to make me sick.'[1] But her dignity was no doubt preserved, and these ladies made their own terms; at the Academy schools the male students were not allowed to leave their places during the life class. Mrs Keene and her daughter Bessie were

delightful and pious women who sat for Burne-Jones through two decades. Antonia Caiva, the finest of his nude models,

> was of the city of Basilicata. She was like Eve and Semiramis, but if she had a mind at all, which I always doubted, it had no ideas. She had splendour and solemnity: her glory lasted nearly ten years.[2]

After the ten years had passed, Ned received 'an ill-spelt, ill-written letter from a hostpial patient saying "Sir, I was always obedient to you. I am poor and ill."' Such was the rapid decline of the Caiva.

Lower down came the girls from the street, on the verge of prostitution. Ellen Smith, the coffee-house waitress, who, Boyce noted, would leave her purse behind and 'Rossetti inserts a sovereign', might be a borderline case; Annie Miller and the 'strapping Scandinavian' were certainly not. Neither was the handsome German woman who aroused Ned's ready sympathy to another attempt at rescue; she was brought home to Russell Place to work as a nursery maid, but 'difficulties arose' and the arrangement did not last long. These girls amused Rossetti, who always treated them with politeness. Fanny Cornforth herself, sumptuously blonde and coarsely good-natured, was installed at Cheyne Walk; Burne-Jones was allowed to draw from her, and she appears in *Cinderella* and *Merlin and Nimuë*. Another of Ned's models, a tall dark girl, a stage dancer, was called Reserva; her name was not, as was suggested to her, of ancient gypsy origin, but 'a freak of Pa's', because she had been born by Notting Hill Reservoir.

Burne-Jones also learned from Rossetti the pursuit of the chance-seen face in the street, the *passante* of Baudelaire, leading to an intense relationship between artist and model, product itself of the great city with its countless dreamers and strugglers through the fog. In this matter Burne-Jones was exacting. His *poesias* depended on the relationship between the story, the face, and the experience it reflected.

Although Rossetti had returned to oils, Burne-Jones continued to work in water-colour, mixed with various media and used much like oil. The underpainting was in monochrome, flat washes were laid over it, sometimes thickly, sometimes as fine as powder, details were added later, mistakes wiped clean with a rag. Sometimes the

underpainting was in gold, sometimes they were gold lights, as though the picture was a precious object for its own sake.

But if the gold suggests the mediaevalising spirit of the early firm, Ned's idea of colour in the pictures he now began to paint was Venetian, or rather that agreeable thing, mid-Victorian Venetian. It was the natural outcome of his studies in Venice, the example of Watts and the *Countess Somers* and the *dolce stil nuovo* of Rossetti who in 1859 had painted an amply Venetian Fanny Cornforth as *Bocca Bacciata*. Arthur Hughes was also setting out for Venice, where he collected quantities of striped materials and returned to paint his Giorgionesque *Music Party*. In this atmosphere Burne-Jones designed his *Idyll* – lovers in dark blue and rose, which Watts bought himself – and the *Astrologia*, for which Augusta Jones sat; this had a large area of crimson, which Ned liked but found difficult, because 'you get the beauty of the colour only in the lights'. But reds and blues are also the language of the emotions, and Burne-Jones was working not only on 'getting it right' but towards some sort of expressionistic scale of colour. There is a sense of tense anticipation in the leaden colouring of *Morgan Le Fay*. The lighting of *Merlin and Nimuë* is extraordinary, a pale gleam of whitish-yellow in the sky and the distant lake just before the darkness advances and hides the death trap to which Merlin advances, his hand on his heart.

These two water-colours of the sixties return to a theme dear to the heart of Burne-Jones, the defence of the enchantress. At Holland House he had implored Tennyson with 'pained face and eager expostulation' not to use the name of Nimuë for the harlot of his new Idyll, and Tennyson had 'good-naturedly changed it to Vivien'. To Burne-Jones the enchantress was neither sinister nor depraved, but an aspect of the weakness of man. There are only two kinds of women, he said, those who take the strength out of a man and those who put it back; but the destructive ones are outside blame, since they are acting only in accordance with their nature.

Of all these pictures, however, the most attractive are the 'Rose' variations which are the direct expression of the happiness of his early married life. The trellis which appears in them, the Chaucerian garden close, is taken from the trellis at the Red House, as is Morris's own trellis wallpaper. *Fair Rosamund* is Georgie in tea-rose colour, against roses, holding a rose. This portrait touched with gold brings

out the soul of the flower and indeed of the bud, where, according to Ruskin, 'all these proceedings on the flower's part are imagined'; it is the Rosamund of Ned's dream at Godstow, in opposition to Swinburne's version. In the *Rose Garden* Georgie stands again against the trellis, in a pose that suggests Luini's *Madonna and child with a rose hedge* in the Brera. With her left hand, as though looking for reassurance, she clasps the end of her leather belt tightly. The canvas of the rose garden has an arched top, echoing the full-blown flowers and Georgie's round head; the feeling is of unclouded happiness. Georgie herself calls it the 'Rosamund time'.

'My little early ones didn't give me the shock I expected,' Burne-Jones said after an exhibition of 1896. 'There was such a passion to express in them and so little ability to do it. They were like earnest passionate stammerings.' When Ruskin returned from Switzerland early in 1863, he found that his father had bought *Fair Rosamund*. This was partly in atonement for his suspicions of the 'low' Mr Jones; '. . . and after my eye had dwelt on the canvases and paper of the first names of the century I am happy to say my evening contemplation of Rosamund yields me the greater satisfaction.' But, as his letter shows, he also had a chivalrous respect for the original. At the stuffy dinner table at Denmark Hill, where the young Joneses had paid two visits, he had made a true estimate of Georgie's worth.

Ned's work for the firm at the time included the long series of Lyndhurst windows – Georgie posing for some of the music-making angels – and he seems to have been partly paid in thirty yards of red serge and a pair of brass candlesticks, so that Russell Square gradually grew to look furnished. He attended the meetings of the firm regularly – indeed, on Christmas Eve 1862, he and Charlie Faulkner were the only two who turned up. But although church windows could fairly be called public work, he was anxious to reach a wider audience; if only it were possible, he wrote to Louie (still faithfully practising her drawing), to publish '100,000 wood-cuts as big as *Death the Friend* or bigger'. These would reach the countless thousands whose childhood had been without beauty.

The most obvious way for an artist to do this in the 1860s was through the magazines, but Ned was cautious about illustrations as he had been about writing 'tales', dreading the temptation to spend too much time on it – the fate which lay ahead of George du Maurier. In 1862, however, he could hardly afford to turn down

anything, and he accepted a few commissions from publishers. From the point of view of his development these illustrations are puzzling. *The Nativity* in Mrs Gatty's *Parables from Nature* is a poorish imitation of Rossetti, while the *Two Lovers Meeting* (*Good Words*, October 1862) is a fine vertical design which only Burne-Jones could have drawn.

Good Words was published by the brothers William and George Dalziel, who in 1863 were projecting an illustrated Bible, with the work farmed out among bright young artists, Burne-Jones among them: something to rival the Lane *Arabian Nights* or the Moxon Tennyson. The Bible, as the Dalziels engagingly point out in their *Record of Fifty Years*, was a 'dead failure'. Writing to the Dalziels in 1880, Ned recalled the difficulties of the whole undertaking, Watts refusing to do 'mere costume pictures' and wanting 'abstract designs from Job and Ezekiel' most unacceptable to pious readers, while Sandys was furious about his proofs (though the Dalziels were used to that). A very interesting rough for an illustration by Burne-Jones survives in the Victoria and Albert, a *Return of the Dove to the Ark*, with the flood-water paved with drowning faces. But Ned implored them not to use his old designs in their *Bible Gallery* (1880) and offered to substitute new ones, otherwise 'I shall feel a constant shame whenever the word Bible is mentioned – which must be a distressing reflection'.[3]

The negotiations in 1862 led to a visit from the Dalziels, who looked round the studio and commissioned two water-colours, a *Nativity* and an *Annunciation*. Although they hoped these might come in handy as Bible engravings, they were principally attracted by the colour. The scarlet and crimson bedroom of their *Annunciation* recalls Carpaccio's *St Ursula*; Rio's *Christian Art*, it may be remembered, described visitors as falling into ecstasy before the picture of the saint's bedroom, and without going as far as this Ned had studied it scrupulously, trying in vain to recommend Carpaccio in his letters to the still obdurate Ruskin.

In 1863 Ruskin brought, on one of his calls to Great Russell Street, a high-minded, middle-aged 'brisk she-shape', Miss Margaret Bell, the headmistress of Winnington Hall girls' school in Cheshire. Ruskin, to her gratification, had paid several visits, and she now invited the young Joneses to accompany him.

Georgie comments shrewdly on the atmosphere of Winnington,

where Miss Bell, relentlessly talkative on all subjects, was evidently cultivating Ruskin; on the other hand, she generously praises the charm of the young girls, and the fact that Ruskin was happy there. And happy he was, reading, dancing, romping and teasing with them, preferring always, as he tells us in *Praeterita*, 'oval faces, crystalline blonde, with straightish hair, the form elastic, and foot firm'. Ned, though less serious, was even more susceptible; taking turns with Ruskin at reading aloud, he was soon 'helplessly in love with several at the same time'. According to himself, he even played cricket with them.

At Winnington he worked hard on his *Legend of Good Women*. This was a point where his imagination drew close to that of Chaucer who, with late mediaeval 'pity', includes Medea, Circe, Dido and the injured Phyllis among his good women, not as seducers but as the martyrs of love. Versions of the series had appeared on tiles for the firm and were used later as window designs for Peterhouse, Cambridge, made at 'the unremunerative price of £3 each'. This set, however, was for tapestry embroideries to be worked by the Winnington girls – in fact in a sense they *were* the girls, since they were to have the blonde oval faces of Ruskin's favourites. Ruskin was inclined to think the panel of Chaucer himself a waste of time – Ned must get on with more 'pets'. With these absurdities he tried to stave off the melancholia which was beginning to threaten his reason.

So great was the happiness at Red House that something like it, the Joneses felt, must be of help to Ruskin, and the tapestries were intended for a house which in the end he never built. Ned suggested Herefordshire – he had never forgotten his first sight of the cathedral; Ruskin was negotiating for land in the Haute Savoie. 'Tell Mr Jones I think I know enough of him not to be jealous of any influence he may have with my son,' wrote old Mr Ruskin to Georgie, in strong disapproval of the scheme. But all ideas of the house and its decoration were put aside when, during the Joneses' second visit to Winnington in the spring of 1864, the old man suddenly died. Ruskin returned to Denmark Hill to become, as he said, a 'child of darkness'. Steely Mrs Ruskin did not, in her grief, relax the restrictions she put on her son; his pictures were still covered on the Sabbath so that he should not enjoy them too much. 'May we come back presently? Georgie would love to be hours and hours with your mother, and

would never tire of reading to her,' Ned wrote, rather recklessly, in his distress.

Ruskin had wanted to take them to Florence again that spring, but this too was now out of the question. Ned, in any case, hardly felt that he had earned a second visit, and Georgie had Philip, already a restless child, to look after. Back in London, they found Rossetti genially installed at Cheyne Walk, while at Red Lion Square Morris and Faulkner were keeping the firm's head above water; in spite of its early success it suffered from lack of capital and 'had to be guided', as Mackail says, 'by the exigencies of the moment'. At Great Russell Street, du Maurier with his new wife was now a close neighbour, and Georgie recalled how she and Emma du Maurier had once meant to engrave their husbands' work and struggled on together with their woodcutting lessons until Emma cut herself severely.

Although the Dalziels's *Annunciation* was finished, Burne-Jones asked if he might keep it in the studio, 'as I do not exhibit, and that is my only way of letting people know what I am doing'. But in the spring of 1864 his career took a new turn when Ruskin put his name forward for the second time as an Associate of the Royal Water-Colour Society. The election had gone through on 8 February, and old Mrs Ruskin's last letter to Georgie had been one of congratulation 'for latterly there appears very great difficulty in obtaining admission'. This was a step which Rossetti had refused to take, but Burne-Jones, with equal resolution, set his will to it. The real battle, as Manet was reminding Degas at this very time, was in the salon.

He therefore wrote again to the Dalziels for permission to show the *Annunciation*. Ruskin would lend *Fair Rosamund*, and *Cinderella* was also ready. The fourth canvas was *The Merciful Knight*, something so odd and distinctive that even the faithful Stephens could only say that it was 'amenable to its own laws'. The subject was taken from the *Broadstone of Honour*; the image of Christ in a wayside shrine leans down to kiss a knight who has forgiven his brothers' murderer. Ned used the forest background approved by Rossetti when he tore up his own drawings in the Sloane Street lodgings; to these he added the familiar rose trellis from the Red House and marigolds, the flowers of suffering, which grew thickly in Russell Square as they will in most London gardens. The

composition of the picure on two flat planes recalls Rossetti's design for the Moxon Tennyson, *Sir Galahad at the Ruined Chapel*, but the central point is the concentration of expression in the two faces. The Christ is still in physical pain, or perhaps has taken it on Himself; the knight is white as death. One might, like the Heir of Redclyffe, 'envy him such an opportunity of sacrifice' or one might consider it morbid nonsense. Burne-Jones knew this perfectly well, but he was determined to submit it with the others to the formidable judgement of the society.

Long before we saw *The Merciful Knight*, however, the committee's doubts were aroused. This became clear when Ned entered the Society's rooms at 5 Pall Mall East to be received as an Associate. The custom was for the committee to rise and shake the newcomer by the hand, but on this occasion two members refused to do so.[4] One of them was 'Old Duncan', the marine painter, just turned sixty, who was to live another twenty years and die unforgiving of young Jones.

The Royal (or Old) Water-Colour Society was already felt to be a venerable institution, having been founded in a small way in 1805. It was proud of its achievements in establishing a genuinely English form of art, which could only be brought to perfection in genuinely English weather. This art had from its early days been associated with the country seats, views and ruins whose proprietors were also the purchasers of the pictures. De Wint had told dealers that 'he only made drawings for gentlemen'. Water-colour, for all its skill and delicacy, was a field exercise. 'Rheumatism, and very shaky legs, bunions and foggy eyesight, take the sketching pluck out of one,' wrote 'old Duncan', in the last year of his life, adding that he was 'an old hulk' who must die quietly at moorings. The English technique was a source of pride, attracting foreign artists, such as Carl Haag, to settle over here and learn its secrets. 'It was in the use of transparent water-colour that it found its strength, and acquired its celebrity,' says J.L. Roget, the historian of the Society. *How* to do it could be taught easily enough – the members were entitled to charge a guinea a lesson, and six lessons were enough to produce an adequately skilled amateur – but the boldness of a true master could not be learned in a lifetime.

Thirty years earlier, in 1832, the Society had received a distinct

check when the New Water-Colour Society started a *salon libre* at 16 Old Bond Street, alleging that the O.W.S. was 'exclusive in the narrowest degree' and rejected fine draughtsmen simply because they hadn't 'the mere slip-slop character of water-colour painters'. This opposition was probably the reason why the O.W.S. began its winter exhibitions of drawings, but the N.W.S. could not be pacified. In 1862 they led the way in an exhibition for the relief of the Lancashire mill workers, gravely affected by the shortage of American cotton. It was to this that Burne-Jones had sent his *Chess Players*, and while the show attracted some publicity, nobody noticed the O.W.S. contribution of £277 12s, raised from a whip-round of the members.

It may be imagined that there was little collaboration between the two societies. In 1858–9, when the government planned to share out the space in Burlington House between the Arts and Sciences, neither of them obtained a gallery, a failure which lay partly at the door of the O.W.S. President, Fred Tayler. Tayler, whose comment on the matter was 'how this is to be achieved, or whether this is the fitting moment, probably opens a wide field of discussion', was the weak genial man preferred by a strong committee. He remained in office from 1858 – when he was already fifty-six – to 1871, and much against his will (for he preferred doing nothing) was to play a decisive part in Ned's life.

But however confident they felt of defying the dissidents of Bond Street, the Society felt the threat of change. De Wint had died in 1849, David Cox in 1859, Prout (old Mr Ruskin's favourite) also in 1859, of apoplexy and 'Bird's Nest' Hunt in 1864. There was a closing of the ranks, and Burne-Jones knew that his exhibits would be received with hostility. He described to Rooke the 'sheer depressingness' of the Committee and the murmur which arose from them of 'when David Cox, Sir, was among us . . .'[5] This hostility had several distinct causes. The society constituted themselves guardians of artistic integrity (pure colour), public morality (nothing morbid, nothing sensual) and a threatened social order. Burne-Jones, with his inadequate training, seemed to them hardly professional, and as a young man absurdly set in his own ideas. Probably only Ruskin's support got him through the first year.

Many of the members still felt a water-colour should be painted with water, although body-colour had always been admitted and

'Bird's Nest' Hunt had scraped away the lights, his maxim being to 'fudge it out'. Fred Walker, elected at the same time as Burne-Jones, scraped and used gum medium. But the pictures Ned was submitting were on paper completely saturated with colour, touched with gold and, in the drapery passages, as thickly laid on as oils. The strongest objection, however, was to the subject. The O.W.S. catalogue for 1864 includes Mrs Criddle's *I Canna Mind My Wheel, A Fair Student* and *The Angel's Whisper; The Mischievous Pet* by Alfred D. Fripp and Briton Rivière's *Stray Kitten*. The mainstay was Welsh and Italian scenery and Birket Foster's reliable drinking cattle. But the mention of Foster is a reminder that the exhibition itself was a fine one, and Fred Walker, for his debut as Associate, was showing his miraculous *Spring*. Among Ned's offerings, *Cinderella*, in spite of its high colour, would 'pass' – in fact another *Cinderella*, by Elizabeth Sharpe, was shown that year. The picture that stuck in the committee's throats was *The Merciful Knight*.

Burne-Jones was a man who could scarcely face a railway carriage or a bad cold, and yet this reception which threatened his whole career, not to speak of the support of his young family, only stiffened his resolve. On touching-up day, when he added to his offence by varnishing his pictures while older members were dabbling in pots of water, he met an atmosphere which he remembered as 'fury . . . *The Merciful Knight* was objected to and hung high . . . there was a sense of continual opposition and even covert insult now and again.'[6] The open insult, which Ned heard perfectly well, was 'papistical'.

The critics, whom he now faced for the first time, were kind to Walker, aghast at *The Merciful Knight*, and even more so (perhaps because it was better hung and easier to see) at the Dalziels' *Annunciation*.

For Mr Burne Jones we know not what spectacles he can have put on to gain a vision so astonishing. Had Duccio of Siena, or Cimabue of Florence, walked into Pall Mall and hung upon these walls their medieval and archaic panels, surely no surprise could have been in reserve for visitors to the Gallery. Let us approach by way of the *Annunciation*. Here is a bedstead set above a garden, at which the virgin kneels in her nightdress; the angel Gabriel in his flight appears to have been caught in an apple tree; however, he

manages just to look in at a kind of trap-door opening, to tell his errand.

This was the *Art Journal*, which added that Mr Jones's exhibits struck a 'distinctly discordant note'. The reference to Cimabue shows that the press was preparing to fight the Pre-Raphaelite battle over again; but the P.R.B. had faced criticism as a group, if not quite as a brotherhood. Burne-Jones, in the summer of 1864, stood alone.

But he made some valuable allies. Birket Foster, an early patron of the firm who had brought the news of Ned's election to Great Russell Street, stood by him, and so did Frederick Burton. At the same time, Burne-Jones, at the age of thirty-one, became the acknowledged leader of a group of young students.

> The curtain has been lifted [Walter Crane wrote], and we had a glimpse into . . . a twilight world of dark mysterious woodlands, haunted streams, meads of dark green starred with burning flowers, veiled in a dim and mystic light, and stained with low-toned crimson and gold . . . it was not, perhaps, to be wondered at that, fired with such visions, certain young students should desire to explore further for themselves.

Henry Holiday was one of them and so was Edward Clifford, attracted, so he tells us, by the 'spirit of other-worldliness' and a desire to know the secret of the colouring and the 'white skies'.

There were two important regular visitors to the O.W.S. who in 1864 saw a painting by Burne-Jones for the first time, and before long became his patrons and friends for life. These were the ship-owner Frederick Leyland, and the Liberal M.P. for Glasgow, William Graham. Leyland (so Whistler told the Pennells) had sold meat pies from door to door as a child in Liverpool, began his career when the shipping magnate Bibby bought one of his pies, and eventually took over the business. Graham was of a very different temperament, an India merchant, a fervent Scottish Presbyterian and an equally fervent lover of beauty. Both were discrimating collectors far beyond kind Mr Plint, whose 'I do love to look on a picture' was now silenced for ever. In 1864 they were both making up their minds. Graham began to purchase in 1865.

Georgie was pregnant again in the spring, and Ned took her

down to the Red House. Her two younger sisters, Aggie and Louie, were always welcome there, and in May 1864 Ned began his magical *Green Summer*, which was to recall for all of them those still early years when Janey had not yet succumed to her mysterious illness, Philip and Jennie and May were babies playing on the orchard grass and the two 'maidens' were carefree, though Aggie, defying the mediaeval mode, complained that her crinoline would not fit into the little bedroom.

Green Summer shows a group of seven girls, dressed in green relieved by touches of red, sitting on the grass while another girl in black reads to them. The air is full of floating white seeds and white birds flying. It is a *poesia* which seems to have no story, but it takes us to the heart of Burne-Jones and his treatment of the subject.

First there is the outward form: the picture strikes the eye as an arrangement of greens in light and shadow, then as a *pastorale*, as though Giorgione had come to Abbey Woods in Kent. Edward Clifford, who later made an 'undistinguishable copy' of it, calls it 'the flower and quintessence of summer', and so it is, even though it was painted in the studio – experience with cold winds and flies sticking to the canvas had shown Ned that he would never be a *plein air* painter.

Secondly, there is the personal reference. The central figures are variations on the Macdonald sisters, Georgie being the reader in black, while Louis is in *Profile perdue* as she is in *Theophilus and the Angel*. Janey Morris presides, more clearly in the 1868 version where she holds a peacock feather, the attribute of Maia, and so of the month of May. In the group is concentrated the 'time of such quality', the source of happiness for Morris and Ned in the summer of 1864.

Thirdly, there is the name, and for Burne-Jones the name itself has power to create substance. The title *Green Summer* is an echo of the end of Book XVIII of *Morte d'Arthur* Part 2: 'How true love is likened to summer'. 'For like as winter rasure doth always erase and deface green summer, so fareth it by unstable love in man and woman. For in many persons there is no stability; we may see all day, for a little blast of winter's rasure, anon we shall deface and lay apart true love for little or nought.' The name, therefore, implies something poised on the brink of dissolution through time and human weakness.

Lastly, there is the 'burden'. This was Burne-Jones's own term, and the example he gave was of a pavement artist's own work, where the burden would be 'I am starving'. The burden of Michaelangelo, he added, is that the nearest thing to God is the body and mind of man. This suggests that 'burden' is not far from Hopkins's 'instress', the totality of the given thing which is not complete until it has been understood by a sympathetic attention. The burden of *Green Summer* is a certain surcharged ache in the girls' expression which gives a tension at odds with their tranquil pose. They do not look at each other; in fact Burne-Jones's figures scarcely ever do look at each other; except in scenes of meeting or rescue. They look inwards or away, and even Morris was doubtful on this one point, saying he would like less 'concentration of expression' in the faces. The burden of *Green Summer* is beauty guilty of its own mortality.

Since March, Morris had been struggling to keep the books of the firm himself: loyal, harassed Charlie Faulkner had gone back to Oxford as bursar of University College. Added to this uncongenial work was the tiresome journey to London – the Red House was three miles from the station – and Morris now put forward, in a revised form their old idea of community living. The Red House, which was L-shaped, could be extended round the lawn. The plans, drawn up by Philip Webb, would make it into a kind of guild workshop:

> Midways of a walled garden
> In the happy poplar land.

The Joneses would live in one wing, and the whole work of the firm, as orders increased, could be carried out on the fourth side.

In September the two families, with their children and the plans, went down to Littlehampton for a holiday during which everything could be discussed. Charlie Faulkner, on vacation, came too with his mother and two sisters, Lucy and 'dear and gifted Kate'. Mrs Faulkner undertook the housekeeping, the days were free for chaff and sea air, and youngest in heart of all was Mr Jones, on leave from Birmingham and the doleful Miss Sampson to play with his little grandson on the beach. Morris, as might be expected, took charge of the construction of sand-castles, and reinforced the merlons and

embrasures with ginger beer bottles. Georgie was near her time and Ned, who usually spent every spare minute drawing, allowed himself to help Morris with the castles and even to throw stones into the water.

On 28 October, back in Great Russell Street, Ned's second son, Christopher Alvin, was born. He lived only three weeks and three days.

Aunt Catherwood had bought a plot on the south side of the newly opened Brompton cemetery, and they buried him there.

Two months ago [Ned wrote to Allingham in December 1864][7], Pip fell ill with the scarlet fever, and then Georgie was prematurely confined and immediately seized with the fever so that for eight days their life was in danger, then when she rallied a fortnight ago her own little child died – for these three months I have done no work, but lived most anxiously from day to day.

Rossetti wrote from Paris advising them to 'leave your present place altogether'. Ruskin had sawdust put down outside the house to deaden the noise of traffic. Swinburne, always responsive to children, wrote the gentlest of letters: 'I had been quite counting on the life of your poor child, and wondering when I might see it.'

There are no entries for work in Ned's book between August 1864 and March 1865. It was clear that if the Red House building scheme went forward, Morris would have to meet the whole expense. This was too much to ask, and the young Jones had to withdraw. Morris, who was ill himself with rheumatism, the whole district having suddenly been discovered to be unhealthy, was bitterly disappointed – 'In short, I cried', he wrote from bed in what Mackail calls 'a very shaky hand', 'but I have got over it now . . . suppose in all these troubles you had given us the slip what the devil should I have done?' This recalls a later entry in Burne-Jones's work-book: 'I asked Mr Morris what he should do when in the course of nature I should be removed – his reply was irrelevant, irreligious, and even coarse – for which I shall also charge.'

Morris's letter ends by begging Ned and Georgie to come to Upton as soon as they left Hastings, where they were recouperating, though it must have been dismal enough in November. 'I would give £5 to see you, old chap.' But this proved impossible, and soon Ned

was busy tramping the streets of London once again 'as far as Kensington', this time for a lodging. Georgie had such a horror of the room where her baby had died that it was agreed she must never enter it again. Fortunately Ned could count on the help of Cormell Price, who had just returned from his tutoring job in Russia; together they moved the furniture, including the Webb dining table and the little painted piano, to 41 Kensington Square. There was nothing but gardens then between the square and the narrow countrified Kensington High Street. No. 41 was on the north side and the light was poor, but there was a garden big enough to play bowls in on summer evenings, and it was quiet.

When they brought Georgie home her complexion – what was called in those days her 'bloom' – was gone, and for the rest of her life she was noticeably pale. To judge from her portraits, her hair had also lost the bronze lights it once had. She was only twenty-five, and Ned thirty-one. She had the strength to rise above her loss, and one of the first things she did was to look out her old music to sing at the piano. But it struck her that somewhere at 65 Great Russell Street she and Ned had left their youth behind them.

8

1865–6

FRIENDS AND ENEMIES

In the spring of 1865 the Joneses were furnishing their new house, of course from the firm. They ordered blue and green serge, 'Pomegranate' wallpaper, and more Sussex rush-bottomed chairs. Workmen came up from Red Lion Square (at seven shillings a day) to fix shelves and, apparently, a bath. Ruskin contributed a set of Dürer prints; Watts, from the twilit depths of Holland House, sent an unexpectedly practical gift, a sewing machine. Ned's tobacco was banished to a back room, and he threw himself into the task of keeping the garden free of cats. Georgie, worried by his frailty, tried to fatten him with milk and rum; this mixture was too much for Aggie, and she nearly fell off her chair at one of de Morgan's tea parties.

Aggie had come for the wedding of their elder sister Alice to John Kipling, an architectural sculptor and art teacher, on 18 March 1865. The Macdonalds were still in Manchester, and as the newly-married couple had to set off almost at once for Bombay, they were married at St Mary Abbott's and the modest wedding reception, with tea and coffee only, was held at Kensington Square. It was on this occasion that the hard-working classical painter Edward Poynter endeared himself to Aggie by staying behind to clean the silver.

Among these domestic scenes Ned began to paint in oils, with three-year-old Philip playing with the empty tubes. Allingham, calling on them later this year, noted that there were two studios, or anyway two rooms used for painting. 'Zephyr carrying Psyche – delightful – precipice, green valley, love's curly little castle below. Designs of St George and the Dragon. Drawings of heads, Circe (a-doing), she stretching her arm across.'

These subjects show the loyalty of Burne-Jones's early patrons, and how little he needed the help of dealers. The *St George and the Dragon* was for Birket Foster's house at Witley. *Circe* was originally commissioned by Ruskin, though it was bought eventually by Leyland. Here Burne-Jones had hit, as he liked to do, on the exact gesture just before the decisive moment. Circe, even at this early stage of the picture, had been given her half-stretching, half-crouching movement which Ruskin described as 'going round the table like a cat'.

At the O.W.S. that year Ned showed *Green Summer, Merlin and Nimuë*, the *Astrologia*, a red chalk head of Becky Solomon, and *Blind Love*. In 1866 he sent one of his most distinctive paintings, *Chant d'Amour*. The triangular structure of three figures – blind-folded Love, the open-eyed girl playing the organ, the seated knight – is another *poesia*, this time in white, scarlet and reddish violet, with no apparent subject beyond the *chanson*:

> *Hélas! je sais un chant d'amour*
> *Triste ou gai, tour à tour.*

The figures sit, entirely self-centred, in their queer little meadow, again not looking at each other, though they could not exist apart. The early dawn light makes a strip of white over the half-seen meadow, and the wind is ambiguous, blowing love's cloak to the left, the woman's hair to the right. The sensation is of music that has just been played and of listening to silences. In fact the picture might be said to have been born out of music, since the first design for it was inside the lid of the Russell Place piano.

The flowers in the foreground of the *Chant d'Amour* are tulips and wallflowers – 'the yellow flowers stained with red' – emblems respectively of ardent love and of bitterness, in the Victorian iconography of flowers. This language, now forgotten, was well understood in the 1860s. George Eliot, as a young girl, used it in letters to her teacher; Ruskin used it to Rosie La Touche; Rossetti, though as William Michael says, 'assuredly the reverse of a botanist', shows considerable anxiety about it in his letters. Strangely enough, all the Victorian flower books seem to be derived from an anonymous *Language of Flowers* published in Edinburgh in

1849, which, the eccentric author tells us in his *Preface*, was written while he was living in Turkey, but homesick for Scotland. This accounts for the odd mixture of names (harebells and cowslips with lemon blossom, liquorice and cactus), reproduced in other publications down to Kate Greenaway's *Flower Book*, where the artist has given up trying to illustrate most of the flowers at all. Burne-Jones, who was later to arrive at a secret flower language of his own, certainly knew this one. The briar rose means 'I wound to heal', yellow iris means 'passion', marigolds are 'chagrin and pain'.

He had always worked hard at flower drawing, and had made copies of the schematised plants in Gerard's *Herbal* which Morris used for some of his early wallpapers. But on the Italian journey of 1862 he had been attracted, in the painting of the quattrocento, by something more mysterious, the green plants springing from the ruins, symbol of new-born life, and the carpet of flowers that accompanies a miracle. In 1862 the National Gallery acquired Piero di Cosimo's *Mythological Subject*. Here the dead nymph lies between two plants whose English name is Love Lies Bleeding. But what is the white flowering weed in the foreground?

The language of flowers is a means of communicating, and yet concealing the secrets of the heart. Burne-Jones's pictures, like Burne-Jones himself, must be numbered among those 'who have learned to disguise themselves and meanly to lie low, so as not to let it be seen what we're really made of'.[1] A fixed meaning, as George Eliot said, substitutes the diagram for the pattern. An unfixed meaning may make a different pattern, though equally real, for sender and receiver. All the same, quite as truly as Morris, Burne-Jones could say that his work, though difficult of access, had 'little skill to lie'.

The chief literary work which Morris had in hand in the mid-1860s was the *Earthly Paradise*. Like the great collections of the Middle Ages, the *Decameron, Arabian Nights* and *Canterbury Tales*, it was to be a cycle of stories drawn from many sources. The title, too, was a kind of challenge to Rossetti and, through him, to Dante; Morris's earthly paradise was not that of the *Purgatorio*, but a place where all that he loved best could be brought together; in fact, he need scarcely have added the world 'earthly' – all Morris's paradises were that, and all had to be lost.

Working in the small hours of the morning before his business day, Morris versified the 'tales' with amazing rapidity and they soon became a vast project, as dear to him as the abandoned Red House itself. Ned was to illustrate the poems – Morris, however, liked the pictures to show the main point of each story and nothing more – and there were to be five hundred illustrations, reproduced not by the newer photographic process but directly from the wood. George Wardle, from the firm, Campfield, the foreman, and Lucy Faulkner all tried their hand at this from what Wardle calls the 'rather rough drawings on tracing paper' which Ned had produced, but they found the work seized away from them by Morris himself. Without apprenticeship, and with 'lively scenes' when things did not quite go right, he engraved the remaining blocks, and Ned drew him as he sat squarely in the lamplight, the floor littered with broken tools.

The *Earthly Paradise* – the Big Book – was to be the firm's first challenge to contemporary book production. They saw it, not in the Dalziel manner with illustrations by many hands and varying quality in the cutting, but as a huge folio of consistent design and every page laid out by Morris. This meant, of course, a great sacrifice of time, and just when, partly through the good offices of William Cowper-Temple[2] at the Board of Works, the firm was receiving some important commissions. One of these was the Green dining-room at the South Kensington Museum, still preserved intact with Burne-Jones's charming windows whose only fault is that they admit very little light, and his twelve panels of the Zodiac on a gold ground. Not unexpectedly, Ned fell behind with these and was sharply called to order by the firm's new book-keeper, Alphonse Warington Taylor. In the margin of his work-book for May 1865 – £5 each for 'designs of fogies and Angels with Kids' – is an entry, 'Taylor disputes this price'.

With Warington Taylor, who had been taken on to replace Faulkner, a new urgency, the feverish energy of a consumptive, was felt in the conduct of the firm. He wrote letters daily, often twice daily. Morris must be kept in hand, his wine bill and even his gas bills cut down, 'good pieces of wood'[3] must be got for Burne-Jones, who was to get all the work for South Kensington done by Christmas. According to Taylor, 'Morris and Ned will do no work except by driving, and you must keep up the supply of designs'. This is an admission that the firm by now depended on the talents of two

people, and indeed, as he tells Webb, 'the Guv'nor and them, he felt, were Celts – their names were Welsh, anyway – 'and we know what that means in the practical line'.

No one resented Warington Taylor's remarks, everyone liked him, and however much he came to deplore Ned's habit of using the firm as a bank ('What does that £60 owing by Ned mean? He never had £60 to pay anybody') his fury never lasted for long. He shared Ned's love of books and music – they exchanged books on Sanskrit and a translation of Renan – and they had both lost a child in the same year. Taylor, 'lean, unkept and of some Bohemianism', was of good family and had been at Eton with Swinburne; he had run through his money and come down in the world, returning to England from his army service encumbered with a handsome, ignorant wife. Love of the arts brought him to the Red House, and although he believed that trade was one of the results of the Fall of Man, he gave all his remaining strength to the firm. It was Rossetti who had insisted that 'a business man is an absolute necessity', and Taylor was voted a yearly salary of £150 to be paid by the members. But symptoms of consumption developed and he had to retreat, 'ghastly thin but full of mental energy', as Allingham described him, to 'frightful lodgings' in Hastings. In June 1868 the handsome wife suddenly left him, and searching her pocket book he found that 'for nearly twenty years she has played the whore'. It struck poor Taylor that Janey Morris might intervene. 'She would go to see my wife and tell her what she alone can tell her . . . we men are obliged to crush our feelings amongst ourselves, but I am ashamed to ask Morris's permission. I am afraid he would think me a fool.' At this juncture Rossetti wrote to him that he was a 'damned scoundrel' to give up such a beautiful woman, which of course was just what Taylor wanted to hear; matters were patched up, but at the end he was alone again, coughing his life away in a little house in Turnham Green. Morris and Ned used to walk across the fields to visit him, and found that his only companions were his cats which, 'even unsexed', he said he found preferable to nonconformists. As he lay dying, Ned tried to lift a fine cat off his chest, to be told. 'O let it stay there, it's my only comfort'.[4]

It was at poor Taylor's urgent persuasion, then, that Burne-Jones struggled in 1865–6 to finish the panels for the Green dining-room and Birket Foster's four pictures of the *Story of St George*. For the first time he had to employ a studio assistant, Charles Fairfax

Murray. Murray, known at first as 'the boy', considered ludicrous because of his bow legs and fuzzy hair and later because of his numerous children, was in fact a shrewd and competent individual. He was shared between the studios and undertook numerous jobs, lining canvases, buying small items and finding lost ones, fetching a plumber when Rossetti's bath began to leak and taking larger paintings about in cabs. Burne-Jones gave him twenty-five shillings a week when he was on duty, and the surprising sum of £60 for copying *St Theophilus and the Angel*. This was one of the few pictures Ned managed to finish in 1866, but the sketch-books show that he was designing jewellery, fantastic armour and drapery, fit for inhabitants of the rooms of the imagination which had been realised in the dimly-lit Green dining-room. His faculty for design was almost too active. Friends who were put up for the night in the dressing-room found it was piled high with Ned's sketch books.

These friends increased rapidly in numbers. Without ever losing his shyness or perhaps because of it, Burne-Jones had a quicksilver readiness of sympathy, feeling other people's pain in his own mind and body, and an earnestness about things that really mattered, which made him one of the most acceptable friends ever to share a hansom cab or listen to a confidence. In company he was brilliantly amusing (though he could only be drawn out gradually) and also amused; he was already noted for his three laughs: the normal, the hearty, and the totally silent and convulsed, which was prized as the unusual response to a really good joke.

In fact one of the few imperfect sympathies of this time seems to have been the introduction of Carlyle. Ruskin, deeply under Carlyle's influence in the years of *Unto This Last* and *Sesame and Lilies*, swept the young Joneses round to Cheyne Row feeling that they must be acceptable to the sage. But Carlyle, who was grudging towards the visual arts and only tolerated Whistler's portrait because it gave him a clean collar, was on this occasion unapproachable. Philosopher-lovers will excuse him because he was midway in his titanic struggles with *Frederick the Great*, animal-lovers because he had recently lost his dog beneath the wheels of a Chelsea butcher's cart, but despite these explanations, the visit was a failure. The Joneses could only console themselves by the thought

that they had seen the tea-kettle lifted by the hand that wrote *The French Revolution*.

One friend, too, was lost for the time being – George du Maurier. Feeling snubbed and excluded by the new intimates who were part-sharing Rossetti's house, he began to publish his parodies of Rossetti and Swinburne in *Punch*. These caused pain and bewilderment, and Morris could only manage to be 'fairly civil' when du Maurier came to the firm to order furnishings for his new house. The loss was, however, partly counter-balanced by a new friend, Alphonse Legros. Legros was a dark, expansive Burgundian, a fine lithographer, etcher and portrait painter, who had come over to England after a run of bad luck. With the help of his old friends of the ateliers, Whistler and Poynter, he was established as an instructor at the South Kensington schools; there, and later at the Slade, he was one of the best teachers they ever had. As a good companion, Legros was immediately surrounded by legend. He refused to learn English, and for fifty years understood only what he chose to. He was said not to be able to read or write (in fact he simply disliked doing so), but had in compensation a wonderful visual memory, trained by the famous Boisbaudran, and could whistle whole operas by ear. In the country Legros appeared as a kind of Tartarin, terribly dangerous on a shooting party; in the drawing-room he frightened the ladies by showing them etchings of the morbid subjects he loved – '*Mais madame, j'adore le laid.*'

To Burne-Jones he was irresistibly drawn, and indeed, as the *Memorials* put it, 'the number of people who surrounded Edward was very great'. When Ned went out, as he did increasingly, he was welcome in several distinct but overlapping circles. To begin with the closest, there were numerous outings to pot-houses and chop-houses with old cronies, and recuperative visits to Turkish baths, after one of which, Luke Ionides tells us, Morris turned cartwheels in Cavendish Square. Ned was still on a good footing, too, with the true London Bohemians of the sixties, whom he had met through the Hogarth Club, the genial drinkers and smokers surrounding Charles Keene, the greatest draughtsman of them all. Most of these intimates cared for old music and old 'clays', some of which Keene dredged up from the Thames; Boyce was there, sad Dicky Doyle, Frederic Sandys, the lordly borrower, and tiresome old Cruikshank, now off the bottle and preaching total abstinence. Still Bohemian,

but much more sumptuous, were the 'evenings' given by the hospitable Jermyn Street tradesman Arthur Lewis, who liked to mix art and good times. At Moray Lodge on Campden Hill, Lewis (until his marriage put an end to such things) offered music at 8.30 and unlimited oysters at 11; the delightful invitation card, designed by Fred Walker, showed a Grecian Muse offering an oyster on the half-shell. Many 'theatricals' came, and Burne-Jones was on the fringe of the theatre which ever since *The Fairy of the Golden Branch* he had loved so much, and Morris scarcely at all.

Little Holland House continued to mingle art and society without oysters, and on a higher plane. Watts had survived, apparently without disturbance, the failure of his marriage to young Ellen Terry. He was affectionate always, and so too was Val Prinsep, who took life more and more easily. Legros had begun to visit there, and Ned met for the first time the most amiable of patrons and artists, George Howard.[5] Howard (later Earl of Carlisle), instantly likeable from his self-portrait in a large all-weather tam-o'-shanter, had married in 1864 the Hon. Rosalind Stanley; this firm-minded young wife was insistent that he must finish his studies under Legros at South Kensington and must not try to live in two worlds, the dedicated and the pleasurable; yet George Howard did manage to combine them. He and Ned were instant affinities. 'The two wives drew more slowly but quite steadily, together', Georgie wrote; she could not know that Mrs Howard's sister, Kate Russell, had described her in her diary as 'a very wee little wife, with her hair cut short, a nice little person'. There was also a younger generation, collected by the tireless Mrs Prinsep – Leslie Stephen, who came, so he says, timidly, and Sidney Colvin, just down from Cambridge and beginning to write on the *Pall Mall*. Another guest was young Blanche Fitzroy, of the house of Rothschild, an enthusiastic student at Heatherley's. It was at Little Holland House that she met and fell irretrievably in love with Sir Coutts Lindsay, an amateur painter and accomplished man-about-town nearly twenty years older than herself. The Lindsays were to be the founders of the Grosvenor Gallery.

More energetic, more spiritual, and even more full of goodwill were the Cowper-Temples, Ruskin's great friends, whose entertainments were likely to be in aid of the new foundation of Toynbee Hall, or of the early temperance movement, or the charitable work of the great unorthodox preacher and writer,

George Macdonald. This was a circle of good people who wanted to do good; Edward Clifford recalled how disappointed the Cowper-Temples were on his first visit to find him 'a polite black-coated young artist rather than a working-man with rudimentary manners and a blouse'. But with their goodness went high spirits. In 1868 we hear of Ruskin leading off 'Sir Roger de Coverley' with Octavia Hill at one of these gatherings, as energetically as he had danced at Winnington.

All this did not preclude many parties given at home. When Morris moved from the Red House to Queen Square, Bloomsbury in the autumn of 1865 he at first tried to give a series of weekly 'jollies' for the firm, but Janey, who had had two babies in two years and perhaps wished to avoid the prospect of ten babies in ten years, began to retreat to her sofa in the grip of a mysterious languor which persisted for the rest of her married life; she found the jollies tiring, and they grew fewer. Rossetti went out much less than he had done, but entertained royally, and both Georgie and her sister record one of the studio parties where the moon shone full on the springtide Thames, lapping just the other side of Cheyne Walk, and in the house, away from the noisy studio, the presence of Lizzie Siddal seemed almost palpable, although she had never been there. The Burne-Joneses themselves kept a family Christmas to which de Morgan, still unmarried, always came. In March 1866 their house was ready enough to give 'a dance, a very swell affair'. Madox Brown wrote,

the house, being newly decorated in the 'Firm' taste, looked charming, the women looked lovely and the singing was unrivalled, and we all luckily escaped with our lives, for soon after the guests were gone, the ceiling of the studio (about 799 lbs of plaster) came down just where the thickest of the gathering had been all night. Morris was to have slept on the sofa on which most of it fell, but, by good luck, he went home to sleep with Prinsep. This I feel triumphantly is something like news, but it prevents Jones having anything for the O.W.S. this year.

It is sad to hear a note of something like satisfaction in this, yet it is understandable that Madox Brown, a much older man who had been forced to take his picures round on a handcart, 'like a pedlar' should feel resentful at what looked like young Jones's rapid success.

Although he had recently been much more prosperous and was now moving from Kentish Town to Fitzroy Square, he who had been so good to Ned when he was young and poor began a gradual withdrawal into settled disapproval. Before they moved house, however, the Madox Browns gave a notable dinner to which everyone was invited and for which even Gabriel bestirred himself and came out, passing like a prince through the small rooms with all his old benevolence. Whistler was there, at his most frighteningly droll, and Georgie had to remind herself that he was said to be good to his mother; Legros had been asked, and Madox Brown tried to explain to him the plot of *Sidonia* in French, a link with old times on an evening when everyone felt on the brink of change. 'And on this day of union and reunion of friends,' the *Memorials* add, 'there was one who had come amongst us in friends' clothing, but inwardly he was a stranger to all that our life meant. This was Mr Howell.'

George and her sisters, it will be remembered, never began a sentence without knowing how it would end, which helps one to feel the weight of her one and only reference to Charles Augustus Howell. At this point he was a newcomer to most of them, having recommended himself to Rossetti in 1865 as a 'nice young chap' by sending him some bottles of Madeira. They saw him as an enterprising, amusing, readily adaptable Anglo-Portuguese, with quick wits and a horse-tamer's physique. What had not yet emerged was that his arrival meant a clash of romanticisms, disastrous to many since Howell, whose adroitness might have made him rich in any other line of sharp practice, was fatally drawn towards the world of creative artists. It was also evident to him that because of his cleverness he was entitled to a living from the less clever, and looking round the table he must have calculated, though incorrectly, where his best prospects would be.

This account of friendships might end with one or two who, while so many doors were opening to Burne-Jones, were becoming rather less acceptable. Swinburne, drinking heavily, was dreaded by now in libraries and club-rooms, but as a poet he was still in full flight. 'His poetry is partly horrible and partly incomprehensible,' Ned wrote to George Howard,[6] 'but partly perfect, and it has a force like a fever that clears the body as a storm clears the air.' To Ned he dedicated his *Poems and Ballads* of 1866, wildly recommending them to his readers.

> Let them enter, unfledged and nigh fainting
> For the love of old loves and lost times,
> And receive in your palace of painting
> My revel of rhymes.

By 'unfledged and nigh fainting' Swinburne meant 'young and old' – at such high pitch did the ordinary business of living present itself to him. Poor Swinburne's equilibrium, 'as far as he may be said to have any' as Boyce puts it, had been completely lost over that wild beauty of the studios, Becky Solomon, with 'hair as the plume of a bright black bird' who appears to be the model for the final version of Ned's *Wine of Circe*. Becky at this time had not begun to drink, and Solomon, nasty, feckless and appealing, was still on the bring of downfall, which he regarded as simply another circumstance of life. It must stand to Burne-Jones's credit that he shared this view as far as it concerned his friends. The inconveniences of drink, homosexuality, adultery and the workhouse in no way affected his regard. 'There shouldn't be *laws* against immorality,' he told Rooke, adding, 'It shouldn't be *illegal* to prefer Frith to Mantegna.'

Drawing – and Ned practised drawing in every spare moment – became at times an aspect of friendship. His little horror pictures, the bogey subjects which exorcised the darker side of his imagination, were for the home circle only, though Charlie Faulkner took a collection of them back to Oxford. The girl in her bedroom who opens the drawer and finds a corpse-like bogey folded on top of the wash is typical of these, the protagonists always being caught by the bogeys unprotected and alone. On the other hand, a series of Topsies, studies of Morris from all angles, each one squarer, more determined, and shedding more waistcoat buttons than the last, begins about this time and must run into many hundreds. Ned even risked a picture of Morris with Janey being sick out of a boat. Living as he did in the age of Charles Keene and Phil May, Burne-Jones could never be counted as a great comic draughtsman, but these sketches, which everybody wanted to keep, were thrown off by real disgust or real affection. A case in point is the set of drawings of Swinburne and his queer entanglement with Adah Menken.[7] With affectionate tact the last picture (where all is over) shows the tiny Swinburne lighting his cigar with his love letters, and emerging as

that which he never seems to have been in any sexual relationship: successful.

A check to dining out and going out came to Burne-Jones in June 1866 when his daughter Margaret was born, only three months, it will be noted, after the ceiling collapsed. Although Ned professed to be put out because he could not go to France with Webb and the Morrises,[8] and although he was surprised at the baby's plump aspect and referred to her at first as 'Fatima', he was lost, and he soon knew it. He became a victim of the helpless blue-eyed object, indeed he entered upon a lifetime's slavery. Margaret was born to charm without effort, whereas five-year-old Phil, who had anxiously predicted that the baby would be either a boy or a girl, was rapidly turning into one of the nerviest children in Kensington.

At the beginning of August 1866, Allingham, who seems to have been sleeping on the sofa at Kensington Square, asked the Jones family to come back with him to Lymington for a seaside holiday. This was cholera year in London, and they accepted gratefully. The outings which he offered his friends were always much the same – a day trip to the Isle of Wight to call on Tennyson, walks in the woods, where Ned did tree studies for the background of the *St George* series, the beach, dinner. 'At dinner Ned lauds Luini; speaks of the injustice of the critics, "wonders when people will begin to speak of me decently."' On 30 August they went to Winchester to meet Morris and Webb, down from London. The day in the city of King Arthur and the Table Round was not quite as genial as expected, since Morris was infuriated by the restorations at St Cross, and dinner for five at the George cost nineteen shillings and was, Allingham notes, very nasty. On Milford beach the next day 'we bury Morris up to the neck in shingle' and one is surprised to find that Morris liked the place and wanted to stay. The next day the weather broke, there was packing to do, good-bye to old Mrs B. at the top of the house who would be hurt if overlooked, a bunch of flowers from Allingham, anxiety over catching the omnibus to the station, another English seaside holiday to join ten thousand gone.

By going to Hampshire they had missed going north for the joint wedding of Aggie and Louie Macdonald: Aggie was married to Edward Poynter and Louie to Alfred Baldwin at Wolverhampton on 9 August 1866. This natural stage in the life of his two 'wenches', Burne-Jones, in spite of himself, regarded as a desertion – by Louie in

particular – and Georgie was wise to avoid the wedding. He was at work on figure studies for *The Mirror of Venus* – young girls amazed at seeing their beauty for the first time under the direction of love – a subject related to Sintram and the reflection in his shield, and to the magic well of the *Romance of the Rose*; it was one of the images which haunted him every time a young girl whom he cared about married or was threatened with marriage. The *Mirror* was one of many pictures that went to Graham, who was prepared now to buy almost everything Burne-Jones could finish. When he had first come to the studio Ned, knowing his nonconformist sympathies, had turned the nudes with their faces to the wall, but he soon found that Graham liked them.

The main task of 1866 – and this was really what Morris had come to Lymington to talk about – was still the *Earthly Paradise*. As he finished each section (he wrote fifteen thousand lines in 1866–7) he read it aloud to Ned and Georgie, and for the first time we hear of Morris's readings as an ordeal – Georgie, with two babies to look after, had to stab herself with pins to keep herself awake. All that was needed now was the illustrations.

To help him with these Burne-Jones had been given, as Allingham noticed, a 'fine copy' of the *Hypnerotomachia Polyphilii*, and this was probably supplied by Morris's new friend Frederick Ellis, a dealer in manuscripts and rare books at 33 King Street, Covent Garden. Ellis was soon to become the publisher of both Morris and Rossetti, or, as Gabriel put it,

> A publishing party named Ellis
> Addicted to poets with bellies.

Morris, introduced to the shop by Swinburne, had taken Ned there two years earlier – 'a pale and fragile-looking young man' as Ellis remembered him, who 'eagerly recommended' Morris to buy (though he would certainly have done this anyway) a magnificent Boccaccio.

The only complete set of *Earthly Paradise* illustrations which Burne-Jones finished (though there are many incomplete ones in existence) was *Cupid and Psyche*; these are plainly derived from the queer, elegant, stiff, Mantegna-like woodcuts of the *Hypnerotomachia*. What edition of it Ned had remains a puzzle. He could hardly have been allowed to

take a copy of the original Aldine Press edition of 1499 on a seaside holiday, for Morris (although he once hurled a 'fine' fifteenth-century folio at one of his workmen) was a great bibliophile, refusing to let women turn the pages of his books because they were so clumsy.[9] In any case, Ned seems to have been as fascinated by the text as by the mysterious illustrations.

The author, Friar Colonna, declares in a preface that his *Strife of Love in a Dreame* (to use the Elizabethan translation) shows 'the vanitie of this life and the uncertaintie of the delights thereof', although in fact it does nothing of the sort. The Friar, or Dreamer, after a dispute with Logic, who urges a more prudent course, follows a maze-like quest in search of his lost love, Polia. At last, in an arbour of white jessamine (the ground flower of Botticelli's *Primavera*) he finds Polia in green silk blown by the wind and with tiny breasts which, as the Friar points out, would just fit into the hand. The triumph of the Venus of Living Nature passes by (a woodcut across the double page, with chariots and elephants recalling the Mantegnas at Hampton Court). The lovers join in a sacrament at Venus's altar, where Polia's torch of virginity is put out and a miraculous briar rose begins to grow. But for the ultimate happiness they wander through ruins and graves of those who have died for love. In the end, the crossing of the magic sea and their union on the island is a deception, for the Dreamer awakes, and the sensation is by no means one of moral enlightenment, but of disappointment.

The *Hypnerotomachia* is a book of daunting complexity. Every object and building described (and they are all described) is symbolic in itself and engraved with further symbols. Colonna and his unknown illustrator have no way to express themselves except by 'meaning within meaning'. But neither had Burne-Jones.

As soon as Morris had engraved the seventy *Cupid and Psyche* drawings on wood Ellis ran off the trial proofs, but they were not a success. Gradually even Morris was obliged to concede that if the Big Book was to be perfect – and it could not be less than that – the blocks would have to be redrawn and recut, an impossibly expensive process. The *Earthly Paradise*, after all the high hopes that had been invested in it, eventually appeared in four parts without illustrations, except for Ned's title-page design of three girls playing music; he had to bear quietly with Morris's cutting, which resulted

in one of them playing the lute with her elbow. He may even have felt a certain relief at the change of plan after Morris had begun to introduce stories from the northern sagas, an element of 'raw fish and ice' which Burne-Jones found quite unsympathetic. But the Big Book, they agreed, was in any case not given up; more than twenty years later it was one of the projects of the Kelmscott Press, and almost to the day of his death Morris still hoped to see it in print. Meanwhile, a sure sign that Burne-Jones was now a truly professional artist was the fact that he did not waste this wealth of designs, but continued to draw on them throughout his life, in many versions and in different media.

It was Georgie's idea that the *Cupid and Psyche* set should be given to Ruskin as a token of gratitude for the Italian journey of 1862. Ruskin, who was not much used to gratitude, was overwhelmed: they were the most precious things he had, 'next to my Turners'. He gave forty-seven of them, as examples of line drawings, to his school at Oxford. At the British Institution in June 1867, he included in his lecture *On the Present State of Modern Art* a passage in praise of Burne-Jones, contrasting him as a painter of the imagination with Doré. This lecturer's habit of contrasting everything with something else, which must necessarily be worse, often clouded Ruskin's judgement; Ned himself felt that out of thousands of designs Doré made a hundred wonderful ones, 'which is saying a very great deal', but he could not help being moved when Ruskin spoke of his own purity of line and 'sympathy with the repose of the constant schools'. The example shown was a sketch for the *Good Women* tapestry, the *Two Wives of Jason*, and Ruskin made the shrewd comment that this Medea was not a sorceress but a counsellor with 'authority, dark and inscrutable'.

This was a moment of something like tranquility in Ruskin's life. Burne-Jones abandoned an attempt to do the portrait which he had asked for, knowing probably the distress which had been caused when Rossetti tried it – Ruskin's face, disfigured by a dog-bite, could only be shown in profile without troubling him. But Ruskin could write to Ned, sure of his understanding, about the disturbing visit of Rose La Touche to Denmark Hill; he sometimes painted in Ned's studio, or they would walk together through Camberwell, Ned teasing him gently by pointing out the Gothic public houses on every corner – 'your doing, my dear'.

But at the same time Burne-Jones was seeing much more of

Howell; this was in spite of the fact that Georgie had come to distrust him. Neither Georgie nor Morris discussed other people in their absence, Georgie because she did not think it right, and Morris because it did not interest him. Howell, on the other hand, was a gossip, extravagant of his talent, with a confidential close-leaning manner which blinded the flattered listener. In 1867 Burne-Jones consulted him eagerly when Whistler, who had reached his most aggressive stage, quarrelled with Legros and knocked him down in Luke Ionides's office. Ned, with the same unexpected fighting spirit he had shown in his schooldays, wanted to take Whistler on; Howell, who was a good mimic, offered to do an imitation of Whistler if anyone would volunteer to stand in for Legros.[10] Howell, as this incident shows, was nothing if not adaptable. He appeared, too, as a man of taste in all departments, could take the burden off the artist's shoulders, and would charge nothing for this. He advised watching the market, and said he had bought in Burne-Jones's pictures at the Anderson Rose sale in 1866 to keep up the prices (though Christie's records show he bought only one (*A Forest Scene*) for £6 10s.[11]). Some things passed imperceptibly into his keeping; according to a list which Ned drew up in 1872[12] he had an early *Danae* which disappeared – 'Howell said it was burnt'. 1866, however, was a year of glory for Howell when he carried out a number of charitable transactions as Ruskin's secretary, an appointment which Burne-Jones seems to have suggested and later regretted. 'I once recommended a secretary to him [Ruskin] in glowing terms', he wrote to Fairfax Murray, 'and you have it in your power to wipe that disgrace out of my life'.[13] This position enabled Howell to regale the company with details about Ruskin's money matters and his love for Rose La Touche. He expanded, and gave 'blokes' dinners'; he got married, everyone was asked, and Ned presented him with a drawing of *Lucretia Trying the Sword*. The only warning voice was still Warington Taylor, who noted that Howell was 'buying and selling freely' and talking of Morris 'with a disrespectful air of joke'. Yet Burne-Jones continued to see him.

There is an uneasy sense of wrong direction about all this. When Allingham called on Robert Browning on 21 April 1867, Browning, who had been complaining about Swinburne's 'fuzz of words', improvised two lines

> Don't play with sharp tools, those are edged 'uns
> My Ned Jones!

Both he and Allingham knew that Ned was getting beyond his depth. This was the result not only of his acquaintance with Howell but of what the *Memorials* call 'another and very notable introduction in those days . . . to a part of what may be called the Greek Colony in London'.

9
1866–7

A THREAT TO THE EARTHLY
PARADISE

By 'the Greek Colony in London' the *Memorials* mean us to understand the leading family in the Greek community of Victorian England, the Ionides.[1]

The Ionides were a great Phanariot family whose property in Constantinople was seized by the Turks in 1815. The head of the House escaped to England with his wife, who wore round her neck their emergency fund of five gold coins. They left behind them the grandmother, who had gone into retirement after finding her husband crucified on the house door by the Turks.

Both in Manchester and in London the Ionides prospered, and by the 1860s they were established as importers of cotton, and naturalised as British citizens. Bayswater, and Holland Park in particular, was their colony, and they had become great patrons of the arts; 8 Holland Villas was the home of Constantine, the head of the family, known as Zeus, or the Thunderer; it was the only house he could find large enough for his princely Turkish carpet, and the fine collections which he was to leave to the nation. His sister Aglaia (later Mrs Coronio) was the friend and correspondent of William Morris. His brother Luke was a *bon garçon*, unsuccessful as a business man but a good companion of artists. Burne-Jones he found 'the most delightful man it has ever been my good fortune to meet'; they rivalled each other in connoisseurship of bottled Bass, and of Tattooed Ladies at fairs and exhibitions.

The close family atmosphere and golden hospitality of the Ionides extended to many relations and connections – Sechiaris, Cassavettis, Homeres, Cavafys, Spartalis. Among these Marie Spartali, the tall

pale beauty 'radiating dignity with every movement', appears and reappears in nineteenth-century memoirs, as she does in Rossetti's later pictures and Julia Cameron's photographs. As a young woman in the 1860s, Marie was usually one of a group of three, who were known throughout the Greek community as the Three Graces. The second was Aglaia Ionides, and third was Mary Cassavetti, who was to give Burne-Jones a new image of beauty and a new depth of happiness and unhappiness.

Mary was born in Athens in 1843, a grand-daughter of the founder of the London House of Ionides. Her father, 'Hadji' Cassavetti, although he had done very well in cotton in Alexandria, was looked at a little askance by the Greeks for his easy oriental ways and his dealings with Achmed Ali. But when Mary was only fifteen Hadji died, and by 1858 she had lost three brothers and sisters, leaving only Alexander, eleven years younger than herself and in no way able to control her. That responsibility was left, after the family had come to London, to the head of the family, Constantine.

Mary's mother, Euphrosyne, was the formidable 'Duchess', the terror of younger relations, though not of her daughter. To a niece, Mrs Cavafy, who tried to make her old clothes 'do', she said, 'You must not continue to wear garments like that, if you want to conserve your husband's love.' She was a woman of marked ability who, when her cook failed her, would take over the kitchen herself and whose daily life was conceived in terms of high comedy. In 1878 she wrote to Burne-Jones from Corfu, heaping approaches on him, 'opening the floodgates', as he put it to Rossetti, 'and she *has* grievances, but she fastens on sorrows . . . [though] nothing can ever make me angry with her.'[2] There was, however, little comedy in the life of her daughter. It cannot be called less than tragic to begin life as the delicious 'child in Turkish dress' of Watts's portrait, and to end, as it is thought, in an asylum.

Warmth and sexual generosity were the note of Mary's beauty. When A.C. Ionides, the writer of *Ion: A Traveller's Tale*, was a small boy, staying at the Ionides's Brighton villa, he was 'larking about at Hobden's baths' and fell in. 'I was put into Mary's dressing-room . . . to await dry clothes. Mary proceeded to undress in front of me, and her glorious red hair and almost phosphorescent white skin still shine out from the gloom of the dressing-room.' At this time she was

about twenty-five, a married woman who had left her husband but was still in control of the £80,000 she had inherited on her father's death; this, at least, was the figure given by Du Maurier in a letter (October 1860) when Mary, 'rude and unapproachable but of great talent and really wonderful beauty', was only seventeen. 'She is supposed to be attached by mere obstinacy to a Greek of low birth in Paris', added du Maurier, who felt that he had attracted her interest in a 'significative' way. But it was not significative, and next year she married her 'low' attachment, Demetrius Zambaco, doctor to the Greek community in Paris. She bore him two children in rapid succession, a boy in 1864 and a girl in 1865.

Dr Zambaco can only be judged from his one surviving letter[3] He writes, as he says, '*comme je bavarde verbalement*', appears kindly, worried and dull, and describes himself as an expert in the '*capricieuse santé des personnages distingués*. He recommends a digestive tube with which he has caused one of these distinguished persons to absorb 100 bottles of meat extract. It was for this that Mary had exhanged the brilliant London life of the house of Ionides.

In 1866 she left Paris with the two children and went to her mother's house at 47 Gloucester Gardens. She had considerable talent as a sculptress and medallist, and she wanted to return to the point of danger where art and society met. The 'Duchess' herself was a generous patron of the arts. Delighted to be rid of Dr Zambaco, she offered to commission a picture for Mary, and took her, with Marie Spartali, to the studio of Burne-Jones.

The subject, in the end, was left to him, and he chose from his *Earthly Paradise* designs the *Cupid Finding Psyche*. This allegory of the soul delivered by love was one of his favourites, and he made from it in the end at least seven finished pictures. When the watercolour version was finished he was overwhelmed and had to negotiate the price (forty guineas) through Legros. 'I am uncertain if, after all, this is a picture which Madame Zambaco or Miss Spartali would have chosen if choice had been possible,' he wrote to the 'Duchess', 'for although they express the kindest sympathy with my work generally I could understand how preferable some pictures would be to another – and for that very reason that I have tried to do better in this case I may have failed more completely – will you please say this for me.'[4] This incoherent letter was sent round 'by hand'.

What struck him about this wild Greek creature, Mary Zambaco,

scarcely disguised as an elegant Londoner, was the famous red hair, and next to that the curious irregularity – as against Marie Spartali's perfection – of her face. 'It was a wonderful head,' he wrote,[5] 'neither profile was like the other quite – and the full face was different again.' More touching still was her expression, as of something that has been unjustly hurt. 'Two things had power over him,' Georgie wrote in the *Memorials* for 1867, 'beauty and misfortune – and far would he go to serve either; indeed his impulse to comfort those in trouble was so strong that while the trouble lasted the sufferer took precedence over everyone else.'

Once again, two romanticisms had met. Mary Zambaco brought to Kensington and Bayswater a Byronic afterglow, a reckless determination to love again, and be again undone. She was a natural force, 'like the billows of the sea' as Ned later described her, and a beauty of the High Renaissance, so that to study her he had to turn seriously for the first time to da Vinci and Michaelangelo. From a human point of view his attitude needs no explanation. 'Since you drive me into a corner', he told Rooke, 'I must confess that my interest in a woman is because she is a woman and is of such a nice shape and so different to mine.'[6]

His reaction to the intense emotional experience of 1866–7 was a fit of depression which left him unable to work, even for the firm. Ruskin came over every day for three or four hours to counsel him, and 'I have been a nuisance to everyone'.[7] By way of relief both families, the Morrises and the Joneses, took lodgings in Oxford for the long vacation. Charlie Faulkner was in residence and eager to see them but there were no larks now and Ned passed through 'a terrible time of perplexity and self-abasement'. He drew street corners, canal banks, plants and animals – no human beings. 'Mention Mantegna to me. I am doing nothing – can't in lodgings with the noise of children,' he wrote to Fairfax Murray. It was a mercy he did not run into 'old Duncan', who was pounding up and down the river that summer in a steam launch, looking for subjects.

Morris's account of the holiday was quite different; though he, too, was ill at first, he soon recovered and was happy messing about in boats, happy, too, to be active and hurrying down from London to read aloud further sections of the *Earthly Paradise*. Both Ned and he were aware that their marriages were reaching a point of crisis, but whereas Ned was on the verge of an experience he couldn't control,

with awkward feelings towards the family he still dearly loved, Morris was grateful for what seemed a truce in Janey's unaccountable tiredness.

> Now came fulfilment of the year's desire,
> The tall wheat, coloured by the August fire
> Grew heavy-headed, dreading its decay . . .

The introductions to the June, July and August sections of the *Earthly Paradise* speak of 'leaving hopes and fear behind' on the excursions up-river, although they end with the hesitant question, 'Have we been happy on our day of rest?' Burne-Jones had been unable to shed his hopes and fears, and it was now time to return to them.

They came back to London to find that 41 Kensington Square had been sold in their absence, apparently without notification, and they could not renew the lease. But to Georgie this did not seem altogether a disadvantage. She knew that Ned was in perilous company, and she directed their search towards somewhere farther out of London. They fixed on The Grange, in North End, Fulham. The site is now part of a council estate, one block of which is named Burne-Jones House. The Grange was to be their home for the next thirty years.

10

1867–70

PHYLLIS AND DEMOPHOÖN:
THE DANGERS OF ENCHANTMENT

Apparently they had first seen The Grange with Allingham the year before, although in his diaries Allingham says that when he first visited them he had no idea where the place was. Fulham did, indeed, seem a very long cab-ride out of London, virtually a retreat into the country.

The Grange consisted of two spacious patched-up eighteenth-century houses thrown together and three-quarters of an acre of garden. Samuel Richardson had lived there, although the Joneses did not know this, and it had the right air of studious seclusion. *Kelly's Directory* shows that it was surrounded by several market gardeners, a basket-maker, a willow lodge (presumably for the basket-maker) two home-made beer retailers, a horse-dealer, and (this alone shows the remoteness of the place) and a private asylum for ladies. There was also a walnut orchard, from which came sounds that Ned explained to an Italian model as the sound of Englishmen beating their wives. At the corner of the lane you could gather briar roses, in their season. Two terraces had recently been built at the back of the house, but the railway was still several fields away. 'It is too grand for us,' Ned wrote to George Howard, 'we have no right to such a place.'[1] But they moved in.

Both parts of the house belonged to a Mr Charles Johnson, and the Joneses chose the north side as having the better light for painting. Even then, to help out with the rent, they shared with the Wilfred Heeleys. Heeley, waiting to go out east, was a steady old friend from Birmingham days; his wife was a quiet young woman. What the *Memorials* describe as 'a veil of green paint and Morris

paper' was drawn over the walls, and the firm, as usual, supplied almost everything, incuding the wine, which Morris imported from France and bottled himself, charging Ned twenty-four shillings a dozen. The consumption at The Grange was about two bottles a day, not a great deal, for although Georgie drank nothing but water Swinburne was a frequent visitor.

In the November of 1867, shortly before they left Kensington Square, Burne-Jones had opened a bank account for the first time at Praed's in Fleet Street. Up till then he had been unable to cash crossed cheques at all. He paid in a deposit of £127 10s, presumably from the sale of pictures, as he was still overdrawn with the firm by £62 6s 9d. He had no idea how to draw a cheque and had to be instructed by Leyland, the first of several businessmen who undertook to help him with his affairs; in this Ned was, most satisfactorily, what a businessman expects of an artist. After Leyland, Graham took over, and after Graham, George Lewis. 'Rossetti had the greatest contempt for my abilities in that way. He used to say, 'My dear fellow, you'll always need someone to look after you – you're no better than a child.'"[2] Yet Ned's helplessness proved, in the end, a better system than Rossetti's.

On 4 March 1868, the new life was signalled by a large party at The Grange 'which', William Michael Rossetti noted, 'I see for the first time.' But Ned could not settle to work in the new large studio. Although Warington Taylor 'kept on at Ned every other day' there are no designs entered in the work-book between June 1867 and March 1868, or again between November 1868 and May 1869. 'This year did little work through illness' was Ned's own explanation.

By the beginning of 1868 his debt to the firm had increased to £121 2s 11d and this was only providentially relieved by a small legacy from Mr Jones's half-brother. The Grange in 1869 did not have the ordered peace, described in so many memoirs, of later years. Besides the familiar shortage of money, there were tyrannous or drunken Victorian cooks to settle, an unexpected pregnancy on Mrs Heeley's part, Alice Kipling's proposal to come on leave from India for a long visit; in the nursery there was an awkward balance of power between the nervous, easily-wounded little boy and the confident, much-admired little girl. But these things did not disturb Georgie so much as the fact that Howell had followed them down to Fulham.

He had established himself at North End Grove, about two miles away, giving William Michael Rossetti to understand that Ruskin had set him up there 'that he may be close to Jones, and keep him in health and spirits'. This was in February, although the Fulham rate books show that no rates were paid on his house between 1868 and 1872. But in spite of the familiar mystery of his finances, Howell was certainly in Fulham. Burne-Jones no longer had to 'run up' to Brixton to see him. The dangerous confidant was close at hand.

In the light of this situation it is sad to read Allingham's account of a dinner party given by the Morrises at Queen Square to celebrate the publication of the *Earthly Paradise*.

> Wed, May 27 [1868]. To Queen Square . . . and find just alighting Mrs Ned in a gorgeous yellow gown: it is a full dress party! and I in a velveteen jacket. Morris, Ned J. (thin), D.G.R. (looking well), Boyce ('has been ill'), F.M. Brown (oldened), Webb, Howell, Mr Wilfrid Heeley, Publisher Ellis and W.A., Mrs Morris, Miss Burden, Mrs Ned (gay) . . .

Georgie's gaiety must be taken as evidence of courage, in every kind of domestic difficulty. Not long afterwards Alice Kipling arrived from Lahorre, in time for her second baby to be born at The Grange. Difficult Phil, and still more difficult Rudyard Kipling (now two years old) were sent to their grandparents at Bewdley. The new baby, a girl, was delivered on 11 June in Ned's study, Georgie standing by and rolling it up in a rug, while Ned 'went out for a walk'. Subsequently the unfailing firm produced an oaken cradle and a workman who for 2*s* 6*d* 'fixed the knobs', but these entries in his account book are not in Ned's handwriting.

As the year wore on Burne-Jones frequently escaped this domestic scene. He had, of course, to call in at the firm, where some of the old easy-goingness still prevailed; when the Prince of Wales opened the new wing at the Great Ormond Street Hospital, they all rushed to the window and hung out Ned's cartoon of Samuel, weighed down with ginger beer bottles. But he also attended large parties of 'the Greeks', and saw a good deal of Howell, Luke Ionides and Legros. Legros was painting his portrait for Constantine Ionides, and this head is a different Burne-Jones from any other likeness, sadder, more sensual, and uglier.

He had begun to try to break with Mary Zambaco, a process which he found painful beyond measure. 3 June 1868 Ruskin noted in his diary as 'a terrible day . . . poor Ned ill'. The pain projected itself in the painter's imagination through the myth of Phyllis and Demophoön. In this legend the Queen of Thrace begs her lover, the son of Theseus, to return, but he delays and she hangs herself, changing as she dies into an almond-tree. As he embraces the tree it puts out flowers and leaves. Ovid's second *Heroides* is an imaginary letter from Phyllis to Demophoön, threatening suicide.

Dic mihi quod feci? Nisi non sapienter amavi – 'Tell me what I have done, except to love unwisely?' This, in fact, was the epigraph which Burne-Jones a year later gave to his picture.

The heart of the Victorian concept of myth, painted by Rossetti and Burne-Jones, interpreted by Ruskin and Pater, is what Pater called the 'latent capability' of the story. Though the mid-nineteenth century was interested in higher criticism and comparative studies, these were felt not to be adequate; they led to the dusty, never-to-be-completed files of Dr Casaubon. The myth is only alive if it is the image of individual experience, and as Ruskin says, if we have 'the material in our own minds for an intelligent answering sympathy'. In this sense Burne-Jones felt the *'dic mihi quod feci?'* in the reproaches of Mary Zambaco. Phyllis had been one of Chaucer's Good Women, but he knew that Mary was not Chaucerian; her ordered image could only be found on the wilder shores of Greece and Rome.

On 24 January 1869, the painter J.W. Inchbold arrived at The Grange, 'without, it would seem, any definite invitation', as W.M. Rossetti put it. Seedy Inchbold, like Solomon but without his alcoholic unworldliness, was a perpetual charge on the Pre-Raphaelite circle. But he had chosen the wrong moment: the crisis at The Grange had reached breaking point.

Private

Poor old Ned's affairs have come to a smash altogether, and he and Topsy, after the most dreadful to-do started for Rome suddenly, leaving the Greek damsel beating up the quarters of all his friends for him, and howling like Cassandra. Georgie has stayed behind. I hear today, however, that Top and Ned got no further than Dover . . . She [M.Z.] provided herself with

laudanum for two at least, and insisted on their winding up matters in Lord Holland's Lane. Ned didn't see it, when she tried to drown herself in the water in front of Browning's house &c. – bobbies collaring Ned who was rolling with her on the stones to prevent it, and God knows what else.

Under the jauntiness of this letter to Madox Brown, Rossetti conceals, as he often does, a real distress. The tone of his letters to Howell – 'I have asked for the next news at once, as if it is bad I shall go and see him without delay' (a great concession) – and to Janey Morris, are in quite a different tone. 'Do let me know any news of Ned and his affairs . . . P.S. How is poor Mary Z?' he adds to Howell (25 January 1869).

The wretched scene began in Lord Holland's Lane (now Holland Walk), behind the Ionides' house at 1 Holland Park. There was heavy fog that night. They proceeded, presumably up Westbourne Grove towards Mary's house at the end of Porchester Terrace. But they stopped short at the bridge over the Regent's canal which marked the place where the two tow-paths met. It was notorious for suicides. Browning's house was 19 Warwick Crescent, immediately behind it, and since at this time he kept geese, which gave instant alarm, in his back garden, he may well have been the source of Rossetti's information. The arrival of the police meant a real struggle – indeed they were lucky to escape trouble, for the number of police charges for attempted suicides equalled those for street-trading in indecent Valentines in that cold January of 1869. There is no reason to think that Mary did not really mean to destroy herself, or that the image did not imprint itself on Burne-Jones's memory. 'I once saw a ghost,' he wrote to Olive Maxse in 1894, 'Georgie says it was Margaret's nurse, who used to walk in her sleep, who stood by my bed – but I think it was a real ghost, because it looked drowned, and the nurse would not look – [sic].'[3]

The attempt failed, Morris and Ned did not cross the Channel, but the crisis was not relieved. 'Forgive my reserve', Georgie wrote to Rosalind Howard, 'but I am obliged to show it in time of trouble or I should break down', adding in a P.S. 'Thus far I wrote this morning, but Edward is so much better than I am now able to tell you that he is at home again, having been too weak to face the journey.'[4] In answer to an anxious letter from Rosalind, she wrote again:

indeed, my dear, I am no heroine at all, and I know where I come short as well as anyone else does – I have simply acted all along from very simple little reasons, which God and my husband know better than anyone – I don't know what God thinks of them – Dearest Rosalind, be hard on no one in this matter, and exalt no one and may we all come well through it at last. I know one thing, and that is that there is love enough between Edward and me to last out a long life if it is given us.[5]

Of this letter one can only say that not many painters, and not many men, deserve such a wife.

But even Georgie could not stand the strain indefinitely, and for the time being she left home taking the children with her. 'Do not speak with Webb or anyone about me,' Ned wrote to George Howard, 'but say I am out of sorts and no more . . . I mean to go nowhere but shut myself up from everyone.'[6] He 'trembled', he said, 'at the sound of the bell', and he had written in the same sense to Howell and Rossetti.

Georgie's refuge, once again, was Oxford. She took lodgings at 18 Museum Terrace, and here she sat, after Phil was in bed, reading the books and imagining she was the undergraduate they belonged to. 'There are a great many hours in every day, I assure you,' she wrote to Rosalind, 'more than usual.'[7]

Ned's natural confidant was Morris, who had dropped everything to make the wild dash to Dover. 'Bare is back without brother behind.' But for Morris the writing of the *Earthly Paradise*, and even the worries of the firm, had been a distraction from the ambiguous situation in his home. Janey's illness was (like all illnesses) taken very seriously by Rossetti; that she understood this is shown by her 'presentiment' that if she were to 'feel myself well, all those I now call my friends would change, and would not be able to stand me'. His concern had grown into an obsession with her beauty, and in 1868 or 1869, into a positive physical need for her presence in the room. Before he had finished her *Portrait in a Blue Silk Dress* he began a study of her as La Pia of the *Purgatorio*, who died in her castle in the marshes, locked up by her husband; 'this is known to him', La Pia tells Dante, 'who wedded me with his jewel.'

Morris steadfastly continued to regard Rossetti, with some

justification, as a sick man. But Rossetti began to treat him with a jocular patronage, even in public, which made Burne-Jones, as soon as he emerged from The Grange, feel wretched. 'You don't know how lonely I am,' he wrote to Rossetti, '. . . if you gird at Top I grow impatient and feel cross – if it's before strangers I feel explosive and miserable and so on – '. This letter is signed 'your sick-at-heart Ned'.[8]

1869 is the year Georgie does not deal with at all in her *Memorials* – she indicates it only through the chapter heading (otherwise quite unexplained) from the Keats sonnet

Heart, thou and I art here, sad and alone!

What is far more difficult to describe is Morris's feeling, throughout these troubled months, for Georgie. She felt it better to destroy his letters. 'I turned to my archives, and find that the letters from your father that I have kept only begin in 1876,' she told May Morris.[9] Possibly she did not need to turn to her archives to know this, for in 1869 Morris felt a loyalty and sympathy for her, combined with a need to give and receive affection, which trembled on the brink of love. The withdrawal of his wife, the situation with Rossetti, made him not jealous but nostalgic, though it is possible for human beings to feel nostalgia for what they have never had. But his deeper tenderness was called out by his knowledge of what Georgie was suffering.

> Peevish and weak and fretful do I pray
> To thee greathearted, to thee wise and strong
> Who bearst the burden of thy grief and wrong
> The world perchance to mock and jest would turn
> My love to thee, and ask what I desire
> Or with the name of some unholy fire
> Would name the thing wherewith my heart doth yearn.

It is clear (as Mr Philip Henderson was the first to point out) that many of Morris's poems of 'the *Earthly Paradise* time' are to Georgie or about her.[10] In another incoherent sonnet he thanks her because she does not 'deem my service sin'. But sympathy in such a case was an awkward matter. 'We two are in the same box and need conceal

nothing,' he wrote in pencil at the end of one manuscript, 'don't cast me out – scold me but pardon me.' We are strongly directed by Mackail to look to the introductory sections of the *Earthly Paradise* for 'autobiography so delicate and outspoken that it must needs be left to speak for itself'. From the introductions to November, December and January, and still more from the fragment *Alone, Unhappy by the fire I sat*, where the woman checks his kiss with the word 'Brother!' it appears that Morris did make some kind of declaration, how decent and embarrassed can be judged from the transparent goodness of his character. 'Rhyme slayeth shame', as he put it, but shame remained in real life.

> . . . nor joy nor grief nor fear
> Silence my love; but those grey eyes and clear
> Truer than truth pierce through my weal and woe . . .

These are recognisably Georgie's eyes, and she dealt with the situation with the dignity of a true daughter of the manse.

'At the age of more than thirty years,' Morris wrote in his last unfinished romance, *Killian of the Closes*, 'men are more apt to desire what they have not than they that be younger or older.' Time, as he very well knew, would heal the relationship, and the 'frank and fathomless' grey eyes would not then be felt as a reproach.

> Be patient, heart, thy day they yet shall fill
> With utter rest – yea, now thy pain they bless,
> And feed thy last hope of the world's redress . . .

Morris 'late made wise', as he says himself, to his own feelings, wanted to give Georgie something – the best thing that he had. For her he wrote out and illuminated, in 1870, his *Lovers of Gudrun*; for her, too, he produced the beautiful manuscript *Book of Verse*,[11] bordered with green leaves. The frontispiece shows him in miniature, in his blue suit and blue blouse, and there is a note to the effect that the illustrations with the exception of page I, are not by Burne-Jones (although he designed them) but by Fairfax Murray.

Meanwhile Mary Zambaco did not accept the idea of parting from Ned, and her erratic behaviour and wild dashes through the fog and rain began to affect her health; this attracted increased

sympathy from Rossetti when he returned to London from Scalands in September 1869. 'I like her very much and am sure that her love is all to her,' he wrote to Janey Morris (5 March 1870). 'She is really extremely beautiful when one gets to study her face. I think she has got much more so within the last year with all her love and trouble.'[12] This letter also refers to an outing – Rossetti and Janey, Ned and Mary, Alecco and his 'flame' (Miss Zarifi, Mary's cousin); they were to go to Evans, the famous supper and singing club where ladies were only admitted to the gallery. Just at this time Professor Norton was regretting, in his dull kindly way, that though he saw Morris often Mr Morris was 'generally too delicate to be of the party'.

Although Burne-Jones had nothing to send to the 1869 winter exhibition at the O.W.S., 'Really he has nothing to show for the year scarcely', Georgie wrote to Rosalind Howard,[13] he was at work on the loveliest series of drawings he ever did. These are the studies of M.Z., which compare directly with Rossetti's dawings of Lizzie Siddal, or Whistler's etchings of Jo. But whereas Lizzie is most touching asleep in her chair, and so too is Jo in *Weary*, M.Z. gazes towards us or away with eyes brilliant with unshed tears. The drawing is not sensuous but precise and delicate, tracing the contrast between the cheek and the cloud of hair streaked with light. They are a lover's drawings, searching by instinct and through the exact pressure of the pencil for the secret of her unhappiness.

But Burne-Jones was not satisfied. He felt, as he was to do many years later in the case of his daughter, that this particular face must be recorded, like a talisman, by another hand. He wanted a picture of Mary by Rossetti. Rossetti was much occupied, preparing his poems for publication in April, but he did not refuse this urgent appeal from Ned. 'I think I have made a good portrait of Mary and Ned is greatly delighted with it', he told Janey. If it had ever been possible to take the affair lightly, he could not do so now. Ned's letter of thanks showed his feelings without reserve.

> I didn't bore you the other day, did I? It is hard not to behave quite badly – but all that portrait-making excited and exhilarated me and made me silly – I was so glad to have such a portrait, and for you to know her a little better – if ever so little – I thought you had little sympathy for me in the matter, before – and as I believed it to be all my future life this hurt me a bit. I can't say how the least kindness

from any of you to her goes to my heart. Before you send it home let me have a frame made that has a door in it that locks up, and that I may return an evasive answer to an inquisitive word. Keep well and strong. I feel as if I depended on you so much – nothing has happened since that I should say it – I may say it if I feel it – ever your affectionate Ned.[14]

The phrase 'as I believed it to be all my future life' shows that at one point Burne-Jones intended to throw in his lot with Mary, which would certainly have meant leaving the country, perhaps for the Greek Islands which he wanted to see all his life, but never saw. That was not an impossibility. In 1869 the Joneses had been among the first to call upon George Eliot and George Lewes when they came back from Germany, unmarried, but living together as man and wife.

The fact that Morris, Burne-Jones and Rossetti could live through these days and months and maintain such a convincing everyday life will only seem strange to those whose marriage has experienced no crisis. The expression of the 'manifest heart' was confided to their poetry and painting and it was almost a sign of desperation in Morris when he turned to a novel of contemporary life.[15] This novel, on fifty-three sheets of blue paper, remains unfinished among his papers at the British Museum, and once again Mackail tells us that it has 'many passages unmistakably drawn from his own experience'. This 'tale' introduces in the opening pages a jilted woman who walks through the rain 'with a feeling of being too late', and creeps, wet and tired, up to her bedroom. 'When I began to take off my clothes – dear, I can't tell you any more what I did, but it was very dreadful.' But the main story, set against the river meadows and farmsteads that Morris loved, concerns two brothers who grow up to be rivals for the same girl. They represent not Morris and Rossetti, as has been suggested, but the two sides of Morris himself. John is practical and doing, a good fisherman with difficulty in controlling his temper, Arthur is the dreamer. The heroine is a Methodist minister's daughter, with grey eyes.

Amidst apparent coldness they would be tender, O how tender with love, amid apparent patience they would burn with passion, amid apparent cheerfulness they would be dull and glassy with anguish. No lie or pretence could ever come near them, they were the index

of a love and greatness of heart that wielded the strong will in her and that serious brow which gave her the air of one who never made a mistake, an [sic] look which without the sanctification of the eyes might perhaps have given an expression of sourness and narrowness to her face.

If Morris does not mean Georgie it is hard to tell what he does mean, since the heroine, Clara, does not in fact suffer any anguish at all. Not surprisingly Morris could not finish his novel – his notes for the ending are on the lines of the *Heir of Redclyffe*, though they show that John will be defeated. He sent part of the manuscript to Georgie – so he told Louie Baldwin – 'to see if she could give me any hope. She gave me none, and I have never looked at it since.'

While Ned continued to draw Mary Zambaco and to bear her reproaches, the 'Duchess', quite undaunted, commissioned him to paint her as Dante's Beatrice. 'A woman in a red dress' is his laconic entry in his list of pictures. The portrait drew him even closer to Rossetti, the one most likely to understand, *poich'io no trovo chi mecco ragione*. But, as no one knew better than Rossetti, Beatrice only wore 'a crimson garment' when she was nine years old, and the Burne-Jones *Beatrice* in a red dress is not Beatrice at all, but Cavalcanti's mistress; in fact, the quotation on the frame is from Cavalcanti's *Ballate*, praising his lady above all others, including Beatrice herself. Beatrice herself at this period of Rossetti's life, meant only Jane Morris.

In 1870 Ned also finished the *Phyllis and Demophoön*. In the later version of 1882 the feeling, as well as the likeness to Mary Zambaco, is lost, but the original water-colour is a study in movement, counter-movement and restraint which he never managed again. The strong impulse comes from left to right as Phyllis, imprisoned against her will in the green sap of the tree, throws herself against the wind, and against the drifting blossoms, towards her lover. 'The head of Phyllis in the Demophoön picture is from the same' – he wrote in 1893,[16]

and would have done for a portrait . . . don't hate [her] – some things are beyond scolding – hurricanes and tempests and billows of the sea – it's no use blaming them . . . no, don't hate – unless by chance you think my workmanship is bad, it was a glorious head – and belonged to a remote past – only it didn't do in English

suburban surroundings – we are soaked in Puritanism and it will never be out of us and I hate it and it makes us the most cautious hypocritical race on earth . . .

To *Beatrice* and *Phyllis* Burne-Jones added an *Evening Star, Night,* and *Love Disguised as Reason,* half comically treated, with Georgie in doctor's gown admonishing her two sisters. The studio became full of work, which overflowed into the next room. All five pictures were sent to the O.W.S. summer exhibition, which opened in the April of 1870. Burne-Jones, to all appearances, had no suspicion that they would cause any trouble.

Most of the notices of the exhibition were as hostile to Burne-Jones as usual. The *Illustrated London News* had bought the rights of Carl Haag's *Bearded Bedouin Smoking* which, according to the reviewer, 'occupied the post of honour', and intended to publish it as an engraving; they compared Haag most favourably to Burne-Jones. This was in no way the fault of Carl Haag, a cosy, gin-drinking German Hofmaler who had been established for twenty years in St John's Wood. The *Illustrated* called Mr Jones's subjects morbid, emaciated, thick-lipped, loathsome were it not for their fantastic unreality, and appealing only to 'dilettante tastes, acquired or pretended to be acquired'. They also, quite unfairly, protested against his use of gum 'to reproduce the present appearance of old Venetian pictures'. *The Times* was even harder. Although their critic, Tom Taylor, didn't like Carl Haag either, and was scornful of the Smoking Bedouin, he was disturbed by the 'spread of mediaevalism'; he was glad, or said he was, that Mr E.B. Jones 'had a large circle of friends and admirers', but that *Phyllis and Demophoön* disgusted him. He could not deny the intensity of the expression of the pursuing nymph, but 'the idea of a love-chase, with a woman follower, is not pleasant'. The *Evening Star,* described by young Sidney Colvin in the *Pall Mall* as 'an embodied soul floating in the cool blue-glimmering twilight', seemed to Taylor a 'figure in light bottle green, grasping, not gracefully, a drapery of rather darker bottle green'.

Although Taylor felt uncomfortable at the deeply-realised subject of *Phyllis and Demophoön,* he made no objection to the nudity of the male figure, and the press were surprised when, as the *Graphic* put it (21 May 1870), the picture was 'unaccountably removed from the walls'. This was two weeks after the opening, and different accounts

of the matter show how confused it was from the start. The *Memorials* speak of an anonymous letter; the Dalziel brothers 'if we remember rightly', thought 'that some great lady had been very much shocked'; Walter Crane blamed 'the representations of influential members of the Society'; and Roget refers to it as 'an unfortunate difference . . . The Painter, it is said, declined to make some slight alteration in removable chalk'. This presumably meant blocking out the genitals. The matter rested on the decision of the President.

The President was still Fred Tayler, who only wanted to finish his last year of office without tiresome disturbances. He called on Ned and asked him to withdraw the picture; this was done at once. It was already sold to Leyland. Then, losing his head, and not liking the empty space on the wall, Tayler suggested that Ned should call on Carl Haag and choose a replacement from one of his ample store of Bedouins. This was a worse insult than the chalk, and Burne-Jones refused. The space was filled up with two small pictures, a *Study* by Willis and a *View of Frankfurt* by Callow, but the effect on Burne-Jones was decisive.

Why should he care so much? The hostility of the critics and of the O.W.S. itself was nothing new, and the campaign against nudity, led by the academician 'Clothes' Horsley, had been fought for years and was no longer taken very seriously. Millais was risking a life-size nude at the Academy (the *Knight Errant*) that very year. Burne-Jones was guilty of many weaknesses, but in defence of his art, never. The real ground of complaint against the picture was surely the poignant reference to a physical and emotional situation which a good many people knew about, and the fact that the half-naked Phyllis had the striking profile of Mary Zambaco. The Ionides, of course, great patrons that they were, were not so ignorant as to think the model for the face must be the model for the body, but the public could think so and did think so.

At some point during those deeply embarrassing weeks Howell was as he put it himself, 'struck'. His own account was that he tried, with ill success, to bring Mary and Georgie together, but there is no question that he interfered and that he caused grave injury.[17] All that can be safely said is that after 1870 he ceased to be Ruskin's secretary. He was never again received by the Ionides or at Little Holland House, and

neither Burne-Jones, who was tolerant, nor Georgie, who was scrupulously fair, could ever feel able to forgive him.

Ned wrote almost in despair to Rossetti to reproach him for the 'countenance' he gave Howell. 'I feel I could not endure a man who had hurt you one tenth part as much . . . it is just to say this much isn't it old man.' In a second letter he says he could overlook Howell's 'looseness in money matters' but 'here are your friends suffering possibly for life from him . . . and it is a great disaster we ever knew him or let others know him . . . when I think of this last I could bury my head in a bag.'[18] Although Rossetti wrote to William Michael that he intended to keep clear of Howell, 'Jones being so much the older and more valued friend of the two', he was beginning to find Howell useful as an agent, and this made him slow to respond.

Georgie stayed away a good deal through 1869, mainly with her family, but she began to feel the need of more counsel than her sisters could give. Morris could not be consulted, for, as he says in a letter to Aglaia Coronio, 'my intercourse with G. has been much interrupted, not from any coldness of hers, or violence of mine; but from so many untoward nothings.' She returned, as so many others did, to the wise friend she had made during the previous year, George Eliot, and formed the habit of calling not on the crowded 'Sundays', but at the quiet end of the day. In the July of 1870 she went with the children to Whitby, where the Leweses were taking seaside lodgings. They went down to the beach, the two women discussed *Faust*, and whatever George Eliot said, it was certainly of comfort. 'My heart smites me that I have somewhat resembled those friends who talk only of themselves to you,' Georgie wrote, '. . . the only atonement I can make is a resolve that what you have said to me in advice and warning shall not be lost.'

Ned, alone at The Grange, wrote affectionately to the children; he was at work on yet another commission from the 'Duchess' – the *Allegorical Portrait* of Mary Zambaco. This beautiful little picture might be related to Rossetti's *Mrs Morris in a Blue Silk Dress*. Mary is in sea-green silk, with a flower and an open book, as in Rossetti's design. The book is opened at a miniature of *Blind Love*, the first version of *Chant d'Amour*, so that the mysterious suspended emotion of the picture, *triste ou gai, tour à tour*, is identified for ever with Mary Zambaco. The flowers are iris and white dittany (passion). The

arrow on the table, which she neither touches nor looks at, transfixes a paper signed E.B.J. 1870. Mary's glance is exceedingly sad, and one of the owners of the picture, after the Cassavetti sale in 1965, was not able to live with it and turned its face to the wall.

Mary's portrait is dated 7 August 1870. At the end of July, when the O.W.S. exhibition closed, he had sent in his formal resignation to the Society. In a dignified letter he had referred to the antagonism which had met him from the beginning – 'therefore I accept your desertion of me this year merely as the result of so complete a want of sympathy between us in matters of Art, that it is useless for my name to be enrolled amongst yours any longer.' He offered the usual thanks and regret, 'but in so grave a matter as this I cannot allow any feeling except the necessity for absolute freedom in my work to move me.' The committee took the risk of asking him to reconsider, but he stood firm.

His decision was made, and he stood to lose a great deal. The Society's gallery was his only direct contact with the public. He had no dealers and no agents. Through the O.W.S. shows he had met his chief patrons, Graham and Leyland, and with Sidney Colvin just established on the *Pall Mall*, and Stephens on the *Athenaeum* he could just begin to count on some understanding notices. Now he would stand, as a painter, entirely alone. He knew, however, that he had the support of some of the profession.[19] The O.W.S. received a shock when Frederick Burton, returned from his summer tour, heard what had happened and resigned in sympathy. Burton had been an exhibitor since 1856, was learned in music and antiquities, altogether a man of standing. When, like Ned, he refused to reconsider his decision, the committee must have felt not relief but dismay.

There remained the important question of the approval of Ruskin.

Ruskin had never ceased to be in close sympathy with Burne-Jones, the only person, 'with the exception of two women, of whom I never see the only one I care for', who had shown him true understanding. In 1868 he had written from Venice to tell him that he was right, after all, about Carpaccio. In 1870 he had been abroad for three months and had missed the O.W.S. exhbition; in August he had written a benevolent birthday letter to Ned, sending him 'a little bit of eatable thing'. He was in seclusion, preparing the lectures on the *Elements of Sculpture* which, as Slade Professor, he would deliver at Oxford in the

Michaelmas Term. In September, however, he suddenly sent for Ned – there is no other word for it – to come to him at Denmark Hill and listen to what he had written: a paper on *The Relation between Michael Angelo and Tintoret*. Ned heard with growing distress a violent attack on Michaelangelo, whose *Sacra Famiglia*, as he knew, had first drawn Ruskin towards Italian art. Now Ruskin spoke of the painter's 'dark carnality', his poor draughtsmanship, fading colours, and the perverted imagination which substitutes 'the flesh of man for the spirit'. The lecture was intended as a serious piece of didactic art history, but Ruskin was a great Romantic and would never have denied that all his opinions were opinions of the heart. Ned could hardly doubt that the Professor had learned from some source or other – possibly from Howell – of the crisis in his marriage and had related it to the Michaelangelesque drawing of the naked Demophoön. It was a reproof to his life through his painting, and Ruskin, in his own way, seemed to have deserted him as surely as the Old Water-Colour Society. 'He read it to me just after he had written it, and as I went home I wanted to drown myself in the Surrey Canal or get drunk in a tavern – it didn't seem worth while to strive any more if he could think it and write it.'

Georgie had returned, with children, buckets and shrimping nets, to The Grange. She set herself determinedly to study organ music and to learn Latin with a refugee scholar, Andrieu. 'People don't really want to die of mental pain,' Morris wrote to his wife (2 October 1870), 'they want to see the play played out.' Burne-Jones, seeing himself disapproved of even where he was most loved, was entering upon what he himself was to call 'the desolate years'.

11
1870–6

THE DESOLATE YEARS

Burne-Jones, however, described these 'desolate years' to Rooke as the 'blissfullest years of work I ever had'. There was truth in both these remarks. Although he had vindicated his independence – a most important matter – he might well feel his resignation as a defeat in the attack on the world which Morris and he had launched together more than ten years ago on the quay at Le Havre. He had not justified himself either at Birmingham, where old Mr Jones, well satisfied with his son's progress so far, might now shake his head again. Gillott, the steel-pen maker ('the best of everything is good enough for me'), died in 1872, and his collection of 'safe' pictures was sold for £164,000; Ned's pictures were no longer safe. After a fair start as a painter, he had to go back into obscurity. He lost a number of patrons, and although Ionides did not desert him, it seems likely that Burne-Jones is meant when 'Ion' tells us that '[Mary] had several *affaires de coeur*; one of them was with an intimate friend of my father, who, disapproving, hurled some thunder right and left, and brought her back. But the friendship between the two men was never the same again.' In addition to this, Howell had damaged him a good deal financially; he was in an awkward position at home, where Georgie (as Rudyard Kipling described her) was never angry, but only sad; he had to fight against a feeling that as a painter he was a lonely and unwanted eccentric. And his genuinely modest nature, exposed to public comment and criticism, shrank away into itself so far that for the time being he found it impossible to meet new people.

On the other hand, Burne-Jones could not altogether regret what had happened. 'I have been a bad man and am sorry for it', he wrote to Olive Maxse, 'but not sorry enough to try to be a good one.'[1] In

the face of the official world of art he had maintained that hand should paint soul, even if the soul appeared as a naked body. Leyland and Graham did not desert him, his friendship with Morris survived the strain of 1869–70 and was stronger than ever. Moreover he had loyal assistants and a devoted family and he was able to develop, without regard to exhibition dates, his distinctive mature style which required slow, sophisticated and patient work. Lastly, it is hard to know whether one should describe as desolate or blissful the fact that he fell in love again.

His appearance on entering the next decade was faithfully recorded by Watts, who had finished the familiar portrait now in the National Portrait Gallery, and had sent it up from the Prinseps' house in Brighton in 1870. Georgie approved of it, so we must take it that the dreaming eyes and long faint beard (Watts thought this the hardest part of the portrait) are her idea of Ned. 'What a blessed thing is painting', he wrote to Watts, 'for now I have a red beard for ever.'[2] Georgie herself had been painted by her brother-in-law Poynter during one of her long visits away in 1869. In this delightful but uncharacteristic portrait, she holds an elegant china teacup and has her hair arranged 'in curly wise', to the dismay of the Howards, who had commissioned it.[3]

Georgie observed in the *Memorials* that 'Edward and Morris, having flagged together, took heart together at the same time'. The firm's production of stained glass, however, did not flag at all, and Burne-Jones designed among other things the magnificent *Corporal Mercies* and six other windows for Brighouse, although nothing is dated in his account book until 14 December. Cartoons he could manage even when he was 'dull and stupid'. As to the emotional situation, both Ned and Morris were beginning to find it intolerable, though their solutions were different. At the beginning of 1871 Morris had discovered his manor house at Kelmscott, but the lease was to be shared with Rossetti. It was agreed that country air would benefit Gabriel's health, and Janey did not appear to be disturbed at having to share the house with him while her husband was busy or away. In July Morris exploded into action, and set off, with Charlie Faulkner, on an expedition to Iceland. This enthusiasm for the 'barren land, populous with ravens' dismayed Burne-Jones. 'Mr Morris tried to persuade me not to like the south,' he told Rooke. But he himself began to pine for Italy.

The impulse to go south was partly the result of a present which the tactful Norton, puzzled by the quarrel with Ruskin, had sent before he left for America. This was a small panel from his own collection, which Ned had had cleaned by an expert he knew at the National Gallery, when it emerged as *Europa and the Bull*, a brown bull and a Europa in sumptuous orange pink. It is attributed now to Palma Vecchio, but to Norton and Ned it was a Giorgione, and as Graham Robertson said, Giorgione was a painter and must have painted something, so why not this *Europa*? In a letter of thanks which is at times alarmingly whimsical – this being one of the defences he was beginning to put up against deep feeling – Ned begged Norton for more photographs and engravings. Mantegnas he wanted if possible, 'nakeds by Leonardo and M. Angelo and Raphael', and 'if Ghirlandajo draws sweet girls running, and their dresses blown about, O please let me not lose one'.

His account book entry for 24 October 1870, '9/- to Wilday [one of the firm's workmen] to Mrs Zambaco', must have been a studio errand, and Mary was still sitting for him; indeed the profile drawing for the second version of the *Hesperides*, which he began this year, is one of the most delicate he ever did. The stories he associated with her were still expectation, disappointment and anguish. He drew her as Cassandra and painted her as Ariadne (both these were for the 'Duchess'). Even the Hesperides, in Morris's *Earthly Paradise* version, are left silent, 'craving kindness, hope, or loving care' when the golden apples are stolen. *Summer*, part of Leyland's set of the *Four Seasons* and described by Malcolm Bell as 'a graceful figure, in a thin white semi-transparent robe', is also Mary; for this likeness of her Morris wrote the couplet.

> Dearest, take it not amiss
> Though I weary thee with bliss.

The naked *Venus Epithalamia*, bought by Marie Spartali (now Mrs Stillman), again has Mary's sad face.

Work continued to be what Morris called it, the faithful daily companion, during the long drawn-out tormenting end of the relationship. Ned had to contend, also, with vexatious 'Howell matters' which continued to come to light for another twenty years. There were pictures which Howell apparently made away with,[4] red

chalk heads copied by Fairfax Murray which he sold as originals,[5] and actual forgeries made by Howell's mistress, Rosa Corder.[6] Howell also tried to extract money out of Luke Ionides by selling him drawings which Burne-Jones had intended as a present, 'and the result was', says Luke in his *Memories*, 'that we did not see Howell any more.' Partly because of these manoeuvres, partly because of the loss of patrons, the Joneses found it hard to manage in 1870–1, although the firm for the first time paid a dividend of £25. But there was in any case much less entertaining at The Grange.

Meanwhile, although he refused to weaken or to change his methods, Burne-Jones was attacked by the occupational disease of the lonely artist, a fear that he was losing grip. On 14 August 1871 he noted that the first three windows for Meole Brace 'cost £40 but were not worth 40d. I have never produced work of such marked inferiority ... let us say no more about it.' But only a few weeks later he was able to make a half-ironical entry. 'St Hugh, St Peter, St George, £36, slight and hurried in handling I admit – but there is my old vigour of design and massive treatment of drapery – now I am off to Italy with the money I have so honourably earned.'

The decision seemed to Georgie very sudden. 'He hardly mentioned it, so as to go without fuss,' she wrote to Rosalind Howard on 27 September. Many English painters, professional and amateur, took the trip as a matter of course and would be there already. Spencer Stanhope was at Bellosguardo, Burton in Rome, Ned's old enemies of the O.W.S. had set up their autumn camp-stools at Vallombrosa. There was an element of recreation in all this, but Burne-Jones did not want recreation, still less did he care about picturesque detail. He was not even travelling, as Morris admitted that *he* was, to escape his 'horrors'. Knowing himself, as he always did, to be a small master, a 'fourth-rate Florentine painter' as he put it, 'in a large commercial city', he wanted confirmation from what was strong, grave, and secret in quattrocento painting. On 16 September he wrote to Murray that he had not slept for four or five nights, and had been told by the doctor that he positively needed a change. Georgie took the children to the Baldwins, Rooke remained in charge of the studio, and Ned set out, after nine years' absence, for Italy.

Travel in Italy was a good deal easier than it had been in 1862. The railway system had been extended, and there was a more or less

uniform currency. But a papal nuncio's visa was needed for Rome as well as a papal police visa to leave it, and not only Baedeker, but all guide books, regarded the Italians as a necessary evil, 'conspiring to embitter the traveller's enjoyment of their delightful country'. Italian hoteliers withheld the bill till the last moment, when 'hurry and confusion render overcharges less liable to discovery'. Water had to be boiled or mixed with wine, flannel must be worn after sunset to avoid 'Ravenna fever' and malaria (from which Ned had suffered in Venice), books were still examined at customs and tiresome religious festivals interfered with the serious business of sightseeing. It is amazing that Burne-Jones, apparently so helpless a traveller, sick in trains, muddled about money, could have managed at all, particularly in view of the rigorous timetable he set himself. Eight weeks was usually recommended for the tour he wanted to make in three. But the spirit was stronger then the flesh.

Burne-Jones recorded his journey in a shilling notebook,[7] on the inner cover of which he wrote:

> Note. Please not to read the writing in this book – the notes are made for myself only – to help a weak memory – they will not amuse, and would have been written in Chinese, if I had known that tongue.

This alone shows how painful had been the exposure of his inner feelings to public criticism.

He went straight through France by rail and reached Turin on 21 September; the first sketch in the notebook is of the Botticelli *Tobit* and the *Triumph of Chastity*. 'These 2 and the Mantegna I cared for alone.' The same evening he was drawing the harbour steps in Genoa and the peculiar way the sails were furled, and making notes – as he did throughout the trip of dark sootoporticos, narrow lighted openings and 'mounting streets'.

Next he took the coast road by *diligenza* ('the company is usually far from select and the carriage uncomfortable') though Sestri Levante and La Spezia to Pisa; he scribbled down notes on mountains and olive groves. The journey apparently took from 5.00 a.m. to 5.00 in the afternoon, but Burne-Jones recorded it as a 'great day'. The 24th was Sunday; he 'did' the Campo Santo in the morning,

rushing on to Florence at noon. Professor Norton, whom he had hoped to meet, was not there, but he was just in time to see the Duomo by daylight, and was so excited that he 'walked about till night'. He allowed two days for the Uffizi, Santa Croce and Fiesole, a morning at San Gimignano where he drew several pages of towers and secret blank stone houses, then, without stopping at Siena, to Orvieto by midnight on the 27th. This was too late for the cathedral, but after a night at an inn he went in the morning and evening to see Signorelli's *The Damned Cast into Hell*. On Friday the 29th he was at Viterbo, but the rush and excitement had affected him oddly and between Fiacone and Viterbo he had a dream, which he was able to put down in the notebook, of the Nine Muses facing the rising sun. He just stopped long enough in Viterbo to see the Signorelli, and 'to Rome by 9 in one evening'.

In Rome, which Burne-Jones was visiting for the first time, a *permesso*, with a recommendation from the appropriate consul, was necessary to copy pictures at the Vatican. Ned ignored this. Although Rome did not live up to his dreams he wrote to Rooke that he no longer felt depressed and in fact was in better health than for three or four years. St Peter's was 'pompous and empty' and he apparently missed the Pietà, but the Pantheon was 'glorious', and in the crowded streets 'no men and women on earth look out of their eyes as they [the Romans] do'.

Monday was troublesome because places were closed and 'a silly fiesta was going on . . . much trouble to see the Sistine'. At 2.00 p.m. the tiresome festivities were over and he rushed in, folded up his travelling rug, lay down on it and read the frescoes through an opera glass. He noted that gold had been used 'a very little to heighten the lights on the lower pictures to counterbalance the ceiling'. Ruskin had been wrong about the deterioration of the Michaelangelos. 'The Sleeping Adam, the Last Judgment, the Botticellis and the 2 Signorellis [*Publication of the Law* and *Death of Moses*] as beautiful as anything in the world' produced a kind of intoxication in which he forgot the embarrassment of lying down on the floor in the middle of a crowd of strangers. In the Vatican he memorised the early Raphaels and the da Vinci monochrome of St Jerome. It is hard to explain why, on the next page, he drew a 'naked man weighing a fat cat on a pair of scales', said to have been seen in a side chapel.

The next stop was a turn northwards to Assisi, which he also saw for the first time. Here he studied intensely, recording the town by heart and setting himself down with his notebook at the street ends, 'all dark except a thin space of sky', or 'windows letting a white light into dark archway'. The Giottos he found 'much hurt by smoke', the *Three Angels and Abraham* gave him 'quite a new idea of Cimabue'. On 3 October the streets were filled with white bulls driven in from the country – it was the vigil of St Francis, though Ned does not mention this – and the picture-crazed visitor took time off to draw them and a litter of his favourite pigs. The next day he was off again by the despised *diligenze* to Perugia, where his hotel window looked out on a street with pots of herbs on every balcony. Here he made notes on a Signorelli musical angel at S. Onofrio –

'the left leg hidden by altar rubbish'. Then there were 'the noble Peruginos – *Solomon* and *The Sybils* but the strangest & most imaginative of all pictures here is one small predella subject by Piero della Francesca of the vision of St. Francis – the monk usually made asleep is here awake & his face is drawn with wonderful tenderness. The colour is dark & seems to resemble night & the gloom of trees & rocks beautifully painted.'

Now he could not wait for Arezzo.

He left Assisi at 11.00 a.m. and the *diligenza* brought him to Perugia by 3.00 in the afternoon on 5 October. People were 'thin and poor, very like Perugino saints, thin-nosed and lipped'. After hastily copying a Signorelli *predella* he rushed out along the carriage-road to the Etruscan sepulchres, where he went down '40 or 50 steps' and made his first studies of a subject which interested him exceedingly – the Medusa's head. There were seveal of these heads on the sarcophagi, protecting the dead against violation of privacy and hated intrusion, and on the coffered ceiling there was the famous Gorgon.

He was much excited on the train to Cortona, and drew the walls following the contours of the enfolding hills, then found the place squalid – 'every other city built on a hill looks more like the name Cortona', but not so the Signorellis 'for which, after all, one came'. Trasimene, to his relief, was not blue, like Lake Como, but 'the right colour of water'. Then at Arezzo he managed a double-page sketch

of Piero's *Victory of Constantine*, showing much more of the river scenery left in the background than there is now; 'flesh colours, white girdles, & olive green & faint blue sky making the tone of his picture', he wrote; here as so often, Burne-Jones was a pioneer of appreciation.

It was time to go back to Florence. *Conservatori* now became tiresome and there are notes 'not allowed to draw it' and 'not allowed to enter the grotto'. A heroic sightseeing Birmingham spirit took hold of him and he rushed round Michelangelo's house (which had been open to the public only since 1858) peering at the great man's slippers and walking-sticks. Since he could not get a print of the *Captives*, most emphatically an example of 'dark carnality', he made careful drawings himself. The next stage, after a few quiet hours at Sta Maria Novella and in the green cloister, was Genoa, and here, among pages of orange and olive trees, hill towns and studies of drapery Ned suddenly drew a baby sitting in the middle of a *piazza*, 'the central and solitary figure'. He was homesick for Margaret.

As he left Italy he summed up: 'I now care most for Michaelangelo, Luca Signorelli, Mantegna, Giotto, Botticelli, Andrea del Sarto, Paolo Uccello, and Piero della Francesca.' This was his mature judgement and he did not change it, but he had seen almost as much outside as inside the galleries and churches.

The last dash was along the coast road through Mentone to Paris. Here the frivolous population were absorbed in the sale of Empress Eugénie's underwear, while the authorities were mounting trials of *communards* and *pétroleuses*. Although Ned had been tormented with nightmares over the siege of Paris, he now ignored everything but the Louvre, and, in the Louvre, the Mantegna allegories. Difficulties were great. Because of the still unsettled conditions, copying was forbidden, and there were now French attendants to deal with. 'I had to steal this note hastily.' The 'notes' included the *Triumph of Virtue*, Vulcan and his streaming cloak from the *Parnassus*, the Venus and the circle of dancing girls, whose hair, as Rossetti said, seems to be felt brushing across the face as each one passes. With admirable persistence Ned 'stole the lovely hair-ribbons of the dancing muse'. He also 'snatched' the olive-crowned faun supporting a dying woman in de Costa's *Myth of Comus*, and a 'leg of Mantegna's Mercury, blue-tipped with gold both shoe and feather'. Though Burne-Jones's taste was entirely his own, he was,

as a travelling artist, worthy after all of Baedeker, who treated every visit to a foreign country as a campaign where victory must never be conceded to the natives.

The book ends with a row of little houses, each with its chimney, backing on the railway – 'London' – and above his list of shops and photographers a pair of eyes squinting terribly – the sign of a lunatic sightseer. Yet Burne-Jones felt 'full of the inspiration I went to look for'. It was the most important journey he ever made. He arrived at The Grange with photographs from Cuccioni, an 'odious smile', as he admitted, of superiority at the sight of London fog, and some Italian tastes, for he immediately ordered oil flasks from the firm.

But Morris had been home from Iceland since the beginning of September, and Ned found himself once again in the middle of 'unspoken miseries'. On 20 October (he got back on the 16th) he was at a dinner party at Queen Square to hear Morris read aloud his new poem, the 'marriage interlude' *Love is Enough*. Neither Rossetti nor Janey were there. According to Bell Scott, Rossetti's engagement 'was, actually, Janey at his own house for the night. Is it not too daring, and altogether inexplicable?'[8]

Although Scott fell asleep during the reading, he was a shrewd observer enough. His letters, as Professor Fredeman has pointed out, show only too clearly how odd the situation appeared to an outsider. But Ned wrote confidently to Norton that Morris's poem was 'wondrously happy', while 'as for Gabriel I have seen him but little, for he . . . gets ill and is better and is restless, and wants and wants, and I can't amuse him'.

Ned also told Norton that he had sixty pictures, oil and water-colour, on hand, and that in the new confidence that Italy inspired, he no longer cared what the public would think of them. The two studios, in fact, were full of unfinished work, in charge of the faithful Rooke. 'His studio was a mass of slightly poised objects', Rooke recalled, 'with but a narrow path between them that he never knocked against them [*sic*]. It was a means of triumph for his subtle nature.'[9] One of these objects was the solid wooden model of Troy Town which is still in existence. It had been constructed to help with another huge undertaking which stood gathering dust in the studio and which eventually, Rooke said, became 'just the size of the room in which it was done, and had to

be built up like a ship in a bottle'. This was the dreaded Troy Triptych, really a work of piety, since it was based on the *Scenes from the Fall of Troy* which Morris planned to write in 1857, but which had been put aside when the Red House was sold. From the never-to-be-finished main canvas Burne-Jones took several designs, including the *Wheel of Fortune*. For the naked male figures he used, in defiance of Ruskin, the studies he had made of the Michelangelo *Captives*. But Fortune, with eyes shut like the Blind Love of *Chant d'Amour*, seems almost too indifferent to turn the huge queerly-drawn wheel which cuts the canvas vertically in two. She is twice the height of her victims (an effect which he may have studied from Watts), and this is only one source of the discomfort caused by this strange picture.

The water-colour version of the *Wheel* (1872–86) took years to complete, and this became characteristic of Burne-Jones as he reached his mature style. He grew used to working alone or with assistants who transferred his designs from brown paper cartoons to the canvas and filled in with monochrome ready for the next stage. He drew numbers of preliminary studies, left weeks for the drying between each stage, started again rather than correct. Often the canvases were put aside and he allowed the subject to grow in his mind, perhaps for years, consulting no one. The scrupulousness of the painter was only matched by the patience of his paying customers.

The colours grew stranger. To Graham Robertson the system seemed like a child 'filling in' from a paint-box, yet he could not deny its power. 'Shot' colours appear, like those of Mantegna's *Allegory*, blue shaded with brown and green with orange. Burne-Jones, Watts explained to Frances Balfour, gave each tone a gemlike texture, 'so that if you examine into it, you find it composed of a vast number of pieces of colour skilfully blended, and each lovely in itself.' The canvases themselves grew much larger, often very tall or 'the lengthwise sort', although Ned knew perfectly well that these were difficult to sell, having done his best to persuade Graham to accept Rossetti's vast *Dante's Dream*.[10] The much greater size of the picture asks the spectator to leave his own world and enter the painter's. It is a dream world, without perspective in depth, but with flat planes of colour; it is a realm of knowledge as well as feeling, or rather the deeply-read Burne-

Jones does not distinguish between the two. Even more since his study of the *Hypnerotomachia*, he had felt the insidious charm of the neo-platonic reading of the myth. 'And say this is really the hidden and religious meaning of the flaying of Marsyas in old stories', he wrote, 'who was a thick-skinned person whom nothing could teach until the merciful healing Apollo removed his outer hide and then he saw things keenly and clearly.'[11] Of the gravely posed figures in his distinctive world one might say, as Ned's diary said about the Romans, that 'no man or woman on earth look out of their eyes as they do'. This is the characteristic Burne-Jones glance, looking either away or inwards; but which? And are they contented or uneasy, and, for the matter of that, are they women or men? Some light is thrown on this by Burne-Jones's remark that he had no use for genius which did not include its own femininity within it.

One subject he took directly from the *Hypnerotomachia* – *Love Among the Ruins* (1870–3), where the lover and his Polia sit among fallen pillars and stones with mysterious inscriptions, hemmed in by the briar rose which rambles over all, and searching for the way to Cythara where in the end they will find nothing but separation. Like *Fair Rosamund* and *Laus Veneris*, it is the answer to the title of an earlier poem, in this case of Browning who ends his *Love Among the Ruins* with a reassuring 'Love is best'. The picture is difficult to judge because it only exists in a large, hard-faced, later version. 'It's better painted,' a friend said to him about this replica, 'but the spirit of youth which was in the other, is not there,' and Burne-Jones agreed. This friend, Stopford Brooke, also noticed how 'onlooking and pursuing' the artist was in the early seventies, and yet 'somewhat more weighted by life' than he was ten years later.

The second version of the *Hesperides* was finished between 1870 and 1873, in some of the richest reds possible in water-colour. It has a strong centrifugal design, as though the dancers were unwillingly bound to their magic tree. Burne-Jones had a passion for dancing, not only for the dancers in Mantegna and Botticelli but for the art of the music-hall. For him, then and for many years to come, the 'Miriam Ariadne Salome' of the halls was Katie Vaughan (real name Catherine Candelon), a true cockney, child of a theatre musician, 'brought out' with her sister in 1872. Katie later became

celebrated in burlesque at the Gaiety, but when Ned went with Luke Ionides to the Adelphi and Drury Lane the high point of her act was the graceful daring gyration of her 'skirt dance'. (Katie, however, to quote her obituary in *The Stage*, 'had always been accustomed to the manners of good society, which in itself is a liberal education.')

Some of the many studies which Ned made of dancers were for a picture which took him twelve years to finish, a work as magical as *Green Summer* and the one by which he might like most of all to be judged. Constantine Ionides commissioned *The Mill* (1870–82) and it is still hung (in a very poor light) among his bequests to the Victoria and Albert. In the foreground are the Three Graces who, as we know from *Ion*, are Marie Spartali (in profile on the right), Mary Zambaco and Aglaia Coronio. The clasped hands are those of the giving and receiving Graces, and they dance, not in a vortex like the *Hesperides*, but in a secret trance, to the music of love on the right. The expression of the women's faces is intense, and the picture, as *The Times* pointed out when it was shown in 1882, 'reflects its truth only from certain mental states', lit by the deep and powerful sunset glow that comes just before dark. Behind them is the gleaming mill pool, perhaps – as *Ion* suggests – a recollection of the mill race under Gothic arches at Alberga, perhaps of the three mills near Oxford within a mile of each other – Milton, Steventon and Sutton Courtney. The naked men bathing in a pool (worrying to Henry James, omitted by the Royal School of Art Needlework in their tapestry version) are in the second plane. Trees shadow the water. At the back are the undershot wheels and the miller's men moving in flat punts with sacks of grain and going up the just-seen steps into the dark interior. Distant though it is, the mill gives its title to the picture, and the 'burden' arises from the harmony between work, recreation and music – a harmony produced by the mysterious twilight influence of the mill.

For the first time in this picture Burne-Jones made a deliberate reference, to be understood by 'the few people I care for', to his Italian masters, to the *Primavera* and to the bathing figures in the Piero *Baptism*. But the mill itself directs us to Ruskin's dreams of the Society of St George, a settlement where wind and water would be the only motive power, steam being 'a furious waste of fuel

to do what every steam and breeze are ready to do costlessly . . . gun-powder and steam hammers are today the toys of the insane and the paralytic'. The mill is a place of peace where even the pool is at rest, flowing out downstream imperceptibly while the dance goes on.

While Burne-Jones sank himself in the long process of finishing these canvases, Whistler was propping up dozens of *Nocturnes* to dry, for any passer-by to see, outside his house at Cheyne Walk, and Pissarro with a group of friends had fled the disturbances of Paris to settle in Norwood, where they were producing delicious impressions of the dreary suburb in rain and snow. All these artists defied the salons, all ignored the others almost completely, with the necessary blindness of painters truly at work.

Burne-Jones of course, had returned from Italy short of money. 'My affairs', he told Fairfax Murray (26 December 1871), 'are in their accustomed muddle,'[12] and he had to ask for some drawings of Fortune which he had 'lent or given' to the acquisitive Murray, so that he could sell them. To Ellis, who had commissioned three figures of Faith, Hope and Temperance, he wrote that he would have to charge for the frames, 'they are not costly. "Evidently not to you," you reply,' he adds disarmingly.

At his back there was always Georgie, 'Georgie is tremendous and stirs up the house into a froth every morning with energy,' Ned wrote to George Howard.[13] She saw to it that he could go straight to the painting room after breakfast, taking his second cup of coffee with him, and struggled to regulate matters for a man whose clothes were shapeless and whose habits, except in regard to his precious tools of work, were hopelessly untidy. It must have been a great relief to her that Howell, in mysterious circumstances, had moved to a house much farther away in Fulham.[14] Georgie, however, could not manage the growing problem of Phil by herself. His grandmother, old Mrs Macdonald, had divined the 'growing power of worry' in the nine-year-old boy. Ned was still drawing from Mary Zambaco, and it was hardly possible that the child could go on much longer without noticing anything. 'How we came to decide finally upon sending him from home to school does not matter', is the way the *Memorials* put it, and Phil's fate was sealed. Worse still, they decided to send this firstborn son, whom they

tenderly loved, to Marlborough, simply because Morris had been there, although he had disliked the place and had learned next to nothing there, 'for indeed', as he recalled, 'next to nothing was taught.' Appealed to, Morris dashed off a letter to Charlie Faulkner at Oxford: 'If you are not dead and buried, I wish to ask you a question . . . Ned is thinking about Marlborough as a school for Phil and wants to know what reputation the school has at present; of course one means principally what sort of chaps they send up to University.'[15] *Why* did one mean this principally? Certainly the headmaster was now Dr (later Dean) Farrar, who had modified the earlier toughness, but nothing would make Phil, now or ever, a suitable subject for public school. But the parents seemed unable to stop themselves. 'Don't send little Stan to school, Louie,' Ned wrote to Mrs Baldwin, 'it's much worse than you would think, and I don't feel sure at all of the compensating good.' Stanley Baldwin was sent to Harrow.

And yet in their treatment of Phil's cousin Rudyard, Uncle Ned and Aunt Georgie could never make a mistake. In *Something of Myself* Kipling left a most touching memorial to both of them, a child's eye view of The Grange as a Christmas refuge from the 'House of Desolation' – the unpleasant lodgings in Southsea to which his parents had unwisely entrusted him when they went back to India. The Grange was a place of wonderful smells of paint and turpentine, where the Beloved Aunt played the organ and the Uncle continued drawing among the children's riots, or hid under a rug to become the 'fitful head', an oracle which answered all questions in a voice 'deeper than all the boots in the world'. Cartoons in charcoal stood about with only their eyes painted in white, a magical effect to Ruddie; his uncle took him to the South Kensington Museum, and gave him *Sidonia* and the *Arabian Nights*. Morris read poetry aloud, sitting astride the creaking rocking-horse in the nursery, while his cousins played with him – indeed only Browning, among all the visitors, declined to do this. After the death of his uncle, Kipling 'begged for and was given' the iron bell-pull of The Grange for his own house in the hope that other children might also feel happy when they rang it.

The six-year-old Ruddie certainly did not guess at the emotional pressures in The Grange. But in the crowded first-floor studio Burne-Jones was at work on another group of pictures, whose theme

recurred throughout his life from some deep source of turbulence. The first *Sleeping Beauty* or *Briar Rose* set, the *Girls with Lanterns* setting out in a boat for the other shore, the second *Mirror of Venus* and 'a procession of girls coming downstairs' are all reflections of the same subject, the confrontation of the young girl with time, experience, change and sex. The young girl, in the early 1870s, was Frances Graham.

Why does the rose have to open, what is the turn of the screw, why does Alice have to realise that they're nothing but a pack of cards? These questions, which the Victorians posed again and again, come from the wry middle-aged onlooker or admirer or both. Burne-Jones, unlike Charles Dodgson or Henry James, was an artist with the normal experience of a man of forty, and from this normality he saw the terrible falling short between expectation and reality. 'There are so many deaths', he told Frances, 'besides the pale face which looks in at the door one day.' But, of course, warning, experience and love are all ignored by the young life starting out. It was at this time that he began to sign his letters with a drawing of a decrepit old man: 'your Ancient Ned', the familiar figure with crumpled trousers, paintbrush in hand.

Frances was the younger daughter of Ned's patron, William Graham, the India merchant and Liberal M.P. for Glasgow. She was the fourth of eight children, brought up in a wealthy home where 'money was not much considered', but with a strong Presbyterian background. She could remember plain high teas at which her father read aloud from the Bible. But Graham's religious convictions, as strong as old Mrs Ruskin's though much more kindly, combined strangely with a passion for beautiful objects and pictures. He collected beyond reason: canvases lay in heaps on the floor. He was an early connoisseur of ikons and Italian primitives, and his flair was so well-known that Gladstone made him a trustee of the National Gallery. With contemporary painters, his 'own' kind of painter, he had a close, almost physical sympathy and was ready with delicate advice and help.

Graham was at first alone in his enthusiasm – nudes had to be smuggled into the house to avoid distressing his wife – but as soon as his daughters were old enough he began to take them on Sunday afternoon visits to the studios.

Frances felt that she did not take after her father, being one of the

'mid-ones' of the family, but she had his very wide-apart changeling's eyes – 'ghost eyes', Margot Asquith called them – with a disturbing fairness of her own. At first the girls felt it very dull when Graham stopped taking them to Cheyne Walk where the 'romantically widowed' Rossetti read aloud to them from *The House of Life*, and began calling instead at The Grange. But Frances soon divined that there was another loneliness there, gentler and harder to reach. Out of it began a friendship which, as she said, 'coloured my whole life', and Graham, who also sensed it, began to ask Burne-Jones to dinner regularly twice a week. In her reminiscences, *Time Remembered*, she describes Burne-Jones as 'about forty, and living a quiet life'. And (although in Swinburne's line 'time remembered is grief forgotten') she adds: 'he was not very happy.'

Frances knew Burne-Jones for nearly thirty years, and when Georgie's *Memorials* appeared in 1904 she was struck by their excellence, but also by how much they left out. 'Long familiarity and loving comradeship, although they tell the truest stories, may not tell all the life of men who dream. It needs another dreamer to do that . . . But failing that book of dreams, those with eyes to see may read much in his pictures, and the rest of the story in that admirable biography.'

With some difficulty, Ned found a present fit for Frances – a copy of Fitzgerald's *Rubaiyat*, illuminated by Morris with gold initials and floral margins and illustrated by himself with six miniatures, each in a different predominant colour. Morris, who had presented the first copy he did to Georgie, intended the second to be for Ned. But Ned could not resist giving the exquisite 'painted book' to Frances. He also, of course, began to draw her. Her profile appears first as the young bride in the *King's Wedding* (1870) where Mary Zambaco is one of the ring of dancers.

1872 was the year of what were almost his last studies of Mary Zambaco. Although he had written in apparent despair about the Faith, Hope and Temperance commission, suggesting that Ellis might like Drink and Polygamy instead, he produced three beautiful figures, the Temperance, obstinately six inches shorter than the others, being 'the best I think – it will only be in the faintest tones I can get, and will take time to finish.'[16] As Temperance, Mary pours water, with a fine sweeping gesture, on to the last fires of love, and Burne-Jones uses, for almost the first time, the elaborately folded

and wrinkled draperies which he now drew easily and which seem to have a life of their own, independent of the body underneath them. Mary's eyes are downcast in this version of her, hiding their light.

Her health had continued to suffer, and in October 1872 Morris wrote to Aglaia Coronio, 'I suppose you will have heard before this reaches you about Mary's illness and how ill she has been, though I hope it all will come right now. I did see Ned for a fortnight and Georgie scarcely more; it was a dismal time for all of us . . . [Ned] has not been well at all, sad dog! apart from other matters.' It is possible that this was one of the nervous and mental breakdowns which recurred at intervals throughout Mary's life. On recovery she made up her mind to try her luck again in Paris, though not with her husband; the 'Duchess', left in charge of her little boy and girl, at once began negotiating with Watts for a portrait, but the uninhibited Greek children were the terror of the studio (Whistler had been quite worn out by little Ossie Coronio) and we find Watts excusing himself – little Demetrius was so tiresome that the painter became ill.[17] Mary, meanwhile, was going, but her image remained, and connoisseurs of that haunting irregular profile will find it in unexpected places – on any of the firm's 'Luna' tiles, or in Burford parish church, where she is in one of the west windows.

Of the Three Graces, only Mrs Coronio was now left, for Marie Spartali was, for the time being, leaving London. Of all the Greeks, Ned had acknowledged her as the most beautiful, 'and so constant of heart am I', he wrote twenty years later, 'that I think so still – she is a Greek and is married to a husband – women often are – I never know why.'[18] Indeed most of her friends, and all her family, were amazed at her marriage to the American, W.S. Stillman. He, however, had a romantic story of his own, having emerged from a Seventh-Day Baptist childhood and a journalist's career as a battered, forty-year-old widower, whose first wife had committed suicide during the horror of the Cretan insurrection of 1866. Marie loved him, and was totally resistant to the idea of marrying into another Greek business house. The myth to which Burne-Jones related her was Danae, quietly watching the building of the brazen tower which will not restrain her. He painted a small panel of this in 1870, and made the allusion even clearer in the later version (1888) which is said to be the best likeness of all of Marie Stillman.

The year 1872 opened and continued with losses of friends and to friends, a grief which Ned and Georgie shared together. In February, Norton, who was travelling in Germany, lost his young wife in childbirth. On 18 March Aunt Catherwood died, at the age of seventy-two. She was buried in the plot in Brompton cemetery, in the same grave as Christopher, with the inscription 'childless, but beloved'. Before her death she had moved from Addison Place to 93 Camberwell Road, and it was here that Ned and Georgie went to hear the will read by candlelight. Apart from the legacies to friends and servants and £500 to old Mr Jones, everything (about £3,000) was left to Ned. He had remained for her the schoolboy nephew whose visits she had so much looked forward to.

The worst blow of all was the breakdown, physical and mental, of Rossetti. Gabriel's increasing fits of gloom had not deeply worried Ned, who was so liable to them himself; but if he had been with Gabriel that summer he would have been able to warn the doctor in charge that 8 June was a dangerous date in the calendar – the eve of the death of Beatrice. On that night Rossetti took a nearly fatal dose of chloral. Although he recovered, delusions of horror and persecution increased. It could not be denied that, in William Michael's words, he 'was not entirely sane'. He was brought back to London, where both Ned and Morris offered to look after him, though as Janey wrote to Bell Scott, 'my opinion is that he would not care to have my husband'.[19] Finally Madox Brown stoutly offered to take him back to Fitzroy Square.

Burne-Jones felt that the very ground had been cut away beneath his feet. Rossetti was not only his glorious first teacher and generous supporter, but the poet who had understood his love for Mary Zambaco. But the link with the past to which he desperately appealed was exactly what was most disagreeable to Rossetti. The one face Gabriel did not care to look on was Might-Have-Been. He left with his attendants for Pitlochry, where Graham had offered him the use of one of his Scottish houses, and in September he went down to Kelmscott.

Morris meanwhile had moved out of 26 Queen Square, keeping it as an office and workshop, and had moved to a small house at Turnham Green. It was only half-an-hour's walk from North End, and Morris was able to come over regularly to The Grange, as he had always meant to do, for Sunday breakfast. Ned had suggested this

idea when he first moved to Fulham, and had got a letter back from Morris 'full of rather more emotion that he usually permitted himself'.

Continuing as they did over more than twenty years, these breakfasts became legendary. Small wonder that Georgie excused herself from the discussions (though she tells us that she did not want to intrude on their 'hour and power') if Ned was really quite so absentminded, and Morris quite so hearty. Occasional visitors watched the meal in dismay. A.W. Mackmurdo says that at table 'Morris spent his righteous anger in bursts of denunciation against the powers that be while EBJ made comic sketches on the envelopes of the unopened morning letters'. A specially large coffee-cup was kept for Morris (it is now at the Walthamstow Galleries) because he had promised his doctor never to exceed one cup. In later years, when Ned offered him a nice piece of ham, Morris shouted that if he fancied swine's flesh he would have it, and cared not how it was called.

The conference on the week's work took place afterwards, and in 1872 there was a start to be made on the great Christ Church window – 'the Oxford commission has cheered me I own', Ned wrote to Fairfax Murray.[20] The firm's middle period glass (of which the Christ Church *St Cecilia* is a fine example) was often in clear pale colouring on a plain or verdure background. Ned remained a perfectionist. 'A Christ and a Magdalene – the latter perfectly lovely (the former I grant a failure as usual)' he noted under 'Jan: 1st 1872'. C.H. against many of these entries in the account book stands for a large-scale commission at Castle Howard for decoration and stained glass, including a Resurrection ('as I live, another!') for the chapel. Fairfax Murray was to assist with the plasterwork but he was so anxious to go to Italy that he left without doing it and Ned, as he wrote to the Howards, felt like beating him. Rooke's brother-in-law, who came as a temporary replacement, contracted smallpox, and altogether Burne-Jones was distracted between the work and the assistants. Further entries in his book suggesting extra payments for 'nausea at repeating the same subject' and 'exhaustion at lifting heavy cartoons' was, he complains, disregarded.

He still remained restless at the quarrel with Ruskin. When Professor Norton returned to London that winter he suggested their going down to Oxford together to hear one of the Slade lectures and

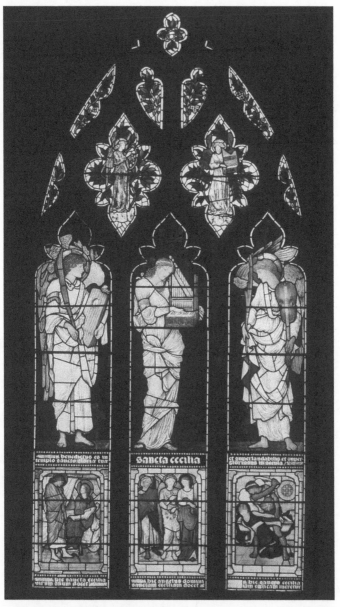

St Cecilia's Window, Christ Church Cathedral, Oxford (1872)
One of Burne-Jones's finest designs for 'the Firm' which Morris
reorganised in 1874. By kind permission of the Dean and
Chapter of Christ Church Cathedral

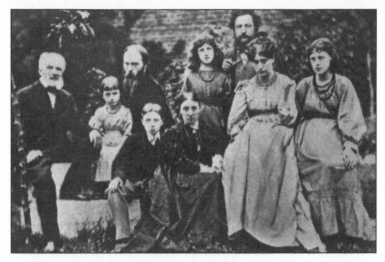

Left to right: Mr Jones (Burne-Jones's father), Margaret, Burne-Jones, Philip, Georgiana Burne-Jones, May Morris, William Morris, Jane Morris, Jennie Morris in the garden of The Grange

Edward Poynter: *Georgiana Burne-Jones*

Edward Burne-Jones and his son Phil

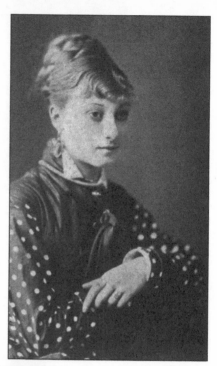

Kate Vaughan, Burne-Jones's favourite dancer

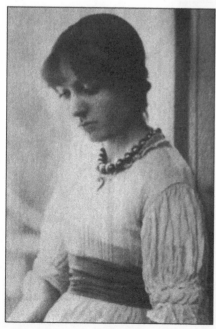

Margaret Burne-Jones in 1880

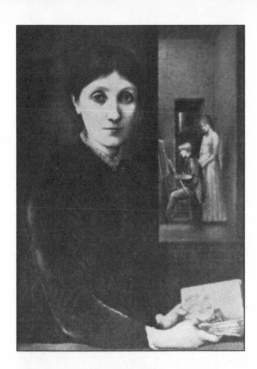

Georgiana Burne-Jones,
with Phil and Margaret
in the background,
begun 1883

Burne-Jones in middle age ('shabby') and ('dressed foppishly'), 1883

Illustration for *The Romaunt of the Rose*, 1874–5

Illustration for the *Aeneid*, 1874–5

Edward Burne-Jones drawing for Angela Mackail, his grand-daughter
(*c.* 1892)

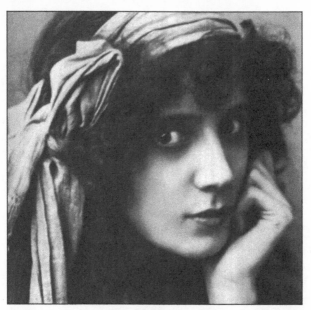

Mrs Pat Campbell in 1896

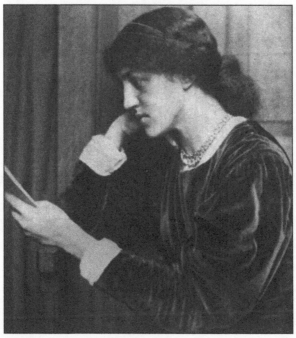

May Morris

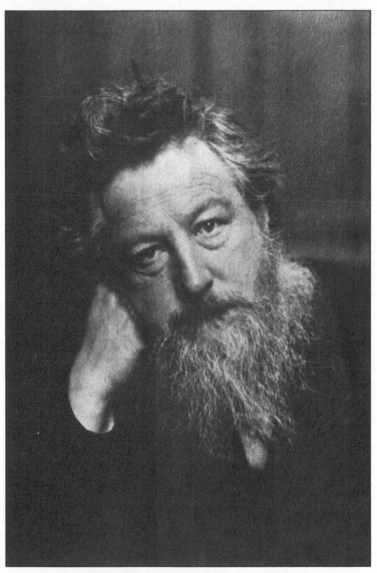

William Morris towards the end of his life

Ruskin must have been gratified indeed to see them in the audience. Once again Ned saw the rumpled queer-looking academic figure, once again he was moved by the Scottish-Biblical intonation, rivalled only by Newman in its power to hold and move. Ruskin was praising Botticelli's illustrations to Dante for two reasons: first, Botticelli had wanted to give the people something they would understand, even though he lost money and brought 'infinite disorder into his affairs'; secondly, Botticelli's 'arrangement of pure line in labyrinthine intricacy' is not an 'idle arabesque' but relates directly to the subject; an example is the *Sybilla Elispontica* in which the withered tree-trunk itself suggests old age.

This idea of drapery answered exactly to what Burne-Jones had been trying to do in the *Phyllis and Demophoön* and *Temperance* – a drapery that 'speaks for itself'. After the lecture he wrote to Ellis that he could not live without a copy of the Botticelli Dante, which apparently was on offer at Quaritch's. Ruskin, for his part, invited Georgie and Margaret for a long visit to Brantwood, where he showed them his treasures and entertained the little girl on wet days by piling up his books and jumping over them.

In the studio, Ned had run into serious trouble with a picture for which Leyland had already waited patiently for four years, *The Beguiling of Merlin*. The beguiling of Merlin, as a subject, punctuated the life of Burne-Jones (1857, 1861, 1869–73, 1874–7, 1884). Now that, with more time to himself, he had begun to study the Latin, Welsh and French versions of the Arthurian story his imagination still returned to this moment, when Merlin willingly goes to his death rather than break the spell of physical love which subjects him to the enchantress. He placed the figures not against a landscape but in the enclosed space of a hawthorn tree in full flower, the 'hawthorn brake' of white May blossom which in the *Morte d'Arthur*, in mediaeval romance, and indeed in Morris's *Book of Verse*, is the traditional scene of love. The branches writhe and twist beneath the load of flowers. The picture was to be the last of his secret acknowledgements to Mary Zambaco.

> The head of Nimuë in the picture called *The Enchanting of Merlin* was painted from the same poor traitor [he wrote], and was very like – all the action is like – the name of her was Mary. Now isn't that

very funny as she was born at the foot of Olympus and looked and was primaeval and that's the head and the way of standing and turning . . . and I was being turned into a hawthorn bush in the forest of Broceliande – every year when the hawthorn buds it is the soul of Merlin trying to live again in the world and speak – for he left so much unsaid.[21]

The bush of white hawthorn comes, not from the *Morte*, but from the French *Romance of Merlin*. In this version Merlin wakes to find himself in a tower not of steel but of air, which can never be undone while the world endures, and it is Arthur and Gawain who hear while they are out walking the thin voice of the enchanter from the maybush. Only in this intensely personal conception did Burne-Jones record how much of him was imprisoned when he broke with Mary Zambaco. The hidden charge of the picture made him even more distressed than ever when his experimental medium failed and the paint refused to bite. Staring at the canvas he felt 'flattered' and saw 'a dishonoured grave' in front of him. 'I don't know if it was my fault or Robersons' – let us call it Roberson's,' he wrote to George Howard.[22] For the new version which he began in 1874 Stillman, at Rossetti's suggestion, eventually sat for the head of Merlin; Ned was diffident about asking him, but he knew Stillman's queer face, almost destroyed in childhood by a lump of falling snow, had the right blankness and whiteness for the enchanted enchanter.

Meanwhile, after the disappointments of 1873, Burne-Jones, although he could not afford it, hoped to have another look at Italy that spring, and to persuade Morris who had found that autumn 'a specially dismal time' to come with him. Morris, who had no longer much interest in easel pictures except for Ned's own, was exceedingly busy, worried about the firm's finances, hated warm weather and, above all, was planning another journey to Iceland that summer. Yet he agreed to come.

Before they set out Ned had time for a very characteristic kindness – he put in a good word for Simeon Solomon, who was arrested on a charge of indecent behaviour in a public lavatory; the only other two people concerned with his well being were Becky Solomon and Walter Pater. That February Ned also took an unexpected step – he exhibited again in public. Two pictures, *Love*

Among the Ruins and the *Hesperides*, were sent to the spring show of the Dudley Gallery. The Dudley was a *salon des refusés* which had been started (originally for drawings only) in 1864 and which had had considerable success, although visitors tended to get mixed up with the queue for the conjuring at the Egyptian Hall near by. When the pictures were shown later in the year at the South Kensington Museum, Gerard Manley Hopkins, on a day visit to London, noted their 'instress of expression'. Among the visitors to the Dudley itself was George Eliot, who wrote somewhat awkwardly to Ned that his paintings, in spite of their beauty, had too much personal emotional in them 'as the result of "outer forces" and not enough of the "inner impulse towards inner struggle".'

In April Morris and Ned started by way of Paris for Florence. It may be hazarded that one of the motives of this odd journey was to make sure of Mary's wellbeing; she had begun work again in Paris as a sculptor and medallist under the name Cassavetti-Zambaco. In any case, Morris did not pretend to enjoy the pictures, being largely occupied with looking round for crockery for the firm; and then, particularly in Venice (where George Howard joined them), there was always the danger that he would be sent into a rage by the restorations. 'He squashed up George Howard's hat, thinking it was his own in his rage at what they were doing to St Marks. He . . . would have liked it all fresh, just done yesterday.'[23] They went to Spencer Stanhope's studio at Bellosguardo, but it rained for a whole week, 'much to [Morris's] joy, because for all his life he can speak of the bleak days he spent in Italy'. Spencer Stanhope, as kindly now as when they had all first met on their painting ladders at the Union, was settling down as a disciple of Burne-Jones; his *Mill*, one of his most successful pictures, was painted at Bellosguardo. Ned, who had found Morris 'rather an exacting companion', stayed on another two weeks after he left, but the cough he had developed at Florence, and the fever he had contracted while he was trying to draw the pattern of the chilly old floor of the Duomo at Siena, left him hardly able to crawl. At Bologna he was actually delirious, and when he arrived back in London it took him months to recover. By his own high standards he had not even brought back many drawings. But he found himself 'pining to be back there, and thinking of little else than high up cities and pictures'. The notion that the name Burne-

Jones should 'really' be Buon Giorno arose about this time, and he wrote to Fairfax Murray (who had met him in Siena) that he was 'meditating', apparently for the first time, a skylight, presumably to try for more solidity of form. But the study of mosaic which he had begun in 1862 in St Mark's and Torcello was the most important thing he brought back this time from Italy.

In September Morris returned from Iceland, more devoted to 'ice and fish and raw snow' than ever, while Ned privately determined never, if possible to go north of Hampstead. The two families celebrated Christmas together at The Grange, with Janey Morris reclining on her sofa and Charlie Faulkner, Allingham, William de Morgan and Frederic Burton as guests. De Morgan, although or perhaps because he would never allow an unjust word about another person, had a bad effect on Ned, encouraging him to tell excruciating cockney jokes; but the children loved them, and although Burne-Jones claimed that he detested Christmas and would like to go back a year in time every 24 December, Rudyard Kipling's memory once again was of real family affection and 'the loveliest sound in the world – deep-voiced men laughing together over dinner'. For companions, Ruddie had not only Phil but his other cousins, Ambo, the son of Georgie's sister Aggie, and the eight-year-old Stanley Baldwin.

At the beginning of 1874, Burne-Jones still largely confined himself to the family and friends of long standing. But Frances Graham and her sister had decided that this curious painter, 'abnormally sensitive' with strangers, must be brought gradually back into the world. By this time they had bribed their father with the gift of one of Ned's drawings, bought for 7s 6d., to allow them to go to the theatre, and the four of them began to see plays together. The girls were wild over Ellen Terry, who had just returned to the stage after her exile and had opened as Portia at the Prince of Wales. She joined them sometimes in Graham's stage box or at supper afterwards; Coventry-born, another Midlander come up to the big city, she was not too impetuous to listen to Ned's diffident voice, so much quieter and wittier than the others around her.

To Frances he began to write a long series of illustrated letters, ready to amuse or interest her at every turn of her life, sometimes confiding, sometimes fantastic, sometimes taking her back to his own images of the past – becoming that already – when he had

shared the world with Rossetti. He asked her, as he asked all his correspondents, to destroy his letters and, like most of them, she didn't. She was one of the first girls, in the London of the seventies, to be allowed to receive her own guests, and she presided over her salon in velveteen dresses of sage green and autumn brown, the colours which Morris was now giving up, but which would be forever identified as 'art shades', with the firm. At these occasions Burne-Jones was a modest onlooker. It was a standing fiction between them that they would run away together, with Frances doing the cooking, 'in which particular', Ned added, 'I am soon pleased'. (This was not altogether true: he told Rooke he could only face two puddings, cold apple pie and cold currant pie.) In the year of his death Frances still gently revived the fantasy, suggesting that they should go and live 'dishonoured in lodgings'. It was the acknowledgement of one dreamer to another. Frances told Mrs Bellock Lowndes, with her usual dash and spirit, 'if she had been born ten years later she would have run off with Burne-Jones'. There was, of course, no such possibility. It was his role to give to her and teach her what he could, and watch her grow up with admiring anguish.

But what sureness and delicacy of hand he shows in the drawings of 1874–5! Morris had launched out on a new manuscript, an illuminated folio of the *Aeneid*, to be done on fine vellum which Fairfax Murray had to send from Rome. Only Ned, of course, could illustrate it, and although the manuscript never went further than Book VI, he completed his set of masterly drawings. No better interpretation of one side of Virgil could be imagined than these tall pale Mantuans with shadowed eyes and dignified gestures, whose deep emotion is transferred to the background. By a brilliant device they often have to bow their heads to fit themselves into the page. Rocks and water twist, unfold in curving lines upon themselves, and we feel the *lacrimae rerum* there. This is a device which is associated with Mantegna and which Burne-Jones used increasingly. It solved the problem of a decorative art which, without losing its formality, conveys an intense disturbance.

Equally civilised, though less severe, is the set for the *Romaunt of the Rose*. The *Romaunt*, of which Ned did a bewildering number of versions, gave him the procession and the searching and finding

themes which he liked, and the queer characters of the *Rose* made in his mind a number of interesting shapes and spaces. Love in the *Romaunt* is a somewhat alarming *natura naturans*, embroidered with plants and animals, but of this Burne-Jones kept only his crown, or hat, of living birds, and created an elegant yet still magical figure. The 1874–6 set was turned into working tapestry drawings by Morris for Rounton Grange, the home of the Yorkshire ironmaster, Lowthian Bell; his wife Florence had grown up in France and was later one of the closest confidantes of Henry James.

The cultured Bells had come to the firm and ordered the 'right' decorations, but by this time Whistler had already exhibited his *Nocturnes* against light grey walls and in his Chelsea house each room was painted a single plain colour with contrasting woodwork. The firm, in fact, was already challenged by a question: why not leave everything plain? Or in Henry James's terms: why not beautify by omission? – which history was to answer, for many years, in Whistler's favour. On this subject Morris was beginning to show a fierce dichotomy and even Burne-Jones was divided. Morris was yearning increasingly, even while the firm was in the middle of these large commissions, for whitewashed rooms and 'little communities among green fields . . . [with] few wants, almost no furniture for instance'. He told Lowthian Bell, who was understandably surprised, that he was tired of 'ministering to the swinish luxury of the rich'. Ned began to talk, even less probably, of a little town with only one street where everyone knew each other and which ended in cornfields at one end and woods at the other.

He was reconciled to living in London, however, in June 1874 when Christie's announced the Barker sale, the pictures being on view at 103 Piccadilly for several weeks by ticket of admission. Alexander Barker, the son of a West End bootmaker, had educated himself entirely and had collected Italian pictures because he liked them. Ned accompanied Frederick Burton, who had now taken over as Director of the National Gallery, to the viewing, and at the sale the gallery acquired its first Signorelli, along with the Botticelli *Mars and Venus* (for £1,050) and the Piero *Nativity* (for £2,415) – the 'colour chord' picture in which colour and music come as close as they well can do. It was partly because of these acquisitions that Burne-Jones never felt it absolutely necessary to make the journey to Italy again.

Nevertheless the 'despair' which he had described to Watts earlier in the year – 'I walk about like an exposed impostor'[24] – became denser during the early summer. In this familiar cycle of depression he suffered from pain which Dr Marshall told him was rheumatism, and that recurrent fear of the hard-working Victorian artist, weakening eye-sight. By this time du Maurier had to work with one eye only, Burton had given up small-scale work entirely and Rossetti, in strong spectacles, was in dread of blindness. Ned's right eye had given trouble since 1871. He had to avoid strain, and while he was resting it his family taught him to play draughts, a game which he called an accurate representation of the miseries of life.

George Eliot, applied to once again for wise words, wrote to Georgie that she should think less about how to enjoy life (Georgie was not quite thirty) and more of helping the wounded on life's battlefield, and making gladness for those 'who are being born without their asking'. By 'the wounded' she presumably meant Ned. 'But the journey to Naworth is a hopeful thing,' she added. This was a visit which Morris and Ned had been induced to make together – so much was always expected from change and fresh air.

Naworth Castle was the Cumberland home of George and Rosalind Howard – George still gently humorous, hating business, wanting only to paint in congenial society, while Rosalind, a devotee of all reforming causes, took all things more and more seriously. The management of the estate was almost entirely in her hands. She was intolerant of human weakness, and must have been surprised to receive a letter from Georgie warning her that Ned had 'bad dreams and painful waking thoughts' and asking her to 'put him in a room not too far from his fellow creatures'.[25] At the castle a family party was expected, but Morris and Ned arrived before this, Morris with a small carpet bag and in an explosive mood (for which he apologised later) on the subject of ugliness and poverty in industrial society; Ned still feeling ill. They had brought their familiar blue linen shirts, but only the minimum of formal clothes were necessary at Naworth, where Rosalind appeared in Pre-Raphaelite robes known as 'bath gowns' and George in low collar, red tie and beret (he was said once to have escorted the Prince of Wales wearing clothes from the poor box).

It had been arranged that since they were, after all, venturing

north of Hampstead they should go over to Hayton, near Carlisle, to see Canon Dixon, that good friend from Birmingham and Oxford days. Dixon was still writing poetry, still labouring in a small country parish, which cared for none of these things, on a history of the Church of England. In the event he was invited over to Naworth. This was at the suggestion of Burne-Jones, who wanted to avoid the 'horrible' Mrs Dixon, whom he ungallantly compared to a bun with currants stuck in for eyes.[26] From the 'abode of splendour', as he called it to Crom Price, Dixon wrote that he found Ned 'in poor health, I grieve to find, and a little quieter in manner, otherwise unaltered'. Morris he also thought was 'gentle', though Rosalind Howard felt that he lacked humanity, and was probably harder still on Ned, since she firmly believed that 'morbid and melancholy people . . . ought to be all cheerful and joyous; did not believe that higher natures were unusually sad, and held that if very sensitive it was good for them to be blunted'.

Morris and Ned fled back to London when a member of family visitors arrived, including Blanche, Lady Airlie, Rosalind's yet more imposing sister. At The Grange, everyone was waiting to welcome Ned, although Margaret was 'deeply asleep' on the sofa. The amount of unfinished work in the studio made him feel giddy, although there were photographs of Botticelli and the Sistine Chapel from Fairfax Murray. Meanwhile Phil, after a summer with the Morris children in Belgium, had to be packed and got ready for Marlborough, where he would try whether it was really good for sensitive natures to be blunted. Both parents suffered over the parting. Georgie 'gave way' altogether, and Ned was obliged, for the first time, to buy a tall hat to take the tearful twelve-year-old down to the school. He gave Phil – who would probably have preferred *Jack Harkaway* – a copy of *Sintram*, and sent him a series of wistful affectionate letters which, though they were treasured by Phil, did not really touch the case. 'I am afraid of seeming silly before everyone or I would run down to look at you,' he wrote. 'Soon you will be reconciled to the change and even glad of it perhaps.' It is no surprise to find that when George Eliot, who did 'run down', called at the school a few weeks later Phil was already in the infirmary.

In October Morris announced, unexpectedly but quite understandably, that he wanted to reorganise the firm. He had

carried it through to success almost single-handed; now he was determined to consolidate it under his own direction, with Wardle as manager. He therefore called on the original partners to retire. Burne-Jones and Webb, who with Morris produced most of the designs, raised no objections, nor did Charlie Faulkner, and Rossetti was prepared to come to an arrangement. Ned's letters to him are clear and sensible, pointing out not only the distress of a public dispute between old friends but the business aspect of the thing. As matters stood they were all liable if the firm failed, and there was still a chance that it might; there was everything to gain from an arrangement, and 'why should all the lawyers we happen to know have it instead?'[27] The difficulty was Madox Brown, whose suspicions of Morris and particularly of Burne-Jones had turned into a deep-seated feeling of injury. Ned 'dissuaded' Morris from sending a pointed letter to Brown and begged Rossetti to intervene. But William Michael had been married that year to Brown's daughter Lucy, and Rossetti felt obliged to stand by his in-laws; besides which Brown, distracted by the mortal illness of his son Nolly, was almost beyond reason. He insisted, for example, that large sums had been voted to Webb behind his back, whereas the minutes showed that he had proposed them himself.[28] Solicitors were called in and the negotiations dragged on until the spring of 1875, when the firm emerged, much impoverished, as Morris & Co., and Brown, to Burne-Jones's regret, never spoke to him again. Ned now became the only figure designer for the firm's window glass, and in 1874, for the first time, he earned more than £1,000 in one year from the firm, although this had left him less time to paint. 'At present I am over-pupilled, for I can scarcely find work for Rooke at times,' he wrote in December to Fairfax Murray.[29]

Morris was able to face the world squarely at the beginning of 1875; as he says in *The Half of Life Gone*, even if love has died there are 'deeds to do, and toil to meet them soon'. Rossetti had left Kelmscott the previous summer, after another serious breakdown; Mary Zambaco remained in Paris. In 1868–70 Morris, who put a very high value on personal freedom, had faced the fact that his wife and Rossetti might want to find happiness together, but the moment had passed. Janey was back in his care (together with her sister, who bored him dreadfully) and he continued to look after her as long as

he could work and breathe. But he seems almost to have reached the stage, described much later by Bernard Shaw, of 'a complete fatalist in his attitude towards all human beings where sex was concerned'. For Burne-Jones at forty, the case was very different. In February 1875 he sent Frances Graham, to the envy of her friends, a Valentine of Love with a crown of birds – his favourite design from the *Romaunt*, but in this case dragging a young girl through the meshes of love. He worked this year on the *Orpheus and Eurydice* drawings, taking Frances for the model of Eurydice and his own face for the resigned and wistful Pluto. He drew her in profile, and this was to remain his favourite view of her.

Frances, however, like the briar rose, wounded only to heal; she believed that Ned ought to meet more people, instead of leaving or becoming silent as soon as strangers arrived. She began by introducing to him a girl who became a lifelong friend, the only girl to whom he opened his heart who was not pretty, not imaginative, but loyal, sensible, solid, and very good for him – Mary Gladstone. The sixth of Gladstone's children, she had been brought up in the huge brilliant rough-and-tumble of Gladstones, Lytteltons and Glynnes at Hawarden, where there were enough people in the family to sing the *Messiah* straight through, and where everyone was sympathetic, but no one listened to what anyone else was saying. At nearly twenty-eight she was only just beginning to feel that she was not a nonentity – not, in the peculiar language used by the Glynnes, a 'phantod', or complete idiot. Whereas she could have only one opinion on politics, she was beginning to make her own judgements on music and painting. Her first visit to The Grange was in 1874, when she saw 'Pygmalion, Creation, Dream of Good Women, Pan and Psyche, a girl in yellow picking flowers, such find colouring, golden yellow and dark olive green,' this last being a commission from Aglaia Coronio. '. . . can't make out whether he isn't over self-conscious,' was her frankly puzzled comment on Burne-Jones, for at Hawarden shyness was hardly allowed. Mary went on to see Watts, Leighton, and Alma Tadema, a reminder that it was the mid-seventies, art was becoming fashionable, and it was the regular thing to visit the more respectable studios on Sundays. Burne-Jones was only doubtfully beginning to 'receive', and was often out when viewers called. But on 17 February 1875, Mary

wrote in her diary that she had met him at dinner at the Grahams 'and much liked it. We talked hard, and he told me lots of things worth remembering. Called Browning's outside "mossy" and said the works of a man were his real self . . . says he has no creative power after noon.' Mary agreed about Browning, who now drank port all through dinner and sat in such disagreeable proximity, puffing and spitting in one's face, that it was impossible to believe that he had written *Abt Vogler*.

No one can read Mary's diaries, edited by her friend Lucy Masterman or her unpublished letters, without feeling how valuable would be her stout support. In spite of a summer outing to Oxford with Morris, when Faulkner and Ned played the old practical jokes by pretending they had forgotten the picnic, 1875 was a year of distress. In March Georgie had to go north to her mother's deathbed; in May Rose La Touche died, with terrible effect on Ruskin's overwrought brain. Rossetti had returned to Chelsea, but he had not been to The Grange for four years and as the *Memorials* put it, he 'had gradually ceased to ask what Edward was doing, or to show him anything of his own'. Swinburne was a faithful caller at The Grange but frequently a confused one; perhaps only Georgie could sort out the problem of one of his letters, written on 'Thursday night as ever is, or would only it's Friday morning' asking how, since he has left his key 'in the pocket of his over-waistcoat', he will manage 'if it snows tomorrow'.

The Howards were as anxious as Frances Graham to take Burne-Jones out of the disasters of his own circle and restore him to what seemed to them a normal life in society. Faced by so much kindly energy, he tried to retreat into the fastnesses of the studio, or represent himself as a passive object. This proved no defence. He could not resist their introduction to the delightful Norman Grosvenor, son of Baron Ebury, a mild but earnest radical reformer and the best of talkers and listeners. Then, in the spring of 1875, the Countess of Airlie arrived at The Grange with a young friend whom she had swept off imperiously with her. Arthur Balfour, who was introduced to Burne-Jones and, in his own words 'instantly became a victim of his mind and art'. This was what de Morgan would have called the rummest go of all. Balfour at twenty-seven was already the brilliant and apparently serene dismissive, with a reputation of alarming politeness, who would join the Fourth

Party, so he said, simply in order to have room to stretch his legs on the front benches. He cared nothing about art, and was thought not to care much about human beings. 'What a gulf between him and most men!' was Lady Battersea's description. Ned's friends were all liberal reformers, Balfour was an icy high Tory. But in the spring of 1875 there was a particular reason for the visit. Balfour had been in love, as deeply as his nature permitted, with May Littelton, Mary Gladstone's cousin, a big, warm, responsive girl to whom he had actually 'spoken' in the New Year; then, on 21 February, May Lyttelton died. Balfour had his mother's emerald ring placed in her coffin, and at the funeral broke down completely. Blanche Airlie had brought him to The Grange to see something quite new – a painter painting – but what attracted him to Burne-Jones was a quality of mind, and there is no better proof than this of Ned's intelligence. It was out of respect for this mind that Balfour ordered a set of pictures for his music room at 4 Carlton Gardens.

Burne-Jones suggested the *Perseus* story, based on designs from the *Earthly Paradise*, a subject which introduced, once again, his favourite themes – seeking and finding, rescue, waiting, reflections. These last appear very early in his work – for example, in a study for *The Lament* (1866) where the model's feet are reflected in the marble floor; in marble, metal or water they had become an obsession with him. The studio was full of beautiful studies of the images of girls in water for the *Mirror of Venus*, and he now had to tackle the reflection in the well of Medusa. He looked at the sketches of the Etruscan Gorgon in his notebook, and haunted the print room of the British Museum.

On 27 March Burne-Jones called at Carlton Gardens to make a survey of the job, and his report, which Balfour kept in his letter-book,[30] shows the amazing confidence, even in the depths of depression, which ten years for working for the firm had given him. The light in the music-room, he tells Balfour, is much too harsh. All the windows must be reglazed and the walls repanelled in light oak. The pictures will hang in a band 'resembling the procession by Mantegna at Hampton Court'. What is more, an oak ceiling must be put in and preferably the room must be lit with candles. One might object that this arrangement would make the pictures invisible both by night and by day, and Ned foresees the incongruity – the room

will not 'go' with the rest of the well-appointed house; but 'what can one do in these days but clear a little space as a sort of testimony that we don't like it although we have to bear it?' In a subsequent letter he gives an estimate of £4,000 for the paintings alone – not frescoes, for he never tried painting direct on to the plaster, except in his own home, after the experiments at the Red House – but six canvases:

> 2 longer ones £800 each
> 3 middle size £600 each
> 1 smaller £400

The whole scene is to have four 'golden pictures' to link it up, and 'pattern work' (the design for this is the Tate Gallery), but this may prove too elaborate. Meanwhile he asks for £500 on account 'as I might be in need of it', so that he can go on with the job while Balfour came to The Grange to approve the sketches. But here the airy perfectionist had met his match. He waited a lifetime for his music room, but Burne-Jones, always on the verge of getting the design quite right, never finished it.

Watts also felt that Ned might benefit from a change of background. In August 1875, after the demolition of Little Holland House, Watts built the Iron House (also known as the Tin Pot) in the grounds of his new site in Melbury Road, and he invited Burne-Jones to share this new studio. Two large canvases with designs blocked in were delivered but never completed, and in fact they stayed there until the Tin Pot was taken down and only the two doors remained. A feeling was growing meanwhile among these people who were so used to getting things done – the Howards, the Prinseps, the Balfours – that Ned should show his pictures in public again – but where? Perhaps, as George Eliot suggested (3 March 1876), in a 'separate little gallery'. This, of course, was not a problem for him alone. 'Mr Burne-Jones is more than right not to exhibit,' Watts wrote in 1875, disgusted with the poor arrangements at the Manchester Modern Art Exhibition. Graham was the person who could formerly have been relied upon to arrange such matters, but he was terribly broken down by the loss of his young son, poisoned in his school holidays by an overdose of medicine and dead in a few minutes in Frances's arms.

From this death Graham never quite recovered, but both he and Leyland were prepared to lend from their collections if a site could be found.

These plans to bring Ned out of seclusion into a confrontation with a new public were unexpectedly interrupted by a crisis which made them, for the time being, seem quite unimportant. For the first and last time in his life, Burne-Jones became interested in politics, and in the perpetual delusion that through political means we can better the human condition.

12

1876–8

A RETURN TO THE WORLD: THE GROSVENOR GALLERY

When Norton visited the young Joneses in 1868 he found Ned 'a strong, almost bitter, republican, and the condition of England is to him a scandal and a reproach. He is a genuine democrat, of a democracy that will endure.' Throughout the past seven years Ned had never changed his opinions on the industrial society. They had been formed when he wrote *The Cousins* and when he patrolled the seething London streets, and renewed at the Working Men's College and again when he visited Birmingham in 1872 and found it 'a hole' where he could scarcely bear to stay, as he told George Howard, 'to save my Brummagem life'. But he had limited his response to the original undertaking made at Le Havre – to help to make nineteenth-century England less blind to beauty. In Morris's wider application: 'I know by my own feelings and desires what these men want. What would have saved them from the lowest depths of savagery . . . reasonable labour, reasonable rest. There is only one thing that can give them this – art.' In Norman Grosvenor, who with Walford Davies founded the People's Concert Society, he found a friend after his own way of thinking. But in 1876 we find him writing to Norman Grosvenor.

> I never cared about any matter so much in all my life and felt so certain of anything, as to how I should decide rightly – or half so resolute to do everything that lay in one's poor way lay ready to hand to help – in my heart I know politics to be the one great subject of life, for which one should put aside all private matters and for which one should give up everything – but as books say

on their title pages I reserve the right of translation. What [sic] I mean by politics – I do from my soul want my country to help mankind – to set aside its low interests that are base in the individual and shameful in the community – I want it dreadfully, so that if at this time we by indifference, folly, or selfishness lose our chance, I shall never in my life days [sic] recover from the disappointment of it . . . I confess it is not a bit my faculty to know what is expedient or advisable in practical business but I am sick of diplomacy and the least taint of it . . . and I can't see what harm can come of saying out what one means and thinks.[1]

The 'matter' which stirred Ned to feel that politics were the great subject of life was the Eastern Question of 1876. This crisis, which agitated liberal and radical England to what might seem a surprising extent, originated from the massacre of Bulgarian Christians by the Turks, most ably reported by the great newspaper correspondents, then in their heyday, and in particular by W.T. Stead. Ned could not fail to be reminded of Mary Zambaco's great-grandfather, crucified on his house door by the Turks. The Bulgarian massacres themselves, dismissed at first as 'coffee-house babble' by Disraeli, led to a threat of war by Russia. Disraeli was determined to support the Turks, not only to check any possible designs on the Tsar on the route to India but because, as a Jew, the Russian pogroms moved him far more deeply than anything the Turks had done. Gladstone, who had retired from the Liberal leadership the year before, emerged to produce his famous pamphlet on 3 September 1876. Forty thousand copies were sold in the first four days.

The real uneasiness went much deeper than the Bulgarian crisis, and involved the whole direction of British foreign policy. Disraeli had become Lord Beaconsfield on 12 August; on 9 November he spoke 'amid the wine-cups' (as Freeman put it) of the Lord Mayor's banquet, of our inexhaustible resources if we chose to draw the sword; in the same year, under the Royal Titles Act, the Queen was proclaimed Empress of India. The whole concept of Britain as a warmaking imperialist power, the whole suggestion that politics and morality had no necessary connection seemed in 1876 to hinge on this one question, and to Liberals the enemy was Jingoism, Disraeli and 'Empress Brown'. It goes without saying that the Liberal ranks were deeply divided, but they had the powerful support of *Punch* and

the *Telegraph*; and the Nonconformist clergy, with a strong chapel-led working-class movement, gave them real moral authority. They stood, however, against a confused but strong popular feeling. Charles Dilke, going home from the Dudley Gallery, saw a small crowd going off in an excess of patriotism to smash Gladstone's windows.

Morris flung himself with all his usual energy into the Liberal agitation and was elected treasurer of the Eastern Question Association. Ned, describing himself to George Howard as 'a boiling cauldron of fury' – as indeed he could be at times – was deeply committed, and found himself, for the first time since the Hogarth Club, struggling with all the disheartening processes of democracy, committees, endless letters, and even public speaking. Although he seems to have been too ill to attend the meeting of December 1876, after which the Queen asked Disraeli whether the Attorney-General could not 'be set at these men', he was certainly there in January 1878, with Faulkner and Crom Price, when the workmen's neutrality demonstration was convened at Exeter Hall and a crowd of thousands sang Morris's 'Wake, London Lads'. By this time Allingham, Watts, de Morgan and even du Maurier had been drawn in. But for this meeting Gladstone did not, as he had in 1876, make a special journey from Hawarden.

After Russia declared war on Turkey in April 1877 and showed signs of winning, Jingoist feeling ran high and support for the agitation began to ebb away. Disraeli felt himself strong enough to defy his enemies, and Gladstone, who had given very little real lead of any kind, appeared to have second thoughts and became engrossed in the coming elections and his own return to power. The Liberal party ceased to oppose. Morris could 'scarcely look people in the face', particularly the working-men's delegations, 'though I did my best to keep the thing up'. Britain emerged from the negotiations with Cyprus, and the next spring Gladstone contested Midlothian.

Morris's retreat from politics was to be temporary only, and Georgie too had discovered that she had a gift for committee-work and organisation. Burne-Jones's disillusionment was total. He never changed his opinions, but he never again expected anything from either politics or politicians. He determined – with every acknowledgement that this might be a sign of weakness – to go

back to his studio and confine himself to his life's proper business, painting.

Meanwhile the new gallery, about which so much had been said, looked like becoming a reality. The promoter was to be Sir Coutts Lindsay, the fifty-three-year-old elegant banker and amateur painter, who contested with Cyril Flower the title of the handsomest man in London and who, it may be remembered, had met and wooed Blanche Fitzroy at Little Holland House. It was not the habit of the House of Rothschild to make marriage settlements for their daughters which gave control of property to the husbands, but Sir Coutts and Lady Lindsay were, between them, exceedingly well off. In 1876–7, amid great interest and many informed rumours, they set about building the Grosvenor Gallery.

Their architect, W.T. Sams, had produced an advanced design for a structure of iron girders, made fire-proof with concrete, with heating and cooling plants worked by steam mechanisms, a hydraulic lift, and a device for modifying the light. Sir Coutts, however, wanted they whole thing to look like an Italian palazzo, and the first thing that anyone noticed in New Bond Street was the imposing stone façade with a Palladian door which had been imported from Santa Lucia in Venice. Inside, as the opening date approached, the décor showed how it had been for either Morris or Whistler to make headway against the natural Victorian taste for accumulating *things* – things, the original Spoils of Poynton, which stood and lay about in the homes of everyone who could afford them. The Grosvenor Gallery, intended as a refined background for fine paintings, was full of plants, velvet sofas, gilded and marble tables covered with Japanese, blue and white and Minton china, globes of rainbow glass and hanging lamps. The statuettes included one of a sailor lad, entitled 'Cheeky': the ceiling was painted blue with gold stars, the walls were divided with pillars from the old Italian opera house in Paris, and on the ground floor was a 'splendid *salle à manger*'.

The most debatable point was the colour of the walls, which were hung with crimson silk damask. Only Watts, who knew that his low-keyed portraits would look better on a strong background, really approved of the damask, and indeed Sir Coutts and Lady Lindsay appear to have consulted no one about the décor but themselves.

They had, however, engaged two young men as assistants. One

was Charles Hallé, son of the pianist, with all the charm and inability to settle to anything that is characteristic of the sons of famous fathers. The other was Joe Comyns Carr, a bit of a lawyer, a bit of an actor, a bit of a writer, a *blagueur* and good companion. Mrs Comyns Carr, charming and excitable, was a new bohemian such as only an English parsonage could produce: her muslin draperies, falling in wrinkled folds, were 'set' by being cooked in a potato steamer. The Carrs, and Joe in particular, became immediate friends of Burne-Jones, but though he may have been slow to realise it, he was facing here a new threat, more insidious than the entrenched hostile official ranks. The Carrs were the forerunner of a new danger, this time from fashion itself. They were among the first of the Aesthetes, and the Aesthetic movement, like all movements led not by artists but their followers, would first dilute, then copy, then exaggerate, then become ridiculous, then grow out of date. It was, after all, a consumer movement, with time and money to spare, centred first on the form, then on Liberty's. When Mrs Comyns Carr writes in her memoirs that 'our predicament when we arrived in Paris without enough money to register our luggage roused screams of laughter', it is not the same thing as Ned alone and hungry in London, or Madox Brown pawning his wife's shawl. With the Aesthetes the protest against the Philistines continued, but in becoming fashionable it became less serious.

Whatever doubts they may have had about the décor, the artists who were invited – and exhibition was by invitation only – were grateful for the princely courtesy of the new gallery. Space was tactfully allocated, and with only two pictures to each bay there was no feeling of overcrowding. The only artist to refuse was Rossetti and he did so only after explaining his reasons in a letter to *The Times* (27 March 1877) in which he added, with his old generosity, that the project must succeed 'were it only for one name associated with it – that of Burne-Jones – a name representing the loveliest art we have'. Ned scarcely ever read the papers, but someone showed him this passage and he wrote to thank Gabriel: 'If there's anything in me for you or others like it's your making.' But it would have meant even more to him if he could have persuaded Rossetti to exhibit. 'I shall feel very naked against the shafts', he wrote again, 'and as often as I think of it I repent promising – but it doesn't really matter – the worst will be temporary disgrace and one needn't read

criticisms. I promised them to write to you about it – and it's true I wish you would send, but that's all.'[2]

Sir Coutts, in sending out his invitations, was anxious not to offend the Academy beyond repair. Not only Watts, but Leighton, Grant, Millais and Alma Tadema, all Academicians, promised to send. Nevertheless, the Grosvenor was felt to be a *contre-salon* on a grand scale. Burne-Jones himself was almost an unknown quantity, although Watts forecast to Charles Rickards that 'Burne-Jones will be very strong . . . in fact I expect him to extinguish almost all the painters of the day, so you may prepare to be knocked off your legs'. The *Mirror of Venus* was now finished, so were six splendid panels of the *Days of Creation*, adapted from a window design for Tamworth church in Staffordshire; he also sent a *St George*, a *Sibyl* (this also was Mary Zambaco and a copy was made for the 'Duchess'), Ellis's *Spes*, *Fides* and *Temperantia* and the great *Beguiling of Merlin*. Nimuë now towered over Merlin in steel blue curves, more like a serpent than a human being, crowned with red hair against the intricate pattern of may blossom. But whether Ned knew it or not the original, Mary herself, was in desperate straits in Paris; 'she was very pale,' Mrs Stillman had written to Rossetti, 'very ill-dressed, and she *must* be very ill, for her hair was quite black.'[3]

The private view of the first Grosvenor Gallery exhibition was fixed for 30 April, and not to receive a ticket was a social death. There were in fact three openings: one for intimate friends on the Sunday afternoon; an immensely grand dinner-party, attended by the Prince and Princess of Wales in the restaurant – the protocol here was arranged, after much anxiety, by Charles Hallé and Arthur Sullivan, who was an intimate of the Lindsays and composed music for *tableaux vivants* at their Scottish house parties; then, on 1 May, came the public opening, when seven thousand people passed the turnstile on the first morning.

All went expecting something strange and, according to Henry James, were amazed to find the pictures the right way up. One entered by the West Gallery, to be confronted by Watt's superb *Love and Death*, then a group of Sir Coutts's own indifferent pictures – there were a good many of these, and some of Lady Lindsay's – then Holman Hunt's *Afterglow in Egypt*, Spencer Stanhope, Frederick Burton and Burne-Jones. Albert Moore and Legros were hung

between Burne-Jones and Whistler, who sent etchings and portraits (including the *Carlyle*) as well as *Nocturnes*. The only picture of his for sale was the *Nocturne in Black and Gold: the Falling Rocket*, which was priced at 200 guineas. In the East Gallery there were the Leightons and eight pictures by the hard-working Poynter, including Georgie's portrait; after that the exhibition was felt to fall off with society scenes by Tissot and Heilbluth's cardinals. The water-colour gallery was a disappointment, except for Dicky Doyle's fairies.

The main confrontation was undoubtedly between the eccentric Whistler and the eccentric Jones. As Graham Robertson put it, 'one wall was iridescent with the plumage of Burne-Jones's angels, one mysteriously blue with Whistler's *Nocturnes*'. But whereas Whistler was a public figure, Burne-Jones, except to his intimates and loyal patrons, had become almost forgotten as a painter. He had not exaggerated when he told Rossetti that he felt naked at this new exposure. The Grosvenor opening was a day of trial, and he emerged from it a successful man. 'From that day', Georgie wrote, 'he belonged to the world in a sense that he never had done before, for his existence became widely known and his name famous.'

Some violent hostility the Lindsays had expected and Mrs Comyns Carr for one would have been disappointed if there had been none. *Punch* was particularly hard on 'the quaint, the queer, the mystic over-much and the Nimuë 'at least twelve heads high'. Lady Butler, in a well-known passage from her memoirs, describes how:

> I felt myself getting more and more annoyed while perambulating these rooms, and to such a point of exasperation was I compelled that I fairly fled, and, breathing the honest air of Bond Street, took a hansom to my studio. There I pinned a seven foot sheet of brown paper on an old canvas and . . . flung the charge of 'The Greys' upon it.

This introduces the question of unwholesomeness. Harry Quilter, that most commonplace of critics, observed, with more sharpness than usual, that Burne-Jones's work 'all has some trace in it of that purely physical side of love, which he depicts in such strange

conjunction with its most immaterial aspect'. Why the conjunction should be strange, Quilter does not say.

More sensitivity might be expected from two visitors who were not professional art critics, Oscar Wilde (still an undergraduate) and Henry James, established the year before in Bolton Street as an observer of the London scene. James, in his own words, was not amused by the *Nocturnes*, was doubtful about the 'aesthetic refinement' and ambisexuality of the Burne-Jones's, but found the *Merlin* 'brilliantly suggestive'; 'Mr Burne-Jones's lionship', he added, 'is owing partly to his "queerness" and partly to a certain air of mystery which had long surrounded him. He had not exhibited in public for many years, and people had the impression that his genius was growing "queerer" than ever.' James felt that this impression was justified. The glaring red walls 'cruelly discredited' the pictures. Wilde agreed about the walls, and disliked the *Nocturnes* almost as much as James, but to him Burne-Jones was a great colourist 'whose colour is no mere delight in the qualities of natural things . . . but expressive of the spirit'.

Among the visitors was an unexpected figure, clearly a sick man, aged, crumpled-looking and wearing an old-fashioned blue stock, accompanied through the galleries by friends. This was the Professor – Ruskin himself. Sir Coutts might well have expected a favourable notice from the great man who (although he did not care for the notion of opposition to the Academy) had done so much to create the climate of opinion which had led to the building of the gallery. But readers of *Fors Clavigera*, which was becoming increasingly disjoined and puzzling, unfortunately found No. 79 clear enough. In it Ruskin complained – saying what no one else had liked to say – about Sir Coutts's own pictures, dismissed the crimson walls, praised Burne-Jones, and took extreme objection to the 'ill-educated conceit' of Whistler in asking 200 guineas for the *Falling Rocket*. This was the painting which he called a 'wilful imposture'.

The exhibition caught Ruskin just after his return from Venice and an intense study of Carpaccio's *The Dream of St Ursula*. The fine detail of the sleeping saint, half confused in his mind with the dead Rose La Touche, made it impossible for him to appreciate the atmosphere, exact and poetic, of the faintly-washed *Nocturnes*. They appeared to him to be colour notes, or at best, studies. The matter –

whatever Whistler might say in his *Ten o'clock* – was, as perhaps it always was with Ruskin, a matter of craftsmanship. *Fors*, after all, was addressed to the artisans of England. In *Unto This Last*, Ruskin had defined just payment as 'time for time, strength for strength, and skill for skill'. He did not see 200 guineas worth of strength in the *Rocket*.

Whistler's law-suit against him was heard in November 1878. By this time it was clear that Ruskin, who had to avoid any subject which excited him for fear of a new breakdown, could not risk any appearance in court. His friends must stand by him.

The line-up of witnesses on 25 November (Baron Huddleston and a special jury) might, if the whole case had not been so distressing, have been considered absurd. Burton begged to be excused, so did Charles Keene, so did Leighton, who was going to receive his knighthood that week. Burne-Jones, unwilling to show himself conspicuously anywhere, hated the idea of the witness-box particularly since the article had praised, in comparison to Whistler, his 'utmost conscience and care' in finishing his pictures; also, he agreed with Whistler on many points, though not in the claim that an artist should stand above society. But love and duty told him he must appear. His fellow witnesses were Tom Taylor, who had consistently attacked him ever since the Plint sale, and, of all people, Frith, who appeared under subpoena. For the prosecution were the painter Albert Moore, an amiable eccentric who took advice on all matters from the Chelsea cabmen on his rank, and William Michael Rossetti who like Ned was answering the call of friendship.

'The weightiest testimony, the most intelligent and apparently the most reluctant, was that of Mr Burne-Jones, who appeared to appreciate the ridiculous character of the process to which he had been summoned to contribute,' wrote Henry James, reporting for the *Nation*. In evidence, Ned painfully declared that he had been a painter for twenty years, but had become known to the public only during the last two or three; he believed that complete finish was the most difficult part of painting and had been acknowledged for centuries as the standard. He praised Whistler's colour and 'almost unrivalled sense of atmosphere': he stuck to it that the *Nocturnes* were the product of labour and skill, but he still regarded them as sketches. He did not think the *Rocket* was worth 200 guineas. By

contrast, he identified Ruskin's Titian (the *Doge Andrea Gritti*) as a 'splendid arrangement of flesh and blood'. Frances Graham, who was in court, recorded his answer to the judge's: 'You are a friend of Mr Whistler, I believe?' 'I was,' Burne-Jones replied, 'I don't suppose he will ever speak to me again after today.' In this, at least his prophecy was correct.

The Pennells, however, who managed to obtain the papers in the case from Ruskin's solicitors, Walker, Martineau and Co., were able to show that Ned's original deposition was far more severe. In these papers he described Whistler's eccentricities as 'a joke of long standing' and said (what was not far from the truth) that Whistler had notoriously 'deprecated the work of all artists, living and dead'. The bitterness that can be felt here dates back to the day ten years before when Whistler knocked down Legros in Luke Ionides' office. Evidently Burne-Jones, from the solicitors' point of view, did not 'come up to proof' because in the event he determined not to bring old scores into court.

Mr Sergeant Parry's conduct of the prosecution was particularly inept, maintaining (1) that Ruskin was damaging Whistler's reputation (2) that no one paid any attention to Ruskin, because he was mad. The outcome has always been felt to vindicate the integrity of the artist against the critic; the trial itself has usually been treated as a comedy, but the results for the protagonists were tragic. Burne-Jones felt wretched at this new breach with William Michael Rossetti. Whistler kept his end up gallantly, greeting his friends in the Grosvenor Gallery and insulting the unsmiling Poynter, Ned's brother-in-law, by shrieking, 'Hullo Poynter! Your face is your fortune, my boy! Ha! Ha!' But a few months later he was bankrupt. Ruskin felt it necessary to resign his professorship, and faced a new period of 'disgustful or ominous dreams' and broken sanity.

But the discomfort of the trial could not check the most unfamiliar wave of success which now carried Burne-Jones, protesting, with it. The modest employer of studio assistants found himself with a school. Edmund Evans began to publish Walter Crane's toy-books in 1878, and in the *Baby's Bouquet* the *Hesperides* was charmingly echoed in *Round the Mulberry Bush*.In December 1879 we find Henry James directing visiting

Bostonians to The Grange. In 1877 at one of the first Wagner rehearsals at the Albert Hall, Ned contrived an introduction to a lady in the audience whose daughter had the right head for Medusa in the *Perseus* series; Mrs Benson was not surprised, replying 'with quiet understanding' that 'she has often been called my Burne-Jones daughter' – this was in the same month as the opening of the Grosvenor Gallery. In 1878 the *Merlin* went to the *Exposition Universelle* in Paris where – so Rossetti wrote to Howell – it was expected to carry off all the prizes, though in fact it was a success only with the critics. Back in London Sir Coutts, yielding to pressure, replaced the crimson hangings with dull olive green, and greeny-yallery was the colour of the hour. Kensington became Passionate Brompton and all who struck an attitude were P.B.'s. 'Delightfully un-P.B. for such a P.B. artist' had been Mary Gladstone's first opinion of Burne-Jones. The English middle class, exhorted by Ruskin, hectored by Carlyle as to what they shall not believe, invaded (so Whistler complained) by Morris and made to hang wallpapers in their homes, refined by Whistler himself and made to hang Japanese fans, finally taught by Burne-Jones a line of drapery and an unmistakable attitude and glance – it was as if they had taken a loving revenge by giving way to everything at once. In Henry James's *A Bundle of Letters* (1879) the English girl abroad wears:

> a sage green robe, 'mystic, wonderful', all embroidered with subtle devices and flowers and birds of tender tint; very straight and tight in front, and adorned behind, along the spine, with large, strange, iridescent buttons. The revival of taste, of the sense of beauty, in England, interests me deeply; what is there in a simple row of spinal buttons to make one dream – to *donner à rêver*, as they say here?

Even the buttons disappeared when Liberty began to drape, more and more softly, both women and furniture. Frith's *Private View of the Royal Academy, 1881* showed, in his own words, 'a family of pure aesthetes absorbed in affected study of the pictures. Near them stands Anthony Trollope, whose homely figure affords a striking contrast to the eccentric figure near him.' 'These were the days of green serge gowns and Morris papers,' wrote Elizabeth Wordsworth,

describing her experiences, in 1879, as the first Principal of Lady Margaret Hall. 'Every lady of culture had an amber necklace.' She also says it was 'simply impossible to imagine any of the Paters in a crowded railway station', a reminder of the finely tuned intellect which was the strength of the aesthetic movement. But Pater's Marius the Epicurean, who seriously considers that life might be concentrated into the flowering and folding of a toga, is a far cry from Morris and Burne-Jones as they set out to 'tell the tale'.

The satirists went to the attack: Mallock's *New Republic* defended the present against the past (although he allowed Ruskin to have the last word against Pater), and du Maurier drew Mrs Comyns Carr, with her beads and cloudy fringe, as Mrs Jellaby-Postlethwaite. In 1879 Millais gave a grand ball at which all the ladies wore Grosvenor Gallery dresses; in the following year Luke Ionides suggested to his crony W.S. Gilbert that he might write an opera based on Burne-Jones's maidens descending the golden stairs, and the outcome was *Patience*.[4] Here Gilbert, faithfully reproducing the popular idea of the movement, muddled everything together, and Grossmith, as 'Bunthorne, a fleshly poet', got himself up, for the opening run, as Whistler. Ned enjoyed *Patience* – he was disappointed that Rossetti could not be got to come to Gilbert and Sullivan – and, again in the face of Rossetti's protests, he made the acquaintance of Oscar Wilde. Although he had many causes of physical and mental distress, the aesthetic craze was never one of them. About the wholesale borrowing of his decorative motifs he protested mildly: the aesthetic sunflowers, for instance, were meaningless, whereas for Burne-Jones (as for Blake) sunflowers were sleeping beauties; he approved of the soft down on their legs, he said, and 'I don't know how they can bear the bees to touch them'. But on the whole he remained imperturbable, knowing that whatever Passionate Brompton was doing, he was doing something else.

In the restless new atmosphere, where he was accepted as a leader, he characteristically became homesick for his old certainties. It was a deep gratification when Oxford offered him an honorary D.C.L., though there were shouts from the undergraduates at the most un-greeny-yallery gown he had to wear and he was asked how he liked the bright red. The years seemed to roll back, Charlie Faulkner was there, and when he

presented the winner of the Newdigate, Jack Mackail, no one could suspect that in a few years this bright young man would deal Burne-Jones a mortal blow. The 'ancient kindness' was also renewed with Ruskin, although they still could not agree about Michelangelo; to relieve the Professor's unhappiness Ned introduced him to France Graham, who instantly became a 'pet'. He took cabs to Swinburne's lodgings for poetry readings, 'agitating affairs', as Gosse described them, with plates and glasses laid out 'like a conjuror waiting for his audience'. He consoled the poet's 'mighty spirit' when a whole new work was left in a cab on a foggy night. He wrote loyally to Stephens. But his calls at Cheyne Walk – though Gabriel appreciated the attention – fell heavy as lead; there seemed nothing left to say. In October 1881, when Rossetti sent him a copy of his last book of poems, Ned had not seen him for eight months, but in answer to an imploring letter of thanks he received only a weak chilling scrawl: 'Thanks, but I am very ill, and not well enough to see you.' Ned had to apply for news to a new bedside companion, Watts Dunton.

On the other hand his sympathy with George Eliot deepened, and became something quite distinct from Georgie's strongly emotional friendship with her. The great novelist was well able to understand the effects of a childhood hungry for beauty, rejection by the world, a sudden access of fame, a highly sexed nature and a conviction – which both of them had held since their earliest years – of being hopelessly ugly. Burne-Jones sometimes went down by himself to Witley, where Eliot had taken a house, and the absent-mindedness of the two dreamers met when she told him one dark night to turn sharp right for the station, causing him to plunge head first over the railway cutting. When G.H. Lewes died in March 1879 he felt intensely for her grief. 'Her table was covered with Hebrew books', he wrote wryly to Mary Gladstone, '- when I say covered, I mean there were two or three . . . it all looked so lonely – and I wondered whether she cares to lie down or get up any more.'[6] A year later, when George Eliot impulsively decided to marry Cross, she tried to break the news to the Joneses separately, going up first to the studio. Georgie found it hard to adjust to this change in the wise counsellor who, as she wrote, had 'looked closely into my life'.

Burne-Jones also began, not boldly, but rather more boldly, to

venture out into a wider circle, and again the prompting came from Frances Graham. The young women who were sensitive to his unobtrusive need for friendship were, in general, part of Passionate Brompton; they wanted to paint a little, or did paint a little. They found Burne-Jones considerate, delightful, enigmatic and an expert at escape. 'I am but a poor wretch, if taken from work but for a day,' was one polite evasion. A typical letter to Miss Stuart Wortley (Norman Grosvenor's sister-in-law) began: 'Heaven is so indignant at the impropriety of my taking you anywhere, that this time it has visited me with the heaviest of all afflictions – and I am shut up with a cold in the head.'[7] A characteristic way of entertaining these young women – a charming, respectable way – was to take them for a walk, perhaps to escort them home from his studio after Sunday lunch. 'Nothing escaped him that we passed by,' Mary Gladstone noted (25 November 1882), 'and he found subjects of pity and amusement as we walked. First a wretched, stooping, white-faced, red-haired girl with a miserable haunted expression . . . then two children in a perambulator screaming . . . with hatred of each other in their looks.' It was not a painter's way of looking at things: he never pointed out light effects or colours; his colours were combinations of the inner mind.

Another account comes from Frances Balfour, the wife of Eustace, Arthur Balfour's brother. In the late seventies she was, as she tells us in her memoirs, a timid young woman conscious of her crippled leg (she had been lame since the age of two) and 'wretchedly farouche in my new life and surroundings'. Burne-Jones was asked to draw her portrait, partly to give her confidence, while her husband read *Cranford* aloud. Ned worked slowly, often stopping to talk. As the delicate drawing progressed Frances fell without effort under his spell. 'It was not so with Mrs Burne-Jones, she was rather daunting.'

These portrait commissions, another result of the success of the Grosvenor, were a new departure for Burne-Jones; he frequently declared he had no eye for a likeness, and recommended William Richmond. Certainly he had nothing like Richmond's competence, but if a *rapport* was once established, particularly with girls and young children, he could produce strange and desirable portraits with a great purity of outline – he would rather begin again than rub out – and a trance-like calm of pose which has about it a

suggestion of tension, either in the hands or the expression of the eyes. His method was to start drawing, and only to go on if the likeness 'came'. In the summer of 1879 he went – although he dreadèd railway ticket-offices – to Hawarden. On 18 August Mary Gladstone noted in her diary that it had been a noisy week, with cousins and the Crown Prince of Sweden and 'the poor little Duke of Newcastle'; then came a week of repose 'and most brilliant the place looked, such depth of green, and bright breezy weather . . . mostly spent lying on the grass under the trees while Mr B.J. drew and I sat to him and an ideal portrait he made.' This pencil head, as Ruskin says, '[with] the pale and subtle tints which give nobleness of expression . . . reaches a serene depth unattainable by a photograph and which is certain to be lost in finished paintings.' The drawing is still at Hawarden and it is sad that the top of the head has been cut off by injudicious framing. In Mary's candid gaze artist and subject exchange, as Matisse said they must, the warmth of each other's hearts.

What was it like for a painter, a nobody except by virtue of his painting and his own personality, to stay in the country houses of the eighties? It was 'horrible', wrote Burne-Jones, looking back on it,[8]

from the dawn when a bore of a man comes and empties my pockets and laughs at my underclothing and carries them away from me, and brings me unnecessary tea, right on till heavy midnight I [was] miserable – and if there is one of all the company that it would be nice to spend all the time with I can never be with her [him I mean] – somebody else steps in first as at the pool of Siloam.

Dicky Doyle was actually driven to hiding *his* wretched underclothes under the pillow, and used to lie in bed pretending to be asleep while the footman vainly searched for them. Like Ned, Doyle was driven to these visits by the unattainable – his hopeless love for Lady Airlie, the Fairy Princess of his later toy-books. For Burne-Jones it was 'one of all the company', often, of course, Frances Graham. To the Lindsays' Scottish mansion, Balcarres (though Mrs Comyns Carr tells us that Blanche was but a poor hostess, and once served paraffin instead of salad dressing, noticed by no one except Arthur

Sullivan) to Naworth, and to the Percy Wyndhams at Wilbury, he could go more confidently, as a long established friend, but still in the expectation of:

> An entrance to that happy place
> To seek the unforgotten face . . .

It may be added that the country houses, except at the height of summer, were icily cold, so that the ascent to the bedroom, candle in hand, was like an Arctic expedition. When Burne-Jones got back to London he took to meeting the unforgotten young women in the heated Palm House in Kew Gardens.

But Burne-Jones was not 'brought out' easily. He feared he might be considered a bore. This danger past, he feared to enjoy himself too much. 'Life and real people beguile me into being unreasonably happy', he wrote to Mary Gladstone, 'and it is hard to see back into the dream country where my real home is.' Out of it, he was always more or less at risk. Frances Balfour was aghast when one of her dinner guests, the Commissioner of Lunacy for Scotland, hard as Aberdeen granite, began to attack Carlyle on the evidence of Froude's *Life*. To Ned, Carlyle (in spite of the unfortunate visit) was an article of faith, and he became 'white with distress and miserable anger, and said he must leave the house if such talk went on'. Only Arthur Balfour had the tact to smooth over the evening.

At the same time – and here he was much more at his ease – the Grosvenor exhibition had led to a reopening of friendship with established painters whom Ned had scarcely seen for years. Val Prinsep, much too easy-going for the old ideals, had for years been 'selling to H.R.M. and satisfying the Royal appetite for dairymaids'[9] – worse still, he had painted the Queen as Empress of India – but he was an old friend; Millais Ned had always loved, and he went with both of them to the Fred Walker retrospective. Leighton, whom he had known, off and on, since the days of the Hogarth Club, was now a *grand seigneur*, tipped as the next president of the Royal Academy; Holland Park Road was regularly blocked with carriages arriving for 'crushes' at his magnificent new house. In 1877 he was extending the Arab Hall, for which Richard Burton was 'nobbling' old tiles in Smyrna, while William de Morgan, having rediscovered the secret of the old lustre, was filling up the gaps with splendid new

ones. Leighton's intention was to 'let loose' Walter Crane and Burne-Jones on the mosaic roof, and although in fact Ned never worked on it, he began to see Leighton much more often and from 1878 onwards he and Georgie attended the yearly 'musics' in the grand salon. These were reunions of the famous in society, art and letters, with exquisite performances, though Burne-Jones did not much care for Mendelssohn. 'Talent and industry have no place in music,' he said.

More unexpected, perhaps, was Ned's sympathy with Alma Tadema. 'Tad' was Dutch, uncompromisingly bourgeois, making frightful puns, comparing friendship to two hands clasped over the same stomach; talent and industry certainly had a place with him – his first commission from the dealer, Gambart, had been for 'a couple of dozen at progressive prices'. He had been established for about seven years with his cosy family in Park Road, St John's Wood, was smilingly surrounded in his studio by Graeco-Roman subjects, always with a bright blue sky, attended fancy-dress affairs in a toga and monocle, and had got up his dining-room as an imperial banqueting hall. Burne-Jones, however, loved him because he was lovable and valued him as a painter of reflections in bronze and marble. 'Tad' freely admitted that he had first become interested in these in the marble-lined smoking-room of the *Cercle de la Concorde* in Ghent. 'No one ever has or ever will paint light on metal like Tadema,' said Burne-Jones, who was beginning to make studies of bronze and gold for *Cophetua*. 'Tad' was also a portraitist from whom much could be learned, and the brilliant *De Epps* (his father-in-law) was shown at the Grosvenor in 1880; so that his favourite riddle: *Q. When is a painter not a painter? A.* None times out of ten – which Brune-Jones tactfully 'gave up' – was not quite so embarrassing as one might expect.

'Tad', who was endlessly hospitable and in touch with European painters, introduced Ned to Jules Bastien-Lepage, who in June 1882 was paying his last visit to England. Bastien-Lepage, already touched by the cancer which was to kill him a year later, was mainly interested in seeing the Rembrandt etchings in the British Museum, but he had time to do a few London sketches and one of them was of Burne-Jones; it is in the painter's own spirit of *faire vrai* – a melancholy, light-eyed, haunted face under a shapeless and yet defiant soft hat.

Much queerer was Ned's encounter with Tissot who by 1877 had had considerable success with his delicious society pictures. But after a visit to the Grosvenor he experienced, it seems, a change of heart. 'A big strong-looking man, and he made me compliments, and said he should paint no more as he had done of late.'[10] Ned never spoke about this to anyone except Mrs Gaskell, being rather doubtful as to whether it was a conversion for the good since although he shrank from Tissot's subject-matter ('fat ladies and cigars') he loved the quality of his paint.

Friendship with Watts was steadfast and needed no renewal. The Signor was well established at what was now called Melbury Village. It was probably at his suggestion that the grey and blue *Annunciation* of 1879 was painted from Mrs Prinsep's niece Julia; she had married the widowed Leslie Stephen. Against a street of tall arches and steps which Ned took from his 1871 notebook, Mrs Stephen appears in all the grave beauty of early pregnancy. The baby grew up to be Vanessa Bell.

The multiplicity of Burne-Jones's life, his total exhaustion after any expedition as well as his own frequent delcaration, which he didn't perhaps intend to be taken too seriously, that he longed for the quiet and seclusion of a monastery, all led Georgie to look about (as she had looked for The Grange ten years earlier) for 'a little house of our own by the sea.' Ned suggested Brighton, which Georgie associated with the Ionides and hated. She 'found nothing', turned her back on Brighton, and walked westwards over the downs to Rottingdean. 'It was a perfect autumn when . . . I entered the village from the north,' she writes in the *Memorials*,

> no new houses then straggled out to meet one, but the little place lay peacefully within its gray garden walls, the sails of the windmill were turning slowly in the sun, and the miller's black timber cottage was still there. The road I followed led me straight to the door of a house that stood empty on the village green, and we bought it at once.

The name of the small whitewashed property was Prospect House. Milk came from the farm in pails (as indeed it had in Fulham when they first went there) and there were cornfields right up to the back window, with a view of the ridge of the downs 'over the tender,

bowed locks of the corn'. From the front windows you could see the solid little grey church, which had survived gales and fires and even the restorations of Gilbert Scott. Its dedication, by a happy chance, was St Margaret's.

It was the first house that had ever belonged to them. Morris himself had never had a place of his own since the Red House was given up, and Rossetti, who had never owned one at all, commented with amazement that 'Ned was culminating'. This was an exaggeration. The house was only just large enough for the four of them, and was rigorously uncomfortable. Rottingdean in 1880 was a secluded, even secret village where boys in the street threw stones at strangers and black oxen were still used for ploughing. The mill had only just stopped grinding the villagers' corn, there was only one horse-bus (known as 'the coffin on wheels') and the grocer, Tuppence, stocked everything from string to seed potatoes. But all this was a relief after the unwelcome changes which had been taking place in Fulham. The District Railway had arrived. All round The Grange speculative builders were running up streets of semi-detached villas. The walnut trees had gone, the briar roses had gone. Fulham had become West Kensington.

The Grange, as a direct result of Ned's new success, had become a scene of redecoration and the dreaded spring cleaning. His account books show extensive orders from the firm, including 'Bird and Vine' bed-hangings and (an unaccustomed luxury) yellow velvet chair-covers. Hot water-pipes were laid (only in the studio, but Victorian families were used to this). W.A.S. Benson was called in to design an additional studio across the end of the garden where the huge canvases could be stored. Ned also bought a new piano from the Grosvenors, offering to take it in exchange for a bundle of old clothes (to which Georgie added a postscript 'Joking apart . . .').[11] The little Russell Place piano had lost its tone, and the replacement had offended by its walnut case – 'striped like a tom-cat, by Jove!' Morris called it. Altogether Burne-Jones spent £250 on redecoration this year, but almost at once he earned £200 from the Brampton windows. At the same time, having noticed some disquieting heart symptoms – and although he treated every cold and headache as a drama, he never said much about these – he silently increased his life assurance.

Margaret was fourteen – 'unfairly pretty', as Graham Robertson

found her. She recognised calmly that she was growing up, and complained that her father's portrait of her in a muslin dress gave her a flat chest. Oscar Wilde rowed her on the Thames, straw-hatted; she sat for Watts, and was the darling of her music-masters. There was no stage of life at which Margaret was not beautiful and composed, and none, up till now, at which Phil had not been unhappy. At Marlborough he had suffered from 'long fits of apathy varied by half-hysterical times of religious anxiety, distressing to see',[12] and had at last been removed to study with a private coach. He was to go to Oxford and to be entrusted to Charlie Faulkner at University College. In 1878 Ned took him to Paris on what must have been an exceedingly dull trip with Crom and Sidney Colvin; Phil, aged seventeen, was taken to Punch and Judy in the Champs Elysées. When in 1880 he at last went up to Oxford he showed for the first time 'simple animal pleasure in being alive' and his parents, without any suspicion of what this might lead to, were for the moment grateful.

On the domestic side Ned had sudden bursts of rashness: one day he dismissed the cook – though he described her as being twice as big as himself, and twelve times as big as Georgie – for being, as he put it, so ugly; in consequence he had nothing but bread and mutton-chops to offer Miss Stuart Wortley, who was due for lunch. The annual visit from Mr Jones was a trial, although Ned was glad to offer him a few weeks away from the cantankerous Miss Sampson. 'My father is here and very trying, very – as parents are always – he sits and admires everything that belongs to me till I could beat him, and it makes me feel wicked and remorseful.' Thirteen-year-old Rudyard Kipling, now at the United Services College with Crom as headmaster, spent part of every holiday at The Grange; Professor Norton's children were often left there.

Georgie, as Ned well knew, bore the burden of everything. About 1883 he began her portrait, a low-toned, quiet study with the children seen through a narrow door. Georgie's eyes, in all their searching directness, are the focus of the picture. Like Mary Zambaco, and Janey in *The Blue Silk Dress*, she is reading a book and holding a flower, but the book is Gerard's *Herbal* and the flower is heartsease, which, Gerard tells us, 'growth in fields and in gardens also, and that oftentimes of itselfe: it is more gallant and beautiful than any of the

wild ones.' Ruskin's *Proserpina* (1882), his strange 'School Botany', tells us that heartsease is the flower of those who love simply, 'to the death', and adds that 'in daily life, one often sees married women as good as saints; but rarely, I think, unless they have a good deal to bear from their husbands.'

13

1878–84

KING COPHETUA: THE STUDIO IN THE EIGHTIES

The second and third spring shows of the Grosvenor Gallery established Burne-Jones as their leading painter, and their queerest and most controversial one. In 1878 he exhibited the *Chant d'Amour* and *Laus Veneris*, in 1879 *The Annunciation*, and in 1880 *The Golden Stairs*. Like all his pictures, except for the portraits, they were based on ideas and treatments that had lingered for years in his mind, a mind that was obliged to repeat certain obsessional patterns corresponding to the inner life. The enchantment of the willing victim, sleep, waiting, imprisonment, loneliness, guiding, rescue, the quest, losing and finding, tending the helpless, flying, sea-crossing, clinging together, the ritual procession and dance, love dominant and without pity, the haunting angel, the entry into life – these returned again and again in his tormenting daily experiences and in his painting, and hence, often with doubtful appropriateness, on the walls, windows and tapestries of his eager patrons.

The *Laus Veneris* is a magnificent object, a craftsman's showpiece, a reminder of Burne-Jones's own saying that painting should be like goldsmiths' work and that in times to come if even a square inch of it is dug up, it should be recognisable as an artifice. Venus's draper, in glowing orange, has even been textured over the paint with a small round instrument. Stranger still, the dread hall of Venusberg is furnished by the firm, with a tapestry version of Ned's *Passing of Venus* on the walls, de Morgan's lustre tiles round the window, and the goddess reclining in a chair which might be from the firm's catalogue. Yet all this is not incongruous; why should it be? It is Burne-Jones's peculiar vision of the Venusberg. He had been

allowing it to grow in his mind since 1861, and this second version had been painted largely during 1873–5. In Swinburne's *Laus Veneris* the goddess weaves 'exceeding pleasure out of extreme pain'; in Morris's *Earthly Paradise* she is, most characteristically, transformed into a healthy naked girl and everything takes place in the open air; in 1876 *Tannhaüser* was given at Covent Garden. But to Burne-Jones, Venus is at the end of her strength. The studies for the head (at Fulham Public Library), are for the 'sick Venus'. The knights who pass by the cold blue square of the window look in, but will not stop. The attendants wait with their music for a signal that never comes. As Henry James (still an 'attentive spectator') pointed out, they have a more innocent and vacant expression than the goddess whom they cannot cure. The *Laus* is a picture of the death of love, though the painter regrets the death. 'You ask me if I have ever found temptation irresistible – no, never – if I have given in I have given in with my whole will, and meant to do it.'[1]

The Golden Stairs, the great sensation of 1880, was a canvas even larger (nine foot by four) than the *Laus Veneris*, as though the painter's world had expanded uncontrollably. The title is from Dante's *non vi si monta periscala de oro* (no one may ascend the golden stair); it was the final form of a design which he had been struggling with under various titles – *Music on the Stairs, The King's Wedding* – for over ten years. His feelings towards it varied, particularly when the main entrants into life – Margaret at the very top, Laura Lyttelton, May Morris (centre), Frances Graham (extreme left), Mary Stuart Wortley (the second to approach the door) – had taken their places on the stair. Handsome, discontented May Morris is central to the picture; not only Bernard Shaw, Cockerell wrote, but Stanley Baldwin fell in love with her, 'and so did Burne-Jones'. Mary Gladstone, visiting The Grange on 29 March 1880, found Ruskin and Mr Hamilton (Graham's partner) 'quite mad, Mrs Birks with her scarlet shawl and locket, and May Morris with her beautiful straight features and parted unfrizzed hair'. From later remarks one can gather that May was rather less than tolerant of 'Ned's nonsense'. At the beginning of 1880 Ned was still writing to see if George Howard could suggest 'a nice innocent damsel or two' to fill up 'the staircase picture'.[2] Nevertheless, it remains a powerful image of whiteness, with its grand spiral movement down the stairs mysteriously suspended, and the growing tension of the faces

approaching the door. Rossetti, who complained that Ned had 'stolen' the design of his unfinished *Boat of Love*, showed that he understood the meaning well enough, for Dante's boat voyage is an invitation to a new stage of experience. Rossetti could have answered the questions which came from all over the world (some are in the columns of *Notes and Queries* for 1880) as to what the picture meant. Even Morris was applied to, but according to May Morris, replied with a grunt.

The Golden Stairs was commissioned by new patrons, Constance and Cyril Flower (later Lord Battersea). Constance was a Rothschild, Lady Lindsay's niece. In 1877 she married her impossibly handsome husband, 'the irresistible man'; he was supposed to be the original of Eric (or Little by Little), and it was said that tailors and boot-makers came to beg him to reveal his secrets. Constance herself would have liked to build a House Beautiful in the slums of Battersea, Cyril's new constituency, and to invite the working people to see her possessions. 'It would have been a splendid experience', she writes in her memoirs, 'but it was not to be.' Cyril preferred Surrey House, Marble Arch. He began to collect – he had been hard up for so long! – treasures innumerable. There were mistakes. In Rome, to Constance's 'utter amazement' he suddenly bought Storey's huge *Sardanapalus*; nothing could be done with it, it had to go to Scotland to be used as hewn marble. In Venice he had to be restrained from hiring Desdemona's Palace on the Grand Canal. His tastes modified slowly. Burne-Jones liked the generous Constance, Cyril not quite so much; anyone who wants to study the art of refusing invitations gracefully might study his letters to Cyril Flower.

The Golden Stairs took time; Burne-Jones put his patron off with the ease of long practice.

> The picture of many maidens – foolish virgins – or by whatever name it is to be called – goes on nearly every day . . . I should like you to see it when it is nearer finish – I have drawn so many toes lately that when I shut my eyes I see a perfect shower of them . . .

In later years, when they had long been owners of the picture, the Batterseas met on a cruise two French 'suffragists'.

> They were quite modern in all their tastes, and proclaimed above all

their allegiance to Rossetti, Watts, and above all others, Burne-Jones. 'Ah, how beautiful is the picture called "The Golden Stairs",' said the older lady. 'I am so glad,' I replied, 'I have it.' 'Indeed,' said the lady, 'and what may be the size of the engraving?' 'Oh,' I answered, 'there are many sizes, some very fine ones, quite large, others small and inexpensive . . . but I have the picture itself.' 'You have the *original*,' screamed the lady. 'Then you knew him – you knew the master?' 'Yes, of course, he was a very great friend of ours.' 'A friend! then you belong to us, you belong to *le monde bohémien!*'

The Golden Stairs, bequeathed by Lady Battersea to the nation, languishes now in the basement of the Tate Gallery.

The reference to engravings shows that Burne-Jones had entered into that strange extension of a painter's life-work, reproductions, the shrunken ikons that disperse him through time and space into the *musée imaginaire*. Like every other Victorian artist, he tried vainly to keep this process under his own control, and both he and Watts (whose work was never reproduced before the Grosvenor exhibitions) were fortunate in being introduced at this time to the photographer Fred Hollyer. Leighton was responsible for this. He recommended Hollyer, who made photographic reproductions of Burne-Jones drawings so delicate that they sometimes pass today for originals. In dealing with Hollyer, and later with the engraver Jasinksi, Ned found himself unexpectedly lucky.

Reproductions of *The Golden Stairs* were advertised next to Floriline Hair Tonic and Epps's Cocoa. Burne-Jones accepted this, still hoping, in this way or any way, to serve a wide public without alteration of his ideals. From 1877 the firm no longer supplied new windows for ancient churches. Morris, in his noble fury against restoration, had made it a principle not to do so, and the Burne-Jones angels for Salisbury Cathedral were the last commission of this kind that Morris himself accepted.[3] For modern churches Ned of course continued to work, and from the Ionides family came the idea that he might design not only the glass but the mosaic for the Greek community's new church, Santa Sophia, in Bayswater. Burne-Jones told Constantine that this was 'the dream of his life' – a dream that compassed his memories of Torcello and St Mark's; but the rest of the community did not know the artist, and the scheme

was turned down. It was not until much later that Alexander, Constantine's son, was able to get his revenge: these same protesters tried to introduce glaring lights into Santa Sophia, and he was able to ask them 'whether the Seven Lamps of Architecture were to be extinguished in Bayswater?' Meanwhile a new opportunity came Burne-Jones's way when Street, who had been commissioned to build the American Episcopal church in Rome, asked him to design mosaics for the apse and choir. The scheme, as might be expected, took shape slowly in Ned's mind, dim with muted gold and crowned with angels. His notes in the British Museum 'secret book of Designs' show that he studied the hierarchy of angels from an account of the Iviron monastery. At an early stage he decided on a Christ in Majesty, with a dark empty space left for the fallen Lucifer. A letter to George Howard, however, even at this early date, shows doubts. 'The Roman church I shall give up. Street is dead that would have come between me and the cloth and helped me with the workmen.'[4] The 'cloth' might, he felt, object to his conception of the cross as a living tree, putting out leaves as a sign of rebirth. Yet even after Street's death in 1881 he struggled on with the commission. A long correspondence opened with the Compagnia de Venezia-Murano. The first sample work was disastrous, the tesserae were the wrong size, the Italian workmen had (of course) given the angels blonde hair and pink faces, whereas Ned wanted 'the hair dark, the faces sweetly pale – the eyebrows straight, the darkness under them steady and solemn'. Rooke, who took yearly sketching trips to Italy, had to do what he could in Venice; Morris helped to sort out the colours. 'I wonder if it would have been better if I had sent no instructions at all . . . I will unsay all my old directions and bid them to do it in their own accursed way – perhaps that would be best . . . O for God's sake let them forget all I said,' Ned wrote, and in fact he was inexperienced in the new media; this is suggested in the dignified reply of Signor Castellani, the director of the company: 'It is not the mosaic as we are used to make, or as we understand.' Although harmony was established and the designs were finished by 1884, the scheme was still not complete at Burne-Jones's death.

At home, Burne-Jones was much concerned with what he called his 'purchases', that is, his ceaseless gentle pressure on the authorities to buy works of art for the nation. 'All our pictures all together to [sic] all England couldn't cost more than a couple of

ironclads that are a mistake in two years' time,' he wrote to Mary Gladstone in July 1882. Funds must be put aside regularly. In 1880 he tackled Joseph Chamberlain on the question of founding the Birmingham City Museum and Art Gallery. In February 1882, the Duke of Hamilton decided to sell the Hamilton Palace collection through Christie's since, as *The Times* put it, 'tall chimneys pouring forth noxious vapour rendered the Palace every year more unsuitable as the residence of a great nobleman'. Burne-Jones would have liked those who worked in the noxious vapour to have something beautiful to see. He accompanied George Howard and Fred Burton to the auction, and, against competition from the Louvre, the National Gallery acquired the Botticelli *Assumption* and *Adoration of the Magi*, the Mantegna panels, and (though certainly not at Ned's suggestion) the Velazquez *Philip IV*. The Botticelli illustrations to Dante, much to his distress, they let go, but he was able to subscribe to reproductions by the Berlin Photographic Company, when they began to issue them in 1884.

Apart from these larger concerns, Burne-Jones was, as he had always been, endlessly patient with private charities and personal appeals. In 1881 we find him offering to teach tile-painting to a friend of Mary Gladstone's who had suffered a bad loss. 'I am not thinking of solace or any such matter – the kind of painting I mean sharpens and doesn't blunt memory.' He was also active in the case of Joseph Skipsey, a collier who had been down the pits since the age of seven. '. . . And I could not bear to watch him look at my pictures . . . the look of his face being satisfied with colour.'[5] Ned hated the idea that Skipsey (or anyone else) might feel he was being patronised. Not money, but 'the upper air' was needed. With George Howard's help, he got Skipsey the job of caretaker at Shakespeare's house at Stratford.

Beneath everything he did was the uneasy longing to go back to Italy. Fairfax Murray and Rooke continued to send back drawings and photographs, and there was really nothing to stop him travelling out with them, or with George Howard, or Spencer Stanhope, or Edward and Aggie Poynter, or even with the Gladstone family, touring under the direction of Sir Stephen Glynne, who 'had the churchums'. The Rome commission made it almost necessary for him to go out, yet he did not go.

Work with Morris was the solid foundation of his life. He did not

go down much to Kelmscott, which was now held on a joint tenancy with F.S. Ellis. Although he was not at all demanding in the matter of comfort, Ned could not quite face the prospect of coarse fishing on the flood-waters and the house itself, where half the kitchen had been turned into a stable for the Iceland pony. Janey was often in Italy. She was much aged,[6] and indeed Morris himself had begun to look ten years older than his real age. But he continued to come to The Grange several times a week to discuss joint undertakings, and from the end of 1881, when he moved his workshops to Merton Abbey, Burne-Jones was called upon for figure designs for tapestry. There were important private commissions. The *Musica* panel, yellow wool embroidery on linen, was designed for Alecco Ionides and his Holland Park house – and George Howard commissioned not only tapestry but the entire decoration of Palace Green from the firm.

Palace Green had become largely George's domain, while Rosalind, who hated it as a centre of idle Bohemians without commitment to the causes of temperance or radical policies in Ireland, kept largely to Naworth. Her little-used boudoir at Palace Green, however, was planned with particular care. It was to be hung with printed cotton in deep rose to bring out the blue-grey of Ned's *Annunciation*, while the *Psyche* series were set as a frieze into the dining-room walls. But the work went along very slowly. 'I am bound to ask your pardon for having neglected this job,' Morris wrote in 1879. 'I wanted to make it a delight . . . I gather that you are disappointed,' Ned continues in 1882.[7] At length Walter Crane was called in, as he tells us in his *Reminiscences*, to help finish the paintings, 'in all stages of completion', and to add raised details in gilt; the *Psyche Sacrificed*, however, Ned declared he must finish himself. Crane, driven almost to exasperation, was still more disconcerted when Burne-Jones 'pretended to assume the manner and language of the ordinary British workman "on the job" . . . and, when Mr Howard came to see the progress of the work, insinuated the broadest hints about prospective cigars and drinks we were to enjoy at our host's expense. 'The decoration was finally completed in 1882 and celebrated with a Christmas party more in the spirit of the 1860s, with the gloomy Poynter and the imperious Countess of Airlie joining in a game of dumb crambo.

But neither the work nor the companionship could hide the truth

that Morris, in the early eighties, was growing away and apart from his friend. After the collapse of the Eastern Question committee, Morris's energy had been expended, almost ferociously, in a dozen ways. He founded the Society for the Preservation of Ancient Buildings in 1878, took up de Morgan's idea of refacing London with ceramic tiles (the whole city, Morris said, could be hosed down every night with clean water), experimented in weaving, dyeing and indigo-printing, threw himself into the business of the National Liberal League. But the evident truth that Gladstone's ministry of 1880 countenanced war in the Transvaal, expansion of Empire, an Irish Coercion Bill and the 'development' of industrial cities drove Morris, once and for all, out of love with Liberal politics. In his public lectures he began to call for an end to an exclusive art lavished on a few thousand 'digesting machines' of the fortunate classes. 'I do not want art for the few, any more than education for a few, or freedom for a few.' With the nagging consciousness that the firm did in fact design for the relatively few who could afford it, he proceeded with magnificent simplicity from one step to another. If neither art nor politics could redeem society, and he had tried both, then society itself must change. The future must lie with Socialism.

Here Burne-Jones could not follow him. His conscience had a different history. It had been formed by the long struggle, against many difficulties, out of the povery of the back shop. 'Some day it will all change violently, and I hate and dread it but I say beforehand that it will thoroughly serve everybody right,' was Ned's honest, but not heroic opinion. More seriously, he held that the same rules which govern individuals in their relations to each other should govern society: decency, sympathy, and respect for privacy. But the thought of a serious difference with Morris sickened him. He noticed a deterioration, even at this stage, in his friend's health. A tower of strength in daily life, Morris now became 'sad after meat', that is to say, he lost grip after the large dinner he usually ate. 1880 was another 'season of dreadful dreaming'. Night after night Ned seemed to arrive at a house in a dull cathedral town, recalled he had once lived in great misery there, was forced to go up the steps and then turned back at the door. He also dreamed of being suffocated.[8]

He was frightened by Morris's growing stoutness – he could hardly lace up his boots, and one of Ned's little drawings of him in the British Museum is labelled 'all more arse'. It was this fear, only

just disguised as a joke, which combined with even deeper ones to produce Burne-Jones's fantasies of Fat Ladies (or Prominent Women). Both Georgie and Frances Horner strongly disapproved of these, yet he continued to do them for nearly twenty years. There are pig-like Fat Ladies in bed, in the Turkish baths, chased naked by a swarm of bees, bending over his easel and stifling him, invading the beath at Rottingdean. The horror of fatness, which he shared with his father, was obsessional – he could hardly bear to see the Sunday joint with its 'lappets of fat' brought into the kitchen. Rubens' naked women nauseated him. The recurrent dream, which he described in 1894, explains itself: 'Sometimes I marry very undesirably, hairy fat women and wake disgusted.'[9] To go to bed with a Prominent Woman was a lurking horror which made a mockery of beauty and sexuality alike.

It seems likely that 1880 was not a year in which the mysterious man in black came up to him in the street and whispered 'God bless you'. 1881, the following year, 'seemed', Georgie wrote, 'from its effects to have been more than twelve months in length, and in the end Edward was a distinctly older man'. The failure of sympathy with Morris, together with the news of Rossetti – who had come back to Chelsea half-crippled under the shadow of a terminal illness – left Burne-Jones 'tired, depressed, confused, stupid'. The bright ones of his youth were fading. He began to work on the design for a picture which meant in the end more to him than any other, the *Sleep of Arthur in Avalon*.

It was to be commemorative of his own dead kings and the disaster which the world would suffer at their loss, not to be amended till the grievous wound was healed, and human beings realised that what they had thrown away was in fact what they needed most. The sleep of Arthur implies his reawakening, if the world would listen.

The design, the last thing he ever worked on in this life, never recovered the strength of its early stages. At the back of Burne-Jones's mind were the long slanting verticals of the mourning queens, the horizontal of the wounded king, moving in a magic boat through blank, motionless clouds and waves to Avalon. These appear in early sketches. As they disappeared, to be replaced by the island itself, the picture grew in size; it was evident that a long struggle was ahead, and an outside studio at Campden Hill Road was rented so that it could be

worked on alone. By January 1885 he had to write to the long-suffering George Howard, who had commissioned the work, that Avalon was getting very expensive – 'quite £3000' – and suggested keeping the large version (he had perhaps always intended to do this) and painting a smaller one for Naworth. This was to be a 'simpler scheme', with apple-trees in the background and a few figures 'life-size at least',[10] and the sketch (which is now in the National Museum of Wales) shows that it would have resulted in the finest picture of all. The water laps in the foreground, the seven separate figures stand apart, each deep in their own grief, two sentries look out across the sea, and above all there are the apple trees from which the island gets its name. These link it with the vanished days at the Red House, and Morris's *Pomona*:

> I am the ancient Apple Queen
> As once I was so am I now
> For evermore a hope unseen
> Betwixt the blossom and the bough.

In April 1882 Rossetti died at the inappropriate lodgings at Birchington where he had been taken in a last search for health. He had been destroying himself, on and off, for the last twenty years. Shields came to break the news to Ned who started out for the funeral but collapsed on the way. It was some kind of consolation to find that he was mentioned in Gabriel's will as 'my friend'. William Michael, relenting, sent Gabriel's spectacles and two or three of his paintbrushes as a memento 'if I needed to be reminded of him, which I never shall', Ned wrote, asking if it was possible to buy 'some little drawing of Lizzie's for Georgie, who cherishes her memory very dearly'.[11] With Fred Burton and Dicky Doyle he attended the sad Rossetti sale and the memorial exhibition at Burlington House. Old friends and new met; Ellen Terry was there in a 'hat and cloak of rough ulster, ignoring the gazes of the crowd' but so were Stephens and Leyland. 'Tennyson sought peace and got it', Burne-Jones told Rooke, 'while Rossetti sought tragedy and tragic his life was.'[12]

During the summer, this tragedy of long estrangement and death gave way to the tragi-comedy of Mr Jones. The old man – he was now eighty – had suffered so much from Miss Sampson that Ned had

brought him down from Birmingham and settled him in Ealing. He called on his father often, and never thought of him as lonely. They were still linked by the memory of the dead wife and mother who was spoken of only in whispers. But Mr Jones probably missed much more keenly the daily tyranny of Miss Sampson. One day in 1883 when Ned called in at his lodgings his father quietly told him he was going to marry the cook.

Burne-Jones found this sudden reversal of everything he had been taught to believe – the silences, the hallowed graveyard walks – exceedingly hard to swallow. When the old man and his new wife wanted to return to Birmingham, Georgie wrote, 'we did not oppose it'.

On 13 January 1883, Morris and Burne-Jones went to Oxford together on what should have been one of the golden moments of both their lives: Exeter had offered them honorary fellowships, and Ruskin, who had taken up the Slade Professorship again, was there to greet his pupils. But we may suspect that Morris had gone there only to please his friend. Four days later he enrolled himself as a member of the Democratic Federation. It was, he said, 'the only society I could find which is definitely socialistic'. With the help of F.S. Ellis he began selling his precious books, devoting the proceeds to the funds of the Federation. Another sacrifice was Hughes's *April Love*. In the following year he was too busy to come to The Grange for an evening every week, and even when he came, Burne-Jones wrote to Norton, 'we are silent about many things, and we used to be silent about nothing.'

To this desertion Burne-Jones could not reconcile himself. His pain was not lessened by having known, for more than two years, that it was likely to happen. In fact, like most human beings, he felt that having suffered in advance he should not be called upon to do so again. He did not question Morris's nobility in offering all that he had in the name of humanity itself. But, having watched the political temperament far more closely than Morris had ever done, he did not believe that much could be gained by any party, even a revolutionary one. He dreaded the rancour inseparable from new movements and could only hope against hope that Morris would teach them largeness of soul. Knowing his friend's emotional balance very well, and not being deceived, as so many were, by his exterior shaggy toughness, he feared for his health and even his life. Above all he suffered from a deep

sense of waste. Morris was born a poet – it was the loss of the poet, not the designer, that he felt most, for the firm itself was busier than ever. They had set out together to make the world less ugly, they had survived the emotional crisis of ten years back, and where was the quest to end now? Morris, the poet of the 'white-flowered hawthorn brake', was soon to celebrate May Day only as a time when:

> The chain the toilers bear
> Is growing thin and frail.

Burne-Jones, as might be expected, did not fail to defend Morris when he heard him attacked. Frances Balfour noticed that he smiled when Morris, 'having preached at a street corner that all things should be held in common', appeared at The Grange 'in explosive indignation' because his grapes at Hammersmith had been stolen in the night. 'Then in graver mood he would praise Morris for his advocacy of "causes" he knew little about '. . . while every minute of his time was precious for his designs, and Burne-Jones would glow like the colours he described.'

Yet Ned had failed Morris, and he knew it, though it was, he believed, the only time he did so. He did not either found or join a Fulham Democratic League. Georgie, on the other hand, an organiser and committee-woman of dauntless courage, would have been glad to do either. She remained a staunch Ruskinian Socialist and till the end of her life embarrassed her loving grandchildren who were ready to 'cry with confusion' when she fixed her clear gaze on some 'unlettered old woman, telling her tidings of comfort from *Fors Clavigera*'. Meanwhile Morris, sure of her understanding, wrote her a detailed account of every step he took. 'You see, my dear, I can't help it,' he told her in 1883, 'the ideas that have taken hold of me will not let me rest, nor can I see anything else worth thinking of.'

The beginning of 1883 brought Ned yet another painful blow. This was the announcement of Frances Graham's engagement to the barrister John Fortescue Horner. She had descended the Golden Stairs. It was a step which she herself described as like coming to port after stormy seas. But she was marrying a man of forty, not so very much younger – Burne-Jones often made this kind of calculation – than he was himself. She was to be taken away to the

depth of the country, to Wells in Somerset. Before she went, she came down to Rottingdean and he painted her as *The Spirit of the Downs*; 'we all', says Georgie, 'recognised the portrait'.

It does not help this kind of regret to know that it is absurd and must always have been absurd. For Frances he had poured out a wealth of invention, not minding if it was lost or kept, but knowing that she had the heart to care for it; he had drawn straight on to linen so that she could embroider it, illustrated, illuminated – 'many a patient design went to adorning Frances and her ways,' he wrote to Ruskin, managing after a struggle to strike the correct tone,

> sirens for her girdle, Heavens and Paradises for her Prayer books, Virtues and Vices for her necklace-boxes – ah! the folly of me from the beginning – and now in the classic words of Mr Swiveller 'she has gone and married the gardener.' Well, I can't remember a tithe of the folly there.

One of the patient designs (it took five years in all) was the beautiful Graham piano, in green stained wood, with seven roundels of Orpheus and Eurydice; Burne-Jones had included himself as a wintry Pluto. The last roundel was the touching *Regained Lost*. 'I wish the past would bury the past,' he once wrote.[13] 'That was the sin of Orpheus, to look behind him, even though Eurydice called.' And to Ruskin he added: 'We'll paint pictures of the wretches, and laugh and be scornful yet.' But he could not bring himself to write to Frances for more than a year after her marriage.

'I have been too miserable for a month past to do anything', he told the always sympathetic 'Duchess'.[14] His eyes troubled him particularly. 'I spent all yesterday at an oculist', he wrote to Swinburne, who after several failed appointments was eager to show him *Tristram of Lyonesse*,

> and when I appear I shall be in blue spectacles like a •••• German – pretend you don't notice – I know it is a great liberty to go in blue spectacles to the house of even one's oldest friend – it's like sitting in a wet macintosh.[15]

The eye failure, he admitted, 'frightened me horribly'.

Yet the early eighties brought him great consolations, without

which indeed this oddly balanced and tender-hearted man could hardly have continued to work as he did. The first of these consolations was the doing of Ruskin himself. Ned's letter about Frances was in answer to a request for a list of all his pictures to date: Ruskin's second Slade lecture was 'to be about you – and I want to reckon you up, and it's like counting clouds'. In this lecture, which placed Burne-Jones in relation to the Pre-Raphaelites and to Watts, Ruskin told his audience that to understand this painter they must adventure 'amidst the insecure snows and cloudy wreaths of the Imagination'; it was a strange land of the heart and intellect, the 'imagination of learning', and yet the drawing was 'entirely masterful', suggesting 'the grandeur of action in the moving hand, tranquil and swift as a hawk's flight, and never allowing a vulgar tremor, or a momentary impulse to impair its precision or disturb its serenity'. Meanwhile Burne-Jones, touched by this fine tribute, but conscious of so many vulgar tremors and momentary impulses, had begun what the *Memorials* tell us was 'the most soothing work he ever did'. This was the *Flower Book*.

The *Flower Book* consists of thirty-eight water-colours in tiny roundels, only just over six inches across. They were given to Georgie, one by one, as they were finished, and are now in the British Museum. They are mostly in bright colours, predominantly blue, touched with gold, or painted on yellow or red which shows through to make the lights. But gold and white are also hatched and speckled over the surface as highlights, and sometimes Chinese white is floated over pale colours to give the effect of clouds and drapery. They are delicate, fresh and strange, and one would have thought, quite unreproducible. But seven years after Burne-Jones's death Georgie had 300 copies printed by the Fine Arts Society for private distrubution, and the reproduction was so meticulous that loose pages are still being bought as originals.

In the *Memorials* Georgie gives no sign of recognising quite how odd the 'soothing work' was. Ned did not do pictures of flowers, but of flower names. The names could not be made up; they had to be collected from old botanists or lists sent by country friends. If the name was right, it opened a direct access, like an intensified view through a small round window, into the world where his own limited range of private images joins the world's store of archetypes – precisely what Yeats described as the *Anima Mundi*. The first

picture he finished, *Love in a Mist*, showed a naked man helpless in a solid cloud of mist. In *Jacob's Ladder* the angels on the ladder seem static while the earth and heaven move in wild circles behind them. *Witches' Tree* returns to Merlin and Nimué. The Grail is carried through a dark wood to a dying Knight in *Golden Cup*. A mermaid has her arms round her drowned man, with a bell ringing under the water, in *Grave of the Sea*. *Meadowsweet* is Arthur in Avalon. *Golden Shower* is in the interior of Danae's tower, with reflections of light from the gold. Love and his flock of birds reappears several times. Angels do not seem to cast shadows, though everything else does. In *Wake Dearest* the Prince bends over the Briar Rose. *Morning Glory* gives the effect of the first light over the cornfields, with an angel floating in a blue mist rapidly disappearing in the heat. In *Welcome to the House*, a little study in shades of gold, an angel opens a heavy gold door to welcome Margaret (though on the whole the faces are not characterised). *Wall Tryst*, in greenish moonlight, is Thisbe putting her letter through the wall, according to Ned's note at the back, where there is a long list of possible names, ending with Broken Hearts. *Arbor Vitae* is an image which was becoming increasingly important to him – the living Cross, shown as a tree growing from the earth. Only the foot is shown, with the lights of Jerusalem in the distance, and two stones on the ground. 'You must not call it Jerusalem, Edward.'

These secret designs, being on a miniature scale, could be easily taken down to Rottingdean, and many of them were finished there. He was supposed to rest, but could not acquire the habit of doing nothing. Nor was Rottingdean, however delightful, quite the centre of peace that he had thought it. Guests were asked down, and a bed found in the village for the unexacting Rooke. In the holidays Macdonald, Baldwin and Poynter relations arrived. Rudyard Kipling was brought down by his headmaster, Crom Price, and for the first time, saw where:

> The wise turf cloaks the white cliff edge
> As when the Romans came.

Up on the downs, as Ned described it, there was 'the smell of a thousand grasses', and the wind blew the mind clean. But in the village there were quantities of dogs and hens which disturbed him

far more than the noise of traffic and (what in the last resort he always needed) plenty of company.

The consoling influence which, with the *Flower Book*, helped him to overcome his distress of 1882–3 was the acquaintance of a small girl. This child was Katie Lewis, the youngest daughter of George Lewis, on whom Ned increasingly relied for help with his business affairs.

Lewis really was, and chose to give the effect of being, like a character out of Dickens – probably Jaggers in *Great Expectations*. He was born, like Ned, in 1833, but as a Jew was not allowed to go to Oxford: he studied at the new University College and was articled at seventeen as his uncle's solicitor's clerk. He liked to recall his first client, a very large woman whose son was accused of robbing the till in a public house. In the years that followed he specialised in fraud and commercial libel, and became the defence solicitor, it seemed, for half the Victorian world. By maintaining a network of underworld contacts he got to know enough about all the adventurers and criminals in London to save many clients from blackmail. He was Parnell's solicitor, and Parnell trusted him; he prepared Whistler's petition in bankruptcy; he acted in the Balham case and was the only man to know who really poisoned Charles Bravo; he handled the difficult Baccarat case and helped to extricate the Prince of Wales. 'Oh, he knows everything about us all, and forgives us all,' said Oscar Wilde, whose real collapse began after Lewis refused to act for him any further. Yet Lewis shared his father's reputation as a reformer and poor man's lawyer. He was proud of his Jewish ancestry and kept on the dark warren-like chambers in Holborn where he and all his brothers and sisters had been born. Here visitors were sometimes admitted to the gas-lit strong-room where the great black deed-boxes were turned to the wall so that no names could be seen. Lewis had his enemies, but he had their measure. He committed nothing to paper – all his secrets would die with him – and a man who had no vices except a weakness for a good cigar could not be got at.

When he was left a widower in 1867 Lewis chose his second wife, like his first, from the German Jewish community, and with her by his side he became a genial patron of the arts. His town house in Portland Place was a centre of music and hospitality. The cellars were packed with rich gifts from his clients – gold and silver, oriental

curios, weapons, vases, cigar-cases; Lewis neither looked at them nor spoke about them. Upstairs in the great rooms were hung the pictures he loved, and from Burne-Jones he commissioned a portrait of his wife and several portraits of his daughters. A place of honour over the drawing-room fireplace was reserved for Katie.

Burne-Jones took two years to finish the portrait – from 1882 to 1884. Katie is dressed, not at all becomingly, in black velvet with black stockings. She lies at full length on Burne-Jones's familiar studio couch, absorbed in reading – the picture is signed on the pages of the book – and her expression is uncompromising and even cross. No attempt has been made to give her solidity – her head does not even sink into the pillow – she is a pattern against the red-brown drapery, while the orange, the black velvet, and the little Yorkshire terrier make an absurd but elegant reference to Ned's favourite *Arnolfini* portrait. Yet this is one of his most successful portraits, and his treatment of the resolute face has the same respect that Lewis Carroll showed to Alice. For at six years old Katie knew exactly how life should be conducted.

George Lewis recognised the quality of the portrait immediately. 'Although he knew enough to hang half the Dukes and Duchesses in the kingdom', Burne-Jones told Rooke, 'he couldn't think how to thank me. He fidgeted about and finally gave me as many boxes of cigars as he could lay hands on.'[16]

It was while Lewis was in Paris with Comyns Carr, during the summer of 1883, that Burne-Jones wrote to the little girl whose Papa was away the famous series of *Letters to Katie*. They contain some of his most delightful drawings – the pigs and the pork pies, the butler dropping the tea things – and some in which the sadness is not far below the surface: he appears as a crumpled, ageing figure being taught to dance by a graceful Margaret, or vainly trying to climb into his own pictures and falling through the canvas. The letters, as Graham Robertson points out in his reticent introduction to the published edition, were written when Burne-Jones was in 'a babyless void'; his own children were growing up and 'he had grown to need the criticism and collaboration of a baby'.

But Katie herself grew up. The imperial certainty of six years old began to fade. Oscar Wilde, writing to Mrs Lewis in February 1882, is already worried to hear from Phil that Katie is turning angelic and 'giving up' to her sister. It was her 'fascinating villainy as a

trenchant critic of life' that had attracted Wilde, and touched Burne-Jones in the sour, forceful little girl whom he immortalised.

As Katie grew up, so too did Margaret, and passing effortlessly from the awkward age which Phil never left, emerged as an enchanting eighteen, 'dispensing', as Burne-Jones put it, 'lower middle-class hospitality with a finish and calm which would not disgrace a higher social position'. The possibility that she might grow up still further – might want to marry – was unthinkable, and therefore unthought of by her father, but in August 1884, when she was getting ready to go to Scotland on holiday, he suddenly became quite certain she would never come back alive. William Richmond was asked to paint a good likeness before she went away. As it happened, Richmond himself had second sight – he 'saw' the death of the architect William Burges in his Gothic bedroom in Melbury Road three weeks before it happened – and he painted a most sympathetic portrait which was hanging on the stairs at The Grange when Margaret returned. It was joined later by Burne-Jones's own *Margaret with a Mirror*, in which her girlhood room is minutely reflected in the round surface of the glass behind her. She holds a sweet pea – in the language of flowers, departure.

> I wonder if in your hand there grows stems of wild-rose such as I have had to paint in my four pictures of the sleeping palace – and if deep in some tangle there is a hoary, aged monarch of the tangle, thick as a wrist and with long, horrible spikes in it? Such a hoary old creature [Ned wrote in 1884 to Lady Leighton Warren] might lurk under the leaves whose aspect would be terrible.

What he could not acknowledge in words must be painted, and in the eighties he returned to the theme of Briar Rose. In this reprise, however, the princess must not, as she had done in his earliest designs, wake up. The sleep itself is much heavier than in the 1870–3 series done for William Graham; it has become a stupor. But the briar with its 'terrible aspect' is the key. The briar is at the same time an obstacle to the prince (the only standing figure), a protection for the precious sleeper, and in its unchecked growth – the roses and thorns break through the very bed that she lies in – it can be felt as a threat to the life of the whole palace and everything living in it. In 1886 Burne-Jones painted a single figure of the Sleeping Princess herself, and gave it to Margaret, an unspoken

special pleading. But at the same time he painted *Flamma Vestalis* – 'looks a little like Margaret', as he noted in his work-list – a study in profile of a not at all submissive vestal.

Perhaps, in the end, only Ruskin truly divined the inner subjects of Burne-Jones's pictures. 'You cannot make a myth unless you have something to make it of. You cannot tell a secret you don't know . . . if the sunrise is a daily restoration and the purging of fear by the baptism of the dew, only then shall we understand the sun myth.' And only if we are afraid to lose a daughter shall we understand *Briar Rose*. Before the Slade lecture Ruskin had given Ned a commission for a painting, a *Rape of Persephone* in memory of Rose La Touche, now eight years under the earth – 'my Persephone' as he had called her when she had stood in the sunlight in the garden at Denmark Hill. The pencil study for this (now at Birmingham) is a tense and agitated design with crowded figures protesting as Pluto sinks with Persephone into the ground – 'a nice garden, a real one, all broken to bits', Ned wrote to Ruskin, 'and fire breaking out among the anemones'. The face is recognisably taken from the pure insipid profile of Rose which Ruskin had drawn himself. But the picture was never finished. Perhaps Burne-Jones could not believe that Ruskin wanted to look further into the heart of that particular myth.

The *Briar Rose*, in various stages of finish, occupied the corners of the studio, but the great exhibit of 1884, whose departure in a cab for the Grosvenor Spring Show left a great bare space on the wall, was *King Cophetua and the Beggar Maid*. For this picture Burne-Jones made many studies, some of them later than the painting. The subject, like *The Mill*, is a tribute to his Italian masters – the design is based on the Mantegna *Madonna della Vittoria* – and the projection of his own deepest inner life. The king in homage offers his crown to the barefoot girl who sits coldly on the throne a step above him, quite alien to the warmth of the golden chamber, the orange trees, the singing boys and the autumnal sunset glimpsed through the high window. Burne-Jones rejected his own earlier concept (and Tennyson's) of the king 'stepping down'. That was not possible. The king has searched through the wide world to find his ideal, but now that she is enthroned his glance is dejected. The painter put forth all his expertise in the painting of metal: the king's armour has become like scales or feathers, and the reflections of the beggar's pale bare feet are just seen in the bronze floor. The predominant colours, blue

and crimson, enter into every tone, even the shadows, so that the king and the beggar, divided by space, are united by colour. But the scattered anemones that fall from her hand mean rejected love, in the language of flowers. All the concentration of the picture is in the relationship between the two, whose eyes cannot meet. They are locked in total absorption and silence. The steady gaze of the beggar, 'truer than truth', straight out of the picture, acts as a reproach all the more powerful because it is unconscious; so important did Burne-Jones consider this head that he had drawn his brush-handle round it to mark the paint. Mary Gladstone, seeing it at the opening of the Grosvenor, recognised a 'bathing feel' – that is, the shrinking of flesh from ice-cold water.

The beggar maid's gaze is without question Georgie's own, although it is not for nothing that it recalls the *Justice* of Giotto's Capella dell' Arena. The head of the king is, just as unquestionably, Burne-Jones himself. Rooke described how, when he was working on the scaffolding in front of the great canvas, he overdid things and 'laid in the king's head perilously near to a cariacature of his',[17] – at which, to his embarrassment, 'the Master' smiled. To Georgie, the picture 'contained more of his distinctive qualities than any other he did', and she persuaded herself that it represented the scorn of worldly wealth. Certainly we cannot miss in it the truth that Newman and Ruskin had taught Burne-Jones. But the king needs no reproof, for he already knows that his gold, though real, is irrelevant. And to say that the picture expresses the painter's consciousness that for thirty years he had been subjected to the test of the highest purity and truth he knew – and that he could not feel he had met the test – does not lessen its significance. To Burne-Jones the beggar maid, totally indifferent to the darkly glowing wealth around her, was 'a queen, such as queens ought to be'.

The *Cophetua*, which caused a great sensation, was bought by Lord Wharncliffe, a cousin of Norman Grosvenor's wife, and despatched to their Yorkshire seat, Wortley Hall.[18] The estate, with its farms and moorlands, extended for thirty thousand acres, but near the house it was covered with a faint greyness from the Sheffield collieries. The Wharncliffes themselves 'were people whose mode of life could only have existed in the late Victorian era. They moved with majesty and had rigid and exacting standards of behaviour and conduct.' It is difficult to think of them under the

disturbing eyes of the beggar maid, but in 1899, on the death of Lord Wharncliffe, the picture was bought for the Tate. This was a disappointment for Georgie, who wished it to go to the National Gallery.

14

1884–90

THE ROYAL ACADEMY: 'TO THINK, JONES, OF YOUR COMING TO THIS!'

The large canvases of the eighties would not have been possible without reorganisation of the work of the studio. Burne-Jones was not, in the ordinary sense of the word, a good organiser. But he was a very good teacher, attracted followers almost without meaning to, and had a peculiar passive ability of eliminating things which caused him inconvenience. On a modest scale, his studio during the eighties became a centre of teaching and production – on a modest scale, because he had none of the problems of the great Victorian 'machines' – the royal portraitists, for example, had to employ a team to produce the fifty or sixty copies needed for distant embassies. Neither, of course, had Burne-Jones any ambition to join the ranks of the artist princes of Kensington. Millais's studio at 2 Palace Gate was reached by a flight of marble stairs overlaid with a Persian carpet, and was hung with Beauvais tapestry and curtains of ruby velvet. In 1886 'Tad' moved into his new house in Grove End Road where the studio had onyx walls and a silver ceiling (for reflected light) and was connected with the house by the famous golden staircase (really brass, 'Tad' insisted, when begging letters arrived asking for a small piece of the banisters). Leighton's house was complete, and the fountain played in the tiled Arab hall. A tour of these studios, increasingly popular as a carriage airing on Sunday, found Burne-Jones offering rush-bottomed chairs in his studio which looked homely by contrast. He never showed his 'props'. Some of them were very simple – a wooden pole with a cross-beam did duty for a tree. Others, such as armour, or Perseus's winged shoes, were specially made, sometimes at home, 'so that

what eventually gets on to my canvas is a reflection of a reflection of something purely imaginary'. Photographs show how his unfinished canvases looked – tall, blocked-in female forms with only the whites of their eyes heightened, waiting like Maeterlinck's souls of the unborn, for their deliverance. *Briar Rose* occupied one wall completely.

Ned's system, as he explained to Stephens, was very simple. If more than a certain number of Sunday visitors came, he hid and listened to their comments.[1] This eventually led, according to Comyns Carr, to his being flattened one day behind his own door.

There were now three studios in operation: in the house, in the garden, and the *Avalon* at Campden Hill Road. The trouble was, as Burne-Jones complained to Watts, that his assistants could prepare in a month what took him twelve months to finish.[2] He left a fortnight between stages for drying, each stage menaced by cleaning and dusting. Most of his assistants, including Edward Clifford and Fairfax Murray, set up for themselves, and even Rooke left in 1879 and bought 'a sublime mansion', but he returned by the day to take charge of everything. Rooke knew the mysterious mixture of varnish, spike oil and a drop of linseed which they would shake up like salad dressing with the words 'let lunacy begin'. He understood the careful checks and rechecks which Burne-Jones made on each drawing before it was transferred, although it is surprising how little apparatus was used. Rothenstein, when he met Rooke in 1904, showed him how to use a T-square and was 'surprised it should be new to him'.

Rooke also dealt with casual callers. Young artists with portfolios to show were welcome at any time, but young ladies from Passionate Brompton were a special category, and Rooke had to manage as best he could during his master's frequent retreats. Burne-Jones was particularly frightened of Evelyn Pickering, Spencer Stanhope's cousin, who later married William de Morgan – 'a plain lady, whom I never look at when I talk to her;.[3] But even plainness did not matter if Ned felt that he could be of help, and give back even a hundredth part of what Mantegna had given to him.

The press of work in the studio was partly the result of the sheer size of the pictures, often over six foot in height. Special openings were made in the wall of the garden studio to pass them through,

and scaffolding was constructed so that two people could work on them at once.

The glass designs of the eighties are fewer, but rich in colour, sometimes spreading right across the panes with overwhelming effect, although rather in contradiction of Morris's idea that 'the more the design will enable us to break up the pieces, and the more mosaic-like it is, the better we like it'. Some are brilliantly stylised, like the sinuous 'Pelican' for Ingestre. But Morris's new preoccupations meant that much more was left to his chief assistant, J.H. Dearle, and a certain friction arose. 'Nov. 1884 raising of widow's son and passage of Red Sea for Kircaldy,' Ned entered into his book. 'These were totally unsuitable to spaces and if this occurs again I will not be responsible for the language I use nor the property I smash.' In 1884, however, he designed the first of his windows for St Philip's, Birmingham, an Ascension ('my fiftieth treatment of the subject'), and glass for his own little house at Rottingdean.

The 1880s also saw a great expansion of the studio as a workshop of applied art. Burne-Jones valued craftsmen, and could get on with them. 'A man who is a good carpenter is well educated, and a man who can smithy a horseshoe is well educated, and a man who knows what other people has said about these things is not well educated at all.'[4] With the help of books lent by Stephens, he designed jewellery which, like the *Flower Book*, showed he had not lost his feeling for small-scale work. Ruskin ordered a hawthorn cross in pure gold to be given to the May Queen at Whitelands Training College. Burne-Jones tried to make Broadwoods let him redesign their pianos altogether, and worked out combinations of gesso, paint and gilding for wall decoration. Not all of these were successful, and nobody liked his attempt to fasten thin sheets of metal on to the armour in the still unfinished *Perseus* series. Perhaps Balfour would have been prepared to settle for anything in order to get his pictures finished and delivered. But it seems that he himself objected to the severed head of the Gorgon, which Ned had introduced to counterbalance the rich nudes, and once again everything had to be altered.

The studio also designed silverwork; at one point Nora Hallé was making a little fire in one corner of the room to heat the metal. In

1885 Burne-Jones received an important commission – a set of wedding presents in beaten silver for a young friend of Frances Graham's, Laura Tennant.

Laura was the daughter of a very wealthy Glasgow bleach manufacturer. With her younger sister Margot she was the presiding spirit of Glen, the great mock-baronial hall in Peebleshire, and a London house full of precious objects in Grosvenor Square. Laura – not unlike Ruskin's Rose La Touche – was a fascinater, a dazzling young woman one moment and at the next as pale and pitiful as a suffering child. Everyone fell in love with her, and indeed she had to be loved – by the crossing-sweeper, by the scullery-maid – or she felt something wrong with her world. To call her an outrageous flirt, as many did, would not give the brilliance of her response to life; one might say, with Mary Gladstone, that Laura was sometimes 'dangerously near forbidden ground'. But generous Mary added that to sit for an hour in a room with Laura was happiness enough.

This Burne-Jones had an opportunity to do when she came to tea, and with her infallible instinct for pleasing, 'half-asked' him to help her towards a new understanding of beauty, as he had helped Frances. But Ned had learned, if not much, at least some wisdom. 'She is a dear little lady,' he wrote to Frances, after making some delicate pencil studies of Laura's head, with its strange eyelids closing from below, like a kitten's. He only felt, when she came to tell him about her engagement to Alfred Lyttelton, that there should be some gesture made 'to appease the envy of the watchers'. The marriage seemed indeed to be a story of perfect happiness, wealth and beauty. But a year later Laura was dead of a haemorrhage after the birth of her baby.

The memorial tablet which Burne-Jones designed – one of the studio's first experiments in gesso – was the effigy of a peacock, a symbol of resurrection in the Byzantine art which he had closely studied for the mosaics. 'And the laurel grows out of the tomb', he explained, 'and bursts through the tomb with the determination to go on living, and refuses to be dead.' The idea was magnificent but formal, and perhaps not quite as suitable for Laura as the epitaph she composed for herself – 'Laura Mary, child of the sky'.

As 1885 opened, Burne-Jones wrote to George Howard that 'Morris growls rather these days' and that he himself was sighing heavily

for ancient times.[5] 'I sing paeans of delight to myself that Morris is quit of Hyndman but I am also heartily sorry for Morris who does win my admiration at every turn,' he added, following at a rueful distance the violent disputes of a body dedicated to universal brotherhood. Morris, who had had to take his Socialist League out of the Federation, wrote to Georgie on Christmas Day that 'it came off to the full as damned as I expected'. In these letters to Georgie he seems, in a sense, to offer her all that he does, and it is from them that we hear about his losses of money and temper; health too, for since 1878 he had been subject to black-outs. It did not help matters that Charlie Faulkner had followed him loyally into the movement, and soon began to show, in his turn, the effects of overwork and public disapproval. 'Morris told me the people hadn't any decent leading', Burne-Jones told Rooke, 'but he, who should have had the best, had to give in to noisy rancorous creatures . . . it was too much for Charlie Faulkner – it killed him by the most painful of all deaths, lasting for years.'

Morris came even less now to The Grange, and left 'unsped by sympathy' to preach at street corners. Janey appeared by herself, 'a glorious wreck' in Mary Gladstone's words, at The Grange garden parties. Burne-Jones faced the years ahead at the height of his fame and with a studio in full production, but without the old sense of comradeship. 'Bare is back without brother behind.'

He remained, of course, as Henry James found him, 'exquisite in mind and talk'. James sensed his restlessness and tactful as ever, took him down to Bournemouth to amuse the convalescent R.L. Stevenson. This went well – much better than when Richmond asked R.L.S. and Ned to dinner, and got both of them to discuss what crimes they would like to commit; the cook, by arrangement, then came in and announced that 'a constable has called, and wants to see one of you gents'. Burne-Jones, veteran of practical jokes since the sixties, was unmoved, but Stevenson was 'very much upset'. Burne-Jones, as might be expected, appreciated R.L.S. as a teller of tales, was glad when in *Catriona* he 'made a woman at last', and regretted that he was too busy to do the illustrations to *A Child's Garden of Verses*. This, indeed, was an opportunity lost.

The Lewises, too, offered him the solace of their house, Ashley Cottage, at Walton. Here their walk through the woods (George Lewis in tweeds) was interrupted when Burne-Jones suddenly saw,

outside one of the keeper's cottages, a girl with 'oat-coloured hair', about twelve years old, 'her hair paler than her face, and her eyes paler than her hair'. He refused to disturb her when he found she was shy, and stood memorising her face, just as in London he would watch tiny children dancing to the barrel organ, fascinated, until the last step.

In 1885 Burne-Jones took the decision to hyphenate his name. This may have been a mistake, for if (like Madox Brown and Holman Hunt) he had left it as it was he would have spared himself the scorn of Whistler who continued to refer to him as Mr Jones, and of later critics who have accused him, of all people, of delusions of grandeur. 'My dear Steev,' he wrote to Stephens,

It is quite right and nothing that isn't a fact.

I have just stuck in at one point the name 'Burne' having long ago, in the natural yearning of mortal man not to be lost in the million of Joneses, put another family name before it, dear Steev, but solely from dread of annihilation,

Yours affec–
Ned[6]

Looking back over the years, he could remember Augusta Jones the model; the great John Jones collection over which he had advised the South Kensington Museum; Owen Jones the designer; Albert Jones, Rooke's brother-in-law, who had come to work in the studio and inconveniently developed smallpox. The playwright Henry Arthur Jones (who nearly changed his name when Mrs Pat Campbell told him it was 'incurably common') became successful (and began negotiations for 'Tad's' old house) about 1882. But Ned would not much have minded being thought incurably common. Morris was disgusted by the change and referred to it as little as possible. The real consideration in the case was Phil.

Phil had come down from Oxford without a degree. His main talent, apart from getting up charades, was comic illustration, and Burne-Jones, fated always to make mistakes with his son, begged him not to do. Phil amiably agreed therefore to become a painter and to train in his father's studio. But he, too, had his dreams of the unattainable. His ambition was to cut a dash in the Prince of Wales's set.

No greater irony could be imagined for the son of the hesitant Ned and Georgie, whose fierce scorn of Vanity Fair remained undimmed through her pilgrimage. But that was what Phil did want; he wanted to escort Lillie Langtry and to owe bills to tailors and wine-merchants and to follow the semi-compulsory, heavily well-fed circulatory movements of society from London to country houses to Le Touquet and back again. It was not a matter of snobbery, but a highly-tuned theatrical sense – society provided a sumptuous and often scandalous show to the public, as though on a lighted stage – that, and an excitable need to *se faire valoir*. For this Phil needed constant supplies of money, and above all, not to be called Jones.

The change of name was the first of a number of decisions where one can feel Burne-Jones losing direction, in everything except his painting. On the evening of 4 June 1885, when he had dropped asleep from exhaustion on the drawing-room sofa, the door-bell rang and a servant came to say that a man was in the hall with a message that Mr Burne-Jones was elected into the Royal Academy. Georgie, who thought it might be a joke (if so, it would have been quite in the style of Comyns Carr), was annoyed and sent the man away; this was rather hard luck for the messenger, presumably one of the Academy models who, by tradition, brought the news and received a sovereign. Next day, however, a letter arrived from the President, Fred Leighton, referring to an 'act of justice' at Burlington House – Ned had been elected by 'the largest majority I ever saw . . . I am not aware that any other case exists of an Artist being elected who has . . . pointedly abstained from exhibiting on our walls.' Burne-Jones, of course, had never put his name forward. He had been proposed, it seemed, by an academician he had never met, Briton Rivière, 'and this touched and surprised him, giving rise to the idea that there might really be in the Royal Academy, without his knowledge, an element of sympathy with his work and his aims.'

If Ned really thought this he must have blinded himself in a strange manner to the spirited in-fighting of Academy politics. What had really been happening? Certainly Burne-Jones had many old friends at the R.A. – Millais, Alma Tadema, Watts and Poynter (Prinsep was still an Assistant); Henry Wells, the 'election manager' of the Academy, had bought some of Ned's very earliest work. Leighton, besides his personal good will, had an uneasy feeling, a kind of nagging conscience, about what Burne-Jones was doing.

Whistler did not worry him, nor did Impressionism, but Burne-Jones, and the movement for which he was held responsible, were another matter. Towards the end of his life he pointed doubtfully at a small copper lantern at Walter Crane's house and asked, 'Is that Arts and Crafts?' To bring Burne-Jones into the fold would be generous, and Leighton was always that, but it would also be reassuring, particularly after the success of *Cophetua*.

But his proposer had been Briton Rivière, and the general opinion can be gathered from Beatrix Potter's diaries:

> June 4 1885, such news, Burne-Jones elected an Associate. Mr Millais says they should have all sorts. Old Barlow is indignant. The fact is, the Academy is jealous of outsiders, and will not, if avoidable, take in any one who may be a rival, which induced Breton [*sic*] to suggest Burne-Jones who is not likely to paint animals.

Unaware of this, Ned and Georgie debated seriously. There was the possibility of wounding Watts and Leighton, the difficulty of exhibiting things in two places at once – to this Leighton quite stiffly pointed out that Ned would surely not slight a body of men who had sought to honour him, by sending more to the Grosvenor than to the Academy. Graham was the man to advise, but he was in the last stages of his final illness and could only give wavering congratulations; George Lewis, for once, had nothing to suggest. Morris, in a letter to Georgie, was uncompromisingly against. But wasn't the battle still in the salon, as it had been at the O.W.S.? Watts wrote that Ned could help the cause of art more effectually inside than outside. And the warmth of the invitation, after the wretched 'silences' between himself and Morris, made him, as he admitted to Watts, feel like a man who is asked into a house as he passes by. The next day he sent his acceptance of the 'unlooked-for honour' and though he followed it with other letters offering to 'yield up his place' he was now an Associate of the Royal Academy.

The feeling of warmth was by no means universal. 'I have not the slightest objection to him being in the Royal Academy,' wrote Luke Fildes, who felt that a 'dead set' had been made at the election. 'I only feel that there has been an indecent haste in rushing him in and a very slavish bowing down to him as soon as he graciously

condescended to be elected . . . it will make all the grosvenorites more offensive than before.' Here spoke the serried ranks of Frith, Marcus Stone, 'Clothes' Horsley and the rank-and-file like Stacy Marks, whose first Academy picture had been *Toothache in the Olden Times*.

Burne-Jones, however, was used to opposition. The point was that his presence in the Academy of 1885 was an anomaly. He was a minor master, but still a master, dedicated to the idea that art speaks, not from surface to surface, but from soul to soul. Even *Punch* felt this. The *Punch* 'Swarry at Burlington House, June 27, 1885' shows Leighton bowing suavely in the foreground, Oscar Wilde in Art Dress in the middle distance, and at the back the bust of Ruskin turning grimly to a bust of Burne-Jones: 'To think, Jones, of your coming to this!'

The question of his first Academy exhibit would have to be faced, but not till the following spring, and that summer all considerations gave way to the long drawn-out suffering of William Graham. Although Rossetti had felt many years earlier that this great collector had lost the will to live, he had been active to the end, until he was too ill to move, in helping his friends the artists. One of the last things he did was to negotiate the commission for *Briar Rose* with Agnew's. When he died on 16 July 1885, Burne-Jones sent some small pictures to be buried with him, recalling in this queer romantic gesture the Graham who had gone up to one of his half-finished canvases and kissed it because it was 'to his mind'. These small pictures are now in the coffin in Glasgow cemetery.

The great Graham collection now came on the market, and it was at the Graham sales in the following year that Burne-Jones's position as painter was confirmed, his pictures fetching £17,000 at auction. Encouraged by this, and by the steps which Burne-Jones, A.R.A., seemed to be taking towards an official career, the Birmingham Society of Artists wrote to offer him the presidency. Ned, who had refused the same offer in 1880, and who had never felt like having anything to do with administration since the failure of the Hogarth Club, now accepted cautiously; he mustn't be asked, however, to speak or lecture, or in fact to act in any way as a president. But he was anxious, as always, to see the schools of design and to meet the students, and in October he paid a week's visit to Birmingham. A visit to the Choyces brought back the past

and so did a call on Miss Sampson; he had kept his promise and had seen that she was comfortably off in her old age. His host was that great Birmingham worthy, W.H. Kenrick, the Liberal M.P. – 'Liberal as the sea is salt' – and chairman of committees innumerable, who had been the great force behind the recent opening of the city's art gallery. Birmingham was now a city of opportunities of the only kind Ned cared about. No one there need now grow up without pictures. While his letter of thanks to Kenrick is rather extravagant in its dream of 'a city of white stone, full of brave architecture', he was justified in looking forward to a great complex of libraries and museums, and he undertook to do two more windows for St Philip's. He could not, fortunately enough, foresee that Birmingham's red brick would in the course of time be turned into white concrete.

He returned to the insoluble problem of the Rome mosaics, and the yet more pressing one of his Academy picture. He consulted no one about the subject, apparently not even Watts who, it is true, was mildly busy, having been taken in hand by the energetic lady who was to marry him next year. Burne-Jones decided to reserve *Flamma Vestalis*, the *Morning of the Resurrection* and the fine *Delphic Sibyl*, painted in a glowing burnt orange which recalls *Laus Veneris* – all for the Grosvenor Gallery. For the Academy he began *The Depths of the Sea*. It was an extraordinary treatment of a mermaid dragging down a naked man in triumph to the bottom of the ocean, unaware that he was already dead. The epigraph he chose from Virgil, *Habes tota, quod mente petisti, infelix*, was ambiguous leaving it not quite clear whether the mermaid or the dead man was the wretch who 'got what was so much desired'. Ned borrowed a model tank from the painter Henry Holiday, and began to study the effect of light under water.

When the work was completed, but before the final glaze was put on, Leighton called round to see it. It was one of his more delicate tasks to make sure that the less conventional exhibitors were not going to send in something that wouldn't do; it took all his urbanity to persuade Watts not to show his triptych of *Fallen and Repentant Eve*. It is obvious that he was taken aback, on his arrival at The Grange, by *The Depths of the Sea*, particularly when Ned told him he meant to put in a number of little fishes. Leighton demurred, but later wrote, 'on the contrary, I like the idea of the fishes *hugely*.' The President sounds desperate. What he was looking at was, 'as Ned

himself described it, 'a dream, well enough', or perhaps a nightmare.

It went to the Academy, where it looked totally different from anything else on the walls. 'It stood forth as the only serious thing in the Academy', wrote Canon Dixon (who had come up to London to see his publishers) to Gerard Manley Hopkins, 'but I am out of sympathy with him.' 'You speak of "powerful drawing" in Burne-Jones's picture,' Hopkins wrote back. 'I recognise it in that mermaid's face and in the treatment of her fishnets and fishermanship, the tail fin turning short and flattening to save striking the ground – the stroke of truly artistic genius' (probably only Hopkins would ever have noticed this) 'but the drowned youth's knees and feet are very crude and unsatisfactory in drawing, as it seems to me.' Hopkins finally and uneasily admitted that 'the male quality is the creative quality, which he [Burne-Jones] markedly has'.

The real trouble about *The Depths of the Sea*, however, which Leighton could not have failed to notice, was the striking resemblance of the mermaid's face to that breaker of many hearts, Laura Lyttelton. Ned did not attempt to deny this, but said 'it was a scene in Laura's previous existence'. This aspect of the picture passed without comment at the Academy, and Leighton must have breathed again. Burne-Jones did not appear on varnishing day, perhaps because Mary Zambaco was exhibiting a terracotta bust of Legros in the sculpture section. He was persuaded with difficulty to come to the Academy banquet.

Far pleasanter than the banquet – where Leighton gave his usual princely address, and there were glee-singers, whom Ned hated – was the Millais retrospective at the Grosvenor earlier in the year. Millais himself appeared with his eyes full of tears, and was said to be regretting the lost genius which was brought back to him by seeing his early work, but this, since he hung the exhibition himself, is most unlikely. Millais wept easily. So many old friends were there, and Ned shared a cab with George du Maurier, all their disagreement disappearing like a mist in sunlight; in his enthusiasm for Millais, Ned stamped so hard that he nearly smashed the floor of the cab. He had seen the *Return of the Dove*, which Morris and he had admired, over thirty years ago, in the print shop in Oxford High Street. A few months later Alfred Hunt, whom they had looked at

from afar in the same print shop, asked Ned to rejoin the Old Water-Colour Society. 'I am useless at all meetings,' Ned wrote back, 'I am not in harmony with associations like the Academy and the Old Water-Colour Society; my real home would be in a society which embraces all art', but, since Burton offered to rejoin as an honorary member, he agreed to accept the invitation. Almost without knowing what was happening, he felt himself being drawn into the Establishment.

On 2 December he noted in his work book that he had completed twenty-five years with the firm. He still had the cartoons for St Philip's, Birmingham, on hand, and he made up his mind to send nothing at all to the 1887 Academy. He had to finish his commitments for the Grosvenor and, as Margaret wrote excitedly to Watts, it was Phil's first show-day. 'Father is very pleased,' she added.[7] The Signor and his wife were in Athens, where the indefatigable 'Duchess' found them an apartment overlooking an orange grove, and suggested a thousand expeditions, which Watts was much too enfeebled to make. But he was able to send his good wishes for Phil's début.

All was not well, however, at the Grosvenor, which was faced with increasing difficulties. As early as 1883, Mary Gladstone noted in her diary that she had seen 'poor deserted Lady Lindsay' at the Rossetti exhibition, 'a garish figure that almost destroyed sympathy'. Her marriage to Sir Coutts, against the advice of her trustees, was in disarray. In the words of her cousin, Lady Battersea,

> there were four years of brilliant happiness, followed by a shock that ended the dream. Blanche was cast in a heroic mould . . . relentless where wrong had been inflicted. The promises of her husband proved unreliable, so the final parting came, and Blanche started life again with her two devoted daughters.

This left Sir Coutts in an awkward fix. The grand Scottish home was given up, but so much of his personal ambitions was sunk in the Gallery that, without Blanche's money, he was driven to strange expedients. He thought of showing furniture as well as pictures, of giving smoking concerts, and of broadening the appeal by opening a restaurant. Burne-Jones particularly disliked restaurants in galleries. The Academy pictures, he felt, would smell of mutton

chops till the end of time. Finally Sir Coutts called in Pyke, a Regent Street jeweller, as business adviser. The balance of power, Ned wrote to George Howard, was as follows:

Pike [*sic*]
Wade
Sir Coutts Lindsay
Hallé
Carr
and then the poor painters – and I don't like it. It seems I am always resigning something or other, though I should have said I was a peaceable fellow enough.[8]

Wade he describes as 'a lesser spirit', and 'Carr and Hallé have been on the point of resigning for a year and a half past'. Evidently they could not agree with Sir Coutts's desperate improvisations. When the Grosvenor closed in the summer of 1887 Ned wrote to Watts, with some relief and apparently forgetting the Academy, that he would be 'as I have always been, a little painter painting away in a room and trying to think of nothing but my work'.[9]

The decision by Carr and Hallé to open a new gallery was based – as Mrs Comyns Carr says frankly in her reminiscences – on the pictures of Burne-Jones and his 'wealthy admirers' who were prepared to subsidise it. The other director was Sir Coutt's nephew, Leonard Lindsay, and Burne-Jones, reluctantly at first, agreed to serve on the committee. Comyns Carr, although he was to become Irving's manager at the Lyceum, was not really a business man. He once, so Ned declared, sent him a telegram beginning: 'Only 20 words allowed, must be brief.' But he had the spirit of enterprise, and this was more than shared by his wife. At the end of the year he began looking for new premises.

Burne-Jones had spent the summer at Rottingdean in the soothing company of 'the blue-eyed maid', his daughter Margaret. 'Twin Sapphires' was Swinburne's name for her, and 'sapphire is truth and I am never without it', he wrote to Frances Horner. He had, however, given Margaret a moonstone, 'that she might never know love, and stay with me'. In the autumn he had to go back to London, where he took charge of Margaret's cat Frill, and wrote to her often. But the moonstone was ineffective. In February 1888 he

suffered treachery. Jack Mackail, the youngish Oxford scholar who had been calling at The Grange for some years past, 'a grave gentleman', Ned thought him, 'who came to talk to me about books', suddenly broke it to him that he wanted to marry Margaret. 'I haven't felt very good about it,' Ned wrote to Watts. 'I have behaved better than I felt. She looks very happy, and before I knew he wanted her, and before I dreamt of any such thing, I though him a fine gentleman through and through, and look what he has done to me!'

Margaret was nearly twenty-two. There was no possible objection to Jack Mackail, except that he wanted to marry her. He came of a race whose determination Ned should have recognised: he was the son of a Free Church minister. Descending on Oxford from Ayr Academy and Edinburgh with sharp weapons of scholarship, he took every conceivable honour in classics and *literae humaniores*. Jowett (Mackail was of course at Balliol) had prepared him carefully for high office in the university. He was tall, self-collected, polite and handsome, radical in politics, never gave himself away, did not smile much; he published three books of poetry, but only in collaboration with Balliol friends; he was so brilliant that it took courage to call him Jack (Burne-Jones substituted 'Djacq' in a vain attempt to turn him into a character from the Arabian nights). In 1884, when he was twenty-five and already a fellow of Balliol, Mackail suddenly accepted an appointment in the Education Department. Of course he did very well there, succeeding at the same time as a scholar, writer and biographer, but the move to London, it now appeared, had been an unexpected impulse of the heart. He wanted to be nearer to The Grange, and to see more of Margaret.

Burne-Jones felt that his premonition of four years ago had, after all, been right. He gave his consent and prepared, as he put it, 'to crumble into senility in an hour' without his daughter.

He had to concentrate on the opening of the New Gallery. A site had been found in an old fruit market at the end of Regent Street. The building itself had been a livery stable; the architect E.R. Robson, recommended by Philip Webb, undertook the conversion, but the site was not vacant until December, and everything depended on being ready by the beginning of May in order to compete directly with the spring reopening of the Grosvenor. This meant working both day and night shifts, and Joe Comyns Carr and

Robson went down every evening after dinner to supervise the job. The naphtha flares round the site lit up the whole of Regent Street. Just before opening time there was a strike among the gilders in the building trade, and Joe had to call in picture framers, who 'obliged' out of personal regard for him, to finish the gilding in the upper gallery.

Meanwhile Burne-Jones roused himself and persuaded Watts and 'Tad' to send off their best. Watts promised his *Angel of Death*, and Ned undertook to finish two Perseus subjects and the large version of *Danae*. It seemed, after all, that the building would be finished in time, and it was designed with much more feeling than the Grosvenor for what the artists wanted. In appearance it was vaguely Hispano-Moorish – the posts of the old stable had become square pillars, and there was a central court with a fountain – but the striking feature was the low ceiling and strong top lighting, which allowed the paintings to be hung at eye-level with the drawings below them.

The opening in May 1888 started brilliantly enough. Gladstone was the first to arrive and went straight to the *Danae*; Lillie Langtry made a spectacular entry, Crown Prince Rudolph of Austria (only a few months before his death at Mayerling) was there. These things were dear to the heart of Mrs Comyns Carr, who had become more worldly since her days as Mrs Jellaby Postlethwaite. But Carr had not calculated on the heat which a crowd would produce in the low rooms, and visitors looked longingly at the *impluvium*, 'just the place', as *Punch* pointed out, 'for a brush and sponge'. Burne-Jones himself had trimmed his beard and attempted to find unwrinkled trousers, such as were worn by Phil, but in *Punch*'s cartoon (drawn by Harry Furniss, who got an excellent likeness) he appears, most surprisingly, as bald and red-nosed, with a smoking 'clay' in one hand and a glass of stout in the other. This was particularly pointed because Carr had not been able to get a licence from the Middlesex magistrates and there were no refreshments – always a mistake on Press Day. Furniss revenged himself further by showing Ned's *Perseus Slaying the Serpent* as a workman struggling with an unfinished waterpipe, while the naked Andromache takes the opportunity of a shower.

Burne-Jones fled to Rottingdean. But the quality of the pictures themselves was not in doubt, and the New Gallery for the rest of his

life was his main, though not his only, place of exhibition. 'The people who said it couldn't succeed,' he pointed out, 'and the press who said it wouldn't, and society who said it shouldn't, all wrong – all wrong as usual, as they always are – the one infallible law of nature that knows no exception.'

The launching of the New Gallery did nothing to deaden his misery at the approaching wedding. He went into the church 'to try and feel what it would be like to hand her over for life to her husband' but only felt 'stupid and dazed'. Georgie's feeling for her lovely daughter was as strong as his own, but she, as was natural, judged differently. 'Truly it is advisable for us to marry if the right thing turns up,' Aggie had written to Louie when the Macdonalds were still girls, and truly it still was. The right thing was love, and Margaret was in love. She bent all her quiet will-power towards an autumn wedding. Georgie had all the preparations on her hands, and in addition the distraught Ned, who went through 'a short torment of jealousy'. After this he became first gloomily resigned, then apathetic. He agreed, with little relish, to let Phil paint him, and Phil eagerly asked Henry Cameron (Julia Cameron's son) to come and take the preliminary photographs. At the same time Ned took the step of making his will. About his intentions there was no doubt. As he wrote to Alfred Baldwin, his businesslike brother-in-law, 'The property is valued at £4 . . . Georgie is to use the £4 until she is translated and Phil and Margaret to have £2 each. Do you see? If my drawings go luckily they may bring in 3d. each and perhaps the chief estate lies there.' The drawing-up was entrusted, of course, to George Lewis, who turned out a real 'solicitor's will',[10] A curious point was that his 'illuminated books, ancient books with engravings, works upon art' were not to go either to Georgie or to the children, but were to be converted into money and paid into the trust capital. These books would include the *Hypnerotomachia*, the reproductions of Botticelli's Dante illustrations, and the many engravings brought back for him by Fairfax Murray.

Morris, who later faced calmly enough the prospect of May's marriage to an impoverished socialist comrade, wrote one of his gentlest letters to Margaret that August. Mackail, dropping his reserve for a moment, asks to be 'pardoned for inserting it' in his *Life*. Morris sent her a carpet from the Merton works 'as an unimportant addition to your "hards"'. In wishing her happiness, he reminded her of how dearly she had behaved to him since she

was a little child 'in the days when I was really a young man, but thought myself rather old'.

Margaret was married at Rottingdean on 4 September. On the evening of the 3rd she gave Ned a letter, telling him that on the whole – as he put it – he had been a satisfactory parent, and this was one of the few letters he never destroyed.

The day itself was beautifully sunny and windy; the fields behind the house were yellow with harvest up to the ridge of the downs. Burne-Jones, waking up early and finding himself in everyone's way, discovered – what he surely might have guessed – that the arrangements were known to everyone in the village and a small crowd was gathering. Someone had the idea of scattering rose-petals as Margaret walked the hundred yards to the church between her father and mother, and they streamed away in the wind and fell everywhere. 'I behaved pretty well,' Ned wrote to Lady Leighton Warren. All references to procreation and carnal lusts had been left out of the wedding service to avoid upsetting him further. There was no music, as the organ at St Margaret's was 'painful to hear', but back in London the Kensington bells rang out for an hour.

After Margaret's wedding, Burne-Jones began the habit of calculating his age every year from the way he felt: in 1888 his age was ninety-seven. He returned to the *Briar Rose* series. 'I want it to stop with the Princess asleep and to tell no more,' he wrote, 'to leave all the awakening afterwards to the invention and imagination of people and tell them no more.'

The Mackails came back to live at 27 Young Street, within easy walking distance of The Grange, and Margaret was by no means as lost as her father had feared; in fact he could go over there any evening, as soon as the painting light failed. In later years one may well feel sorry for the conscientious Mackail, as he sits for the head of Melchior in the Exeter tapestry, gets stuck in the sash-window at Young Street, struggles with Morris's biography and accepts patiently his bedroom at Rottingdean, with two rush-bottomed chairs, a towel horse that fell down and an old oaken cupboard with an opening three feet above the ground. He never complained, came back to tea every day at four, lived a life of dignity and scholarship and refused, it is said, the Mastership of Balliol so that Margaret would not have to leave her parents. Burne-Jones

could do nothing but try to feel happy in her happiness. But he continued to paint *Briar Rose*.

He was revived that autumn by Kipling's *Plain Tales from the Hills* and the thought that Ruddy, of whom he was a judicious critic, was 'losing the manner of a pressman'. George Lewis took him to court to watch the Parnell case, his lifelong sympathy with Ireland was wrought upon and he became such a convinced Parnellite that George Howard absolutely forbade mention of the subject in his letters. In October, he received an invitation which was to have a far greater importance in his life than he at first realised. This was to the first Arts and Crafts Exhibition.

Both Burne-Jones and Morris had at first looked at the Arts and Crafts movement with some distrust, Morris because he felt that they did not belong to the 'useful classes' but were amateurs who would lose money, and Burne-Jones because he was afraid of being 'got at'. His letters to Selwyn Image (later the editor of the *Hobby Horse*) show him in full retreat ('come on Thursday at 5 o'clock as I have to go out and we could talk as we went along')[11] and his suspicions were justified when Image wanted to print some of these 'conversations'. Later he got Margaret to answer Image's letters and unwanted gifts of peppermints. But the original committee of the Art Workers' Guild, which in 1888 produced the Arts and Crafts Exhibition Society, included W.A.S. Benson, the architect and craftsman who had adapted the house at Rottingdean and who had made the king's jewelled crown for *Cophetua*. It was Benson who got Burne-Jones to interest himself in the movement which, particularly through its effect in Scandinavian countries, turned out to be one of the most far-reaching results of the influence of the firm. It must be repeated that Morris and Burne-Jones, those lovers of decorative richness, cared also for simplicity, whitewash and fine line. Things should be either like the king or like the beggar. Some of Burne-Jones's later drawings and jewellery designs are simplified almost to the standards of the Bauhaus.

Ned was delighted, too, to hear that his old friend Kate Faulkner was exhibiting a decorated piano at the Arts and Crafts; he had never managed to get Morris to look at musical instruments (though Bernard Shaw persuaded him to say he might try his hand at a fiddle) but for two years past he had been helping Kate with her designs. For her sake and Benson's he attended the private view, but there was an

unfortunate misunderstanding. 'I kept taking people up to [the piano]', he told Stephens,[12]

> and praising it and lauding it to the skies without noticing a label
> on its top which attributed it to me . . . I only designed the *form*,
> trying to follow the lines of an ancient harpsichord . . . so a false
> impression of my character has gone forth, not for the first time.

The great thing, however, was that the exhibition was well attended. Morris, as Mackail says, 'seems to have underestimated the amount of public interest which had at last been aroused . . . in the difference between good and bad decorative art.' It was at the exhibition, too, that Morris heard a talk by Emery Walker on letterpress-printing, and he began to let his mind turn towards the last of his great crafts.

The winter was very cold, and in January 1889 old Mr Jones died. He was buried in Brompton Cemetery, side by side with Aunt Catherwood and little Christopher. His widow, the cook whom he had so unaccountably married, was treated with exquisite courtesy by Ned, who offered her the last vacant space, in time to come, in the family grave. But she found another husband, and the space remains empty still.

The Grange, Ned wrote to Professor Norton, was 'silent and full of echoes' without Margaret, and he was not so absorbed in *Briar Rose* that he had nothing for the second exhibition of the New Gallery, and had to ask Watts to send something extra. Morris often had to leave The Grange early, even from the Sunday breakfasts, for League meetings. Three years earlier Ned had even feared for his life in the street-rioting – 'many thanks, Ned, for your anxiety, but lay it aside for the present', Morris wrote back. But the time was coming when the curves of their two lives would draw together again for the close.

In July 1888, Morris had written to Georgie that he was 'a little dispirited over our movement in all directions'; in 1889 the executive of the League was captured by anarchists, who removed him from the editorship of the *Commonwealth* (though he continued to finance it) and abolished the office of chairman as 'quasi-authoritarianism'. Morris's interest in the League, though never in socialism itself, began to diminish, and as his vision broadened into the golden hay-harvests

of *News from Nowhere* he wrote to F.S. Ellis, 'I am really thinking of turning printer myself in a small way.'

Burne-Jones found it hard to wait for the moment when Morris would come back to what he still felt was his true self. 'He hasn't enough practical leadership to button his own waistcoat,' he wrote in exasperation to George Howard.[13] The waistcoat indeed was frequently undone, and Ned's drawings show him searching helplessly for the buttons on one of his own wondrously patterned carpets. 'They talk, talk, talk,' Ned wrote of the times when he sat silent, listening to discussions on socialism, 'and none of them knows – not one and all the time great hidden movements are going on that will change the world, unnoticed, unsuspected, out of reach of the furthest sight.'[14]

In March, Ned and Georgie went as usual to Leighton's yearly musical afternoon in the noble drawing-room of his great house. These 'musics' were a very different matter from Alma Tadema's cheerful concerts, where 'Tad' had frightened Paderewski terribly by letting off a clockwork tiger under his chair. They were occasions of retrospect, because Leighton never asked anyone new except the ever-growing number of children who sat behind the flowering plants in the north window. 'No new faces come, and that is kind of him,' Ned wrote. The performers – Joachim, Madame Neruda, Paderewski – gave, after Leighton's royal 'hush', the very best they had in them. 'But it is pitiful', Ned added, 'to hear the guests say to each other, "you don't look changed, not a bit." They do look changed, dreadfully changed.'

Leighton took the opportunity to ask Ned whether he would let his *Cophetua* and *Depths of the Sea* go, as part of the British section, to the Paris Exposition Universelle. With the owners of the pictures Leighton himself would deal. After great hesitation on many counts, Burne-Jones agreed, and from the summer of 1889 can be dated the beginning of his influence in Europe.

He had, it may be remembered, exhibited *The Beguiling of Merlin* in Paris in 1878, but without making a wide impression. The atmosphere of 1889 was quite different, and the ever-efficient Luke Fildes, entrusted by Leighton with the hanging, was disgusted by the attention Burne-Jones's pictures received. The jury, he felt, was 'a mutual admiration society'.

In fact it so happened that the *Cophetua* made the best possible

contrast to the glittering Paris of the Expo, which the Tour Eiffel, although not quite ready in time, epitomised. The Beggar Maid appealed equally to the Symbolists in their pursuit of the soul through its expression in form and nuance, to Puvis de Chavannes, who recognised its ritual qualities, and to Sâr Péladan and the lunatic fringe. From these last Burne-Jones received an invitation in 1892 to exhibit with the Rose & Croix, 'a disgracefully silly manifesto' as he told Watts, which he quietly and politely avoided. Puvis de Chavannes was a different matter. Although they never met – fortunately, perhaps, as visitors were disconcerted by Puvis's frock coat and hearty appetite – they corresponded with each other as two masters in their own way. In December 1889 the French government conferred on Burne-Jones the Cross of the Légion d'Honneur, and three years later he was invited to contribute some drawings to the Musée du Luxembourg. It was on this occasion that Whistler (whose *Portrait of the Artist's Mother* was in the Luxembourg) wrote to the director that 'if his Mummy had to keep such bad company he could not let her stay any longer at his *auberge*'.

Although Burne-Jones felt honoured by French compliments to the 'ideals I care for', he was not at all anxious, either then or subsequently, to go over to Paris – to 'run over' as Phil kept suggesting, usually by telegram, and enjoy his 'triumph'.[15] He dreaded the very idea: 'I can't go gadding about like that, being very old.'[16] But French visitors, from 1889 onwards, came frequently to The Grange – Paul Bourget, as the close friend of Henry James, later on Barthes, Arséne Alexandre, Robert de la Sizeranne, the Belgian Fernand Khnopff. Khnopff, who lived a good deal in England, became an acquaintance, and was 'a nice fellow', Burne-Jones told Rooke, 'but he liked to stand amid rings of admirers, like an omnibus, twelve inside and sixteen out.'[17] The most startling admirer by far, who may be taken to represent the fashionable French reaction to Burne-Jones at the turn of the century, was the 'Baronne' Deslandes. Mme Deslandes was a tiny, formidable, blonde Jewish *Lionne*, mysterious as to age and provenance, given to strange gestures and long, swimming, short-sighted glances. Waiting in Paris in her all-white salon for the annulment of her marriage, she was somewhat at a loose end and began to write novels (*A Quoi Bon?* and *Cruauté*), which were compared to the scent of white lilac, or the notes of a

violin on a hot night. After the Expo she began to dress *à la Botticelli* in Morris materials sewn with jewels, and produced for *Figaro* a rhapsody (rather than an article) on Burne-Jones, calling him a primitive who united the griefs, both experienced and dreamed of, through countless ages with the emotions of the cruel nineteenth century. She induced Ned to paint her portait, and he chose to represent her with a crystal ball (he had had this in the studio since he painted *Astrologia*) which at the same time stood for an imperial globe and a child's toy. The feeling of the household at The Grange as a whole was against these visitations. 'William announces "It's the French, sir," as though it was the Battle of Hastings,' Burne-Jones complained.[18]

The Exposition Universelle, however, spread his reputation beyond France. The Catalonian critic Casellas went to the British section in search of *Postprerafaelismo*, and liked only the 'irremediable sadness and mysterious symbols' of *Cophetua* and the mermaid of *Depths of the Sea*, an ambiguity, it seemed to him, 'between pleasure, ignorance and perversity'. In the years that followed, Barcelona, already committed to stained glass and the *arquitectura ruskiniana*, developed its great modern movement, and Burne-Jones's drawings appeared, without permission, in *Juventut*; in one number, in fact, he is illustrating d'Annunzio. His influence can easily be seen in the delicious musical women crowned with flowers by the sculptor Escaler, and in the early work of the group that included Opisso, Nonell, Güell, and Picasso.

John Christian has shown that his reputation declined in France after 1895,[19] but in Catalonia, Belgium and Germany his name was invoked much longer in the struggle against industrialism and the slow death of the spirit.

In October 1889, the Kiplings returned to London from India, and Rudyard, after a few weeks' stay at The Grange, found himself rooms in Villiers Street. His new establishment in the thick of pubs and music-halls deeply impressed his cousin, Phil Burne-Jones and 'Ambo' Poynter, as did the world-travelled Ruddie himself; they brought him their problems. 'Ambo' was scarcely ever out of trouble and Phil was in a 'hole'. He had sold an autobiographical article to a 'disreputable publishing syndicate'[20] and Ruddie had to accompany him to Fleet Street to get him out of their clutches. Phil's autobiography, whatever else it contained, must have made some

reference to the unreliable nature of money and women. Already there were matters which could not be entrusted to the professional care of George Lewis.

Throughout the eighties and early nineties we have glimpses in Burne-Jones's letters of Phil worn out by the night before and breakfasting with his eyes shut, of Ned 'staggering to bed at nine' while Phil is just making his toilette to go out, of Phil ordering boots from a celebrated firm in Knightsbridge ('the firm says it is celebrated, and that is my authority'), which arrived in a case marked GLASS WITH CARE, making Ned think wistfully of Cinderella.[21] Once, in his periodical destruction of old papers, Ned came across Phil's old reports from Marlborough: good conduct, bad at French, takes an interest in mathematics.

Ned understood Phil's weaknesses better than Georgie did; in fact he understood the position of parents pretty well altogether – 'their looking such an incredible age', he said, 'is so much against them.' But he had to admit that Phil, though always affectionate, was difficult to live with. The household at The Grange, after all, had increased as Burne-Jones grew more prosperous, and took some management. Besides Rooke and his assistants there was a studio 'boy' and Pendry the dwarf, who ran errands, gave glasses of wine to the thirsty cast-makers and kept children in fits of laughter by pretending to be afraid of the dragons on the Chinese carpet. To offset the Hoffmanesque figure of Pendry there was Mrs Wilkinson, the cleaning-woman, in a perpetual state of armed warfare with Ned, menacing him with brooms and soap and a peculiarly significant, 'Good-morning, sir'. William, like all good butlers, was a depressive. One of the parlourmaids, Annie, stayed with Georgie till her death; it was Annie who called on Kipling in his lonely bachelor days in Villiers Street and offered to sew on his buttons – as it seemed to Kipling, in a very insinuating manner. Georgie, in spite of Annie's fidelity, considered that the relationship between servants and employers was 'either a bloody feud or a hellish compact'.

The Rottingdean house had also been enlarged in 1889. Burne-Jones, who earned about £950 this year for the firm's glass and tapestry designs, was able to buy the small property next door, and W.A.S. Benson threw them together to make the present North End House. There were now rooms for everyone, and a 'bower' for Margaret with a window opening on to a pear tree full of birds. The

small downstairs kitchen Burne-Jones turned into a smoking-room for men only, the 'Mermaid', with a blazing wood fire and a view 'over and beyond the green garden to a line of downs beyond which the sun set'. His friends could drink stout or ginger-beer and play dominoes. The trouble was that by far the most frequent domino-players were Luke Ionides and Charles Hallé, of whom Georgie disapproved.

Even in the 'Mermaid' there was nothing to sit on but hard wooden settles, for it occurred to no one (except Phil) that comfort, as opposed to beauty, was at all necessary. It was in the following year that Newman died, and Burne-Jones recalled that 'in an age of sofas and cushions he taught me to be indifferent to comfort, and in an age of materialism to venture all on the unseen'.

Nevertheless, in the winter of 1889 Ned could not quite face the icy draughts of Rottingdean. Georgie went down there for Christmas with Margaret, who was pregnant, and Jack Mackail. On Christmas Day Ned, Phil and Rudyard Kipling had dinner together at an 'Italian pot-house' – Solferino's. The proprietor had not expected any customers, and gave them a free bottle of wine, because they looked so lonely.

15

1890–2

BRIAR ROSE: BURNE-JONES IN THE NINETIES

The final version of *Briar Rose* was the culmination of flower languages – the 'burden' of the thorn and the rose. On 6 April 1890, Burne-Jones wrote to his old patron Leyland that, if he cared to, he could come and see the four paintings – the *Briar Wood*, the *Council Chamber*, the *Garden Court*, the *Rose Bower* – they would all be in the studio by the end of the week. He was totally exhausted, too close to the work to be able to judge it.

It was the only time he had ever used direct historical reference. 'I took the pains to make the armour of the knight many centuries later than the palace and ornaments and caskets and things and the dresses of the ladies and courtiers.'[1] The passage of time was essential to the concept – the long years of childhood when the maiden seemed at a standstill, oblivious to threat. The colour was in the same range of *Cophetua*, purple, rose madder, bronze and blue-grey, with the addition of a strange sea-green. 'Colour exists only where there is tenderness,' Ruskin had written in the *Two Paths*, 'it should be thinner than the grooves in mother-of-pearl, and the final touches quite invisible.' The picture was finished. The princess in it would never wake.

The arrangements for showing *Briar Rose* had been made by Graham with Lockett Agnew. He was to receive £15,000. It was by far the best commission he had ever had. The four pictures were to be exhibited at Agnew's Old Bond Street showroom, and a condition of sale was that they should be shown afterwards for a week at Toynbee Hall, free of charge to all who wanted to see them. They had already been reserved by Alexander Henderson (later Lord

Faringdon), the financier and connoisseur, to be hung (where they still are) in the music-room at Buscot Park, near Lechlade on the Upper Thames, not far from Kelmscott.

Both the exhibitions, in the West and East End, were strikingly successful, and his fellow artists, the only people whose opinions he cared for, told him he had been right to exhibit the pictures by themselves, without distractions. There were a few dissenting voices. Gordon Craig, taken there by his mother Ellen Terry, felt himself quite unmoved as she stood there with tears streaming down her face. But Edward Clifford spoke for the many when he described them as 'the pictures of the century, I think. Burne-Jones may not be the greatest, but the pictures belong to our own time, and touch different nerves.'

Yet *Briar Rose* was not understood. On the one hand, Morris wrote a set of verses which relate the paintings to a vaguely socialist future which will 'smite the sleeping world awake'. On the other hand, Roger Fry, twenty-four and only just down from Cambridge, thought the series 'very wonderful' though he wrote that he 'liked best the one that I had seen before of the knight lying dead in the thicket of roses – it is the only one in which there is any serious attempt at a unity of light and shade.' Fry was judging by the standards of Impressionism, and not of 'the hand that is more true than real'. Only Stephens in the *Athenaeum* said all that Burne-Jones wanted, and he begged him to come to The Grange to choose a drawing 'for affection's sake and old times'.[2]

Alexander Henderson had bought Buscot Park only in the previous year, and when Burne-Jones went to supervise the hanging of the pictures he offered to paint connecting panels, carrying the briar rose over panels showing a hall, a basin and towel, a kitchen with a cupboard, a terrace and a curtain. The whole room was now one harmonious scheme. Balfour, who had now been waiting fifteen years for his *Perseus* series, had to content himself with hanging the *Briar Rose* studies, during his premiership, round the dining-room of 10 Downing Street.

With *Briar Rose*, Burne-Jones exorcised the loss of Margaret. He accepted her as a young mother – the picture on which he was working for the rest of the year was a Nativity, the *Star of Bethlehem*. In May 1890 her first baby was born. It was a girl, Angela, and Ned, who had suffered endless terrors, entered as a grandfather into a

new term of slavery. 'If Margaret has others I won't let my heart go out to them as it does to this one,' he wrote to Mrs Stillman,[3] but that was something he never learned to avoid. He made hundreds of endearing pen drawings, and his stories about Angela grew so numerous that even Margaret refused to listen to them.

Burne-Jones entered the nineties, then, with rather fewer financial worries than usual, as a famous painter in his own right, and well able to face the new decade. Long practice had made him master of his own strange art – 'in my own land I am king of it'. This land was open now to a new generation, offering them:

> The silver apples of the moon,
> The golden apples of the sun.

'I had much trouble with my senses', Yeats wrote in the first draft of his *Autobiographies*, 'for I was not naturally chaste and I was young ... I was a romantic, my head full of those fascinating faces, in the art of Burne-Jones, which seemed always waiting for some Alcestis at the end of a long journey.'

The paintings drew further and further apart from any outside influence, except perhaps the hundred years from the end of the twelfth century when, Burne-Jones thought, artists had discovered a new secret of drapery, and the figures on the entrance porch of Chartres Cathedral were given 'coats like no coats ever were'.[4] He could suggest what he wanted with a shadow of body-colour or a touch of gold. He experimented with silverpoint which he made from a sharpened sixpence, and with small gold drawings on vellum. There are sketches in the *Secret Book of Designs* which he never carried out, and which look to a further stage, beyond anything he ever did. At the other end of the scale, Rooke and he toiled away at the vast canvases which he knew might never find purchasers. He made his final supreme designs for stained glass. He began his last collaboration with Morris with illustrations for the Kelmscott Press.

Burne-Jones was not deceived as to the nature of success. He was saddened by the triumph of the Impressionists, not so much on his own account as for the sake of art itself. 'They do make atmosphere,' he said, 'but they don't make anything else; they don't make beauty.' How could he calculate the shifts of time by which the coal wharf at Argenteuil, and even Upper and Lower Norwood, would

come to appear a dream world as remote from ours, and as romantic, as his own? It was slowly borne in upon him, too, that his biography might have to be written one day. This of course would be entrusted to Georgie, but, horrified by the account of Rossetti in Bell Scott's *Autobiographical Notes* ('inaccurate and somewhat malignant gossip'[5]), he found himself driven to watch sale rooms for his own letters. In November 1890 Ellen Terry wrote to Graham Robertson: 'Howell is *really* dead *this* time! Do go to Christie's and see what turns up!' Fairfax Murray went both to Christie's and to Bain's, but whatever secrets Howell had, died with him. Burne-Jones himself burned many hundreds of letters, though he hated to lose Swinburne's.

About his life from day to day, the *Memorials* are less and less informative as time goes on. But in spite of his own retiring nature, his last years are very well documented, rather better perhaps than he would have wished. In 1892 Rooke began to keep his studio diary, though he could only note things when the Master was out of the room, or when they were painting on different levels. Interviewers and journalists began to intrude, to Burne-Jones's evident distress. An affectionate but clear-sighted view is given in Angela Thirkell's *Three Houses*; Angela was from the first a 'noticing' little girl, as well as a triumphantly spoilt one. (Burne-Jones outdid both Millais and Gladstone, with whom he entered into serious competition as a grandfather, by allowing Angela to butter her bread on both sides.) His impact on the young artists of the nineties – 'no one was very old in the nineties' – can be felt in Graham Robertson's *Time Was* and in William Rothenstein's *Men and Memories*. To Rothenstein, assiduously searching for portrait subjects, a visit to The Grange seemed like entering from the open air into 'the depths of a shady grove. There was something both rich and sober therein, of which the Victorians alone had the secret.' Graham Robertson, who got to know the family much better, was struck by the change that took place when the great painter got away from the house into the studio, still more so when Burne-Jones advised him that what would really help him would be 'to get into the most ridiculous mess over some woman'. Besides these memoirs there are a large number of letters, both printed and in public or private collections. Burne-Jones usually asked his

correspondents to burn his letters, but very few of them did.

Burne-Jones brushed lightly with the nineties, taking them on their own terms. The Aesthetes of the seventies and the music-hall culture of the eighties were succeeded by a decade of sensibility which led either into the dead end of the Yellow Book or to the dangerous heart-searching of the 'Souls'. The Souls were the inner group of friends who had been brought closely together, in the first instance, by the death of Laura Lyttelton. Sensitivity and intelligence – every moment of life was felt – held them together by a kind of electric tension between one great country house and another. We recognise the 'great want met' of Henry James. The Wyndhams were Souls, so were the Duke and Duchess of Rutland, Algernon West and Godfrey Webb (both in love with Laura), the Earl and Countess of Pembroke, of whom Burne-Jones was to make one of his last portraits, Arthur Balfour, George Curzon, Frances Horner. Mary Gladstone and Lady Battersea were not Souls; Sir William Harcourt's remark that all that he knew about the Souls was that they had very beautiful bodies, shows the mystification of those who were excluded. Balfour, 'King of the Souls', asked to describe their vanished day, said it was 'imponderable as goassamer and dew'. In deliberate contrast to the amusements of Prince Tum-Tum and his intimates, the Souls were moved only by beauty and the intensity of friendship. Katie Vaughan, whose art had developed since Ned admired her in the seventies was their chosen dancer, Burne-Jones was their painter. Elusive as before, he was with them and not quite of them. In their own phrase, he was an occasional Soul.

The theatre of the nineties offered a relief from the intensity of the Souls. Just as Ned had tried to get Rossetti to come to *H.M.S. Pinafore*, so now he made efforts – believing in its relaxing power – to take Morris to the theatre, although this was a risky business; he sometimes answered back loudly from the audience, or turned up covered with blue dye, since, as Mackail says, 'when he began to add dyeing to his other handicrafts, appearances were completely given up.' Ned enjoyed simple spectacles – he liked taking friends to see the elephants at the newly opened hall at Olympia, and to a melodrama which apparently contained the line 'The man who can lay hand on a woman except in the way of kindness is unworthy of the name of a British sailor'. Pantomimes – although he was inclined to think

fairy stories should be told straightforwardly, 'just as they happened' – pleased him when they reminded him of the *Fairy of the Golden Branch*, and he would go to see anything played by his great friends Ellen Terry and Mrs Pat Campbell.

All in all, Burne-Jones cut an acceptable figure of the nineties. His silvery beard was shortened to an imperial, and although his tailor, Standen, complained that his bill was only £5 a year and not worth sending in, he acquired a wideawake and a deerstalker, and for cold weather, a sealskin coat lined with red silk. (Sealskin was throughout the Victorian era the sign of an artist's modest success. Fred Walker had bought a sealskin waistcoat for the long-ago first showing at the Old Water-Colour Society; Howell had bought Whistler's *Henry Irving* for £10 and a sealskin coat; Rossetti had given a coat to his mother not long before he died.) Burne-Jones could allow himself, too, a really good cigar; Georgie wrote nostalgically of 'our dissipations' when they would go to a decent restaurant and take a cab home, not walk as in younger days. As a host, Ned felt that his own ideas about eating were too simple and frugal, and Phil or the knowledgeable Comyns Carr might be called upon to help; 'I know no more what dinner to order than the cat upon the hearth – less, for it would promptly order mice,' he wrote to Carr after inviting the Alma Tadema and the George Lewises to Previtale's. Music became more than ever important – never Wagner, except for *Parsifal*, which brought to him 'the very sounds that were in the Sangraal chapel' – but private concerts with the Henschels and Dolmetsches and public ones given by, for example, Sarasate, among whose admirers was Sherlock Holmes. We catch glimpses of Burne-Jones playing dominoes with Lord Salisbury, or taking Oscar Wilde home in a four-wheeler when he was 'the saddest man in London'. Sarah Bernhardt and Paderewski came to the studio. Indeed his influence went farther afield than Europe. The Kiplings had taken his work with them to India, drawings of Fat Men went to the Tuan Muda and the Ranee of Sarawak, the lepers of Molokai received a *St Francis* which Edward Clifford took out to Father Damien. Clifford described his anxieties as the sufferers, with their fingerless hands, lifted the precious picture out of the boat and carried it to shore.

When, during the nineties, bicycling divided the nation into those who could and those who couldn't afford, Burne-Jones, like Whistler

(but unlike Balfour and Henry James), gave up the attempt to learn; but he did so with some regret, having heard of two young bicyclists, a man and a woman, perfect strangers, who 'crashed at Ripley, were picked out of a hedge and woke up to find themselves in the same bed'.[6]

This was only one of hundreds of stories, always delivered in a gentle murmur, for which he became celebrated even in the conversational arena of the nineties, where hostesses arranged their talkers in orchestral counterpoint. Ned admitted that he '*contributed to history sometimes*' when telling them. As Balfour put it, 'you never knew where you would find B.J.' Some of their distinctive rueful tone can be felt in the story of the old French artist who drowned himself rather than submit to the 'new ways' of Delacroix: 'there wasn't much water in the ditch, but he had rare and high principles, and lay on his face and held his breath and finished, rather than wake up to such a fickle world.' Then there was the sage who was asked to divide a bag of walnuts according to the higher wisdom, 'not as man divides, but as God divides,' and gave to one five, to another fifty, and to another none; the story of Wang, the Emperor of China, on whose bath-tub was written, 'Daily one must renew life'; the true story of the fat lady who patted Burne-Jones's leg under the table and said 'good dog', so that he didn't know whether it was better to keep still or waggle enthusiastically; a dream: 'I was talking to God himself – I knew it was He, but dared not look, and he said: "I have no money" – the only personal communication He made to me, and it sounded as if I had been trying to borrow, doesn't it?'[7]

Although he seems to have liked country house-parties less than ever, he continued to go, though Georgie very rarely went with him. His letters show what his unfailing unobtrusive politeness hid: Lady Elcho's house was unbearably cold (though not quite as bad as Kelmscott, where your water-jug froze as soon as you opened the window), Hawarden was 'like a railway-station', and on one occasion Mrs Gladstone forgot to put out sheets and pillowcases. Clouds, on the other hand, built by Webb for the Percy Wyndhams and decorated by the firm, was a wonderfully unpretentious 'great house' until it was burnt down in 1889, only three years after it was finished. Delightful letters – then called 'bread-and-butter letters' – and showers of little drawings followed the visits. Sometimes these

were made on misty windowpanes, and were lost for ever. One beautiful series was found round the outside pages of a *Bradshaw's Railway Guide*.

To the Burne-Joneses of the nineties returned William Morris quite unchanged, as shaggy and soft-hatted as ever. 'Morris belongs to the big past, when we were all young and strong and ready to beat the world to bits and trample its trumpery life out,'[8] and he still did, in spite of his noble dreams for the future. Morris's understaking had been to give 'decent leading' and to make people listen to socialist doctrine; however the Movement developed in years to come, he had done what he set out to do and, without meaning to, had given it a dignity it could never have got in any other way. Retired from the active struggle, he still felt that under a social democracy 'the perception and creation of beauty shall be felt as necessary to man as his daily bread'. In this spirit he began his research into the printed book.

Burne-Jones, of course, must be the chief illustrator for the Kelmscott Press. May remembered that Ned sometimes mildly complained that to hear Morris talk, you wouldn't think there were any other artists in the world, and Morris agreed that you wouldn't be far wrong; Bernard Shaw found that Morris was 'beyond reason' on this subject. Side by side with his own romances he was impatient to print the sacred books of their young days at Oxford, the *Morte*, Chaucer, Ruskin's *On the Nature of Gothic*, even *Sidonia*. The two men of fifty-seven felt like children together. They spent hours reading comic weeklies about the misadventures of Ally Sloper (and his daughter Tootsie and her friend Lardi Longsox). A collection was begun of photographs of Wagnerian prima donnas – all of them Prominent Women. The Sunday breakfasts went on till noon, when Georgie presided, almost invisible behind the large joint of beef. Morris's attitude to her was one of deeply affectionate companionship. Rooke was surprised to hear him 'call the Mistress "old chap"'. He complained bitterly about her new dresses – Georgie had started to wear a bustle. The restraints of the *Heir of Redclyffe* were at last relaxed, Morris gave way to emotion more freely and his language became 'unreserved'. 'I was ashamed of him – no I wasn't – I was proud of him, but I pretend to be ashamed', Burne-Jones told Rooke.

Morris and he rejoiced together when, in 1890, drawing (though

not yet painting) became one of the subjects taught in elementary schools. They had been campaigning now for a long time to open this particular gate of the imagination to every child. On the other hand, Ned seldom or never encouraged beginners to take up art as a profession. An exception to this came in the spring of 1891.

Since Margaret's marriage, The Grange had no longer been open to callers on Sunday. But not everybody knew this, and in the spring of 1891 on a day when Oscar and Constance Wilde were expected to tea, a very young artist, who 'happened' to have his portfolio with him, called with his elder sister. This was Aubrey Beardsley, and when the two young people were discreetly turned away by William, and 'left somewhat disconsolately',

> I had hardly turned the corner when I heard a quick step behind me, and a voice which said 'Pray come back. I couldn't think of letting you go away without seeing the pictures, after a journey on a hot day like this.' The voice was that of Burne-Jones; who escorted us back to his house and took us into the studio, showing and explaining everything. His kindness was wonderful as we were perfect strangers he not even knowing our names . . . I can tell you it was an exciting moment when he first opened my portfolio and looked at my first drawing . . .

'All this from the greatest living artist in Europe', as Beardsley says in his letter. Burne-Jones decisively admired the drawings, but clearly thought of them as sketches for large-scale paintings. He suggested a course of study with Frederick Brown at the Westminster School of Art. Then he showed Beardsley the Mantegna prints round the drawing-room walls and suggested that he should go to see the originals at Hampton Court. He had divined that the real point of sympathy between himself and the nineteen-year-old boy was the processional and ritual nature of their art.

The Oscar Wildes took the Beardsleys home in their carriage, and Burne-Jones provided introductions to Leyland and Puvis de Chavannes, and a good deal of further advice. Nevertheless, it seems that it was Mabel – 'the pretty red-haired sister', as he called her to Rooke – who had caught his eye and induced him to ask the young creatures back to The Grange. He was no less distracted than he had always been by a charming face.

On the verge of old age, he drew as studiously as ever from the model. Bessie Keene came as her mother had done; she sat for *Aurora* and for the *Vespertina Quies*. Bessie was an excellent sitter, though unfortunately in love with a heartless Mr Inwick, said to 'look like the heroes I paint, and I am rather kind, and taken an interest,' Burne-Jones wrote.[9] He was haunted by the type he had himself created. A lady called under the assumed name of Pomeroy, saying that when her hair was brushed forward over her forehead she was considered to look like Madonna 'and that's your type, Sir'. Respectability still prevailed. Kate Dolan (a favourite model of Millais') came, and Miss Tueski, who only 'sat for the hands', because she had reserves. Burne-Jones liked Jewish models. 'When they have beauty it is real beauty . . . nothing I like so much in the way of work as drawing out their hidden expressions and wondering what their lives are like.' A little girl from Houndsditch came for the *Sponsa di Libano* to screw up her face and blow like the wind. Another Jewish model 'was too proud to look at my drawing; when she was putting on her hat to go I showed it and said, 'Is it beautiful?' She said, 'No, it's lovely, not beautiful.'[10]

Male models were harder to find, and nineteenth-century male costume unpaintable; only plumbers in corduroys, with string round the knees, would 'compose', Ned thought. (Whistler, it may be remembered, had wept at the difficulty of getting Leyland's legs, in their tight trousers, right.) But occasionally the 'unforgotten face' appeared. In 1894, when the workmen were at Rottingdean fixing iron piers for 'the rubbishy blackguard little trumpery railway' from Brighton, Burne-Jones saw a workman driving piles in the sand who was just right for Perceval. 'Once they chose Kings because they were like that' – but he hardly thought he could ask the foreman to let him sit.[11]

Perhaps this was just as well, and it was certainly just as well that he avoided telling the foreman what he thought of the Volk Railway. The truth was that the Burne-Joneses were not altogether popular at Rottingdean. Ned made a number of protests about the noise and took legal measures against the introduction of electric light. When the windmill caught fire, only Phil and a sailor tried to save it, while a small crowd collected to watch the blaze and began to throw stones. Mackail's scholarly lecture on 'Rottingdean: Past and Present' fell on deaf ears; 'it would have been just as good if he'd said: "Once there was no village here, not even a road to the sea."'[12]

Anything more unlike the 'frankly and openly joyous' folk of *News From Nowhere* than the inhabitants of Rottingdean could hardly be imagined.

There were many happier moments, however. On the anniversaries of Ned and Georgie's wedding – Dante's day – two wagonettes dragged the children of the village up the downs for a picnic. Rottingdean was (and is) grateful for the beautiful windows he designed for their church; and the sea air, so everyone was convinced, was good for his health.

In the late spring of 1891 he badly needed to recuperate. He was an early victim of the influenza epidemic and the subsequent 'nightmare of gloom and despair', as he described it to Sir Henry Layard; promising, however, if Sir Henry would come and see him, not to describe all his symptoms. His recovery was very slow. Rooke was dismayed to see the Master arrive at Rottingdean in a weakened condition, vague and penniless, having apparently been robbed on the Victoria omnibus.[13] A fall on a slippery wooden pavement had jarred his arm in its socket. Certainly he grew more absent-minded, and it was not unusual, though annoying, for him to undress, dress again without thinking, and then have to undress once more. Clothes and boots all in one piece, he thought, would lessen life's difficulties.

There was a great deal of work to do. Burne-Jones turned down a commission for the mosaic decoration of St Paul's, a church he had always hated. But the *Avalon* had come back from the Campden Hill studio, and he had to finish the *Sponsa di Libano*, a very fine design (developed as usual from an earlier one) of a serene bride standing among fertilising spice winds. The firm was doing the glass for Whitelands Training College and had just accepted another important commission. William Knox d'Arcy, a millionaire from Australia, had settled into a great Gothic mansion at Stanmore, described by Morris, who had been to see it, as 'a house of the very rich – and such a wretched uncomfortable place', but the firm had agreed to decorate the first two floors and to design a staircase, mosaic floors in daisy patterns, a ceiling for the banqueting hall, even electroliers, and, most important of all, a set of Burne-Jones's tapestries illustrating the adventures of Arthur's knights. It was for these that Ned had wanted the head of Perceval.

Why should William d'Arcy, after making his pile in the Mount

Morgan gold-mines, and coming back to the old country which he had left at the age of seventeen, want to live surrounded with Arthurian tapestries? In truth, he had embarked on a quest of his own, for he had formed the quixotic idea that there might be oil in the deserts of Persia. In 1890 he was opening negotiations for a concession of 500,000 square miles which he would defend against all foreign syndicates, until in 1908 a payable well was found at last and in due time the Anglo-Persian Oil Company was formed. The tapestries were not hung till 1894, but after that d'Arcy negotiated, for nearly thirteen years, under the shadow of the Ruined Chapel and the Siege Perilous.

Burne-Jones approached the mass of work with a sensation of hardly being up to it. 'Oh, but such a changed old Ned,' he wrote to Watts, 'so old – so worn out – so dispirited – they say it is influenza – and perhaps it is.'[14] Georgie, on the other hand, 'commands and forbids with increasing energy . . . and looks younger than she has done for many years.' But the burden of supporting the household, and, of course, Phil, who is 'not as hard at work as we are, you and I', fell on Burne-Jones's shoulders, as did the many private charities and kindnesses of which he said little. In 1891 he was also in correspondence with Watts about the possibility of helping Madox Brown. Brown had not spoken to him for years, but Burne-Jones had surreptitiously collected £900 for a memorial presentation, 'and there shall be no talk of his circumstances', he told Watts, 'but we will ask him to paint some subject for this price.'[15] According to Ford Madox Ford, by no means a reliable witness, the picture was painted and Brown sent out invitations for a private view, but when he saw Burne-Jones arriving with Leighton he turned off the gas and plunged the studio in 'gloom of the most tenebrous' rather than let the detested Academicians see his work. But Ned knew that helping old friends was a delicate matter. In 1888 he had arranged an exhibition of Inchbold's work at the New Gallery, to 'try to win him a little renown'. Another problem, which by this time had become familiar, was the reappearances of Simeon Solomon, who would arrive 'pretty well drunk off the embankment to cry over his fate . . . and the fire of the gods was on his head once.'[16] Solomon was, by fits and starts, a pavement artist in Bayswater, but Ned (perhaps feeling that Selwyn Image owed him something) arranged for his *Medusa's Head stung by its own Snakes* to be published in the *Hobby Horse*. Swinburne, on the other hand, was safely in the

charge of Watts-Dunton at Putney, and a quite unexpected bond of sympathy arose: Swinburne, in his fifties, had become devoted to babies, was a respected figure in toy-shops, and was one of the few people who could really enter into Burne-Jones's feelings about Angela. In 1892 their friendship was 'breached and shattered with rivalry' over a delightful photograph of Angela pulling Ned's beard.

Perhaps, after sixty years, work, friendship, family and illness should be enough to fill a man's life. But in 1891 he began to work on a design which he had put aside since 1885, *The Sirens*. Of all his unfinished paintings this is the one we might most regret. It is a picture where magic is in control – 'more true than real' – since a square-rigged ship under full sail is putting, apparently without wind (and as though in defiance of 'old Duncan'), into a shallow cove. Burne-Jones, as a boy, had

> got all my strongest impression of the beauty of ships and the sea from the Welsh coast – from seeing the great three-masted ships sail past Menai and Bangor. I think a three-masted vessel in full sail is one of the loveliest sights in the world.[17]

The Sirens stand before the surrounding rocks, waiting for the ship to beach in the empty foreground, where the water just laps on to the foreshore, and the bones and armour of the few who have landed and met their death lie among the sea-grass. The glances of the sailors and the Sirens are just on the point of meeting. The time is *l'heure bleue*, the last gleam on the horizon before the dark comes.

In October 1891 Burne-Jones wrote to Leyland, who wanted to buy the picture, that:

> it is a sort of Siren-land – I don't know when or where – not Greek Sirens, but any Sirens, anywhere, that lure men on to destruction. There will be a shore full of them, looking out from rocks and crannies in the rocks at a boat full of armed men, and the time will be sunset. The men shall look at the women and the women at the men, but what happens afterwards is more than I can tell.

But the design suggests that he had not forgotten Ruskin's words in *Queen of the Air*: the Sirens, Ruskin says, are spirits of 'constant

desires – the infinite sicknesses of the heart – which, rightly placed, give life, and wrongly placed, waste away; so that there are two groups of Sirens, one noble and saving as the other is fatal.'

Burne-Jones lost his head repeatedly, but at least he did this in the grand manner. The Siren of his last decade was 'noble and saving'. In the spring of 1892 he fell in love again.

16
1892–4

'THE BEST IN ME HAS BEEN LOVE'

The 'bright presence' was Mrs Helen Mary Gaskell, known always as 'May', to whom Burne-Jones wrote: 'Sunday of Beauvais was the first day of creation, and the day I first saw Gabriel would be another – and there are six – and the seventh day is any day when I see you.'[1] One of the most understanding of the 'Souls', she was the daugher of Canon Melville of Worcester – 'I love parsons, and can talk about ancient Oxford to him, and he and I are contemporaries, YES, YES, YES I will have it so,' Burne-Jones wrote rather wildly, feeling his age, in 1893.

In fact, May was twenty-five years younger than he was. She had two grown children, a daughter, whom he painted, and a son, whom he taught to draw. In appearance she was frail and charming, with a cloud of hair and slightly hollowed cheeks. The flower which Burne-Jones assigned to her was the lily of the valley (Love Revived). Of her husband, Captain Gaskell of the Ninth Lancers, not much can be said, except that he was a nice fellow with a terrible temper, told barrack-room jokes, and was often away. He had knocked about the Middle East with Holman Hunt, but otherwise was not known to care about art. Captain Gaskell was not a Soul.

Certainly at the beginning of 1892 Burne-Jones felt desperately in need of 'help for pain'. He had another bad attack of influenza – this time he fainted and narrowly escaped being crushed by a horse-bus – and he became a 'passive machine' when it was discovered that an eye operation was necessary. This was carried out at home, not altogether tactfully perhaps, as while he was being carried upstairs he saw the doctors heating a red-hot wire 'like mediaeval torturers'.[2] Work was impossible, and in fact for the whole of 1892 he had nothing to show in the way of paintings except further

cartoons for the Rome mosaics and four *Perseus* subjects designed seventeen years before. He drew himself in carpet slippers, defeated, in an arm-chair, and surrounded by blank canvases. William de Morgan, in England that year to lecture, was shocked at his old friend's appearance and begged him to come away from the fogs and 'flu to Italy.

Georgie placed great confidence in a new and safe acquaintance who had become a frequent caller at The Grange. Dr Sebastian Evans was a Birmingham man – Ned had met him during his visit in 1885, when Kendrick, wanting to indulge the 'archaic craze' of his distinguished guest, had introduced Evans, who was planning a High History of the Holy Graal.[3] 'Sebas' was not a doctor of medicine but of law, though as Burne-Jones charitably said, he was too clever to practise law or anything else. After receiving Evans cordially, he promised him a frontispiece for the High History, though he lost interest when he found it was a 'rational' and historical explanation of the Quest. Sebas joined in reminiscences of old Birmingham and in discussions of philosophy and art, during which he, like Rooke and Selwyn Image, was busy taking down surreptitiously everything that was said. Rooke began to dread the 'mixed asthmatic coughing fit and deprecatory laugh' which heralded the Doctor's approach – still more so when his newly-published volume of poems arrived and he proposed reading them aloud in studio.

But Ned's confidante was not the safe, tediously coughing Dr Evans, but the ethereal May Gaskell. 'What are you doing to-night . . . who is daring to talk to you – is he worthy of seeing you – is he worthy of seeing you and living on the same green ball of an earth?' Bitterly he regretted his own age and ugliness, the face which, as he put it, had glared from his shaving mirror and haunted his dreams for years. Between 1892 and 1895 he wrote to her as often as five or six times a day, confiding everything to her 'wide-eyed mercifulness that has no hardness or arid firmness in it'. Mrs Gaskell, if not firm, must have been a tactful woman. She managed a difficult situation extremely well.

She had been introduced by Frances Horner and first came to The Grange at the beginning of 1892. On seeing the studio she 'pronounced the word that rankled' – that is, she said it was in a

mess. For her sake Burne-Jones submitted to spring cleaning; she struck him immediately as someone for whom he would do anything:

> Do you remember (oh why should you remember?) one Sunday afternoon coming very late and Georgie and Phil and I were in – I don't think you liked your visit – so many of one family, and you quite alone – and I couldn't bear you to go out alone into the cold and darkness and wanted to see you safe then – always fidgetting to see you safe – what impudence – and you said you had come on a bus [sic] facing the wind and liked it – and then I hoped you were really stronger than you looked . . . as for me I was happy because you had come – and how many thoughts – and wanted to make a great fuss of you and couldn't tell how it could be – or what I could do . . .[4]

But he could, as he had with so many others, show her what beauty was, for in spite of their three houses (3 Cumberland Gate, Beaumont in Lancashire, and Kidlington Hall in Oxfordshire), Mrs Gaskell, that 'lovely worried little woman', was starved of beauty. He began, of course, by taking her to Hampton Court to see the Mantegnas.

The slightest illness or absence of Mrs Gaskell caused Ned extravagant worry, and it was painful for him to see her, as he nearly always had to do, in society. 'Sometimes you looked ill and sometimes you looked young and lovely and both hurt – can you understand why they both hurt . . .'[5] When Morris read aloud his seemingly endless translation of *Beowulf*, Burne-Jones shut his eyes and thought of Mrs Gaskell. When he was left alone at The Grange with a chop for his dinner, he impulsively wrote a note begging her to come round – she should have the chop – and his 'hungry eyes could drink from the fountain of life'. Often he stayed too late, or talked to wildly, and once he did a drawing that was indiscreet. All this meant gentle reproof, but he asked for very little. 'Ah, dear heart . . . I know it is difficult for you to write now – in the day time impossible – and I love to think of you sleepy tumbling fast asleep at once and waking late.'[6] He faithfully destroyed all her letters as they came, keeping only the

latest one which he carried about – 'such are my principles' – in his trouser pocket. All that remains of what she wrote is an occasional 'very like him!' in the margin of a letter. But perhaps he did not exaggerate when he told her that she had saved his life. She had reached 'the root of the well of loneliness that is in me', and made it possible for him to paint again.

> I keep thinking of that first sight of you – and why didn't you come in dreams to me last night instead of Mr Longman – damn Longman – but I still see those divine little figures moving in a land no man ever saw, in a light none can dream of – better than Italy sun ever did.*[7]

'. . . I had a glimpse of what a heaven life could be – of sustained ecstasy at visible beauty.' He had only felt this once before, in 20 October 1894, 'in a painted church at Oxford'.

This comes close to the heart of Burne-Jones's painting, and explains why in spite of illness and depression, the year 1892–3 was, he told Mrs Gaskell, the happiest one he had ever known. 'I suppose I have learned my lesson at last . . . *the best in me has been love*, and it has brought me the most sorrow, but it has this supreme excellence, that in its sight no mean thing can exist.'[8]

With this inspiration Burne-Jones began his first rough designs for the Kelmscott Chaucer. 'The form and detail of the great folio', Mackail writes, 'was taking definite shape in Morris's mind.' Ned was struck, half enviously, half pityingly, with the difference between them. As Morris arrived with his familiar satchel full of work, with his enormous impatient enthusiasm, he seemed past the disturbance of any kind of human passion. 'No disaster can touch him now,' Ned wrote to Mrs Gaskell, 'and my happiness hangs on a little thread.'

> He is a world to himself – isn't it great to be made like that? Such strength as his I see nowhere – I suppose he minds for me more than for anyone, yet the day I go he will lose nothing, only he will have to think of himself instead of thinking aloud – no more than that. Yet side by side at Oxford it looked as if we had

just the same thoughts about all things. The invisible seed was growing – sometimes in the depths I think mine the best. Only it is so short lived on the crest, and the trough is so deep and long.[9]

In saying this Burne-Jones seemed to have overlooked (even though he designed the frontispiece) the late romance which Morris was writing every day before his household was awake. In these marvellous tales the young man is always setting out anew on the journey, the grey-eyed maidens of the Wondrous Isles and the Acre of the Undying have 'no mere good will, but longing and hot love' and the return is always to Upton or Kelmscott, where all abide in contentment. But this was a dream, while a letter from Mrs Gaskell might come at any moment.

Morris still read aloud as the generations passed. Rudyard Kipling had only half understood when he recited the sagas, sitting on the nursery rocking-horse. Angela refused to listen altogether. Georgie, who had stabbed herself with pins to keep awake for the *Earthly Paradise*, was still at her post; Rooke could tell, through the closed door, whether he was reading prose or poetry to the Mistress.

Denis Mackail, Margaret's second child, was born on 3 June, and Burne-Jones, once again, went through a torture of anxiety and amazement at Mackail's apparent calmness. Only three days later he had news of the death of his royal patron Frederick Leyland. Leyland had died on a train between Mansion House and Blackfriars, going to business as usual. In his way the President of the National Telephone Company had been a kind of saint of patronage, suffering in the cause of painting not only Whistler's furious satire but many smaller things – Aggie Poynter had been taken in childbirth at one of his dinner parties, the indolent Val Prinsep had married his daughter. His famous 'royal black sulks' had never touched Ned, who had received at his hands nothing but kindness. Now he was given the commission for his old patron's tomb. The strange little Byzantine sarcophogus which he designed shines out, totally different from the surrounding memorials in the shades of Brompton cemetery.

At the Leyland sale Whistler's *Princess du Pays de Porcelaine* fetched 420 guineas, four Botticelli illustrations to Boccaccio fetched 1,300 guineas, and the *Beguiling of Merlin*, which started at 1,000 guineas, was bought by Agnew's for 3,600. This was another thing for which Whistler was not to forgive Burne-Jones.

Summer was spent at Rottingdean, where the family gathered in their hundreds for the marriage of Stanley Baldwin to Lucy Ridsdale, from the much grander house across the village green. Phil showed no signs of following Stan's example. 'I know very little, indeed next to nothing about Phil's history with D.D.,' Ned wrote to Mrs Gaskell,[10]

> something has hurt him and embittered him . . . I can say very little to him because he never tells me anything . . . Ah me I do hate marriage and think it a wicked mechanical device of lawyers for the sake of property and such beastliness, and so I can't pity him for not getting what he wanted and yet I do.

In the middle of his distress Phil valiantly attempted from time to time to cheer up his gloomy elders, but always with poor success. He took Poynter out to the Café Royal, but they were besieged by prostitutes who followed the gloomy Poynter into his cab. He took Ned to the Savoy, but Whistler was there with a party of his friends, and the evening was ruined for both of them.

This, of course, was after the return to London, when the autumn fogs descended and Burne-Jones felt poignantly the rapid passing of time. In November he met Millais in the street, in tears: the doctors had given him the first warning of a mortal disease. A few weeks earlier, as the result of many tactical moves, many pleas and persuasions, Ned had agreed that the winter exhibition of the New Galleries should be a retrospective of his own work. The owners had been applied to. His lifetime's work was coming back to him. His age, that year, he put at 175.

'It is a mixed feeling I have about those ancient paintings of mine,' he wrote to Mrs Norman Grosvenor.[11] 'I feel as if I should be glad not to see them again sometimes . . . just at first I felt as if it was a little hard on me to have two Days of Judgement.' The idea of judgement, which had never been far from Ned's mind since

childhood and always present to Georgie, weighed upon him more and more. 'There are days of bede,' he told Mrs Gaskell, 'fifteen days before the trumpet blows and day by day it grows so dreadful that no tongue can tell it – but the wind is the worst.'[12] Had he, or hadn't he, done what he had undertaken to do? In the winter of 1893 he was deeply moved by Francis Thompson's *Hound of Heaven*. Like the poet, he could make only pitiful attempts to hide from the Judge who followed after.

The kindness of friends made the retrospective tolerable. Du Maurier wrote a particularly delightful letter of nostalgia, 'très doux et un peu triste', on the 'special glamour – the Burne-Jonesiness of Burne-Jones'. Another outcome was to be a magnificent volume, *Edward Burne-Jones: A Record and Review* by Malcolm Bell, illustrated with Hollyer photographs. But Ned, probably alarmed at the solemn tone of the book, seems to have given little, if any, help. He turned his biographer over to Stephens, explaining that Malcolm Bell is not only a lady, but the son of Poynter's elder sister. For the moment he felt unexpectedly younger. 'You are pretty much the age I first knew you,' he told 'Steev', 'about thirty or so, and I feel a few years younger – if I catch sight of myself in a tall mirror it is a mocking surprise, but I get over it and forget it.'

The retrospective ended with a party at the New Gallery. Ned had hoped this would be 'an evening of friends' and was appalled to find that 'everyone' had been invited and the Comyns Carrs were in a state of agitation over the reception of Prince Tum-Tum, while Cardinal Vaughan insisted on being received, in full pontificals, in the street. All that mattered to Ned was that Frances Horner was ill and had to refuse, and Mrs Gaskell, who was getting ready to go to Italy, could not come either.

His own quiet personal celebration was to resign from the Academy; since *The Depths of the Sea* he had exhibited nothing there,[13] and he regretted the hostility which was preventing his election to full membership. He was sorry to hurt Leighton and Watts – but, as he explained, he felt at the Academy as though he was kept 'on the hall mat . . . and I want to be away and free and in the open air.'[14] He resigned as courteously as possible. His presence in any academy was an absurdity. After writing the letter on 10 February 1893 he felt, as he

told Mrs Gaskell, 'cleaner than soap and mops can make me', (Mrs Wilkinson was on the rampage again).

During the 1893 Georgie's energy, which had always been astonishing in anyone so small and frail, became formidable. Still 'commanding and forbidding' with equal firmness, she threw herself into the organisation of the South London Gallery in Camberwell, which was to show pictures without charge to the poor children of Peckham. Leighton was enlisted as President. 'Georgie I haven't seen for days,' Ned wrote to Watts. 'She is somewhere behind a heap of Rossiter's correspondence[15] . . . I can see only the top of her head, but I believe she is pretty well.' The prospect of the Local Government Act (which was passed in the following year, one of the last achievements of Gladstone's administration), meant that she would have scope for activity in the politics of Rottingdean, and Burne-Jones looked ahead to his prospect with awe. He bought two hats with a feather, one for Angela, one for Georgie, to induce a gayer mood, and Angela, at least, liked hers.

In his intense craving for sympathy he made many other confidantes. Mrs Pat Campbell responded, she declared, with all the warmth of her Italian nature to the beauty of The Grange. She must stretch out her arms to it, she said – she would arrive and ask to lie down in a darkened room, since there was no peace in her own house, or even retreat to Rottingdean, where Ned told her to hire a good piano, at his expense, from Brighton. The walls of her blue and white drawing-room were crowded with Burne-Jones engravings; but among them, unfortunately, was an extravagant picture by Phil, representing 'Stella' gazing longingly at the stars, while worshippers looked upon her from below as a star. Phil, who was silly about so many things, was becoming silly about Mrs Pat.

Burne-Jones, on the other hand, understood Mrs Pat perfectly, but felt that a little of her went a long way. She was incomparable, she had fine eyes ('God gave me boot-buttons, but I invented the *glance*') – but she had not the native generosity of dear Ellen Terry.

He found a gentler and closer companionship with two young sisters, both of whom he taught to draw, Violet and Olive Maxse. Burne-Jones, who was affectionately treated by all the pretty

daughters of his friends (with the exception of May Morris), was particularly in tune with these two daughters of a sensitive artistic mother, separated from her husband, Admiral Maxse. Violet, in the memoirs she wrote as Viscountess Milner, calls Burne-Jones 'deep and true and unselfish under the chaff'. 'My dear,' he wrote to her in March 1893, when she was going off to Paris to try her luck as an art student,

> A certain kind of silly rubbish has always helped me – deep down we are all face to face with a certain solemnity – we can guess that much of each other with certainty even if we know nothing – so I shall be silly till you want me to be sad, and then you shall have all the sadness that is in me . . . whether I see you or not, God bless you, my dear.

This letter strikes the note of true feeling he had for beginners in life, as well as his surface gaiety: when Violet became engaged the next year to Lord Edward Cecil, he told her that he hoped many men would drown themselves on hearing the news. Olive, the 'unparalleled and exceptional darling', he drew and wrote to again and again. He was her 'affectionate, failing, but still reasonable E.B.J.' To Mrs Gaskell he confided that he was trying to think of someone who would 'do' for Olive; Charles Hallé was in love with her, but he was not steady enough.

Spring brought a characteristic depression. 'I don't know myself these days that my pride seems gone as if it had never been . . . my Fortune's Wheel is a true image, and we taken our turn at it, and are broken upon it.'[16] He was working badly: he compared himself to the fallen Lucifer of his Rome mosaics. On 9 March 1893 he wrote to Mrs Gaskell that, on the whole, he wished he had never been born.

> . . . indeed what a solution of troubles that idea suggests – and who would have been the worse off? Georgie? Well it would have been much better for her – she could have married a good good clergyman – Phil and Margaret . . . they wouldn't have been born at all or would have waited a more favourable opportunity. My friends? . . . they would never have known their inestimable loss . . . My purchases? [i.e. for the National Gallery] O they could

have saved their money – the art of the country? Well there is no art of the country . . .[17]

He was aware that he was making a fool of himself and staying too late, so that he had to be sent tactfully away, at Mrs Gaskell's. In April there was a third and much more violent attack of 'flu. Reduced to a diet of quinine and beef tea, he drew himself as a skeleton – 'O but it looks rather graceful and like Kate Vaughan – I meant a limp thing.'[18] The weather was oppressively hot, even at Rottingdean. The emotional strain was reaching breaking point; Ned appealed to that wisest of all counsellors – if he believed it was in a good cause – Arthur Balfour. Balfour was still in the thick of the fight over the second reading of Gladstone's Home Rule Bill, and it is astonishing to find that he spared the time to take the train and horse-bus down to Rottingdean because of a letter from Burne-Jones (who had still not finished the *Perseus* decorations) 'telling him I had a perplexity about the conduct of my life'. 'Thank God for holy friendship', Ned wrote to Mrs Gaskell after this visit, 'to take away my bitterness and disappointment of the past and make my last days here the best of all'.[19]

Although Burne-Jones ends this letter by telling her that he worships and loves her more every day, Balfour had clearly advised moderation, and he returned to The Grange and the studio. Apart from his other work for the firm he wanted to supervise the three-light east windows for Rottingdean which he had both designed and presented 'in gratitude for Margaret'. It was a proud moment when the grave-digger told him that the village approved of the windows and thought them the finest ones in Sussex.

The stout child led by a guardian angel in the predella was of course Angela, but Burne-Jones, among his four portrait commissions for this year, had been asked to paint three-year-old Dossie, the daughter of Mary Drew. The picture was to be a present to Gladstone himself. In 1885 Mary Gladstone had married Harry Drew, a local clergyman, and Ned had sent her a quiet, sincere letter of congratulation on being 'out of the great world' at last. Dossie, however, was a tornado of energy, barefoot and wildly curly, and so uncontrollable in the studio that Ned had to get photographs made at Styles, in Kensington High Street.[20] But he loved Dossie. 'Tell me about [her] – her plans – her views,' he wrote to Mary – and his

touch with little children never failed. At the age of eighty-one, when she was Mrs Parish, Dossie remembered the painter's kindness and the fascination of watching the mice running round the water pipes in the garden studio. Miss Helen Henschel, who also sat for him as a tiny girl, arrived in a green dress and was delighted to be 'mistaken' for an apple.[21]

Another sitter was Lady Windsor (later the Countess of Plymouth), an exquisite Soul. He painted a discreetly elegant full-length portrait with a scheme of cool grey-greens which would focus the eye on the dark red hair. Yet even in the *Lady Windsor* tension is present – much more so in *Miss Amy Gaskell*, where it appears in the slight nervous gesture of the hands. The stillness in a Burne-Jones portrait is deceptive, or rather it is always possible to see how precarious it is and with what difficulty it has been won.

So far Morris had paid him £300 in advance for the Chaucer drawings, and these, he knew, must have priority. He had promised to do two or three a week, but couldn't; he told Mrs Gaskell, '*you* know why – I must lock myself into a room, but I can't lock my soul up – but Morris . . . never fails, nothing disturbs the tranquil stream of his life . . . he looked so disappointed that I had done nothing since last year – and I couldn't tell him why . . .'[22]

Progress, however, was not always a tranquil stream and Morris 'would roar "d–d bad!" and grump'. The discrepancy between their ideas was becoming obvious. As Burne-Jones reread Chaucer, determined to be absolutely true to him, he was struck by how Provençal the poet was at his greatest. Morris wanted illustrations of the Miller's Tale, while Burne-Jones was lost, once again, in the magic rose-garden. Worse still, although he enjoyed the actual restriction of the page form, the delicate pencil drawings were, more than ever before, quite out of key with the great wondrously bordered folio for which Morris, at the same time, was drawing the ornaments. Catterson-Smith was called in to translate the plates into black and white; he had to work on photographs brushed with Chinese white, and draw on them with Indian ink, altering all the shadows and half-tones into lines so that they could be cut on wood by W.H. Hooper. 'I have had to give a drawing lesson to the lad,' Ned wrote. 'The lad is about 35, but still a lad – as in art one is a lad at a hundred.'[23] The best comment on the undertaking is the anxiety of Sydney Cockerell (who began to act as Morris's secretary in 1893)

to pass the whole thing off: writing to May Morris in June 1922, he suggested putting the blame on Burne-Jones's eyesight ('he no longer possessed the extraordinary actueness of early days'), but later added, 'I think it better *not* to give as a reason the failure of B-J's eyesight as at no time would he willingly have made the necessary black and whites. He hated the restriction of tone that they involved. The Cupid and Psyche drawings were all made in pencil. The drawings are wonderfully delicate things – pencil not silverpoint.'[24] And so, too, in spite of increasing pain from his eyes, are the whole Chaucer set, though only twelve out of the eighty-seven were made from earlier designs. An edition of Chaucer with the original illustrations in collotype would be a revelation, not only of Burne-Jones as a draughtsman, but of the poet who wrote:

> My peyne is this, that whatso I desire
> That have I not, ne no-thing like thereto,
> And ever sets Desire myn herte on fire . . .

Morris, of course, never dreamed of employing anyone else. Ned felt overwhelmed with tenderness at his enthusiasm. At this time too after the restrictions of the past few years, Morris launched out recklessly on buying illuminated manuscripts. Before a purchase, Ned noticed that he always said 'prudence is a mistake', and after it he would get some bottles of good champagne for Janey, 'to set her up'.[25] At The Grange he was sometimes so noisy in denunciation of everything modern that even Georgie 'prayed for patience'; then he would be taken up to the studio to design capital letters. The amount he ate was also giving rise to anxiety. At the Sunday breakfasts he liked 'many things on the table and more on the side table'. He would consume sausages, haddock, tongue and plovers' eggs and then liked to go and look at the side table 'and wish he had something else'.[26]

The summer continued hot, and Alice Kipling exhausted Ned's patience by staying at Rottingdean for three months (the Kiplings had come back from India to retire). For this reason he went up to London more than usual. In June, Dent began to publish the *Morte d'Arthur*, in parts with the Beardsley illustrations, something which Ned had looked forward to ever since the young artist had paid his timid call at The Grange. He was bitterly disappointed. Some of the

drawings were slovenly – Beardsley had got tired of the commission – and others were fantasies on his own style with borders of phallic stalks and pods. Burne-Jones was under no illusion as to why he mistrusted both these and the later drawings. 'Lust does frighten me, I must say,' he told Rooke. 'It looks like despair – despair of any happiness . . . I don't know why I've such a dread of lust. Whether it is the fear of what might happen to me if I were to lose all fortitude . . . let myself rush downhill without any restraint.'[27] Beardsley, who had begun by finding Burne-Jones 'inimitable' ('Imitable, surely, Aubrey', replied William Rothenstein), called for a second time at The Grange. Rooke saw 'the back of him, going out of the door', with all that this expressed. He had come to tell Burne-Jones that he hated King Arthur 'and all mediaeval things', and Burne-Jones felt the boy had only come 'to show off and let me know that my influence with him was over, as if it mattered in the least whether it was or not . . . you know they're impeccable, the young.' But some time later he met Mabel again in Victoria Street and 'she came up to me with her simple, straightforward-looking face with a saddish look on it, as though to say I'm sorry [I] don't like what my brother is doing any longer – at least that's what I thought it looked like.'[28] He never knew that when five years later Beardsley coughed himself to death in a hotel room in Mentone, the prints of the Mantegna procession were still pinned up round the walls.

Unsettled and miserable as to both present and future, Burne-Jones began ranging the streets, looking again for the places where he had walked long ago with Rossetti. In July the crisis came. He did in fact 'lose all fortitude', and wrote to Mrs Gaskell that he could not go on without her:

> . . . hadn't I better say I'm going to you – there must be a scene some day – I don't like to hurt – can't bear to hurt, but go to you I must – I think about it every moment – and I see all the rooms – and talk to you all day long – and so I see you haven't all forgotten the room . . .[29]

It is impossible to tell how Mrs Gaskell answered this wild scrawl or how she calmed him on this occasion, but in any case the approaching shooting season obliged her to leave London with her husband for Beaumont. Georgie was staying with her sister in

Brighton, and so was not with Ned when either this, or the next blow fell: *Love Among the Ruins*, which had been sent to Paris for reproduction by photogravure, had been drastically damaged. William Rothenstein, who was over in Paris, happened to be in the room when Goupil's man came round to Whistler – an unlucky choice – with a desperate appeal for advice. The picture was water-colour, they had treated the highlights with white of egg, the paint was coming away and what was to be done? It was one of the best opportunities for a laugh that Whistler had ever had and he must have felt avenged at last for the trial.

Phil came home at once from Paris, where he had been enjoying himself, to break the news and to be of what help he could.

Burne-Jones had lost other pictures – one of the Rome cartoons had been burnt at Clouds in 1889, and *The Merciful Knight* had, at this time, disappeared altogether[30] – but none had the emotional charge of *Love Among the Ruins*, painted soon after his break with Mary Zambaco. The owner was a Yorkshire patron, who told Ned that he had hidden the ruined canvas from his old father, so that he could die without knowing what had happened.

'It is quite irreparable, but it is life, and all in the bargain – I don't know who made the bargain,' Ned wrote to Georgie. Although Phil had been in every way good and kind to him, he felt that he could stand no more, and went straight to Beaumont. There he was taken on gentle walks to the lake and the farmyard, seeing everything with unnatural sharpness, as one does in a state of unhappiness. Gradually he resumed his lifelong study of piglets and, since Mrs Gaskell had acquired one, of pugs. Olive Maxse and Mrs Pat had also bought pugs, and he was beginning to get a good pug likeness. With this strange consolation – but he caught health from Mrs Gaskell, he said, as others caught sickness – he went back to London and to work.

The first task was to start an oil replica of *Love Among the Ruins*, and this, after his golden days at Beaumont, went forward in an unexpectedly cheerful atmosphere; Gaetano Meo, who sat for the lover, was given a joke cigar with a firework in it. *Vespertina Quies* was finished from Bessie Keene, and this was a soothing deep blue and grey twilight picture, indebted to Leonardo, but as Legros always said, 'il faut voler des riches, et non pas des pauvres.' It was autumn, and his friends began to come back to London. If he could

not see Mrs Gaskell, he could rely again on the seven posts a day, and 'Why shouldn't I write when I like – when I like nearly every minute?' At any London dinner party, too, he might meet her. He dreamed of an ideal dinner table. Instead of Henry James and the Ranee of Sarawak, who were actually coming that evening, he would have[31]

ME

MRS GASKELL | OLIVE

ME | ME

17

1894–6

THE KELMSCOTT CHAUCER AND THE PARTING OF FRIENDS

On 27 January 1894 Gladstone, on the point of retirement, offered a baronetcy to Burne-Jones 'in recognition of the high position which you have obtained by your achievement in your noble art'.

'The honour', Georgie comments in the *Memorials*, 'was accepted.' 'The one person in the house who distinctly disliked it was the mistress,' Rooke wrote in his diary.[1] Watts had refused a title on the grounds that artists should not be rewarded in the same way as politicians, and to Morris, of course, the idea would be unmentionable. Nor did Burne-Jones want a title, but Phil did. Unstable as ever, he actually wept as he begged his father to accept it. 'I didn't feel that I ought to let my own notions stand in his way or affect his life one can't tell how,' Burne-Jones told Rooke. To Norman Grosvenor and his wife he wrote doubtfully, 'I suppose it is right since friends say so and it concerns them as much as me – concerns Phil most – oh that Phil – I am almost in a hurry to be gone that he may light a long cigar and march down Bond Street – will a rich widow want him now? Many years older than Phil – that makes me anxious – wish I hadn't thought of it.'[2]

Such was the atmosphere at The Grange that the honour must indeed have been hardly worth it. According to Graham Robertson, when the documents about the baronetcy arrived (Burne-Jones said they asked 'am I clean and sober? – why did I leave my last place?') Morris was downstairs and there was terror lest he should get wind of them. Almost furtively, poor Ned began to design 'the necessary heraldic arrangments'. The motto which attracted him most was

voluisse sat est (it is enough to have desired) but in the end he chose *sequor et attingam* (I will follow and attain). As for his crest, he felt that as his only traceable ancestor was a schoolmaster, he ought to include a birch and exercise books, but in the end he drew a pair of wings in a circle of fire. 'I scarcely dare tell Georgie, so profound is her scorn – and I half like it and half don't care 2*d*.', he wrote pathetically to Mrs Gaskell. Perhaps he need not be known as 'Sir Edward'. 'Surely,' he reflected, 'surely people say "Millais" and "Leighton"'. I'll give Ralph [Mrs Gaskell's butler] £5 a year always to announce me as Mr.'[3] But Georgie remained implacable; this mark of success, a very notable one for a painter who had steadfastly refused to consider public opinion, must be put with the other offerings of Cophetua and rejected.

His bad dreams remained:

> needless journeys – train catchings – sea journeys – gloomy waters . . . I seldom dream of anyone I love – have never yet dreamed of Margaret – sometimes Georgie who is always unkind in dreams, but I have established the tradition and it never varies . . . much of infancy and dark frightening rooms and staircases and footfalls following me – and doors that are dreadful and of beasts that frighten me.[4]

At all costs, he felt, he must remain a painter; all invitations to write or lecture, even at Birmingham, he rejected – it would mean trying to be fair, and all his strength lay in 'knowing no midway between loving and hating'. In April he sent a *Sir Galahad* to the Old Water-Colour Society – the first time he had exhibited there for twenty-four years. But another huge canvas, unfinished and unfinishable, now occupied one end of the studio – *Love's Wayfaring*, a nightmare vision of love bound to its own car, dragged by naked men and women, and filling stiflingly a narrow street, like the streets of the hill towns of Italy.

The plates for the *Canterbury Tales* were complete, and he began on the *Romance of the Rose*. In July he was drawing Chaucer's bedroom, giving Chaucer his own face, and, in a queer state of desperation, writing to Mrs Gaskell at the same time: 'there I've sketched him in – put him in bed – little book by him – and curtains and a window in his bed and I've drawn his spirit going out of a door

... the spirit of him shall not be drawn faintly but stronger than the sleeping figure ... we are getting to the truth at last ...'[5]

Meanwhile Georgie had found work dear to her own heart. The Local Government Act had been passed, giving authority to elected parish councils in all villages of more than 300 inhabitants to manage all local affairs which did not concern the Church. The Act was thought of as a return to a form of mediaeval popular administration, and it was ironic that Morris was not too tired to care for it. But Georgie was now set, with all the strength of will in her tiny iron body, to help him in the cause they both served. The parish councils could either be a stagnant version of the old vestries, or they could be active; Georgie was determined that Rottingdean should be active. She sent Morris a copy of a fighting pamphlet which she was printing to distribute to the electors.[6] It reminded them that the ballot was secret, that voting was equal for rich and poor, and called upon them to take charge of their own affairs. Georgie was standing as a socialist, of course, though politics were not named. The squires of Rottingdean, where things had gone along comfortably for centuries, were immediately up in arms. Georgie, supported by the Ridsdales, was demanding a public wash-house. Battle was prepared. 'Georgie's love – she is so busy – she is rousing the village – she is marching about – she is going like a flame through the village,' Burne-Jones wrote to Watts.[7]

He was left largely to his own devices, and to Mrs Wilkinson, who 'infests the house when Georgie is away' and now carried so much equipment that she had to go through the doors sideways. Margaret and Phil both complained at his crumpled appearance. Largely for Mrs Gaskell's sake, as he assured her, he resolved to make the attempt to 'dress foppishly'. He was deeply impressed, certainly, by Phil's sudden appearance in something quite new, 'ridged trousers'. Burne-Jones had never seen creases in trousers before, and they interested him, as all shapes did. 'They have a ridge in them only when new, but I hear it can be simulated if a maid who is skilful sits up the night before and irons and irons them.'[8]

Certainly Burne-Jones not only made a creditable appearance before the Queen when he went to pay his respects at the Palace, but impressed the journalists who managed to make their way into The Grange. Of these Julia Cartwright (Mrs Ady) for the *Art Journal* (Christmas 1894) was much the most successful, making a business-

like catalogue and even getting Ned to say that he still thought of himself as a follower of the Grail. Georgie read the article aloud to him and he felt flattered, though the illustrations were 'horrid, they were'.[9] L.T. Meade, the novelist, did less well for the *Strand* (July 1895), particularly on the interview. 'It puzzles me much', Ned is supposed to have said with a sigh, 'to know what special interest the public can take in the ordinary domestic life of a man, whether he is well known in his public capacity or not.'

Arsène Alexandre, a veteran of the literary disputes of Paris, came with some apprehension, fearing he would be thrown out if Burne-Jones discovered that he knew Whistler. As a friend of the symbolists (he had even at one time lived in a tower) he had been struck at the New Gallery retrospectively by the 'signs'. In the 'pale and contracted faces' of the *Perseus* series and the 'trace of agitation even in the deepest rest' he had understood the doubtful balance of tranquillity and suffering. In consequence he was rather dashed by the painter himself, finding him 'an affable gentleman . . . the reverse of ascetic, with a short white beard'. He had expected 'the dreamy worn face of Watts's portrait'. He did not realise that too much solemnity always had a disastrous effect on Burne-Jones.

When he spoke to Julia Cartwright about the Grail, Burne-Jones was not only thinking of the *Avalon*, although it had been moved back to the studio at The Grange, but of the cartoons for the Stanmore tapestries. There were five scenes, the round table, the setting out, failures in the quest, the attainment of Galahad and a ship crossing lonely seas. Among the foliage of the verdure border hung the knights' shields, and Burne-Jones took a world of trouble and consulted many authorities over the correct arms. His imagination, however, lingered over the rejection of Sir Lancelot – Rossetti's subject in the Union murals, thirty-eight years ago. There was a familiar irony, too, in these struggles with the red cross of Sir Galahad and the chapel argent of Sir Bedivere, while Morris absolutely refused to admit the existence of Sir Edward. The employees of the firm called him 'the Bart' behind his back, and that was all. He looked ruefully at a French newspaper cutting describing 'la petite maison qu'habite Sir Edward Burne-Jones – Sir Edward, comme l'appelle familièrement son vieil ami William Morris . . .'[11]

In July he went down to Rottingdean and took Angela for her first paddle 'in undomesticated waters'. This was a relief, since he had

just got through the unenviable task of 'speaking to Phil'. One may imagine that this interview largely consisted of apologies from both sides. A few days later, Phil had collapsed altogether – 'tired, I suppose,' Burne-Jones commented doubtfully. He had to 'clamour for brandy' from a haughty barmaid to revive his son.

Phil went to Blumenthal, Ned repaired once again to 'the Rottingdean hole'. Crowded with donkeys, babies and chickens, it seemed to him much noiser than London, and although the Parish Council elections were not until December, there was a feeling of bitterness in the air. Suddenly Ned left them all, took the train for London and arrived on Mrs Gaskell's doorstep, 'I must and will take any chance of seeing you that I can for my life's sake.'[12] He did his best, he told her, to 'hide things that would burn through'. The one thing he dreaded was to go too far, and lose her.

A telegram arrived at The Grange. It was from Phil at Blumenthal: 'Implore come immediately.' The wretched Burne-Jones started packing; luckily Luke Ionides came to explain how one got tickets. The trouble turned out to be financial, and two days later father and son crawled back together across Europe. Small wonder that Ned's age on his birthday this year was 485, or that he had nightmares of being examined in subjects he knew nothing about. From this time, too, he began to have decisive warnings of heart trouble. As always, although he remained, as he admitted, an alarmist by nature and on principle', he made very little of serious symptoms. Heart failure he had recognised ever since his schooldays when he had collapsed over the doorstep with his prizes. 'Hearts may bang themselves about as much as they like,' he wrote, after a visit to the doctor, 'it may come again and probably will – and will not matter.'[13]

Nevertheless, looking back as the summer wore on, he felt that his most relaxed, indeed his sanest moments had been spent with 'theatricals'. Earlier in the year there had been an outing with Ellen Terry, Henry Irving and Kate Perugini, when they had all had to hire a fly to get back to London, because dear Ellen Terry had suddenly taken against the train and declared 'she wouldn't get into the nasty thing'. At the end of August he had got a job at the Lyceum for a young burlesque actress, Olga Christer, whom he had seen as Romeo. It was quite understandable that he should be drawn towards the warmth of the theatre and that in the end he should

follow the example of Alma Tadema and try his hand at stage design.

In May 1894, at the Théatre de l'Oeuvre, Lugné-Poe and his company had put on *La Belle au Bois Dormant* by Henri Bataille. This production is said to have had sets by Rochegrosse based on Burne-Jones's *Briar Rose*, but there is no record of negotiations with Agnew's. (The obvious intermediary would have been the American poet Stuart Merrill, who was acting manager, or possibly Robert d'Humières, who collaborated on the play and was a translator of Rudyard Kipling.) The first night was howled down by one of the theatrical factions of Paris, and Bataille was so embittered that he never printed the text. But clearly (if this word can be applied to an affair of veils and reveries and cloudy multiple meanings) Lugné-Poe's production came very near to the true meaning of *Briar Rose*. The scene opened with the Prince awakening the Princess, but she is wretched in the modern world of the evil fairy, represented by a palace of steel girders, and a kindly power puts both of them to sleep again for ever. They lie like two statues, while veil after veil of transparent blue descends, and behind them the Briar Rose grows again. 'La Princesse est joyeuse d'aller vers ses rêves de jadis.' Here we are within echoing distance of *Le Grand Meaulnes*.

Very different was the first production in which Burne-Jones was induced to lend a hand himself – the Lyceum *King Arthur*. The subject was approached not with the reverence of Lugné-Poe, but through an easy cloud of late-Victorian cigar smoke. Irving had shown Comyns Carr (who was managing the theatre) a play by Wills and asked him to knock it into shape. Carr declared that he read it aloud to Burne-Jones in the garden studio while he was working on the *Avalon*, in which case Ned must have heard such lines as:

> GAWAIN: His name, my lord, is Lancelot.
> ARTHUR: Lancelot, ah!

However, the play gave great scope for stage effect, and had a leading part for Irving; Sullivan agreed to do the music, and, of course, only Ned could do the designs. Alma Tadema had made sketches for the Lyceum *Coriolanus*, though, as he said, he had 'no end of difficulties in persuading them to be truly Roman in

appearance'; on Arthur and Guinevere there could be no greater expert than Burne-Jones.

'In the main I should like to keep all the highest things secret and remote from people; if they want to look they should go a hard journey to see.' This remained Burne-Jones's considered opinion on the Arthur story. He accepted the commission because 'weak moments come to me through friendship. I can't expect people to feel about the subject as I do, and have always. It is such a sacred land to me', he added. Gradually he was drawn into the excitement of designing costumes and armour. He made sketches for the five main scenes – the magic Mere, Camelot, the Maying of Queen Guinevere, the Chamber in the Turret, the Passing of the Barge.

Unlike 'Tad', who was an expert scene painter, Burne-Jones knew nothing about large-scale effects, and in October 1894 he went to the Lyceum to see the work in progress. It was here that the first signs of trouble appeared. Old Hawes Craven, the foreman painter, received him cordially enough; in fact it turned out that he had worked on the sets of the first play Ned ever saw, the *Fairy of the Golden Branch*. Unfortunately, the reminiscences, aided by a glass of whisky, which Ned felt was called for, excited the old man and he broke into a comic dance, to the embarrassment of his sons who were acting as assistants and stood by 'with sour and gloomy expressions'. More whisky, and Craven began to call the sword Excalibur 'Excelsior', and to address Ned himself as 'Sir Arthur'. After this, although Burne-Jones went again to show Margaret the stage-machinery and to try his hand with the large brushes, he became understandably cautious.

King Arthur was rehearsed under difficulties. The Christmas pantomime was still playing, and the stage manager, unable to get to work until the matinée was over, trusted a good deal to chance. On one occasion the platform of the Royal Maying collapsed and Queen Guinevere and her attendant damsels crashed to the ground. How lucky that the queen was Ellen Terry! Burne-Jones gave various reasons for the delay which prevented his going to rehearsals until the last moment. He kept away just as he had kept away from the Rome mosaics: he suspected that his instructions were not being followed, and thought it best to detach himself. When he did go down to the first dress rehearsal, his heart sank. Sullivan and Carr were both fussing about at the front of the house – 'Sullivan in a

fury – telling me he would have given £100 to be out of it' – while Carr drew him aside and complained about Sullivan. Irving, alone on the stage on a golden throne, was declaiming: 'And then, my own true Guinevere, my queen – what's gone with the gas there? Who's up there?' The play seemed even worse than Ned remembered. Sir Mordred had to say that he had seen the queen and Lancelot 'lip to lip cuddling beneath the may', and there were 'jingo bits about the sea and England which Carr should be ashamed of'. As for Merlin, 'they have set aside my design and made him filthy and horrible . . . Morgan le Fay is simply dreadful . . . she is half divine in the ancient legend – as Merlin is – here they are scandal mongering gossips.' The armour, specially made in Paris, was effective, and when the glittering knights assembled with their banners for the quest there was a moment of real magic in the theatre; apart from that, Ned felt that Perceval looked 'the one romantic thing'. (This, by the way, was ungrateful to Forbes-Robertson as Lancelot; he had seen the Pre-Raphaelites through, from the day when he sat as a boy for Love in Rossetti's *Dante's Dream*.) Finally Irving complained that the hawthorn brake looked like a cauliflower, and substituted a canvas rock.[14]

At midnight, by which time Irving had only rehearsed two scenes, Ned went home. Before the opening he got Irving to make a few changes – 'it is enough for its purpose the whole thing'. But he avoided the first night (14 January 1895). 'The morning papers say I was there, constantly leaving my box to superintend,' he wrote. 'I was here all evening playing dominoes.' The reviews were not unfriendly. *The Times* said that 'the dim spectral light of the Mere accorded ill with the glare of the footlights', but also that the play, over four hours long, had held the audience. However, the 'Guvnor', as King Arthur, had no intention of putting himself out. He was too lazy to get up and walk towards the lake, so that the mystic arm in white samite had to approach *him*.

King Arthur, however, ran for a hundred nights, went to America, and lost all its scenery in a warehouse fire. Burne-Jones's conception had, as he said, 'gone to nothing . . . why? Never mind.' His friendship with Ellen Terry and the 'Guvnor' was unaffected – so, too, of course, was his feeling for the Grail. 'To care as I care and as 3 or 4 others care one must have been born in the lull of things between the death of Keats and the first poems of Tennyson. There

was some magic in the air then that made some people destined to go mad about the S. Grail.'[15]

That autumn, Burne-Jones had to face the fact that his pictures were beginning to not sell. The popular artist was Sargent, whose work he disliked though he was fond of him personally, 'so the time of lying must begin'. But his own large canvases looked like staying in his hands. Criticism did not worry him; it never had. 'How can you ever read criticism dear heart, and how can they be wise, seeing what haphazard people write them?' he wrote consolingly to Mrs Gaskell.[16] But the loss of his old patrons, he told Rooke, made him feel like a 'discarded mistress'. He arranged an exhibition of drawings at the Goupil Gallery, and for the first time he asked dealers to the studio. The presence was so objectionable that the studio had to be fumigated with cigars after they left, and Ned felt he kept a specially unnatural tone of voice for them. Sometimes he indulged a daydream in which Barnato and Rothschild entered with a cheque-book and begged him on their knees to sell them a picture.[17]

In October, he had been to Hawarden and Beaumont, with Georgie this time. Perhaps there was some disloyalty in the letter to Mrs Gaskell which he scribbled desparately on the return train via Crewe: 'I wonder if I can write . . . at least it will help to pass the time if I can – Georgie is sound asleep, nor have I anything to say to her . . . Crewe – that is where I wanted to travel with you two years ago, to see you safe and get soup for you and hot water too . . . doesn't it seem years and years since that day? – it isn't two years yet – such a long way we have travelled since then not all of it a summer journey . . .'[18] But he felt only tenderness and admiration for Georgie as she braced herself for the local council elections. She had taken on no easy task, and it was sad that Morris, although he wrote wishing her well, was still too tired to take more than a lukewarm interest. Many of the villagers, too, were apathetic, caring nothing about the insanitary state of their cottages. Others, like Mr Tuppence the grocer, 'Trunky' Thomas, who owned the bathing machines and did a bit of smuggling, and 'Stumpy' Mockford the beachcomber, were just as much opposed to change, and to any inquiry into their doings, as the squire and the farmers themselves. But Georgie swept all before her: 'Many a man goes across the world to find a fresh

chance to better his life, and here is one brought to our doors,' she had written in her pamphlets. 'Shall we take it?' In December she was elected, with a majority of 'those who think as I do' on the Parish Council. Burne-Jones, left in London, continued to paint on the *Sirens*.

Quite undeterred by the fate of *King Arthur*, he began a new season's theatre-going. On 5 January 1895 he had been with Phil to the disastrous first night of *Guy Domville* when poor white-faced Henry James had to face a hostile audience, jeering at his play. In the thick of the shouts and catcalls Phil stood up and began sarcastically to applaud the demonstrators in the gallery, making things, by his generous impulse, much worse. They even succeeded that spring in getting Morris to the theatre; he came to 'a tavern', and to *Charley's Aunt*, which he enjoyed. But this was the last time. He absolutely refused to see Mrs Pat as Juliet.

It was only one sign that a change in Morris, which, Georgie tells us in the *Memorials*, 'we tried to think was nothing more than the usual effect of time.' Morris began to talk of 'finishing off our old things' as though the business of life was almost behind him. He could only take short walks. A terrible possibility appeared which Ned felt as a 'suspended sentence', and dared only consider sometimes.

What could he do for Morris? 'His soul is in the Chaucer – he thinks of nothing else . . . it would be hard on him if it wasn't finished . . . he must have risked much money with it – five or six thousand pounds.'[19] The printing went forward. Ned put aside part of each day for the last drawings and took his friends round to the Kelmscott printing-room, though he stopped doing this after Lady Rayleigh, 'seeing the immeasurable care and toil of the printing, asked if it couldn't be more easily done by machinery' and Morris was in danger of exploding.[20] To the expense of the *Chaucer* was added the heavy purchases of 'painted books'. For a year past Ned had wanted to save 'so that [Morris] might not be bothered about money . . . it's the only thing I can think of now to help him with.'[21] He set himself to review his assets – the unfinished work in the studio.

In hand were *Psyche's Wedding* (finished that April), *Aurora, The Fall of Lucifer, Love and the Pilgrim, Venus Concordia,* and *The Car of Love*. These last four all went to the New Gallery and came back unsold, although he had painted on them or painted duplicates the

next year. *Love and the Pilgrim*, the old haunting design from the *Romance of the Rose*, was to be a dawn picture in monotone, 'a rich black and silvery picture'. Worry over the placing of the figures made Ned dream that he had painted a barrel of spirits, with labels, round Love's neck, like a St Bernard. The immense *Car of Love*, on a canvas especially made at Roberson's, was now dedicated to Mrs Gaskell, and 'IN GLORIAM DOMINAE MEAE will be written very small somewhere'.[22] Phil thought it colourless and suggested pink nipples and knee-caps. *Aurora* went forward more easily. The background was taken from the sketches he had made at Oxford in 1867, though the view from the canal bridge where he had drawn a woman bathing her baby was 'all gone, every bit', he told Rooke.[23] Meanwhile *The Dream of Launcelot*, with the threatening forest round him, was in its first stages, but he felt it looked 'like a park, not the strange, wild place it ought to be'.

Burne-Jones could not be sure of getting ready money, if it should be needed, for any of these paintings, but neither now nor ever would he change his ideas to suit other people. From the firm he could still count on about £700 per annum, and there was £1,000 for the Stanmore tapestry designs. But Phil only worked occasionally, and had to be supported. Out of the £15,000 for *Briar Rose* he still had £14,000, but that was invested and he paid his life insurance out of the interest; Georgie's future, and possibly Morris's, must be secure. He decided to sell all the drawings, the favourite ones, which he had kept in the studio – the illustrations to the *Aeneid*, many that he had intended for Ruskin's Oxford Museum, all, in fact, except the head of Mary Zambaco . . . 'the Heads done from that strange weird-looking damsel I wouldn't sell – for a time at least I will keep them,' he wrote to Mrs Gaskell.[24] He seems strangely to have ignored the fact that Mary Zambaco had returned to London and was living, a successful sculptress and middle-aged beauty, at 6 Clarendon Place, within easy walking distance, in fact, of Mrs Gaskell. She lived in his mind only as the wild, delicate Phyllis and Nimuë. But even to part with the rest of the drawings, and to see their empty spaces, was an agony; he had an artist's true affection for 'the little ones'.

Portrait commissions, although Burne-Jones never went on with them if the likeness didn't 'come', were welcome. In the spring of 1895 Frances Horner came to London, an honoured visitor, with her

golden-haired daughter Cecily; Frances's birthday, as Ned well remembered, was in April, and Cecily's portrait was to be a present from her husband. Then Frances returned to Somerset, 'to the milking pails and buttercups and daisies and all that is good for her – poor Frances.'[25] He could never quite believe that anyone wanted to live permanently in the country.

Apart from this interlude – and the portrait was one of his most successful – 1895 was a year of catastrophe for his friends. In 1895 Georgie and Ned attended Leighton's last 'music' – *Flaming June* on the easel, his godchildren dancing round the fountain as the President came down the steps to say a courteous farewell to each guest; then, ashen pale and obviously very ill, he turned back into his House Beautiful. A few weeks later Luke Ionides was in bad trouble – 'the ugly Luke matter', Ned called it – and left The Grange in tears, while Georgie 'scornfully' went off to Rottingdean and the Parish Council. The clouds were gathering too round Oscar Wilde – the irresistible Oscar who had entertained Phil and Margaret, who had been so excited by the birth of his first son that he told Mrs Maxse: 'He's like a sun-flower!' On 3 April Burne-Jones waited in misery for 'the probable ruin of Wilde tomorrow'. To the evidence of the trial he reacted at first with extreme disgust, not because of Wilde's sins of the flesh, but because he had spent £50 a day on boys at the Savoy while his wife was left in difficulties.[26] He took the practical step of lending Constance £150 to tide her over. In public, he told Mary Drew that he intended to defend Wilde as best he could. If Wilde liked the worst society as well as the best, 'I undertake to say that [the worst] is more serviceable to art . . . and knowing Oscar's many generous actions and the heavy merciless fist of London society . . . [I] shall speak up for him whenever I hear him abused.'[27]

Distress of a different kind arose from the dinner in honour of Alphonse Daudet, given by Henry James on 6 May at the Reform Club. It is curious to find that although Burne-Jones still declared he knew no French at all except 'oui!' (which had got him into difficulties) he was included on this occasion among the French-speaking guests. Daudet was half paralysed with syphillis and demanded what James referred to as 'strange precautions' because of his weak bladder, but he talked brilliantly and James congratulated himself on a successful evening. On Burne-Jones, however, sitting between James and du Maurier, the effect was

depressing in the extreme. Everyone talked about friends who were ill, dead or blind. Daudet could only lift his glass with two hands and Ned regretted the days when 'men drank deep and waxed merry'. If only some women could have been there![28]

In 1895 young William Rothenstein – who rather liked doing this sort of thing – took him to the Café Royal to meet, after so many years, Alphonse Legros. 'It amused me to sit in this place with these two great artists: Burne-Jones saying that of course Rothenstein would have an absinthe.' Burne-Jones was charming and funny and glad to see his old friend, but Legros had fallen on evil days. With the help of George Howard and Watts, Ned found the usual way out: there was a secret subscription to buy Legros's *Les Femmes in Prière* for the newly-opened Tate Gallery.

And Morris was no better, even though he was struggling to go on with some of his public work, and actually spoke on a socialist platform on 1 May that year. But he had a new project for the Kelmscott Press – a folio edition of *Sigurd the Volsung*. Burne-Jones, who was confidently asked to do thirty illustrations, was struck with dismay. He was no more in sympathy than he ever had been with 'raw fish and ice', the stories of the north. His comment on one subject – *Atli's Hall in Flames* – was '. . . it never happened . . . in the second place, it isn't desirable that it ever should have happened.'[29] His imagination rejected the myth. Out of sheer affection he took the work down to Rottingdean, but could do nothing with it, though he started the designs for the *Romance of the Rose*. Meanwhile Morris was 'urgent with me', so Ned told Swinburne to illustrate the Miller's Tale, which only shows how little he can really have considered the style of his old friend's work. Indeed, it was Morris's practice to look at the cuts upside down, to get an idea of the 'blacks'. The nearest Ned got to a bedroom scene was the Wife of Bath's Tale, and even there the knight and his bride look sad indeed. All this time he had an aching sense of Morris's physical weakness. There was something 'mysterious' about Morris's illness, he told Rooke. 'I hope they won't send him away – it breaks his heart to leave his books', he wrote to Fairfax Murray.[30] In the summer he took a week off to work on the picture of the passing of the king – the *Avalon*.

In the autumn the business of going out to dinner began to be tedious. One had to pretend to have read the new books, and Burne-

Jones had not read Stevenson's *Letters*; and Sidney Colvin, always after some job or other, was at every dinner. In his own quiet mind, as he worked at the Chaucer, the fantasies were not quite a joke. In his old age, he told Phil, he would have to be fastened in his chair and given things to play with. '. . . I shall want the vellum Chaucer to daub over with colours and some vermillion to paint the faces red.' But Phil told him that the book would still be valuable and would be catalogued in the saleroom as 'coloured by Burne-Jones in his dotage'.[31]

As to public affairs, Ned, the much-loved friend of both Gladstone and Balfour, made it a rule to talk as little about politics as he could, though he worried about them much more. He was profoundly distressed by the Jameson Raid and the prospect of war. 'Ours is a material empire', he told Rooke, 'leaving traces in stout and soda-water bottles, and no material empire can last for ever; it might go in fifty years or even half of that . . . I love the immaterial in English achievements.' He was thinking of the many hundreds like Lockwood Kipling, Ruddie's father, who had spent his working life reviving the craft traditions of India. 'Let's have no more dominant races, we don't want them,' he added.

Georgie had been distressed by a letter from Morris at Kelmscott, wishing he had not wearied himself out in attempting the impossible, but 'swallowed down my sorrow and anger' and taken to bed, like Icelandic heroes; 'I am grown old, and see that nothing is to be done.' She, on the contrary, was determined that something should be. In Rottingdean she had seen to the repair of the fire engine and the railways round the village pond, formed a footpath committee, and helped to appoint an inspector of the knacker's yard. On such things a social democracy is based. Once again, Ned told Olive Maxse, she was marching 'with great decision on her features'. But the opposition she had stirred up, particularly among the farmers over the question of rights of way, was strong. The villagers, Burne-Jones wrote to Lady Rayleigh, had been diverted by a wreck on their beach – a grand piano had been washed up with a whale, a baby, whisky and a bundle of sermons – but in the parish elections afterwards Georgie had lost her seat, and there were 'feuds innumerable'.[32]

Georgie was undaunted. Ned, in spite of himself, went on searching for the kind of sympathy where one weakness and

disheartenment met another. There could of course be defeats even there.

> What do you do when a lady weeps? [he asked Rooke]. Either you take her to your bosom and try to comfort her or you do nothing. If you allow your feelings to carry you away and you do the former, her husband is sure to come in or a visitor is announced: and if you do nothing, what a fool you look . . . I did nothing . . . I suppose that little lady is saying 'that old fool very likely thought I was crying because of him – it would be just like a man's conceit'.[33]

On 27 December, he could report that he had finished the Chaucer drawings, although his eyesight was seriously affected (one eye by now was almost useless). The last drawings to be done were for *Troilus and Criseyde* – the most elegant, but also the strangest. In this at least he had not failed Morris. 'I have worked at it with real love,' he wrote to F.S. Ellis.

1896, however, opened with the familiar troubles at The Grange. 'I generally go and see Burne-Jones when there's a fog,' Ellen Terry told Bernard Shaw. 'He looks so angelic, painting away there by candlelight.' But the studio was leaking and even the famous bell-pull which Ruddie had loved was out of order. Rooke overheard the Mistress say there was nothing she liked to see so much as a paid bill, and the Master replied that a back is bare without money behind. He began to arrange another show of drawings, his third in three years, this time with the Fine Arts Society. 'When I'm taken with all my unfinished pictures and studies to the Fulham Workhouse I shall want to occupy the whole of it, and then all the poor of Fulham will have to turn out and come and live here instead . . . sometimes I feel I should be well content to die . . . but at other times I have had such joy in being alive as I could hardly contain.'[34] The happiness, though, was always paid for by depression and 'a hopeless state of mind'.

Besides the pain from his eyes he was worried about a certain loss of memory. 'Shall I be a wearying old man, I wonder, if I live much longer?' he wrote to Mrs Gaskell. Stephens had asked him about the Lancelot pictures and he could only write:

I don't think it can be very closely identified – I meant it for a symbol generally of the rejection of Lancelot but the words are in the book of the S. Grail somewhere – and I have been hunting for them and cannot find them – because of the cussedness of things – I know they are there for I copied them out the other night – not quoting them from memory – which fails me much at present – it is the subject of the failing or rejection of Lancelot in his quest —35

He was going out even less than before, remarking that though he hated to be made to feel revolutionary, dinners in restaurants made him work out the cost of feeding hungry children at 4d. each. Mrs Gaskell was always an exception, but on only three occasions in his life was he allowed to take her to a 'pot-house'. Weekends in country houses had also lost most of their meaning; they were 'two days stolen out of time', and he was not sure how much time he had left.

In January Leighton died. He lay in state at the Royal Academy with his Presidential gold medal on the bier and his paints and brushes framed in velvet; at noon, 'punctual in death as in life', his cortège entered St Paul's. It was a princely funeral, but of a magnificence which could only depress Ned (as Browning's had done) because it had nothing to do with art. He had loved Leighton – 'always noble and jolly' as Poynter called him – and yet his death, and even Millais's and du Maurier's later in the year, were lessened for him by his fears for Margaret, who was pregnant again, and for Morris. 'Mr Morris comes in very ghostlike, feeble, and old looking; followed by Mistress and Pendry with a low easy chair . . . Mr Morris no longer able to pick up his keys and has the devil of a job getting his trousers on and off . . . can only look at his books for five minutes together . . .'36

On 22 February Ned went with him to consult an eminent physician, Sir William Broadbent. Part of the trouble was that the doctors could not or would not say what was wrong with Morris. Broadbent diagnosed diabetes, but said there was no immediate danger. Ned did not believe this. On the following Sunday Morris did not come to breakfast, nor did he ever come again in the old way.

But there were other callers at The Grange who could not be neglected. On the same 22 February Constance Wilde arrived

unexpectedly. She had come from Bordighera to break the news to Oscar of his mother's death. Wilde, she told Ned, was 'changed beyond recognition, but they give him work to do in the garden and the work he likes most to do is to cover the books with brown paper – for at least it is books to hold in his hand – but presently the keeper made a sign with his finger and like a dog he obeyed and left the room . . . it is all inexpressibly dreadful – I wish they could see their way to let him go . . . the youngest child has quite forgotten him already.'[37]

Comyns Carr and Hallé were anxious to know what Ned would be showing at the New Gallery, and under pressure he finished *Aurora* (Rooke helping him up to the last minute with the reflections in the river). But sometimes Ned felt an absolute necessity to look at things quietly by himself, and this was not easy for someone who had become, as Rothenstein put it, 'an enviable figure who had gained the homage of the greatest minds of his day'. When he went to the British Museum to look at mosaics, officials 'sprang at him' and 'showed him things'. The exhibition of Tissot's illustrations to the New Testament that April was of particular interest because Ned remembered Tissot's strange 'conversation' after his visit to the Grosvenor Gallery. 'But dear Henry James was there and began to sum them up critically', ruining it for Burne-Jones, who just wanted 'to place them in my own mind'.[38] And yet he was afraid of his own thoughts. Anyone who has ever had a sleepless night will respond to his description of the small hours:

> After a time the clock begins to strike slowly, and as it says 'one' you think 'oh, that's terribly early' and then it goes on to 2 and 3 and you say 'Come, that's not so bad' – then at 4 and 5 'it'll be morning soon' and 6 'it must be full daylight out of doors now' – when 7 sounds 'Pendry will be here with the hot water in a minute'. But then it goes on to 8, and you start up in horror, and as you hear 9, 10, 11, 12, one after the other you realise the full misery of your position, the whole night yet to go through.[39]

Sometimes he played draughts against himself (the charm of this is that you always lose), or read *The Broadstone of Honour* all night.

When morning came he could start work. Frances Horner's visit had led to a design which was an affectionate allusive tribute to

their long friendship, the *Magician*. Burne-Jones gave his own face to the necromancer who is himself enchanted, and drew Frances as the young woman who looks away from him and into the magic mirror at a ship crossing distant seas. He had hoped to get the dark tones a little like the blacks of the *Arnolfini* portrait, which, after a lifetime's study of the masters, he concluded was the greatest picture in the world. But 'the Magician isn't within 100 thousand leagues of it'. A little panel was prepared at the same time, 'to help sell the biggest one' if possible.

Morris in the spring of 1896 was pressing on with several projects besides the *Chaucer*. He had set his heart on a *Morte d'Arthur* with Ned's illustrations, a Froissart, and an edition of the *Hill of Venus* with the *Earthly Paradise* cuts of thirty years earlier. This last was to be written in prose, simply to give a better lay-out, although Burne-Jones still hoped he might do it in verse with 'whack-fol-de-rol right up to the margin'. All this was in addition to the *Sigurd* with which Ned told Rooke he was 'hopelessly stuck'. In spite of this he offered to increase the number of designs to forty, which 'roused Morris', Mackail says, 'to a little fresh life'. But the great hope, which almost seemed to be keeping Morris alive, was to see the Chaucer through the press. The elaborate title page had been finished earlier in January. The last time he went anywhere with Ned was to look at the manuscripts at the Society of Antiquaries. In June he was sent to Folkestone, 'a change of air' having been suggested, rather strangely, as a cure for diabetes. Friends came regularly to keep him company and report on the printing of the Chaucer, and on 24 June the first fully bound copy of the great book was brought down and put in his hands. Out of the edition of thirteen copies on vellum one was sent to Swinburne and another was for Burne-Jones, who made a present of it to Margaret on her birthday; her own third baby had been born on 1 July – Mackail remaining, as it seemed to Ned, 'quite impassive' – and it was the finest thing he had to offer her.

The doctors' next suggestion was that Morris should try a sea voyage to Norway. They talked of an improvement. Ned could not see it, nor could Janey, nor Philip Webb – those who knew him best – but it would be another 'change of air'. While he was away Burne-Jones went down to Rottingdean. He could do nothing except 'a few little drawings in tints of gold on coloured grounds, and my heart is

about as heavy as it can be' even though Margaret brought down the three children and Phil came back from Monte Carlo. Phil always knew when his father really needed him, and the two erring human beings consoled each other.

If Morris were to die, what would be left? The century was closing on an imperialist nation, preparing for next year's jubilee, well on the way to destroying everything that was relevant to the human scale of living in a small green country. More people than ever lived on a blackened earth, under clouded skies. 'Shoddy is king', Morris had said, and with all his influence in so many directions, the values of craftsmanship were more in peril than ever. In Burne-Jones's own chosen field of painting, Impressionism seemed to be all anyone cared about, not hand painting soul, but hand painting hand. 'A disappointment to find the future of painting turning in that direction, so opposite to all I've wished and thought . . . Difficult to prevent Georgie from seeing too much of it. It isn't fair to let it affect her.'[40] But beyond all this he would lose his friend; the king would die. 'Fellowship is heaven,' says Morris's John Ball, 'and lack of fellowship is hell.' As for Georgie, every heart has its own bitterness. In January Morris had sent her the last poem he ever wrote. It began, as in former days, with the flowering may – 'the blossoms white upon the thorn' and ended with

> The hail and the haw on the wandering sea,
> And one farewell to Hope.

Burne-Jones believed, with justice, that the future would partly be shaped by Morris's ideas. But he had to live in the present. 'As soon as Morris was back from the voyage it was clear what he would soon be . . . [He was] no more than a glorious head on a crumple of clothes. His poor body had dwindled away to absolutely nothing. The strain of watching it was terrible.'[41] 'Such hopes as I had of the voyage but all are dashed,' he wrote to George Howard.[42]

Morris was brought back to Kelmscott House. Almost his last gleam of excitement came, Burne-Jones thought, when he turned over in bed to spit and broke all the breakfast things, including Janey's best blue teapot. Ned or Georgie called at Kelmscott House every day. Graham Robertson describes how one evening Janey saw her guests downstairs and when asked how Morris was 'she made

no reply, but turning to the wall, fell against it, her bowed head hidden in her hands'. Morris lay in bed in his first-floor room, suffering from the heat and craving for rain. '. . . real rain,' Janey wrote to Lucy Faulkner; 'we have been taken in so many times by the leaves against the window.'[43]

From his sickbed Morris still talked of the *Morte d'Arthur*. The last letter he had been able to write himself, Mackail says, 'was one of a few lines to Lady Burne-Jones, who was at Rottingdean, on the 1st of September. "Come soon," it ended, "I want a sight of your dear face."' On 8 September he dictated the last chapter of his last 'tale', *The Sundering Flood*; '. . . so when Osborne saw it would not better be, he wept and bade farewell to the Lord of Longshaw . . . and it is not said that he met the Lord of Longshaw face to face again in this life.' On Friday, 2 October, Morris did not recognise Burne-Jones. 'I cannot leave him or go away at all,' Ned wrote to Mary Drew. On 3 October 1896 Morris died.

When Burne-Jones came he asked to be taken to the room where his friend lay dead and to be left alone there. 'There was for a short period a look of something like indignation about him; but that soon passed away . . . all that about the beauty of death I don't believe a rap in . . . But I'm sorry for the world . . . he could do without it, but the world's the loser.'[44]

18
1896–8

ROTTINGDEAN AND *AVALON*

The letters began to come in. To Olive Maxse he answered disjointedly: 'O little Olive, write I can't . . . I am quite alone now – quite quite I don't think he had much pain . . . And so it's over – this is something is over – and I can't be the same any more.'[1] To Watts he could only write 'dearest Signor – This is a little hand grasp, that's all – just a squeeze of the hand.' Only Ruskin, from whom a word would have meant so much, was silent. Although he still talked at Brantwood of 'my dear brother Ned' he no longer took in what was happening around him.

The coffin left Paddington in a carriage decorated with green leaves like a chapel and was drawn to Kelmscott churchyard on a haywain. Nothing more different from Leighton's funeral could be imagined. 'The little waggon with its floor of moss and willow branches broke one's heart,' Ned wrote to Mrs Gaskell, 'the King was being buried, and there was none other left.'[2]

Some of the hundreds of letters were answered for him by Margaret and Georgie, who told Mrs Pat Campbell that they had come back 'prepared to go on living for as long as may be, not to droop and waste the days'.[3] She added that Morris had left nothing unfinished, forgetting perhaps the novel on blue paper, about which she had given him no hope. Her task now was taking care of Ned – 'feeding as far as he will let me – companioning as far as may be.' Drawing he could always do, and he turned to the work which always came easiest to him, cartoons for glass. In the last months of 1896 he designed two windows for Newcastle upon Tyne, *David Lamenting* and *David Consoled*. He had started on this subject deliberately, facing his own fear, and recollecting David's words over the dead child: 'I shall come to him, but he shall not come again to

me.' The *Jesse Tree* and *Jacob's Ladder* windows for Rottingdean were wonderfully well adapted to the tall thin lancet windows in the tower; they were paid for by the parishioners in memory of the Revd Arthur Thomas, who died in 1895. This popular vicar (according to Ned, who had been fond of him) had kept a good horse and known every flower and bird on the downs; indeed, instead of the prescribed questions on catechism he had asked the little boys how many birds' eggs they could recognise. The windows were installed the following year. Then, for the west window of St Philip's, Birmingham, he did the superb *Last Judgement*. No agitation here, the dwellers on the earth simply stand waiting for their sentence. The whole effect depends on the late afternoon sun slanting through the glorious red of the massed angels' wings. It is a window for Evensong.

While Morris was alive, the day when a window was finished would be a kind of picnic when both families went down to the works to see it propped up against the light. Now Ned went over to Merton Abbey once or twice a week by himself to see to the execution of the glass and above all to the colour, where Dearle was least to be relied on.

A letter to Mary Drew sets out the business side of commissioning a window. The Gladstones wanted a west window for Hawarden church to commemorate the life of their father, and they wanted him to see it before it was too late; Gladstone was in his eighty-seventh year. Burne-Jones explains that they must first get an estimate of cost from Dearle, who would then send him the template to work on. The cheapest plan is to fill up the bottom and top with grisaille and use figures which he has designed already, then 'all the cost can be expended on splendid colour – a window is colour beyond anything and [this] should be the chief thought'. Mary's brother, he says, keeps asking for a central figure, impossible in a four-light window – 'I can see he is thinking of a picture all the time'. In a window 'the figures must be simply read at a great distance . . . the leads are part of the beauty of the work and as interesting as the lines of masonry in a wall – and the more of them . . . the deeper the colour looks . . . It is a very limited art and its limitations are its strength.'[4] He is writing, he tells her, with Angela and Denis pulling at his legs, and his tiredness is clear enough. But the Gladstones did not want a design that had been used before, they

were ready to pay whatever was necessary. The templates arrived. Burne-Jones put off the job until the right idea and the right design should come to him.

Angela and Denis, impervious (Angela in particular) to anything except what they wanted at the moment, were the great consolers. Their grandfather amused them with book after book of drawings, including the almost too horrible ones which strong-minded little girls like best. As with the *Flower Book*, the name suggested the idea. In the corner at Rottingdean where the children sometimes had to stand for a punishment, Burne-Jones painted a kitten playing with its mother's tail. Angela took this wealth of pictures for granted, but envied him for being allowed to draw on the walls.

Georgie, as she had said, refused to droop and waste the days. Another address to the parishioners of Rottingdean was printed – *What We Have Done* (1896). She wanted £40 spent under the provisions of the new Lighting Act, and she was still indignant that many of the cottagers had no chance to wash all over. On the question of the public bath and wash-house she was defeated, but she won back her seat in December.

The strength which she had and gave to others was taxed to the uttermost. When Ned was asked whether he found the tall models he used for drapery studies were 'overbearing' he said no, it was the little women who were always bursting with energy. To Rooke he praised 'the Mistress's cheerful and resolute outlook, always the same.' His letters, in fact, show him worrying about her health more than about his own.

His first public appearance after Morris's death (to which Georgie quietly guided him) was a celebration in February at the New Gallery of Watts's eightieth birthday. First, a children's party (dominated by Angela), then two weeks later an evening party, a concert by Joachim with Agnes Zimmerman at the harpsichord. The Signor's reaction to this was characteristic. He hoped it would give as much pleasure to others as it was misery for himself. Burne-Jones, although in acute pain from his eyes, went there to hear music and to meet old friends, including Lady Somers, whose portrait had been one of the first pictures he saw in Watt's studio. After this, throughout the year he retraced the paths of friendship as though he could gain strength from that sacred earth. He went out to The Pines, where Swinburne, deaf, voluble and affectionate as

ever, read him yet more ballads. He saw more of Holman Hunt, whose eyes in old age, he told Mrs Gaskell, had the exact tint of white currants. By a stroke of luck he acquired *The Pet* by Walter Deverell, who had shared with Rossetti the long-ago room in Red Lion Square. Morris's cherished *Sigurd* appeared in 1898, even though in the end it only had two illustrations, and not long afterwards the Kelmscott Press closed down for ever. Burne-Jones even painted a last version of the Prioress's Tale, the decoration for Morris's wardrobe which he had done in Red Lion Square. All this matter of the return to the past was obsessive, as though he wanted to deny his own progress towards his later spare, abstracted and elegant style.

The *Pilgrim* went to the New Gallery that spring, but the one substantial commission was a replica of *Hope*, largely executed by Rooke, which went to America in March; Burne-Jones said he hoped this would support the household through the summer. Rooke, watching minutely, was not satisfied with the Master's state of health. His face, Rooke thought, looked grey. Ned's consultant at this time was Dr Harvey, whose son, like so many others, had come to The Grange to learn to draw. Harvey recommended Burne-Jones to smoke less, sleep more, and to try 'a change of air'. The loss of a friend is not, of course, a recognised clinical condition. But the greyness was odd, and his fingers began to look grey too, like a dead man's, or like Leighton's. Leighton had died of an attack of angina pectoris.

The 'change of air' made Ned think of the north of France and the quay of Le Havre. 'Already I see [Morris] far removed, and cling in my memory most to the days when we seemed equal and began the tales,' he wrote to Frances Horner. Mrs Gaskell was just setting out for Chartres and Beauvais on the way to Italy, and he told her painfully not to miss the 'angel with the dial' and the kings and queens at Chartres 'with such lovely folds as can hardly be imagined'.[5]

Georgie also wanted to go to northern France; she had been allowing herself pilgrimage into the past on her own account. In April she went to Upton to see the Red House, which neither Morris nor Ned had done since it was sold in 1865. 'The apple blossom was out,' she found, but she was told there would soon be streets all round it. To prepare Ned for the journey to France and to what

Morris had called 'the kindest and most loving of all the buildings the earth has ever borne', she took him for a fortnight to recuperate at Malvern Spa, only to be met with bitter winds and snow 'and the usual tale of its being quite unusual to have such a May there'. Stout-hearted Georgie did her best to prevail against the weather and the absence of pictures in the hotel, which drove Ned to reading the 'Requests to Vistors', because at least they were in a frame. But the holiday was even more exhausting than most, and at the end of it she felt it best to leave him with Rooke and to set out for France herself with the Mackails. They were not to be away long, and in any case there was plenty of company at Rottingdean, where North End House had been lent for the summer to Rudyard Kipling.

Ruddie had come back to England and showed all his usual warmth towards his family circle. Burne-Jones felt he owed his nephew a debt of gratitude for making Phil's picture, shown at the New Gallery in April, into a centre of attention. Phil had exhibited his *Vampire*, a horror picture of Mrs Pat Campbell, over whom he had now lost his head completely. Kipling had written the verses for the catalogue:

> There was a fool, and he lost his heart
> (Even as you and I!)
> To a rag, a bone, and a hank of hair . . .

Burne-Jones took this from a completely professional point of view. He knew Mrs Pat was quite undisturbed at being called a rag and a bone – she had survived worse things – and that Ruddie once again had come to Phil's rescue.

Being a guest in his own house Burne-Jones found to be an odd experience, but (not walking as well as he used to do) he hired a kind of fly to get to the downs and breathe the sea air. The *Memorials* speak of Rottingdean this year as his 'haven of rest'. But to Mrs Gaskell he wrote that he had brought no work with him because he could not think what to bring, 'and now come candles, and an endless evening – lasting hours and hours and when it has lasted an eternity and you look at the time it is always half past six – but never mind – courage – ever your E.'[6]

The tedium was of course not the fault of 'Ruddie of my heart'. Crom Price, who was still allowed to smoke (and still, according to

Ned, in love with someone different every week) came down as well, and they all three talked into the small hours when the first dawn winds began to stir off the sea. In politics, however, Kipling and his uncle could not agree. Burne-Jones was aghast at the Jubilee. Legros had been commissioned to do some elaborate decorations in papier-mâché and gilt of Britannia, Law and Prosperity, and for friendship's sake Ned had done his best to praise them; 'all this enthusiasm spent over one little unimportant old lady is the one effort of imagination of the English Race.' But he hated the screaming crowds and the officers with 'brass-coloured moustaches and ridiculous bottoms in the saddle', and the 'naked calves swelling with pride' of the Seaforth Highlanders.[7] Such pride must lead to certain disaster. Kipling's view, equally Ruskinian, was of the empire as a harmonious whole to which every part contributed. He felt that his uncle, while he was in humour and imagination undoubtedly king in his own country, in politics was 'a great child'. Yet Kipling's *Recessional*, 'lest we forget' – although Burne-Jones absolutely declared that he had nothing to do with it – was written that summer at Rottingdean. It was thrown into the wastepaper basket, rescued by Professor Norton's daughter Sallie who was staying with the Kiplings, and referred to Aunt Georgie, who took it up to London that evening and despatched it to *The Times*.

If Kipling expressed his deepest feelings for his uncle anywhere, it was surely in *Kim*. Who else is the old lama, whose life is a quest which others do not understand, who can draw with pen and ink in a way that is almost lost to the world, who shows Kim his art 'not for pride's sake, but because thou must learn', and who tells stories that hold him spell-bound? When he leaves the lama to discover his own identity, Kim reminds himself that 'roads were meant to be walked upon, houses to be lived in . . . men and women to be talked to . . . they were all real and true – solidly planted upon the feet – perfectly comprehensible', but he leaves behind him the unworldly quest of his master, who has had a sign that his remaining time on this earth will be short. In fact, Kipling returned to the manuscript of *Kim* immediately after Burne-Jones's death. But if he thought that his uncle's art had little connection with his real life, then he did not altogether understand Burne-Jones.

As far as daily work was concerned, there were two things that really mattered now to Burne-Jones, the *Life of William Morris* and *Avalon*. The biography had been entrusted to Jack Mackail. Although Mr Philip Henderson has shown that Mackail had an ordinary human curiosity (telling Mrs Coronio, for instance, how extraordinarily interesting he could make the story of Mary Zambaco 'if one were going to die the day before it was published'), he was still felt by the family to be reserved and austere. Rooke noted that the Master 'didn't like' to ask Mackail how he was getting on with the *Life*.[8] Ned himself was supposed to be preparing notes, but kept losing them, attributing this, as most of us do, to the 'malignity of matter'. He wrote, however, a delightful account of the years at Oxford and the time at Red Lion Square.

The *Avalon* came near to breaking Ned's heart. Face to face with the vast canvas he found, now when he needed it most, his old certainty of design deserting him. For the last two or three years he had fallen into the dangerous habit of consulting other people – Lady Lewis was asked about the *Car of Love*, the path in *Aurora* was widened because 'several people had mentioned it', he considered painting the wings crimson in *Love and the Pilgrim* when it came back unsold – but then the red would have to be 'quartered' right through the picture. The *Avalon* went through a bewildering series of changes. 'Painting pink harper purple' . . . 'the reds are disaparing from Avalon' . . . 'Pilgrim was thought too grey, so making effort to get colour into Avalon' . . . 'taking out watching figures from wall' . . . 'mailed trumpeter now vivid blue', Rooke noted day by day in 1897. 'No-one seems to like Arthur,' the Master told him, 'when there's something going on in a picture they can make it out, but when all is the beauty of repose they feel it is dull.' But they had not found *Briar Rose* dull. The cost of straining the canvas for *Avalon* alone had been over £70, and the picture had been in the studio for eleven years. Of course this did not matter. What mattered was that *Avalon* should not 'turn out no more than a piece of decoration with no meaning in it at all and what's the good of that?'[9]

Was it worthy of the dead King? First the hill fairies waiting for the reawakening, then the battle raging in the distance seemed wrong to Burne-Jones and he painted them out. Their place was

taken by one of the best passages in the picture, the disturbing cloud formations in the western sky. The disappearance of the sea – meant at one point to have 'the bottle-green colour of waves seen over the side of a boat' – took away the remoteness of the magical sea passage which can be felt in the earlier versions and in the sketch for the *Sirens*. But the likeness of Morris was good. Graham Robertson, visiting the studio, was surprised that Arthur should be 'a little man'. He is shown, in fact, as 'a glorious head on a crumple of clothes'.

So often in his career Burne-Jones had said that because he cared so much, he had done less well. Arthur must be lost, the picture must give a sense of loss, but also the possibility of return. Burne-Jones was not a great hoper. 'Hope is a mere luxury, not a necessity,' he said; 'the fortunate may safely indulge in it.' But at the point where hope becomes faith, the faith that the world would listen one day to what Morris had to tell them about joy in work, about respect for the earth and its growth and the people on it, about possessing nothing that you do not know to be useful or believe to be beautiful – in that faith Burne-Jones was immovable. He himself was no more than an old painter, the old enchanter. 'Every year when the hawthorn buds it is the soul of Merlin trying to live again in the world and speak – for he left so much unsaid . . . Arthur will come back out of his restful sleep but Merlin's fate can never be undone.'[10]

The fate of Merlin was to know the truth that no one would listen to, to know the secrets of humanity and yet to be helpless in the power of his weakness for women. Of his own will he is imprisoned in the tower of air stronger than steel. When in the June of 1897 Burne-Jones was invited to a Jubilee dinner given by a hundred 'representative women' he declared that he wanted them to vote, wanted them to govern, but could not bear them to ask him out, instead of waiting to be asked. That summer Amanda Pain, the daughter of the painter Rudolf Lehmann, wanted him to design the frontispiece for her novel *St Eva* (the long-suffering heroine plays a lute, lives in Melbury Road, and wears 'Burne-Jones blue'), and he drew for her a lovely head of a girl, nicely engraved by the French artist Emile-Louis Derbier. In July, in a letter to Mrs Gaskell about a party they had both attended the night before, he wrote: 'Did you see last night a very beautiful radiant-looking woman – she stood for a time in one of the doorways – extraordinarily lovely – I wanted to

talk to her but it wasn't easy because of the music and the people – you didn't seem to see her – but manners, public manners and the expected decorum of social life made it difficult . . .'[11] Burne-Jones, after all those years, could still be surprised that Mrs Gaskell 'didn't seem to see' this entrancing newcomer. But even in these letters to her he is still marvelling over the difference between men and women.

From another party Georgie had to bring him home because the music was poor. 'It was no sign of faiblesse', she told him encouragingly, 'not to enjoy that party.' The summer was very hot, but he stayed in London throughout August, because Phil was painting his portrait. The standing tired him (Phil wanted to show him in front of his easel), but the picture, commissioned by Professor Norton, was 'very like this old man'. Perhaps, after all, Phil might be settling down to work, but 'about Georgie I am troubled often', he wrote. Her expenditure of energy frightened him. How could she be got to rest, or indeed to think about herself at all?

In the studio, Rooke and he were what can only be termed messing about. 'A warm-coloured background' was laid over the *Perseus* (Balfour's music-room was still unfurnished). They redid the background of the portrait of Lady Lewis, and put more thorns into the *Pilgrim*. They had been worried for nearly a year over the 'shape between Pilgrim's sleeve and his knee', and to Burne-Jones every shape in life was either right or wrong; he could not bear anyone else to cut a slice of bread for him, because 'in bread, shape is everything'. He found it more and more difficult to pronounce anything as finished. By this time he could not read or write at all without glasses, although Phil, dashing in on rapid visits, reminded him that there had never been a time when he hadn't said he felt decrepit. Considerable pressure was now needed for him to undertake anything new. Mary Drew's letters, however, told him that her father was sinking, and he set himself to finish the Hawarden window. There is no sign of weakness in this design of 1897. The problem of the four lights is solved by a majestic Nativity which goes across them all. With the strange, spiky forms of Burne-Jones's latest work and clear, cold blue and brown colouring, there is a concentration of all the lines on the Mother and Child, the last thing visible in Hawarden church today as the evening light fades. The old pattern-maker could still make a pattern.

Merton Abbey seemed 'ghost-ridden', as though Morris were still looking over the shoulder of the workers, but it must be visited. Burne-Jones took Mrs Gaskell down with him to see the new window put in hand, and after this he felt a moment of encouragement. Leaving the Gaskells' house after dinner on 28 August, he took a hansom (instead of the sedate four-wheeler which he considered suitable to his age). The horse bolted and came down. 'Indignantly I wriggled out . . . my mind full of happy things that no cabs or rain could touch', and he heard 'the clashing of the Kensington bells – a tumult of noise that I love'.[12]

Kensington, he felt, would 'see him out'. He would stay at The Grange – however much he liked to talk about retreating from the world – till he was turned out or carried out. After that, perhaps the almshouse, if one was allowed to paint there. The tenancy of The Grange ran out in 1902, and this was a source of worry. But the renewal of the lease was child's play to George Lewis (now Sir George), whose help, the *Memorials* tell us, 'made all things plain to us'.

It might be easier to finish the *Avalon* in a larger studio, with room to step back and judge it properly. In September, the immense canvas was moved to 9 St Paul's Studios, about half a mile from The Grange. This building was another surprise of Sir Coutts Lindsay, and for the first time Ned had the advantage of a really good north light. He went out to Roberson's, where he was now a venerated figure, to get 'new brushes – new paints – new everything'.[13] But he did not feel able to start work there until the following spring.

In late autumn, when the Kiplings had moved to The Elms, just across the green, the Burne-Joneses went down to Rottingdean for their winter holiday. The grandchildren came, and Ned set about making a portrait of little Denis Mackail, who unfortunately proved even more mobile than little Dossie; he purchased sleeping dormice for the children's Christmas stockings, and made a wooden fort which he blew up for them. Georgie was deep in a new enterprise, the transference of the South London Art Gallery to public ownership; she launched into a sea of correspondence.

Immediately after Christmas, Burne-Jones went back to London to supervise the Rossetti exhibition at the New Gallery. Lord

Faringdon did not want to lend his Rossetti if it meant blank spaces on the walls, so Ned offered to paint replicas of *Knights and Angels at the Chapel* to put in their place. On the way to Buscot to arrange this he called on Janey Morris at Kelmscott; he had had 'a very sad letter' from her earlier in the year. 'She was always used to be managed for, and is only now learning what she's lost', he told Rooke.[14] At the exhibition itself he was worried by several forgeries, one apparently by Howell, but he felt indescribably moved at seeing the first version of 'the finest thing Rossetti ever did, of Beatrice dead . . . the early watercolours are the best – the oil ones don't count . . . he got to love nothing else in the world but a woman's face.'[15] Apart from this, music consoled the winter for him, he said, and not much else. He had a clavichord made for Margaret, and she played to him.

At the beginning of 1898 Burne-Jones was sixty-five, and more puzzled than ever by a world which was too arrogant to recognise that its restlessness was the result of a neglect of beauty. Why did no one bother to go and look at an exhibition of 'old Florentine pictures', why did they not listen to polyphonic music or the clear notes, each distinct from the other, of the harpsichord? Why did some people (including Mrs Gaskell) rush to Bayreuth to hear 'glorious stories' sung by squat men and Prominent Women? Mary de Morgan had told him that at her East End social club she had been asked to 'vamp' at the piano. What was 'vamping'?

From this it is evident that to Burne-Jones the perception of beauty meant being able to distinguish clearly between one thing and another, just as the reality of beauty consisted of uniting the form and the spirit. As to his own work, 'everything must go through its period of neglect; if it survives that and comes to the surface again it is pretty safe.'

Rooke entered 14 January in his diary as 'A dark day. Pictures came back unsold from the O.W.S. Only pictures with cows in them had sold.' The same thing had been true in 1864, though the cows were no longer by Birket Foster.[16] Burne-Jones's friends became even more anxious than usual that he should try the effects of a long visit to Italy. Spencer Stanhope, who had been over in the summer, wrote once again to recommend Florence, even though there were electric trams in the streets now, and lady bicyclists. Frances Balfour

thought his life might have been prolonged if only he could have agreed to Italian winters.

'Spring 1898. Illness, absence, anxieties', Rooke wrote. The absence was the Mistress's, for though Burne-Jones could not be induced to escape the fog, Georgie had agreed, for reasons of health, to go to Bordighera with the Alma Tademas and Phil. Phil was going on to Monte Carlo, where he thought he might see Lillie Langtry. Ned 'rejoiced have having sent me to a sunny land', Georgie wrote in the *Memorials*, 'though nothing would have tempted him to come among its villas and hotels.' He pictured Bordighera as 'a kind of celestial Malvern'. There was a great upset at her departure on 28 January, and then 'the quiet of it! There's been nobody here since Thursday!' While she was away Ned wrote to her every day, and said as little as he could about an attack, his fourth, of influenza, followed by another period of 'beef tea and nightmares'. In one dream he found himself throwing paint over Charles Hallé. All this beef tea was probably not helpful; W.A.S. Benson called and cheered him with some bottles of claret.

Rooke thought it best to take him down to Rottingdean. Although 'Ruddy (beloved of my heart) is in South Africa . . . he would go – and he will always be going away – any place where mankind is flighty',[17] still there was the trusted sea air, and work to be done on the *Prioress's Tale*, which had found a purchaser. 'Sat. 6 March 98. I did not find him at Victoria and came down in separate carriage to Rottingdean catching sight of him on the platform preparing to get into a fly, grey-complexioned and worried-looking.' Rooke was relieved when the Mistress returned in March. Burne-Jones walked part of the way along the Brighton road to meet her. Georgie thought he looked worn, but not, after all, much thinner.

Mrs Gaskell was also in Italy that spring. From her travels the year before she had brought Ned engravings from Orvieto which had moved him so much that he avoided looking at them when he was tired; this year she promised to bring more. In the meantime, worried by his concerns over *Avalon*, she suggested changing the rocks in the foreground to flowers. The alteration by no means improved the picture. Spring flowers meant a change of season, so the apples had to be painted out and with them went the last trace of the wild orchard of Avalon. However, Ned wanted to try it. Rooke would take him to Kew Gardens. 'I must have something besides

irises – NOT lilies . . . one poppy I have put for sleep – I think it shall stand alone.'[18] Lilies of the valley were only associated with Mrs Gaskell herself. Before leaving in February she had sent a bunch of them to the studio. 'I've aimed continually at debasing her mind,' Burne-Jones told Rooke wistfully. 'I can't reach her pride, I can't reach her revenge . . . a great blow it is to see all my most valuable teachings thrown away on her.'

He was still forcing himself to go down to Merton Abbey for the last stages of the work on the Nativity window – cementing the glass and soldering on the lead ties to attach the lights to the bars. Apparently he also went to Hawarden to see the window set up, and found that after all it did not meet his specifications. The late churchwarden, Mr Bell-Jones, could remember Burne-Jones's visit, and he remembered him as a very angry man; he saw him in his mind's eye standing in the churchyard surrounded with fragments of smashed purple glass. The latent violence in the artist's gentle nature, like his strong will, would not have surprised Rooke who had been 'terribly put out' a few months earlier when he had lent the Master a book. It was *The Autocrat of the Breakfast Table*, which Rooke probably felt was safe and indeed dull enough. But he must have overlooked Chapter VIII, where the Autocrat explains why artists are 'prone to the abuse of stimulants' and tells us that 'the dreaming faculties are always the dangerous ones, because their mode of action can be imitated by artificial excitement.' This was an insult to the dream and the imagination itself, and Burne-Jones put a red-hot poker right through the book.

The 13th April 1898 was the first day at work at the St Paul's studio. *Avalon* hung there alone on the bare wall. One or two friends called, but to Rooke the place looked vast and empty. He had brought sandwiches for their lunch. When Georgie went down again to Rottingdean, Ned dated his letters to her from 'Avalon'. 'I shall let most things pass me by,' he wrote, 'I must, if ever I want to reach Avalon.'

But he could not let them pass. On the way to dinner with the Gaskells on 21 April he saw on the posters the first news of the Spanish-American civil war. His stomach sank at 'a world of needless misery and bloodshed of all kinds that is about to begin'. And he believed Britain could not avoid war in South Africa. 'The Empire countries will have us one by one.' To this wide distress was

added a personal one. Mrs Gaskell, peaceable and gracious as she was, was a soldier's wife, and her daughter Amy was soon to marry a soldier. Her public work lay ahead of her (she organised the first library service for troops in hospital during the second Boer War), but he could see already that her loyalties must lie further and further apart from his. Perhaps it was just as well. Perhaps the time for such intense friendships was over for a man who, as he said himself, was so old that he had seen oak forests rise and fall. But 'love and hatred, devotion and fury are the things that move people – by which men and women are revealed to one another. Without them all is so dead-alive . . .'[19]

He still hoped that the Kelmscott Press, or possibly Longman's, might bring out the *Cupid and Psyche*, although Sydney Cockerell, with considerable experience of Burne-Jones's power of delay, must have had his doubts. Meanwhile Mrs Pat Campbell had asked him to design her costume for a new production, Maeterlinck's *Pelléas et Melisande*. She came to read him the play. The yearning of the characters towards an elusive happiness is a pale shadow of the Quest, just as Maeterlinck's colour specifications – water's smile, rose-awakening, amber dew – are an even paler shadow of Morris and Liberty. But Burne-Jones recognised the affinity, and the translation was by Jack Mackail, with Forbes-Robertson – who else? – as Goland. He grew interested, made suggestions for the sets, and designed for Mrs Pat a wonderful dress 'like a gold umbrella case'. The opening was to be at the Prince of Wales on 21 June.

Burne-Jones's last portrait drawing was of Mrs Gaskell in a muslin dress.[20] This pencil study shows that, as might have been expected, her face had been the inspiration of many of the Chaucer illustrations. He made her a present of the drawing.

Three days a week had to be given to the *Avalon*, the area to be painted next day being carefully marked out with chalk. Something was still not right about it. Burne-Jones began another gouache of three of the figures. On 13 May, Rooke came in at 9.15 a.m. to find 'the Master sitting low down, quiet and motionless as he can make himself, painting irises at the bottom of Avalon'.[21]

What killed Burne-Jones? The grey complexion and the tiredness – he often fell asleep now on an outing or in front of the *Avalon* – were evidently indications of a serious heart condition, and any shock, even a bad dream, might bring on his first attack of angina

pectoris. But in May he was still dining out and seeing callers every day at The Grange. On 19 May, Gladstone's death was announced; on the 28th he went to the Abbey for the funeral. On 9 June, Dante's day, he could not make out the hands on the school clock across the road, although it was twelve o'clock on a bright summer's morning. On the other hand, on the 14th Sir George Lewis, certainly not an unobservant man, thought 'he had never seen Ned looking better' as they talked together after dinner. The following day a letter came from Mary Drew to say that the window had been put up at last in Hawarden church.[22]

On the 16th Ned came back from another day's work on *Avalon* and found tea-time visitors. One of them was an artistic niece of Spencer Stanhope's, who may well have been commissioned to have a last try at getting Burne-Jones to Florence. Certainly she told him that she herself could only work at the Villa Nuti. Freda Stanhope was only one more of the many young Kensington ladies who, Burne-Jones had told Rooke, should be kept somewhere where they could not get at painters, but painters could get at them; but he was touched when he found that she was copying a little Carpaccio in Florence because she wanted to study the reds, just as, thirty-five years before, he had studied the *Dream of St Ursula*. His courtesy became real interest, he lit a candle and took her to see all that he was doing in the upstairs studio.

When the visitors had left Ned wrote a letter to Rudyard Kipling, who was back in England, telling him he wanted to come down to Rottingdean and see him. Then he and Georgie settled down to a familiar quiet evening, Georgie reading aloud by lamplight. They went up to their rooms, but in the middle of the night Burne-Jones woke with acute pain in the heart. He called out to Georgie, who hurried in to him, but not long after she got to him, he died.

The memorial service on 23 June 1898 was the first ever held in Westminster Abbey in honour of a painter, as the result of an individually signed petition sponsored by the Prince of Wales. So many people came and so notable were they that *The Times* reporter lost grip, and had to apologise for leaving out distinguished names. But by this time the ashes of Burne-Jones

had been quiety buried in the outside wall of the south transept of Rottingdean church.

The funeral there, on 20 June 1898, was as unpretentious as possible. Nobody wore black; indeed Margaret came in a white dress. Rooke made a last entry in his diary. 'Someone sent lilies of the valley.' Georgie also brought flowers to be carried to the grave – a small wreath of hearts ease.

NOTES TO THE TEXT

With a few exceptions, references have only been given for hitherto unpublished material. Printed sources are given in the bibliography.

Abbreviations

Castle Howard, E.B.J. to G.H.	Letters from Edward Burne-Jones to George Howard, Castle Howard collection
Castle Howard, G.B.J. to R.H.	Letters from Georgiana Burne-Jones to Rosalind Howard, Castle Howard collection
H.M.G.	Letters from Edward Burne-Jones to Helen Mary Gaskell
R.D.	The studio diaries of T.M. Rooke. The page numbers are from the duplicate of a copy belonging to Mrs Celia Rooke, which is deposited in the Victoria and Albert. Some corrections have been made from the original copy made for Lady Burne-Jones, which is now in the possession of Mr Lance Thirkell
Walthamstow	William Morris Gallery, Walthamstow

Chapter 1
1. R.D. p. 46
2. R.D. p. 160
3. R.D. p. 46
4. R.D. p. 468
5. R.D. p. 470
6. R.D. p. 218
7. 19 May 1896 in G.B.J.'s copy of R.D.
8. R.D. p. 38
9. R.D. p. 491
10. Undated letter to Olive Maxse, Lord Hardinge of Penshurst
11. 19 May 1896 in G.B.J.'s copy of R.D.
12. R.D. p. 139–40
13. 19 May 1896 in G.B.J.'s copy of R.D.
14. R.D. p. 452
15. R.D. pp 452–3

Chapter 2
1. R.D. p. 452
2. R.D. p. 401
3. R.D. p. 139
4. letter to Olive Maxse, 3 August

1894. Lord Hardinge of
Penshurst
5. R.D. p. 413
6. R.D. p. 465
7. R.D. p. 192
8. R.D. p. 562
9. R.D. p. 469
10. R.D. p. 532
11. R.D. p. 139
12. R.D. p. 139
13. R.D. p. 20

Chapter 3
1. R.D. p. 294
2. R.D. p. 468
3. Fitzwilliam Museum Library
4. *Oxford and Cambridge Magazine*
 January 1856
5. These details are all from *The
 Working Men's College
 Magazine*, 1859–62

Chapter 4
1. Frederick Catherwood, the
 artist and traveller. His *Views of
 Ancient Monuments in Central
 America* was published in
 London in 1844
2. R.D. p. 139
3. R.D. p. 324
4. R.D. p. 377
5. R.D. p. 104
6. H.M.G. 19 March 1893
7. R.D. p. 423
8. R.D. p. 381
9. R.D. pp. 15–16
10. R.D. p. 405
11. R.D. p. 219
12. R.D. p. 19
13. R.D. p. 488 Rooke suggests in a
 pencil note that the joke may
 have been Comyns Carr's
14. R.D. p. 555
15. R.D. p. 520
16. Leigh's subsequently became
 Heatherley's School of Art
17. R.D. p. 430

18. R.D. p. 556
19. R.D. p. 465
20. R.D. p. 430
21. to F.G. Stephens, undated, *c.*
 1890. Bodleian
22. H.M.G. 14 August 1893

Chapter 5
1. R.D. p. 450
2. *The story of the Painting of the
 Picture on the Walls and the
 Decorations on the Ceiling of the
 old Debating Hall in the Years
 1857–1859*, OUP 1906
3. R.D. pp 124–5
4. D.G. Rossetti to E.B.J., undated,
 1858. Fitzwilliam
5. G.B.J. to F.G. Stephens, 11
 January 1905. Bodleian
6. R.D. p. 433
7. D.G. Rossetti to G.B.J., Paris
 Sunday 1860. Fitzwilliam

Chapter 6
1. Rossetti and his circle had
 become interested in this home
 through a friend, Major
 Gillum. There is a poster for
 the home in the background of
 Madox Brown's *Work*
2. R.D. p. 558
3. This letter is now in the
 collection of Professor
 Fredeman
4. Letter to Mary Gladstone,
 undated 1879. B.M. Add MSS
 46,246
5. Professor Lang quotes this
 remark from an unpublished
 note by Bell Scott in a footnote
 to his edition of Swinburne's
 Letters
6. R.D. pp 8–9
7. Letter to D.G. Rossetti, 10 June
 1862, Colbeck Collection,
 University of British Columbia

Chapter 7
1. R.D. pp 364–5
2. H.M.G. January 1893
3. letter to Dalziel Brothers, undated B.M. Add MSS 39168 ff 59, 61
4. R.D. p. 251
5. R.D. p. 501
6. R.D. p. 119
7. Letter to W. Allingham, December 1864. Fitzwilliam

Chapter 8
1. R.D. p. 425
2. William Cowper Temple took the name of Cowper-Temple in 1869, when the Broadlands estate was made over to him
3. Letters from Warington Taylor to Philip Webb, D.G. Rossetti and others, 1866–9. Victoria & Albert, Reserve Case JJ35
4. R.D. p. 297
5. Burne-Jones may have met George Howard earlier than this. There is a *Tristram* drawing in the Victoria & Albert, apparently for the Bradford windows commissioned in 1862, with a note saying that George Howard gave some assistance with the figures
6. Castle Howard, E.B.J. to G.H., undated 1867
7. *Ye True and Pitifull Historie of ye Poet and ye Ancient Dame* BM Ashley 3428
8. Letter to Philip Webb, June 1866. Victoria & Albert, Reserve Case JJ35
9. R.D. p. 69
10. Castle Howard, E.B.J. to G.H., undated 1867
11. Prices pencilled in on Christie's copy of the Anderson Rose

sale, 23 March 1867
12. His list is now in the Fitzwilliam Museum
13. Letter to Fairfax Murray, 6 December 1872. Fitzwilliam

Chapter 9
1. Information from Mrs Francis Cassavetti and *Ion: a Grandfather's Tale* by A.C. Ionides (1927)
2. Letter to D.G. Rossetti, 3 November 1876. Colbeck Collection, University of British Columbia
3. Dr Zambaco to Mme Onou, 17 June 1880. B.M. Add MSS Eg/3234
4. H.M.G. January 1893
5. R.D. p. 69
6. Castle Howard, E.B.J. to G.H. September 1867

Chapter 10
1. Castle Howard, E.B.J. to G.H. 22 October 1867
2. R.D. p. 69
3. Letter to Olive Maxse, 27 March 1894. Lord Hardinge of Penshurst
4. Castle Howard, G.B.J. to R.H. by hand, undated 1869
5. Castle Howard, E.B.J. to G.H. by hand, undated 1869
6. Castle Howard, G.B.J. to R.H. by hand, undated 1869
7. Letter to D.G. Rossetti, undated ? 1870 (quoted in part in *Portrait of Rossetti* 1964 by R. Glynn Grylls)
8. G.B.J. to May Morris, 6 September 1910. B.M. Cockerell Papers, Add MSS 52,734
9. B.M. Add MSS 45298 (b)
10. *A Book of Verse* is now in the Victoria & Albert

11. D.G. Rossetti to Jane Morris, B.M. Add MSS 52,333A (quoted in part in *Portrait of Rossetti* 1964 by R. Glynn Grylls)

12. Castle Howard, G.B.J. to R.H. 5 September 1869

13. Letter to D.G. Rossetti, undated 1869. Colbeck Collection, University of British Columbia In November 1878 Burne-Jones sent the 'Duchess' a drawing of Mary Zamboca by Rossetti, and received from Corfu 'three closely-covered sheets of a rather hysterical order', complaining that she preferred this drawing to the one she herself had commissioned from Rossetti (Surtees 541, now in the Clemens-Sels Museum), and accusing the artists of exchanging the two. Rossetti complained that Burne-Jones's drawing should never have been sent away at all, since it was a gift, and Ned replied in great distress that he had 'returned it by mistake never having known till this year that it had been a gift of yours'. This drawing (probably Surtees 542) can hardly have been the portrait which Rossetti specially drew for Burne-Jones in 1870, and the whereabouts of this are unknown. The letters quoted are in the Colbeck Collection, University of British Columbia

14. William Morris's unfinished novel. B.M. Add MSS 45,328

15. H.M.G. undated, January 1893

16. The story about Howell trying to bring Georgie and Mary Zambaco together was told to the Pennells by Whistler in his old age as something which Howell had told *him* more than thirty years earlier, and even then Whistler spoke of 'the touch of realism which only he could have invented'. Nevertheless the story has been repeated in several biographies – proof of the compulsive power of Howell across space and time

17. Letter to D.G. Rossetti, Colbeck Collection, University of British Columbia

18. The Annual Register for 1871, for example, discusses the incident and says that 'it is pretty generally held that the Society showed an extravagant degree of prudery'

Chapter 11

1. Letter to Olive Maxse, undated, 1890s

2. Letter to Watts, December 1870, Watts Gallery

3. Castle Howard, G.B.J. to R.H. 28 September 1869

4. In a list of his work begun in 1872 E.B.J. entered '1863. A Danae burnt in a fire . . . Howell said it was burnt, therefore it was not.' Fitzwilliam

5. Letter to Fairfax Murray 14 July 1873. '. . . a disagreeable affair about one of the copies of red chalk heads of mine you made for Howell.' Fitzwilliam

6. R.D. p. 479

7. This notebook, which is quoted in the *Memorials*, now belongs to Miss Mary Chamot

8. Quoted from the *Penkill Papers* (now at the University of

British Columbia) by Professor W.E. Fredeman. *Bulletin of the John Rylands Library* Vol 53, No. 1, Autumn 1970, and Vol 53, No. 2, Spring, 1971

9. R.D. p. 88

10. Letter to D.G. Rossetti, undated, but annotated by W.M. Rossetti as seeming to refer to the hanging of Gabriel's large Dante's Dream on the staircase of Mr Graham's house'. E.B.J. offers to throw his own picture out of the window if necessary to make room for it. Colbeck Collection, University of British Columbia

11. Letter to Mary Gladstone 14 April 1881. Fitzwilliam

12. Letter to Fairfax Murray 26 December 1871. Fitzwilliam

13. Castle Howard, E.B.J. to G.H. 1 August 1872

14. Mysterious, because Howell told Rossetti that he was receiving compensation from the District Railway for the move from North End House, although he seems never to have paid rates there and the District Railway did not in fact have to purchase it. They *may* have paid compensation on his second house (Chaldon House) though the only authority for this is Howell himself, since the railway company's solicitors, Baxter & Co, have long since disappeared.

15. William Morris to Charles Faulkner 18 November 1872. Walthamstow

16. Letter to F.S. Ellis, undated, 1876. Fitzwilliam

17. Watts to Mrs Cassavetti, 4 May 1876. Mr Francis Cassavetti

18. H.M.G. 19 March 1893

19. Penkill Papers, University of British Columbia

20. letter to Fairfax Murray, 16 October 1872. Fitzwilliam

21. H.M.G. February 1893

22. Castle Howard, E.B.J. to G.H. undated, 1872

23. R.D. p. 496

24. Letter to Watts, January 1874. Watts Gallery

25. Castle Howard, G.B.J. to R.H. 31 July 1874

26. Castle Howard, E.B.J. to G.H. undated, 1874

27. Letter to D.G. Rossetti, undated, 1874. Colbeck Collection, University of British Columbia

28. From the same letter

29. Letter to Fairfax Murray 10 December 1874. Fitzwilliam

30. Letter to Arthur Balfour 27 March 1875. Balfour Papers, B.M. Add MSS 49838

Chapter 12

1. Letter to Norman Grosvenor. 'Friday 11 or 16' 1876. Lady Tweedsmuir

2. The N.E.D. gives the earliest use of the word 'aesthetic' in the meaning of 'having good taste' as 1871

3. D.G. Rossetti to Jane Morris 2 December 1877. B.M. Add MSS 52,333A

4. Ionides seems to have influenced Gilbert to change his libretto back from a story of rival curates. 'I want to revert to my old idea of rivalry between two aesthetic fanatics, worshipped by a chorus of female aesthetics,' he wrote to Sullivan on 1 November 1880

5. H.M.G. 20 September 1894

6. Letter to Mary Gladstone,
 October 1879. B.M. Add MSS
 46,246

7. Letter to Miss Stuart Wortley,
 undated, 1877. Lady
 Tweedsmuir

8. Letter to Olive Maxse, 8
 October 1893. Lord Hardinge
 of Penshurst

9. Castle Howard, E.B.J. to G.H.
 30 September 1870

10. H.M.G. 24 April 1896

11. Letter to Norman Grosvenor
 26 December 1877. Lady
 Tweedsmuir

12. Letter to Mary Gladstone 22
 November 1880. B.M. Add
 MSS 46,246

13. Letter to Miss Stuart Wortley,
 undated, 1877. Lady
 Tweedsmuir

Chapter 13

1. H.M.G. 18 January 1893

2. Castle Howard, E.B.J. to G.H.
 undated, 1880

3. Other commissions such as St
 Philip's, Birmingham, and St
 Margaret's, Rottingdean, were
 accepted by Burne-Jones
 personally

4. Castle Howard, E.B.J. to G.H.
 undated, 1880

5. Letter to Mary Gladstone,
 Autumn 1880. B.M. Add MSS
 46,246

6. In his recollections of sitting for
 the head of Love for Rossetti's
 second version of *Dante's Dream*
 (1870–1871), Sir Johnston
 Forbes-Robertson speaks of the
 beauty of Marie Stillman and of
 Mrs Morris,
 'of course a much older
 woman', although in fact
 there were scarcely three

years difference between their
ages

7. Castle Howard, E.B.J. to G.H.
 February 1882

8. Letter to Mary Gladstone,
 October 1880. Fitzwilliam

9. H.M.G. 9 August 1894

10. Castle Howard, E.B.J. to G.H. 1
 January 1885

11. Letter to William Michael
 Rossetti 3 July 1882.
 Fitzwilliam

12. R.D. p. 476

13. H.M.G. August 1893

14. Letter to Mrs Cassavetti 7
 August 1883. Mr Francis
 Cassavetti

15. Letter to Swinburne, undated,
 1883. Brotherton Colletion,
 University of Leeds

16. R.D. p. 472

17. R.D. p. 32

18. Life at Wortley Hall is
 described by the Wharncliffes'
 niece, Lady Tweedsmuir, in *The
 Lilac and the Rose* (1952)

Chapter 14

1. Letter to F.G. Stephens,
 undated, 1886. Boldeian

2. Letter to Watts, undated,
 1881. Watts Gallery

3. H.M.G. undated, 1894

4. H.M.G. August 1894

5. Castle Howard, E.B.J. to G.H.
 January 1885

6. Letter to F.G. Stephens, June
 1885. Bodleian

7. Margaret Burne-Jones to
 Watts, dated 'the Saturday
 before Good Friday', 1887.
 Watts Gallery

8. Castle Howard, E.B.J. to G.H.
 November 1887

9. Letter to Watts, undated,
 1887. Watts Gallery

10. Burne-Jones's will was signed

on 21 August 1888 and probate was granted on 12 July 1898. He left (after the sale of pictures still in the studio) £53,493 9s. 7d. Later codicils refer to advances made to Phil and Margaret to be taken into account in part satisfaction of their shares

11. Letter to Selwyn Image undated. Bodleian
12. Letter to F.G. Stephens 8 October 1888. Bodleian
13. Castle Howard, E.B.J. to G.H. 5 September 1887
14. H.M.G. July 1894
15. H.M.G. 25 March 1893
16. Letter to Miss E. Muir, 9 June 1890. Fitzwilliam
17. R.D. p. 535
18. H.M.G. undated, 1893
19. article in La Revue du Louvre et des Musées de France no. 6, 1972
20. These details are from Charles Carrington's *Rudyard Kipling* (1955)
21. H.M.G. January 1893

Chapter 15
1. R.D. p. 519
2. Letter to F.G. Stephens, undated, 1890. Bodleian
3. Letter to Mrs Stillman, December 1889. Fitzwilliam
4. H.M.G. 24 April 1897
5. H.M.G. marked 'late 1892 or early 1893'
6. R.D. p. 407
7. Marked 'early 1893'
8. H.M.G. 16 January 1893
9. H.M.G. 1 April 1895
10. H.M.G. July 1893
11. H.M.G. September 1894
12. H.M.G. 16 May 1896
13. R.D. p. 512
14. Letter to Watts, undated,

1891. Watts Gallery
15. Letter to Watts, undated, 1891. Watts Gallery
16. H.M.G. undated, 1893
17. R.D. p. 529. Burne-Jones, however, told Mrs Gaskell that he had only seen the sea twice before he was twenty-three

Chapter 16
1. H.M.G. marked May-June 1894
2. R.D. pp 9–10
3. W.H. Kendrick to Sebastian Evans 5 December 1885. Bodleian
4. H.M.G. 13 October 1894
5. H.M.G. 'latest night', 20 March 1895
6. H.M.G. 26 October 1894
7. H.M.G. 26 October 1894
8. H.M.G. undated, 1893
9. H.M.G. undated, marked 'such a lovely letter'
10. H.M.G. 13 May 1893. 'D.D.' was the pet name of Edith Balfour, who became the second Mrs Alfred Lyttelton
11. Letter to Mrs Norman Grosvenor, marked December 1892 or January 1893. Lady Tweedsmuir
12. H.M.G. 14 August 1893
13. Burne-Jones's only other exhibit at the R.A. was a set of drawings for *Troilus and Criseyde* in 1894
14. Letter to Watts 10 February 1893. Watts Gallery
15. W. Rossiter was a member of the Work-Men's College and the founder of the South London Gallery
16. H.M.G. March 1893
17. H.M.G. 9 March 1893
18. H.M.G. 13 May 1893

19. H.M.G. May 1893
20. Letter to Mary Drew, undated, 1893. Fitzwilliam
21. personal information
22. H.M.G. marked 'late 1892 or early 1893'
23. H.M.G. marked '1893–4'
24. Sidney Cockerell to May Morris 8 June 1922. The Clover Hill edition of *Cupid and Psyche* (1974) gives an opportunity to compare collotypes of the original drawings with the wood engravings
25. R.D. p. 24
26. H.M.G. undated, Sunday 1895
27. R.D. p. 564
28. R.D. p. 522. Burne-Jones was probably wrong about Mabel's expression, but was certainly one of the earliest admirers of her red hair, which was to be immortalised in Yeats's *To A Dying Lady* and Ezra Pound's *Pisan Cantos*
29. H.M.G. July 1893
30. R.D. p. 541 *The Merciful Knight* reappeared in Birmingham on 9 May 1898, and is now in the Birmingham City Art Gallery
31. Letter to Olive Maxse 20 October 1893. Lord Hardinge of Penshurst

Chapter 17
1. R.D. p. 429
2. Letter to Norman Grosvenor, undated, 1894. Lady Tweedsmuir
3. H.M.G. marked 'Jan-Feb 1894'
4. H.M.G. 9 August 1894
5. H.M.G. 23 July 1894
6. There are copies of these pamphlets at the Grange Museum, Rottingdean
7. letter to Watts, undated 1894, Watts Gallery

8. H.M.G. 20 April 1895
9. letter to Mrs Ady 27 November 1894. Fitzwilliam
10. H.M.G. 28 September 1894
11. H.M.G. 22 July 1894
12. H.M.G. 11 July 1894
13. H.M.G. marked 'Jan-Feb 1895'
14. This account is taken from H.M.G. 6 January 1895, Mrs Comyns Carr's reminiscences, and the review of the first night in *The Times*
15. H.M.G. 30 March 1895
16. H.M.G. May 1895
17. R.D. p. 409
18. H.M.G. 13 October 1894
19. H.M.G. undated, 1894
20. H.M.G. 1 April 1895
21. H.M.G. May 1894
22. H.M.G. April 1895
23. R.D. p. 72
24. H.M.G. 2 May 1896
25. H.M.G. 1 April 1895
26. H.M.G. 25 May 1895
27. Letter to Mary Drew, undated, 1895. Fitzwilliam
28. H.M.G. 1 May 1895
29. R.D. p. 474
30. Letter to Fairfax Murray 2 September 1895. Fitzwilliam
31. R.D. p. 172
32. Letter to Lady Rayleigh, Xmas 1895. Fitzwilliam
33. R.D. p. 458
34. R.D. p. 156
35. Letter to F.G. Stephens 7 May 1896. Bodleian
36. R.D. p. 228
37. H.M.G. 22 February 1896
38. 24 April 1896
39. R.D. p. 498
40. R.D. p. 213
41. R.D. p. 276
42. Castle Howard, E.B.J. to G.H. 20 August 1896
43. Jane Morris to Lucy Faulkner

15 August 1896.
Walthamstow
44. R.D. p. 277

Chapter 18

1. Letter to Olive Maxse, undated 1896. Lord Hardinge of Penshurst
2. H.M.G. 9 October 1896
3. G.B.J. to Mrs Pat Campbell 6 October 1896. Quoted by E. Penning-Rowsell in the *William Morris Society Journal*, vol: 2 no. 1 Spring 1966
4. Letter to Mary Drew, undated, 1896. Fitzwilliam
5. H.M.G. 24 April 1897
6. H.M.G. June 1897
7. R.D. p. 424
8. R.D. p. 421
9. R.D. p. 404
10. H.M.G. February 1893
11. H.M.G. undated, 1897
12. H.M.G. September 1897
13. R.D. p. 497
14. R.D. p. 460
15. R.D. p. 478
16. Birket Foster's house at Witley and his collections were sold in 1894, and he went into retirement until his death in 1899
17. Letter to Dr Jessop 21 April 1897. Fitzwilliam
18. H.M.G. undated, 1897
19. R.D. p. 552
20. Three versions of this drawing exist, one in the possession of Mrs Gaskell's family, one in the Colbeck Collection, and one in the Courtauld Institute of Art
21. R.D. p. 553
22. R.D. p. 569

APPENDIX 1: SOURCES

1 Unpublished Material

PRIVATE COLLECTIONS

Mr Francis Cassavetti — Letters to Mrs Cassavetti

Miss Mary Chamot — Burne-Jones's Italian notebook, Sept-Oct 1871

Lord Hardinge of Penshurst: — Letters to Olive Maxse

The Dowager Lady Hardinge of Penshurst: — Letters to Violet Maxse

Mr George Howard: — Letters to George and Rosalind Howard

Mrs Celia Rooke: — Diary of T.E. Rooke

Mr Lance Thirkell: — Burne-Jones and Macdonald papers

Lady Tweedsmuir: — Letters to Norman Grosvenor and Mary Stuart Wortley

PUBLIC COLLECTIONS

British Museum: — Letters to Arthur Balfour, Add MSS 49838
the Dalziels, Add MSS 39168 ff. 59, 61
Mary Drew, Add MSS 46246
Mrs Gaskell, Add MSS 34217–8 LL 1935
Cockerell Papers, Add MSS 52078 vol. LXXXVI & CL
Morris: Shorter Poems, some unpublished, copied by Mrs Jane Morris, Add MSS 45298B

Morris: the unpublished novel, Add MSS 45328
D.G. Rossetti: letters to Jane Morris, Add MSS 52333A
Georgiana Burne-Jones: letters to May Morris, Add MSS 45347
Dr D.T. Zambaco: letters to Mme. Onou, Add MSS Eg3234

UNPUBLISHED MATERIAL

Bodleian Library:	Letters to F.G. Stephens
Brotherton Collection,	Letters to Swinburne, Watts-Dunton, and D.G. Rossetti
Colbeck Collection, University of British Columbia:	Letters to D.G. Rossetti, with some annotations by W.M. Rossetti
Fitzwilliam Museum Library:	Materials for the *Memorials*, deposited by Lady Burne-Jones Burne-Jones's account book with Morris & Co., 1861–97 Burne-Jones's working list (incomplete) of paintings, from 1862
Miriam Lutcher Stark Library, University of Texas:	Letters from D.G. Rossetti to C.A. Howell
Watts Museum and Gallery, Compton, Surrey:	Letters to G.F. Watts
William Morris Gallery, Walthamstow:	Notebooks of J.W. Mackail Letters to Charles and Lucy Faulkner from William Morris and Mrs Jane Morris
Victoria and Albert Museum:	Letters from Warington Taylor to Philip Webb, William Morris and D.G. Rossetti, 1866–9, Reserve Case JJ35

2 Select Bibliography

ALEXANDRE, Arsène *Sir Edward Burne-Jones* (2nd series), Newnes' Art Library, 1907

ALLINGHAM, William *William Allingham: A Diary*, ed. H. Allingham and E.B. Williams, Longman, 1911

ALMA-TADEMA *Sir Alma Tadema's World-Famous Home*, Sale Catalogue, Hampton & Sons, 1919

ANGELI, Helen Rossetti *Pre-Raphaelite Twilight: the Story of Charles Augustus Howell*, Richards Press, 1954

ASQUITH *The Autobiography of Margot Asquith*, introduced by Mark Bonham Carter, Eyre & Spottiswoode, 1962

BALDRY, A.L. *Burne-Jones: illustrated with 8 reproductions in colour*, T.B. & E.C. Jack, 1909

BALDWIN, A.W. *The Macdonald Sisters*, Peter Davies, 1960

BALFOUR, Arthur *Chapters of Autobiography*, Cassell, 1930

BALFOUR, Lady Frances *Ne Obliviscaris: Dinna Forget*, Hodder & Stoughton, 1930

BARRINGTON, Mrs G.L. *The Life, Letters, and Work of Frederic Leighton*, George Allen, 1906

BATTERSEA, Constance Lady BELL, Malcolm *Reminiscences*, Macmillan, 1922

—— *Edward Burne-Jones: A Record and Review*, Bell, 1892

BERLIN PHOTOGRAPHIC COMPANY T*he Works of Edward Burne-Jones. Ninety-One Photogravures reproduced from the original paintings*, 1901

BLYTH, Henry *Smuggler's Village: the Story of Rottingdean*, Privately printed, no date

BIRKENHEAD, Sheila *Illustrious Friends*, Hamish Hamilton, 1965

BROOKE, Stopford *Life and Letters*, ed. L.P. Jack, John Murray, 1917

BUFFENOIRE, Hyppolite *Les Salons de Paris: Grandes Dames Contemporaines: La Baronne Deslandes*, Paris, 1895

BURNE-JONES, Georgiana (G. B-J.) *Memorials of Edward Burne-Jones*, Macmillan, 1904

—— *Address to the Electors of Rottingdean*, Privately printed, 1894

—— *What We Have Done*, Privately printed, 1896

BURNE-JONES, Sir Philip *Notes on some unfinished works of Sir Edward Burne-Jones, Bart.*, Magazine of Art, vol. XXIII (1900)

CAMPBELL, Mrs Patrick *My Life and Some Letters*, Hutchinson, 1925

CARR, Mrs Alice Comyns *Reminiscences*, ed. Eve Adam, Hutchinson, 1925

CARR, J. Comyns *Some Eminent Victorians*, Duckworth, 1908

—— *Coasting Bohemia*, Macmillan, 1914

—— *Introduction, Catalogue for the New Gallery Retrospective of the work of Sir Edward Burne-Jones, Bart.*, 1898

CARRINGTON, Charles *Rudyard Kipling: his Life and Work*, Macmillan, 1955

CARTWRIGHT, Julia *Sir Edward Burne-Jones, Bart*, The Art Annual (Art Journal, Christmas Number), Virtue, 1894

CHANDLER, Alice *A Dream of Order: The Mediaeval Ideal in Nineteenth Century English Literature*, Routledge & Kegan Paul, 1971

CHRISTIAN, John Gordon *Introduction, Catalogue for the Burne-Jones Commemorative Exhibition, Fulham Library*, 1967

COHEN, Lucy *Lady de Rothschild and her Daughters, 1821–1931*, John Murray, 1935

CLIFFORD, Edward *Broadlands As It Was*, Lindsey, 1890

COLVIN, Sidney *Memories and Notes of Persons and Places 1852–1912*, Arnold, 1921

—— *Edward Burne-Jones, The Portfolio*, February 1870

CRANE, Walter *An Artist's Reminiscences*, Methuen, 1907

CRATHORNE, Nancy with Katherine Elliot of Harwood and James Dugdale, *Tennant's Stalk*, Macmillan, 1973

DALZIEL *The Brothers Dalziel: a Record of Fifty Years Work*, Methuen, 1901

DE LISLE, Fortunée *Burne-Jones* (Little Books on Art), Methuen, 1904

DENT, Robert *The Making of Birmingham*, J.L. Allday, 1904

DIGBY, Sir Kenelm *The Broadstone of Honour, or the True Sense and Practice of Chivalry*, London, 1822 (Editions of 1845–8 are without Book 4)

DOUGHTY, Oswald *A Victorian Romantic: Dante Gabriel Rossetti*, Muller, 1949

DUFTY, A.R. *Introduction to The Story of Cupid and Psyche* (reproductions of the original woodcuts for the *Earthly Paradise*), Clover Hill Press, 1974

DUGDALE, Blanche *Arthur James Balfour, by his niece, Blanche Dugdale*, Hutchinson, 1936

DU MAURIER *The Young Du Maurier: a Selection of his Letters, 1860–1870*, ed: Daphne du Maurier, Peter Davies, 1951

DUNN, Henry Treffry *Recollections of Dante Gabriel Rossetti & his circle*, Elkin Matthews, 1904

EDEL, Leon *Henry James*, Hart-Davis, 1953–62

ELIOT, George *The George Eliot Letters*, ed. G.S. Haight, Oxford University Press, 1954–6

EVANS, Sebastian *The High History of The Holy Graal, translated from Volume 1 of Perceval le Gallois*, Dent, 1898

FALK, Bernard *Five Years Dead*, Hutchinson, 1938 (includes reminiscences of Simeon Solomon)

FILDES, L.V. *Luke Fildes, R.A.: A Victorian Painter*, Michael Joseph, 1968

FORBES-ROBERTSON, Sir J. *A Player Under Three Reigns*, Fisher Unwin, 1925

FOUQUE, H. de la Motte *The Seasons: Four Romances from the German*, London, 1843 (*Sintram and his Companions* is the winter romance)

FREDEMAN, W.E. *Pre-Raphaelitism: A Bibliocritical Study*, Harvard, 1965

—— *Prelude to the Last Decade: D.G. Rossetti in the summer of 1872, Bulletin of the John Rylands Library*, vol. 53, no. 1 Autumn 1970 & vol. 53, no. 2 Spring 1971

FRITH, W.P. *My Autobiography and Reminiscences*, Richard Bentley, 1887

FRY *Letters of Roger Fry*, ed: Denys Sutton, Chatto & Windus, 1972

GAUNT, W., and M.D.E. Clayton-Stamm *William de Morgan*, Studio Vista, 1971

GIROUARD, Mark *The Victorian Country House*, Oxford University Press, 1971

GLADSTONE *Diaries and Letters of Mary Gladstone*, ed. Lucy Masterman, Methuen, 1930

GRYLLS, Rosalie Glynn *Portrait of Rossetti*, Macdonald, 1964

HAIGHT, Gordon S. *George Eliot, a Biography*, Oxford University Press, 1968

HENDERSON, Philip *William Morris: His Life, Work, and Friends*, Thames & Hudson, 1967

—— *Swinburne*, Routledge & Kegan Paul, 1974

HENLEY, Dorothy *Rosalind Howard, Countess of Carlisle*, Hogarth Press, 1958

HOLIDAY, Henry *Reminiscences of My Life*, Heinemann, 1914

—— *Stained Glass as an Art*, Macmillan, 1896

HOPKINS, G.M.*Notebooks and Papers of Gerard Manley Hopkins*, ed. Humphrey House, Oxford University Press, 1937

—— *Correspondence of Gerard Manley Hopkins and Richard Watson Dixon*, ed. C.C. Abbott, Oxford University Press, 1935

HORNER, Frances *Time Remembered*, Heinemann, 1933

HUEFFER, Ford Madox *Ford Madox Brown: A Record of his Life and Work*, Longman, 1896

HUNT, W. Holman *Pre-Raphaelitism and the Pre-Raphaelite Brotherhood*. Macmillan, 1905–6

IONIDES, Alexander *'Ion', a Grandfather's Tale*, Cuala Press, 1927

IONIDES, Luke *Memories*, privately printed, Paris, 1925

IRONSIDE, Robin *Pre-Raphaelite Painters*, with a descriptive catalogue by John Gere, Phaidon, 1948

JACOBS, Joseph *Some Recollections of Edward Burne-Jones*, Nineteenth Century vol. XLV, January 1899

KING, A.W *An Aubrey Beardsley Lecture*, R.A. Walker, 1924

KIPLING, Rudyard *Language of Something of Myself*, Macmillan, 1937

'FLOWERS, THE' Anonymous, printed Edinburgh, 1849

LESLIE, G.G. *The Inner Life of the Royal Academy*, John Murray, 1914

LETTERS TO KATIE (Burne-Jones's letters to Katie Lewis) ed. W. Graham Robertson, Macmillan, 1925

LEVEY, Michael *Botticelli and Nineteenth Century England*, Journal of the Warburg and Courtauld Institutes, vol. XXIII, July-December 1960

LOWNDES *Diaries of Marie Belloc Lowndes, 1911–1947*, ed. Susan Lowndes, Chatto & Windsus, 1971

LYTTELTON, Lord *Glynnese Glossary* (the private language of the Glynne, Lyttelton and Gladstone families), privately printed, no date

MAAS, Jeremy *Victorian Painters*, Barrie & Jenkins, 1969

MACDONALD, Grenville *George Macdonald and his Wife*, Allen & Unwin, 1924

MACKAIL, J.W. *The Life of William Morris*, Longman, 1899

MALLOCK, W.H. *The New Republic: or, Culture, Faith and Philosophy in an English Country House*, London, 1877

MEINHOLD, Johann Wilhelm *Sidonia the Sorceress*, translated by Mrs Wilde, Parlour Library, 1849

MILLAIS, J.G. *The Life and Letters of Sir J.E. Millais*, Methuen, 1899
—— *Sir John Millais: his House and Studio*, Magazine of Art, vol. 4, 1881
MILNER, Viscountess *My Picture Gallery, 1886–1901*, Murray, 1951
MORRIS, May *William Morris, Artist, Writer, Socialist*, Blackwells, 1936
MORRIS, William *Letters of William Morris to his Family and Friends*, ed. Philip Henderson, Longman, 1950
NORTON *Letters of Charles Eliot Norton with biographical comment by his daughter Sara Norton and M.R. de Wolfe Howe*, Constable, 1913
NOTES & QUERIES Series X, vol. III, 88, vol. X 427, 491 (queries about *Phyllis and Demophoon* and *The Golden Stairs*)
ORMOND, Richard *A Pre-Raphaelite Beauty* (Marie Stillman), Country Life, 30 December 1965
PAIN, Amanda *St. Eva*, Osgood, McIlvane, 1897
PELLECER, a Cirici *El Arte Modernista Catalana*, Aymà Editor, 1951
PENNELL, E.R. & J. *The Whistler Journal*, Lippincott Co., 1921
—— *The Life of James McNeil Whistler*, Heinemann, 1908
POTTER, Beatrix *The Journal of Beatrix Potter 1881–1897*), transcribed by Leslie Linder, F. Warne & Co., 1966
PRINSEP, Valentine *Reminiscences*, The Magazine of Art, vol. XXIV, 1904
QUILTER, Harry *Preferences in Art, Life and Literature*, Swannenschein<I>, 1892
RICHMOND *The Richmond Papers*, ed. A.M.W. Stirling, Heinemann, 1926
ROBERTSON, W. Graham *Time Was*, Hamish Hamilton, 1931
ROBICHEZ, Jacques Le Symbolisme au Théatre Lugné-Poe et les débuts de L'Oeuvre, L'Arche Editeur, 1957
ROGET, J.L. *The Old Watercolour Society: with an account of its schools and exhibitions, principally in the reign of Queen Victoria*, Longman, 1891
'ROMANCE OF MERLIN' *Roman de Merlin, translated in 1450*, ed. H.B. Wheatley, Early English Text Society, 1865
ROOKE, T.M. *Introduction to the catalogue of the Tate Gallery Centenary exhibition of the work of Burne-Jones, June 7 1933*
ROSSETTI, D.G. *Letters of Dante Gabriel Rossetti*, ed. O. Doughty and J.R. Wahl, Oxford University Press, 1965–7
ROSSETTI, W.M. *Rossetti Papers 1862–70*, Sands, 1930
—— *D.G. Rossetti: His Family Letters, with a Memoir*, Ellis & Ellis, 1895
—— *The P.R.B. Journal, Pre-Raphaelite Diaries and Letters*, Hurst & Blackett, 1900
ROTHENSTEIN, Sir William *Men and Memories*, Faber, 1931
ROYAL ACADEMY *Laws Relating to the School, the Library and the Students*, 1862
RUSKIN, John *Mythic Schools of Painting: E. Burne-Jones and G.F. Watts*, in *The Art of England*, Allen, 1883
—— *On the Present State of Modern Art*, The Works of John Ruskin, Library Edition, ed. E.T. Cook and A.D.O. Wedderburn, vol. XIX, Allen, 1902–12
—— *Letters to M.G. (Mary Gladstone) and H.G.*, ed. the Rt. Hon. George Wyndham, Privately printed, 1903
—— *Diaries of John Ruskin 1838–47* and *Diaries of John Ruskin 1848–73*, ed. Joan Evans and John Howard Whitehouse, 1956 and 1958

APPENDIX 1: SOURCES

—— *The Winnington Letters*, ed. Van Akin Burd, Allen & Unwin 1969

—— *Sublime and Instructive: Letters from John Ruskin to Louisa Marchioness of Waterford, Anna Blunden, and Ellen Heaton*, ed. Virginia Surtees, Michael Joseph, 1972

RUSSELL, Bertrand and Patricia *The Amberley Papers* (includes reminiscences of Rosalind Hoard and of Burne-Jones at Naworth), Hogarth Press, 1937

ST MARGARET'S CHURCH ROTTINGDEAN *Parish Magazine*, 1896-

SEWTER, A.C.*The Stained Glass of William Morris and his Circle*, Yale University Press, 1974–5

SHANNON, R.T. *Gladstone and the Bulgarian Agitation*, Nelson, 1964

SHAW, G.B. *William Morris As I Knew Him* (Preface to vol. II of *William Morris, Artist, Writer, Socialist*), Blackwell, 1936

SIZERANNE, Robert de la *La Peinture Anglaise Contemporaine*, Hachette, 1895

—— *The Late Sir Edward Burne-Jones, Bart., D.C.L.* Supplement to *The Artist* vol. XXII. June 1889

STEPHENS, F.G *Edward Burne-Jones, A.R.A., The Portfolio*, vol. XVI, November 1885 and December 1885

—— *D.G. Rossetti, The Portfolio*, Seeley & Co., 1894

STEVENSON, C.R. *Sir Edward Burne-Jones*, O.W.S. Club 9th Annual Volume, 1932 (includes a list of Burne-Jones's exhibits at the O.W.S.)

STIRLING, A.M.W. *William de Morgan and his Wife*, Butterworth, 1922

SURTEES, Virginia *The Paintings and Drawings of D.G. Rossetti: A Catalogue Raisonné*, Oxford University Press, 1971

SWINBURNE, Algernon *Letters*, ed. Cecil Y. Lang, Yale University Press, 1939

THIRKELL, Angela *Three Houses*, Oxford University Press, 1931

THOMPSON, E.P. *William Morris, Romantic to Revolutionary*, Lawrence & Wishart, 1955

TILLOTSON, G. and K. *Mid-Victorian Studies*, Athlone Press, 1965

TUCKWELL, REVD W. *Reminiscences of Oxford*, Smith Elder, 1907 (includes recollections of Rossetti and his circle at the Oxford Union)

TWEEDSMUIR, Lady *The Lilac and the Rose*, Duckworth, 1952 (includes recollections of Norman Grosvenor and Lord Wharncliffe)

VALLANCE, Aymer *The Decorative Art of Sir Edward Burne-Jones, Baronet*, The Art Journal, Easter Number, Virtue, 1900

WATERS, B. AND MARTIN HARRISON *Burne-Jones*, Barrie & Jenkins, 1973

WATTS, Mary S. *George Frederic Watts: The Annals of an Artist*, Macmillan, 1912

WILDE, Oscar *Letters of Oscar Wilde*, ed. Rupert Hart-Davis, Hart-Davis, 1962

WILLIAMSON, G.C. *Murray Marks and his Friends*, John Lane, 1912

WILSON, Michael *The Case of the Victorian Piano*, Victoria & Albert Museum Yearbook no. 3, 1972

WOOD, T. Martin *Introduction to Drawings of the Great Masters: The Drawings of Sir Edward Burne-Jones*, Newnes, 1907

WORKING MENS COLLEGE MAGAZINE ed. R.B. Litchfield, January 1859–1862

YEATS, W.B. *Autobiographies*, Macmillan, 1926

YONGE, Charlotte M. *The Heir of Redcliffe*, John W. Parker, 1853

ZAMBACO, Dr D.A. *Mémoire sur la Lèpre Observée à Constantinople*, Paris, 1887

ADDENDUM TO BIBLIOGRAPHY, 1997, by Cathy Gere

Place of publication is London unless otherwise stated.

APOLLO MAGAZINE *Special issue on Burne-Jones*, November 1975 (includes articles by L. Lambourne, J. Christian, B. Waters, M. Lago.)

ARTS COUNCIL *Catalogue, Burne-Jones: the paintings, graphic and decorative work of Sir Edward Burne-Jones, 1833–98*, ed. Penelope Marcus, Hayward Gallery, 1975–6

ASH, Russell *Sir Edward Burne-Jones* Pavilion Books, 1993

BARTRAM, Michael *The Pre-Raphaelite Camera*, Weidenfeld and Nicolson, 1985

BROWN, Ford Madox *The Diary of Ford Madox Brown*, ed. Virginia Surtees, New Haven, Yale University Press, 1981

CASSIVETTI, Eileen 'The Fatal Meeting and the Fruitful Passion: Edward Burne-Jones and Mary Zambaco,' in *Antique Collector*, March 1989, pp. 34–45

CECIL, David *Visionary and Dreamer: Two Poetic Painters, Samuel Palmer and Edward Burne-Jones*, Princeton, New Jersey, Princeton University Press, 1983

CHRISTIAN, John *Introduction, Letters to Katie from Edward Brune-Jones*, British Museum Publications, 1988

—— *Introduction, The Fairy Family: a series of Ballads and Metrical Tales illustrating the Fairy Faith of Europe*, by Archibald Maclaren, illustrated by Edward Burne-Jones, North Berwick, East Lothian, Dalrymple Press, 1985 'A Serious Talk: Ruskin's place in Burne-Jones's artistic development,' in *Pre-Raphaelite Papers*, ed. Leslie Parris, Tate Gallery Publications, 1984

—— *Introduction, The Little Holland House Album*, by Sir Edward Burne-Jones, North Berwick, Dalrymple Press, 1981 (facsimile of an album of poems transcribed and illustrated by Edward Burne-Jones)

DORMENT, Richard 'Burne-Jones's Roman Mosaics' in *Burlington Magazine*, February 1978, pp. 72–82

LAGO, Mary (ed) *Burne-Jones Talking*, John Murray, 1981

MacCARTHY, Fiona *William Morris, a Life for Our Time*, Faber and Faber, 1994

MARSH, Jan *The Pre-Raphaelite Sisterhood*, Quartet, 1985

MERRILL, Linda *A Pot of Paint: Aesthetics on Trial in Whistler v. Ruskin*, Washington and London, Smithsonian Institution Press, 1992

NEWALL, Cristopher *Grosvenor Gallery Exhibitions: Change and Continuity in*

the Victorian Art World, Cambridge University Press, 1995

NEWMAN, Teresa and WATKINSON, Ray *Ford Madox Brown and the Pre-Raphaelite Circle*, Chatto & Windus, 1991

POULSON, Christine 'Costume Designs by Burne-Jones for Irving's Production of King Arthur,' in *Burlington Magazine*, January 1986, pp 18–24

RUSSELL, Frances 'Advice to a Young Traveller from Burne-Jones: Letters to Agnes Graham, 1876,' in *Apollo*, December 1978, pp 424–7

TATE GALLERY *Catalogue, The Pre-Raphaelites*, Tate Gallery, 1984

TAYLOR, Ina *Victorian Sisters: the remarkable MacDonalds and the four great men they inspired*, Weidenfeld and Nicolson, 1987

WARRELL, Ian *Catalogue essay, Burne-Jones, watercolours and drawings*, Tate Gallery, 1993

APPENDIX 2: PAINTINGS BY BURNE-JONES MENTIONED IN THE TEXT AND NOW IN PUBLIC COLLECTIONS

Of the more important pictures mentioned in the text, the following are in private collections: *Beatrice, Fair Rosamund, Green Summer* (1868 version), *Heart of the Rose*, and the portraits of Frances Balfour, Georgiana Burne-Jones, Margaret Burne-Jones, Dossie Drew, Mary Gladstone, Frances Graham, Cecily Horne, Katie Lewis, Lady Windsor (the Countess of Plymouth).

The following are in public collections, or in private collections which are shown to the public:

Annunciation, The (1876–9) Lady Lever Gallery, Port Sunlight
Avalon (begun 1881) Ponce Museum of Art, Puerto Rico
Beguiling of Merlin, The (1872–7) Lady Lever Gallery, Port Sunlight
Briar Rose (1894) Buscot Park, Faringdon
Chant d'Amour (1865) Museum of Fine Arts, Boston
Danae (1888 version) Glasgow City Art Gallery
Depths of the Sea, The (1886) Fogg Art Museum, Cambridge, Mass.
Flower Book (original watercolours) British Museum Print Room
Golden Stairs, The (1876–80) Tate Gallery, London
Hesperides, The (1870–3 version) Birmingham Museums & Art Gallery
King Cophetua and the Beggar Maid (1880–4) Tate Gallery, London
Laus Veneris (1873–5) Laing Art Gallery, Newcastle
Love Among the Ruins (1894 version) Wightwick Manor, Wolverhampton
Love and the Pilgrim (1877–97) Tate Gallery, London
Love's Wayfaring (begun 1872) Victoria & Albert Museum, London
Merciful Knight, The (1863) Birmingham Museums & Art Gallery
Merlin and Nimuë (1861) Victoria & Albert Museum, London
Mill, The (1870–82) Victoria & Albert Museum, London
Phyllis and Demophoön (1870) Birmingham Museums & Art Gallery
Sidonia and Clara Van Bork (1860) Tate Gallery, London
Sirens, The (begun 1870) Ringling Museum, Sarasota, Florida
Sibylla Delphica (1886) Manchester City Art Gallery
Sponsa di Libano (1891) Walker Art Gallery, Liverpool
Vespertina Quies (1893) Tate Gallery, London
Wheel of Fortune, The (1872–6 version) Hammersmith Public Libraries, Fulham Branch

INDEX

Notes: Edward Burne-Jones is abbreviated to EBJ. Works are by Burne-Jones, except where indicated.

parties 96–9, 113, 114
'Passionate Brompton' (PB) 171–2,
 174
Pater, Walter 115, 148, 172
patrons 51–2, 91, 97
Perseus 217, 228, 242, 284
Perugino 48, 134
Phyllis & Demophoön 122–4, 127,
 147
Piero della Francesca 134, 135,
 152–3
Plint, T.E. 52, 57, 61, 66, 69, 85
Poetry of Christian Art (Rio) 49–50
politics 158, 160, 161–4, 189,
 192–4, 207, 220, 222
 see also under Burne–Jones,
 Georgiana
portrait painting 129, 174–5, 178,
 180–1, 224, 267
Poynter, Edward 90, 96, 101, 167,
 170, 188
Pre-Raphaelite Brotherhood (PRB)
 18–19, 23, 26, 35–6, 46,
 53–5, 85
Price, Cormell "Crom" 7–9, 10, 23,
 27, 163, 280
 EBJ's letters to 12, 15, 22, 68
Princep, Mrs 47, 55, 56, 57, 64
Princep, Val 47, 53–5, 57, 59–60,
 97
Prominent Women 190, 234
Prospect House, Rottingdean
 178–9, 196–7, 226, 246,
 250, 260
Psyche series 188, 266
Punch 96, 162, 211, 217–18

Rape of Persephone 200
Red House 66, 80, 87–9
Red Lion Mary 45, 46, 58, 59, 71
Red Lion Square 44–5, 47, 55–6,
 58, 59, 74
reproductions 31, 185
reviews 123, 126, 167–8, 183,
 223–4, 228, 259, 264
Robertson, Graham 230, 283
Rome 133–4, 186, 212

Rooke, Thomas 5, 14, 22, 24, 131,
 136, 229, 230
 studio diary 230
Rossetti, Dante Gabriel (1828–82)
 18, 29, 44, 75–6, 88, 91,
 102
 and women 35, 40, 45; and du
 Maurier 96;
 and EBJ
 apprenticeship 33–50; first
 meeting with 33–6;
 friendship 51, 59–60,
 61–2, 70, 116, 165–6;
 infatuation with 29, 31,
 32, 36–7, 41
 and the firm 67, 68, 70, 94,
 155; and Howell 125; and
 Janey Morris 117–18,
 136; and Mary Zambaco
 120–1; and Morris 35,
 41–2, 66–7, 118; and the
 PRB 53–5, 65;
 breakdowns 145, 155–6;
 character 39–40; reaction
 to wife's death 71, 74;
 studio described 34–5;
 illness & death 190,
 191–2; *Dante drawing the
 Angel* 23, 31; *Fra Pace* 35,
 45; *Hand and Soul* 40–1,
 46; *Maids of Elfenmere* 29,
 31, 32, 64; *Mary
 Magdalene* 58–9
Rossetti, William Michael 34, 52,
 113, 169–70
Rothenstein, William 230, 254, 268
Rottingdean 236–7, 258, 267,
 269–70, 278, 291
 see also Prospect House
Royal Academy 30–1, 36, 43, 61,
 75, 166, 209–13
 EBJ resigns from 247
Ruskin, John 14, 17, 33, 60, 91,
 157, 227
 on beauty & morality 4–5,
 18–19; at the Working
 Men's College 34, 58;